# Tattoo FAQ

# Tattoo FAQ

## All That's Left to Know About Skin Art

Holly Day

Backbeat
Books

Guilford, Connecticut

Published by Backbeat Books

An imprint of The Rowman & Littlefield Publishing Group, Inc.

4501 Forbes Blvd., Ste. 200, Lanham, MD 20706

www.rowman.com

Distributed by NATIONAL BOOK NETWORK

The FAQ series was conceived by Robert Rodriguez and developed with Stuart Shea.

All images are from the author's collection unless otherwise noted.

Book design and composition by Snow Creative

Library of Congress Cataloging-in-Publication Data available

ISBN 9781493047635 (paperback)

ISBN 9781493050772 (e-book)

♾™ The paper used in this publication meets the minimum requirements of American National Standard for Information Sciences—Permanence of Paper for Printed Library Materials, ANSI/NISO Z39.48-1992

Printed in the United States of America

To Sherman, Wolfgang, and Astrid, with so much love.

# Contents

# Acknowledgments

This book could not have been possible without the contributions from the following truly amazing tattoo artists: Vincent Castiglia, Myles Karr, Roxx, Amanda Wachob, Jessica Weichers, Dan Sinnes, Lionel Fahy, Nuno Costah, Colin Dale, Yasmine Bergner, and Joey Pang. An impossibly huge "thank you" goes out to my dear friend Emek, who never fails to come through when I beg him for art.

# Introduction

When I was fourteen, I got my very first tattoo. I had just stepped into my best friend's house when he jumped at me with a safety pin wrapped in ink-soaked thread and started poking at my arm. Not wanting to seem like a "girl," I watched him, bemused, until he finished—and then I had it: a two-inch-square hand-poked cross tattoo on my upper arm.

"Now you do me!" he ordered, and so I did—and that's the story of both the first time I got a tattoo, and the first time I gave someone a tattoo.

Skip ahead to five years later, when I was nineteen and had just moved into my first apartment. I couldn't think of any better way to commemorate moving into my new place than giving myself another tattoo—this time, a blurry skull and crossbones on my ankle. My roommate, Leigha—who was the coolest person I'd ever met, down to the amazing black widow spider tattooed on her stomach—sat there watching me stab myself over and over with a needle jammed into the end of a pencil for most of the night, occasionally offering to take me to a real tattoo artist when this thing I was doing had healed enough to cover it up with something decent.

I never did get the crappy tattoo on my ankle covered, and wore it and my first cross tattoo as a badge to my sometimes-regrettable youth. When I became a mother myself, I briefly contemplated getting my hand-poked tattoos covered with something nice—until my then-one-year-old son, Wolfgang, said my blurry skull-and-crossbones tattoo was a "very friendly frog," and the crooked, hand-poked Egyptian ankh tattoo on my big toe was actually "a little boy, just like me." How could I ever cover those tattoos up after that? And my first tattoo? I don't know what ever happened to my friend Nathan, but I always think of him when I see my faded cross, and I don't want to forget him.

This book is a culmination of both my interest in tattoos and tattoo culture as well as my absolute fascination with people in general. My two greatest loves in life have been history and anthropology, both in and out of the academic setting, and the universal practice of body modification seems to be one of the few unifying, cross-cultural links that ties all of mankind together. Whether it's been saints or priests tattooing themselves out of

penance, or indigenous Americans tattooing themselves in celebration, or girls enduring ritual tattoos on Fiji to celebrate coming of age, or some kid walking into a tattoo parlor or someone's living room to a waiting safety pin—off the street, tattoos are an integral part of our humanity's history, and an indelible way to mark the most important events in our lives.

# When Tattoos Became Mainstream

## A Brief Overview of the Practice

When did tattoos become mainstream? Perhaps a better question would be, when did tattoos *stop* being mainstream? For it seems that for as long as people have known that a smudge of ash rubbed into an opening in the skin would leave a permanent mark, tattoos have been a facet of some society, somewhere, throughout human history. Just because it's only grown in popularity in mainstream Western society during the past hundred or so years, it doesn't mean that it hasn't been a very common thing somewhere else in the world.

Every people on the planet have had a tradition of tattooing. From the ocean-faring Polynesians who spread their culture from Tahiti to Hawaii and New Zealand, to the ancient Egyptians and the nomads of Africa, to both North and South America and the ancient peoples of Eurasia and the Middle East, tattoos have been used to mark rites of passage, offer relief from pain and illness, provide magical protection against evil, or carry an identifying family mark. While the idea of having a tattoo has been, up until recently, considered a risqué activity of a certain subsection of the population, the reality is that getting a tattoo has been a fairly ordinary thing for most people to do for thousands and thousands of years.

All over the world, mummies have been found bearing evidence of tattoos, from "Ötzi," the famous five-thousand-year-old Iceman found frozen in a mountain range between Italy and Austria, to the four-thousand-year-old mummy of the Egyptian high priestess Amunet, to the three-thousand-year-old tombs of Pazyruk warriors discovered in Siberia, to one-thousand-year-old Incan mummies discovered in South America. Evidence of tattooing practices has even been discovered in caves in France and Spain, where tiny clay pots of pigment and bone needles have been dated as far back as fifteen thousand years.

## Magic and Tattoos

Most likely, the first tattoos were completely accidental. Perhaps someone got scraped in a fall and got ash in the wound, which left a distinct mark that remained long after the wound healed. Or perhaps the first mark was made while trying to remove a small insect buried under some person's skin, and the insect's blood permanently stained the entry hole even after the insect was removed. We can make up any story we want to accompany our theories of the first tattoos, because people have been tattooing themselves and one another long before anybody started writing down *why* they do anything. However that first mark was made, it wasn't the last.

From what we can gather, it does appear that people all over the world attached magical and/or medicinal properties to tattoos—at least, in the beginning. That's no big leap for anyone—the idea that you can make a mark on your body, or someone else's body, and rub a little ash or animal blood or plant material into it and you have a mark on your skin forever is magical in itself. And, as in acupuncture, being tattooed in afflicted parts of the body can help relieve pain, albeit temporarily. Many of the middle-aged Iceman Ötzi's simple straight-line tattoos appear to have been made in areas of his body suffering from age- and work-related degeneration, including around the wrists, along the lower back, and his ankles. Examination of his body has shown that he was suffering from severe arthritis in many of the parts of his body that were tattooed, suggesting that the tattoos were either made to relieve the pain, work as markers for an acupuncturist to follow, or perhaps were put there to magically ward away additional pain.

Aside from the few well-preserved tattooed female mummies discovered in Egypt, thousands of clay figurines have been found throughout North African sites displaying patterns resembling tattoos. In ancient Egypt, many female mummies have been found with abdomen tattoos that could be interpreted as promising fertility as well as protection spells for both the infants in their wombs and the pregnant mothers themselves. The most common tattoo seems to have been a wide, fishnet-like pattern of dots that would expand with pregnancy, possibly to "keep everything in" as the pregnancy progressed. Many of these ancient Egyptian tattoos were made by incising the flesh with a bundle of wide, flat needles and rubbing pigment into them, leaving both a slightly raised scar and a colored mark, as many peoples in Africa still do today. While there's no real way of knowing what sort of ink the ancient Egyptians used for their tattoos, the nineteenth-century English writer William Lane observed that Egyptian tattoo ink

during his time was made with soot and human breast milk and rubbed into one's freshly pricked skin.

## Tattoos and the Western World

As the forefathers of Western civilization, we can probably blame tattooing's first falling out of favor on the ancient Greeks, and later, the Romans, both of whom associated tattoos with barbarians—which included the Britons, Iberians, Gauls, Goths, Teutons, Picts, Scots, and basically anyone in Europe who was not part of the Republic. While "civilized" Greeks didn't generally have any tattoos themselves, they did tattoo their slaves and criminals so that if they escaped, they'd be recognized by the identifying marks. Slaves were sometimes repeatedly tattooed due to changes in ownership. The Greek philosopher Bion claimed that his own father, a former slave, had "instead of a face, a document" because of all the tattoos he'd received from being passed from one household to another. The emperors Caligula and Theophilus famously used tattoos to punish (and in Caligula's case, solely for entertainment) members of their court, while Plato once suggested that a man guilty of robbing a temple should have the crime tattooed on his face and hands and exiled from the Republic.

Despite the disgrace of having a tattoo (or *stigma*, as is the Latin word for tattoo), the Romans had a very specific formula written and preserved for making tattoo ink, officially attributed to the sixth-century Roman physician Aetius. His formula calls for a mixture of acacia bark, corroded bronze, tree gall, vitriol (sulfuric acid), and water. More than likely, his mixture was a lot more painful and toxic than the traditional mixture of wood ash and water that the barbarians were using, or squid ink, as early Romans and Greeks often used as a medium.

Across the Mediterranean, Jewish law forbid its followers from having tattoos of any sort, although there's textual evidence that slaves of Jews were often tattooed with their owners' names. This ban carried on through to the early Christians, and, as Christianity spread through Europe and especially into Rome, tattooing fell out of favor with the "civilized" world and was considered as something only pagans and barbarians did, although Roman soldiers continued to give themselves tattoos to commemorate battles. Constantine the Great, Rome's first Christian emperor, banned facial tattoos during his reign, and in AD 487, Pope Hadrian officially banned tattoos altogether as an affront to God, and required the undoubtedly painful removal of a tattoo if discovered. Despite these stringent conditions,

however, many people still risked getting tattoos for a variety of reasons. Christians who made the pilgrimage to Jerusalem often got a tattoo to commemorate the event, while Saxons, Danes, and Norse continued to wear a tattoo of their family crest as had been traditional before the advent of Christianity. However, after the eleventh-century conquest of the Normans, who brought with them an absolute disdain for tattooing, the art almost completely disappeared from Europe altogether.

## Tattoos and Colonialism

Tattoos were rediscovered and brought back to the Old World when explorers of the New World and the South Seas brought back tattooed natives from South America and the Philippines to exhibit across Europe, some as slaves, and some, such as Prince Giolo of Meangis—a small island in the Philippines—with the promise of a return home as soon as their tour of the courts of Europe had concluded. Predictably and sadly, though, almost all the exhibited natives soon died of a variety of diseases that they had no defenses against. Prince Giolo was reportedly skinned after death and his tattoos preserved and displayed in the Oxford Museum, although no known pieces or detailed drawings exist today of his elaborate tattoos.

The official word *tattoo*, derived from Tahitian word *ta-tu* or *tatua*, entered the lexicon when the famous explorer Captain James Cook returned to England with a tattooed Tahitian named Omai in 1769. Decorative tattooing was such an advanced art with many Polynesian cultures that, for a brief period, there was a grisly demand for the heavily tattooed heads of Maori tribesmen among a certain subset of European connoisseurs. Polynesian tattoos were made using a special ink created by beating the gum of a local tree into powder, which resulted in a very black ink that was easily absorbed into freshly pricked skin without significant infection or scarring, unlike the much more caustic gunpowder that was being used to color tattoos throughout the Middle East at this same time.

By the opulent Victorian age, tattooing began to creep into English society itself. Even though the mainstream population of Great Britain still considered tattooing as something only savages practiced, getting a small tattoo to commemorate special events or personal rites of passage became fairly commonplace among the British upper class. Less than a century after Cook brought the Omai to London, even the King of England had a tattoo. Edward VII sported a Jerusalem Cross tattoo on his arm, put there when he was still the Prince of Wales to commemorate his trip to the Holy Land,

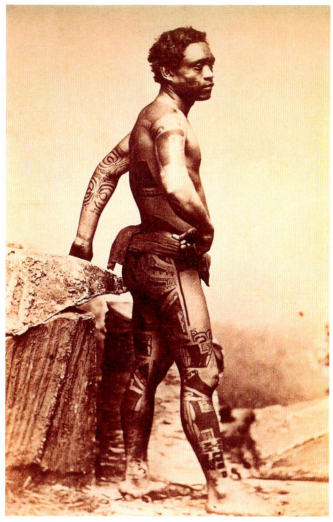

This 1880 photo shows a Marquesan warrior and his elaborate tattoos. Unfortunately, Marquesan culture suffered greatly at the hands of European colonialism and missionary interference.
*Wikimedia Commons*

while his son, George V, had a dragon tattooed on his own arm to commemorate his trip to Japan. Victorian men weren't the only ones to have tattoos, either—many well-heeled Victorian women sported tattoos as well, including Winston Churchill's mother, Jennie Churchill, who had a dainty tattoo of a serpent around one wrist, given to her by Tom Riley, who was considered the best tattoo artist in England at the time.

During the English occupation of India and Burma (Myanmar), many British soldiers got tattooed during service. Field Marshall Earl Roberts of the British Army went so far as to state, "Every officer in the British Army should be tattooed with his regimental crest. Not only does this encourage esprit de corps but also assists in the identification of casualties." Other soldiers went briefly native in their search for a tattoo—the author George Orwell had a series of tiny blue circles tattooed on his knuckles while stationed in Burma, supposedly a local charm to ward off bullets, snakebites, and other disasters.

## Tattoos in the New World

Across the ocean, New World colonists from France and England were encountering whole new groups of people for whom tattoos had had important cultural significance for thousands of years. Native Americans—from the Iroquois on the East Coast to the Inuit in northern Canada, and from the Dakotas in the Midwest to the hundreds of tribal groups found all along the West Coast—all practiced tattooing to some degree. Many fur traders found that getting a tattoo themselves made it easier to be accepted by these potential new clients. Quite a few of these tattoos were associated with marriage rites, and the fur traders' native wives and especially fathers-in-law required the new husbands to get at least one ceremonial tattoo to mark the blessed occasion. Historically, many French traders found it a good business practice—and probably pretty convenient for a fur trader separated from his home country and own people—to marry into a tribe to get in a chief's

Jacques Arago made many wonderful pictures of Hawaiians and their tattoos during the nineteenth century.          *Wikimedia Commons*

good graces. As many tribes, including the Ojibwa, traditionally tattooed the bride and groom as part of the ceremony, it only makes sense that these same markings would have been made on a foreign groom.

As most of the continent was being slowly transformed into the United States through war and land acquisitions, tattoos were also slowly making their mark on the citizens of the new country. Slaves brought over from Africa often bore ornate tribal scars and tattoos, many of which were impossible for their owners to cover with conventional clothing. One of George Washington's African-born slaves, Sambo Anderson, had vivid facial scars and tattoos and wore gold earrings in both ears. On Washington's death, Anderson was freed and given a parcel of land, on which he hunted wild game and sold his catches to many of the finer establishments in the area.

By the Civil War, many men already bore tattoos commemorating previous wars, as surviving a battle has historically been the most popular reason in Western civilization to ever get a tattoo. Recent immigrants, especially working-class Irish and Germans, who enlisted were especially known to have either military or family crest tattoos, possibly because they never expected to see their original homes again and a tattoo was a concrete tie to a past life. Tattoo artists were often made very welcome in camps on both sides of the Mason-Dixon Line, where they were kept busy tattooing thousands of soldiers across the country.

After the Civil War came to its bloody conclusion, the first tattoo parlor was opened in Washington, DC, by Martin Hildebrandt, a German immigrant with the distinction of being the first licensed tattoo artist in the United States. Hildebrandt and his contemporaries were still giving tattoos the traditional way, with one to several handheld needles dipped in ink and repeatedly poked into the skin. In 1875, Samuel O'Reilly opened his own tattoo parlor in New York's Chinatown, and soon debuted his invention, the electric tattoo machine, which he patented in 1891. A brilliant entrepreneur as well as inventor, O'Reilly sold his machine to the public in a kit that included patterns and colored inks, much as tattoo kits are sold today. By the turn of the twentieth century, every major city in the United States had at least one tattoo parlor.

## Tattoos Become Mainstream

For the early part of the twentieth century, the dichotomy between the two main groups who received tattoos was startling. On one hand, most people entering military service had at least one tattoo—especially in the Navy,

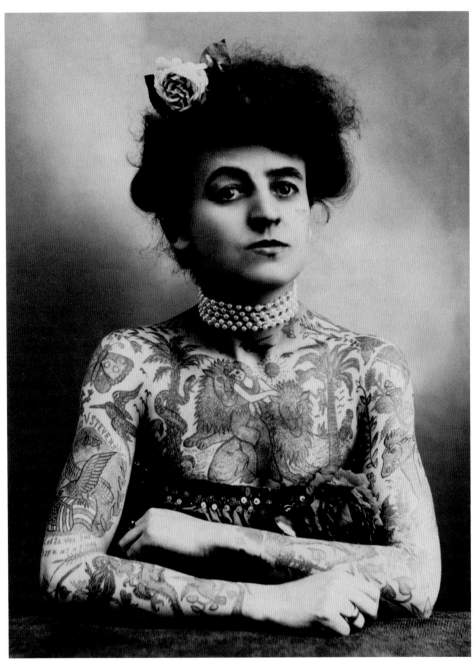

Maud Stevens Wagner is generally recognized as the first known female tattoo artist in the United States.                                                                                     *Wikimedia Commons*

which estimated over eighty percent of its enlisted force was tattooed as early as the Spanish-American War—while on the other hand, you had the very upper classes hiring the very same tattoo artists working near the docks to come to their houses for private tattoo sessions. After the invention of his tattoo machine, O'Reilly received so many requests for tattoos that he had to hire an apprentice, Charles Wagner, to keep up with the workload. Wagner took over the business after O'Reilly passed away in 1908, and continued to work as a tattoo artist until the very day of his own death in 1953. During his career, he revolutionized the art by introducing tattooed cosmetics and pet and livestock identification tattoos, as well as several modifications to O'Reilly's original tattoo machine design.

While tattoos were never actually illegal in most of the country —outside of the age restrictions regarding *getting* one—there was enough moral disapproval in mainstream America, outside of the acceptable military tattoo, that most people just did not get them. It wasn't until the 1960s that tattoos began to appear in the counterculture, first, on the motorcycle gangs that were comprised of many ex-military men, especially those returning from the Vietnam War, and next, on the skin of artists and musicians who wanted to be identified with counterculture groups like the Hells Angels and the Black Panthers. For perhaps the first time in US history, people were getting tattoos not to commemorate going off to or surviving a war, but to protest one. As the Vietnam War lost popularity with mainstream America, more people began to identify with the counterculture movement that had opposed the war from the start, which included their style of dress and, to a smaller extent, tattoos.

The 1960s was also the time when the medical community began experimenting with laser tattoo removal, which had limited but promising results. Before then, tattoos could only be removed by dermabrasion, acid peels, or removing the skin completely through surgery. The introduction of the Q-switched neodymium: yttrium-aluminum-garnet laser (Nd:YAG) made tattoo removal significantly less painful, and through repeated treatments, could completely remove most tattoos without leaving much more than a rash that would fade with time. The fact that people now had a choice of whether to keep their tattoos forever made the idea of getting a tattoo a lot less intimidating, and tattoo parlors all over the country found themselves swamped with business.

When the risk of blood-borne pathogens was linked to tattooing, many cities—including New York, which outlawed tattooing from 1964–1997— banned tattoo parlors entirely. Opponents cited the danger of hepatitis

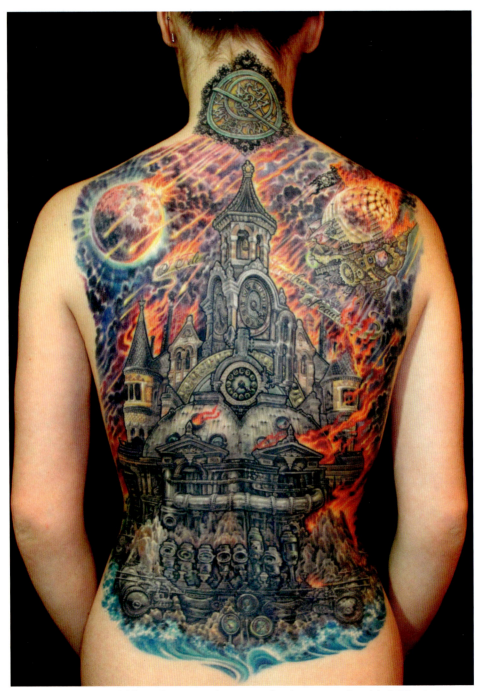

Tattooist James Kern folds modern, sometimes-apocalyptic concepts into his full backpiece tattoos.

*James Kern*

from unsanitary needles and the temptation of young people to get markings and then, a New York City councilman said, "regretting it the rest of their lives." Later, the fear of AIDS kept tattooing from becoming legal, even with the growing acceptance of it in the underground community. For years, tattoo parlors operated secretively until the 1990s, after the art had become increasingly popular and tattoo parlors became almost universally legal again.

Today, the tattoo industry brings in over $1,650,000,000 annually in the United States alone. Fourteen percent of total adults in the United States report having a tattoo, with an estimated thirty-seven percent of adults between the ages of eighteen and forty having at least one tattoo at the time of this writing. With the advent of technology, innovations in pigments, and the constant influx of bold, new artistic styles from the tattoo artist community itself, it's clear that our obsession with inking ourselves up is far from being over.

# Africa and the Middle East

## Ancient and Contemporary Practices

The continent of Africa and the Middle East have incredibly rich histories of tattooing, going back to antiquity. Unfortunately, the twin legacies of colonization and missionary work have caused most of the indigenous tattoo traditions in these regions to become nearly obsolete, while the transatlantic slave trade decimated populations so entirely that there are no written records at all of where tattooed slaves came from, or what their tattoos meant. Many African groups' cultural heritages ended the moment they landed in America, with languages, legends, and practices like tattooing being condemned to extinction in the New World. While there are still vibrant cultures that practice traditional tattooing in certain isolated pockets, such as West Africa, most contemporary tattoo artists in African and the Middle East are heavily influenced by Western and Eastern practices.

While there is plenty of evidence around the world of people tattooing themselves for thousands of years, it's on the African continent that we find the earliest evidence of tattooing in societies with a written historical record. The great thing about this is that, while the frozen mummies in Siberia and Europe might be covered in beautiful, elaborate tattoos, without some sort of historical reference point to begin from it's impossible to know for sure if their tattoos were decorations or served some deeper, significant purpose. Social anthropology is such a flexible "science" that interpretations of tattoos in preliterate societies can change in the span of a few years.

However, when dealing with the remains of literate society, we can match the names of gods and goddesses to any existing tattoos, because the names of the gods and goddesses and even concepts can be matched to the tattoos. And while we may not know the true intent of these tattoos, we can at least

make an educated guess about what those gods and goddesses and tattoos meant to the people who worshipped them.

## Ancient Egypt

From what we can tell, there's no specific word for tattooing or tattoos in general in ancient Egyptian. This isn't that uncommon in a lot of older cultures, especially if ritual or decorative tattooing has been practiced in a specific culture since preliterate times. There is, however, a line in the papyrus *Bremmer-Rhind*—"Their name is inscribed into their arms as Isis and Nephthys . . ."—that seems to refer to tattooing. The hieroglyph *mentenu* in the phrase has been translated as "inscribed," and has a very general meaning that may also be translated into "etched" or "engraved" or "marked" on the body, depending on the translator. Many Egyptologists believe this is a possible reference to tattooing. However, at least one female Egyptian mummy has been found with both tattoos and ornamental scars, so *mentenu* may also refer to scarring, branding, or cutting a design into the flesh with a knife. Whatever the case, the hieroglyph *mentenu* does refer to marking up the body in some permanent way—whether it's one specific way or many ways, we just don't know.

What we do know is that the earliest examples of tattoos from a literate society have been found on Egyptian mummies. One of the most complete tattooed Egyptian mummies is that of a woman named Amunet, who was discovered in 1891 by the French Egyptologist Eugène Grébaut. Amunet was a priestess of the goddess Hathor from the Eleventh Dynasty (2160–1994 BCE), and when her mummy was unwrapped from her linen funeral wrapping, it was discovered that she was covered with a series of tattoos,

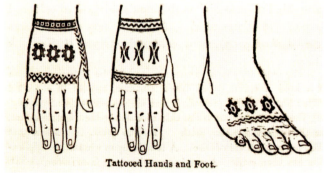

**Tattooed Hands and Foot.**

Explorer Edward William Lane drew many examples of Egyptian tattoos common in 1836 in his journals.

*Wikimedia Commons*

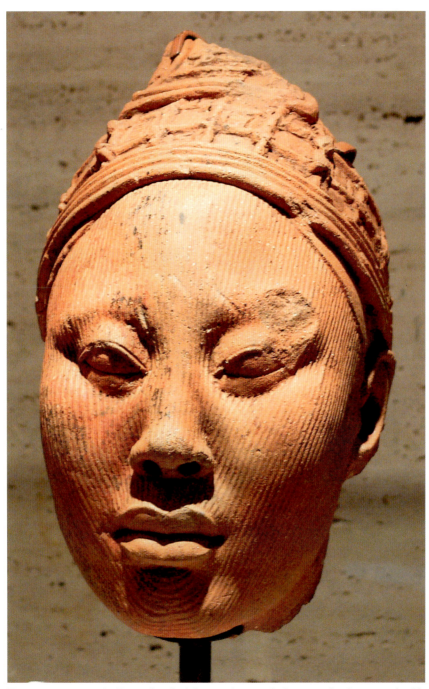

Terra-cotta statues indicate that facial tattooing was being practiced among the Ife people in twelfth-to-fourteenth-century Nigeria.     *Wikimedia Commons*

including dotted lines on her stomach, parallel dotted lines on her arms and thighs, and in a netlike design on her navel. Hathor was the cosmic mother who gave birth to all life on Earth, and this netlike tattoo has been associated with her worship, especially in cases of asking for her protection of unborn children and pregnant women. Tiny statues of pregnant women have been found through Egypt with this netlike tattoo on their abdomens, as well as other female mummies who have shown to have given birth.

Many modern archeologists believe that Egyptian women's tattoos had a therapeutic role and functioned as magical protection during pregnancy and birth. During pregnancy, the netlike pattern would expand in a protective fashion in the same way bead nets were placed over wrapped mummies to protect them and "keep everything in."

The oldest example of a tattoo that shows an identifiable picture rather than just a geometric design or repetitive pattern comes from a clay bowl found in a tomb dated to 1300 BCE. The remarkably intact piece of pottery shows a young Egyptian woman playing a lute, with a tattoo of the dwarf god Bes—generally portrayed as an ugly, apish dwarf wearing a tattered animal skin around his shoulders or tied around his waist with his genitalia partially or completely exposed—tattooed on her thigh. In Egyptian mythology, Bes is the lascivious god of revelry, fornication, male vitality, and sexual excesses. In addition to his duties as master of ceremonies at orgies, Bes served as the patron god of dancing girls and musicians. His image is found on steles and vases, while on amulets he is often represented simply as an engorged phallus. When hung at the head of a bed, these amulets were supposed to ward off evil spirits. This additional tattooing of Bes at the top of a woman's thigh would again suggest the use of tattoos as a means of safeguarding pregnancy and especially birth, since Bes, despite, or perhaps because of, his animalistic urges and reputation, was also the protector of women in labor. Other artwork depicting Egyptian tattooing practices include faience figurines from the Middle Kingdom (2000–1700 BCE) known as the "Brides of the Dead." These figures are portrayed with abdominal markings similar to the markings found on female mummies, as well as diamond shapes on their legs and X-shaped torso markings that may represent tattooing.

While no male Egyptian mummies have been found with tattoos, tattoos have been found on the faces and hands of male Nubian mummies that may have been punitive or religious tattoos. Egyptians also wrote about the tattoos of their neighbors—the tomb of Seti I, who reigned in Egypt from 1294 to 1279 BCE, features paintings of four Libyans depicted with

geometric patterns on their arms and legs. Some historians believe that in ancient Egypt, only women were tattooed, while men were circumcised in a similar rite of passage. Because this seemed to be an exclusively female practice in ancient Egypt, mummies found with tattoos were once dismissed by nineteenth and early twentieth-century archeologists as belong to women of "dubious status," described in many cases as "dancing girls," "entertainers," "courtesans," and "concubines." Considering that some of the tattooed female mummies were buried near the palace site at Luxor in an area associated with royal and elite burials, it's very likely that these women had royal or high social status as well as the kings found buried there. Even Amunet was originally described as "probably a royal concubine" and not the high-status priestess she was eventually revealed to be by her funerary inscriptions.

An implement best-described as a sharp point set in a wooden handle, dated to 3000 BCE and believed to have been used to create tattoos, was discovered by archaeologist Sir William Matthew Flinders Petrie at the site of Abydos in the 1890s. In the same archaeological cache, Petrie also found a set of small bronze instruments that resembled wide, flattened needles that, if tied together in a bunch, would provide repeated patterns of multiple dots. These instruments are almost identical to implements used in nineteenth-century Egypt by nomadic traditional tattoo artists. The English writer William Lane (1801–1876) observed of these nineteenth-century Egyptian tattooists, "the operation is performed with several needles (generally seven) tied together: with these the skin is pricked in a desired pattern: some smoke black (of wood or oil), mixed with milk from the breast of a woman, is then rubbed in. . . . It is generally performed at the age of about 5 or 6 years, and by gipsy-women."

## Ancient Persia and the Middle East

According to an old Arabic saying, tattoos enhance the allure of a girl; they are the intimate jewelry that a woman uses to entice a man and express her feminine desire, something that would normally be difficult or impossible for her to convey in her regular, highly coordinated and regulated contact with men. Historically, public displays of anger, desire, and lust are considered embarrassing emotions to witness among many of the nomadic tribes of the Middle East, so tattooing has supplanted many of these emotions as an outlet for suppressed or hidden feelings. While the sensual aspect of tattooing has been in decline for much of the past two centuries, tattooing

is still a common practice among many nomadic groups of the Middle East, such as the Bedouin and the Al bu Muhammad. Up until just recently, men from the Al bu Muhammad tribe in Iraq wouldn't even consider marrying a woman without tattoos.

Tattooing has been a facet of Persian and Arabic culture since prehistoric times. In present-day Libya, both male and female tattooed mummies have been found. Some male mummies bear tattooed images relating to sun worship, while other male mummies, such as those discovered in the tomb of Seti I dating from around 1300 BCE, were tattooed with pictographs symbolizing Neith, a fierce goddess who led warriors into battle. The tattoos of the female mummies of this area closely resemble those of the female mummies from neighboring Egypt, and are most likely linked to fertility and childbirth.

Up until the nineteenth century, a woman's tattoos were designed specifically to enhance her sensuality, and while the designs themselves had specific meanings, the location on the body that was tattooed was even more symbolic than the actual picture. Arabic prostitutes had tattoos of dots, stars, crosses, and flowers on their hands, arms, and breasts that were purely decorative. Belly dancers wore their skirts low around their hips to show off their tiny, intricate navel and back tattoos. Middle Eastern women from all social classes often wore garments open from the neck to the navel to display their tattoos, which usually consisted of red, black, and blue flowers, birds, and animals. In 1927, German artist Carl Arriens noted that Bedouin women would "proudly display the tattoos on their breasts to any traveler showing interest," while "Lebanese women were also willing to show their tattoos to travelers without shame." Nowadays, however, erotic tattoos on the breasts and in the pubic region among most women in the Middle East are almost nonexistent, while the most common decoration among women are very modest tattoos between the eyebrows, along the jawline, and, less commonly, on one or both ankles.

Middle Eastern men—apparently, going back as far as ancient Egypt—have always been much less elaborately tattooed than women, and many tribes even considered tattoos on a man shameful unless the man had served in a military campaign. In the nineteenth century, many Afghan men who had served in the English or Indian armies had their name and often their region of origin tattooed on their wrists. This is possibly for the same reason that men in the US Civil War around this same time period had had their names tattooed on their bodies before their first military campaign: because they didn't expect to come back from these military campaigns and

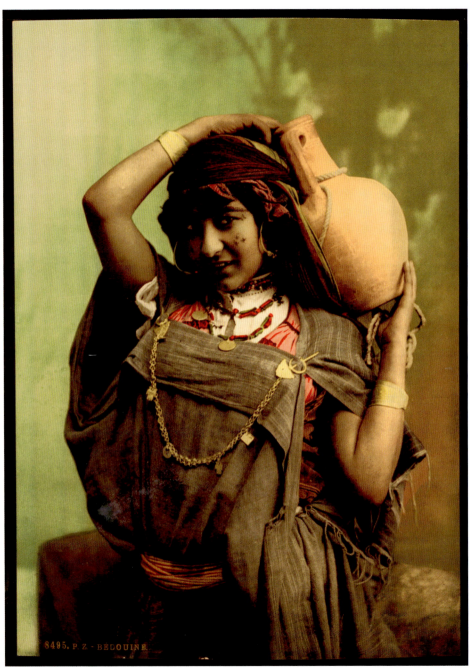

8495. P. Z - BEDOUINE.

Bedouin women wore facial tattoos specifically to accentuate their beauty.    *Wikimedia Commons*

expected their bodies to be stripped of any identifying possessions. Without some sort of permanent identification on their corpses, there would be no way for someone to write up a war casualties list to inform survivors back home.

In the 1950s and 1960s, half of the Iraqi army had one or more hand and wrist tattoos that were not only used for identification purposes, but also were intended to give the bearer power and courage. The designs often consisted of stylized registration numbers, but were also often geometric designs, patterns of dots and lines, astronomical symbols, or simplified animals.

## The Nawar

Nomadic artists were responsible for most of the tattooing in the Middle East and North Africa right up to the beginning of the twentieth century. These nomads, the Nawar, traveled through Syria, Egypt, Libya, Iraq, and Iran, originally following the also-nomadic Bedouins—their best customers—but also tattooing the regional peoples they encountered as well. Because the Nawar were responsible for all of these people's tattoos—sometimes one or two people were responsible for all of the tattoos given in a single season—the whole region shared the same tattooing styles and motifs. The Nawar were known for producing an incredibly high-quality, very dark and potent tattoo ink mixing soot, water, paraffin or plant sap, and, if available, mother's milk, which was treasured for its magical properties.

It's believed that the Nawar traveled outside of the Middle East as well, tattooing the Catholics of Bosnia and Eastern Europe, and may have even encountered and exchanged ideas with pre-Christian peoples of the region, such as the indigenous peoples of Russia and the Mediterranean, who practiced tattooing themselves. The Nawar were also heavily tattooed, using their own bodies as a billboard of their talents. Women of the Kurbat—another nomadic group closely related to the Nawar—in Syria and western Iran still tattoo their faces, but are careful that their personal designs are completely different from their Bedouin clients', as the Bedouin are very particular that their tattoo patterns are worn only by them.

Besides the local populations they encountered, the Nawar also tattooed Christian and Islamic pilgrims traveling to Jerusalem, Mecca, or Medina. In Turkey and Armenia, a tattoo was an important commemoration of a pilgrimage. In fact, the Turkish word for tattoo is *haji*, which comes from *hajj*, the word for a Muslim's pilgrimage to Mecca. However, tattooing wasn't

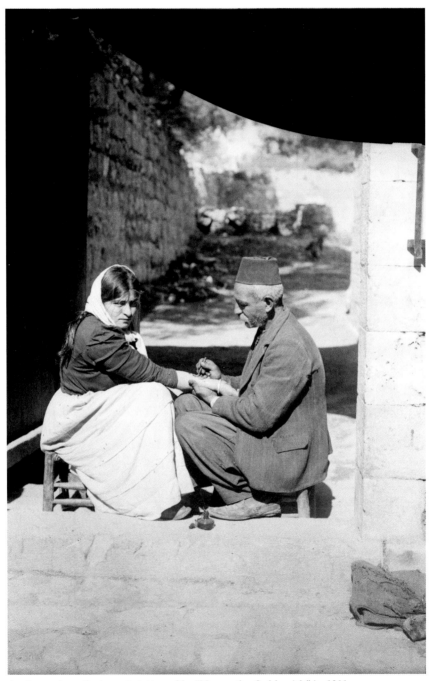

An Armenian pilgrim gets tattooed by "Nerses the Goldsmith" in 1911.

*Library of Congress*

exclusively reserved to mark pilgrimages to Mecca. Parents in Armenia and Turkey both would sometimes tattoo their children with a crescent moon to ward off the evil eye, a practice that started way before Islam was founded.

Tribal ambivalence to tattooing comes from each group's interpretation of the Koran. The Koran does not strictly forbid tattooing, but some Islamic theologians have written laws condemning tattooing based on their own interpretation of passages. The fact that there is no central Islamic authority governing every single Islamic country means that there's no blanket prohibition against tattoos except in the individual countries where it's forbidden. Because of this, tattooing is very rare in Iran and has been completely outlawed in Afghanistan since the early twentieth century, but is still common in Syria and Iraq. Even in Afghanistan, though, where having a tattoo can get you thrown in jail, authorities tolerate therapeutic tattoos, or when young and naïve young men get them—especially among the rural communities, where many pre-Islamic practices such as tattooing still exist.

The one universal rule among Muslims, however, is that the tattoos must not directly portray sentient beings, and are therefore generally based on abstract geometric and floral designs. The tattoos are composed of circles, lines, dots, waves, triangles, stylized depictions of objects, and very occasionally, reductions or abstractions of animals. Depending on the artist, tattoo recipient, and cultural group, most animals are or are not sentient, and therefore may or may not be depicted in a tattoo.

Whether it's officially illegal or not, however, most people in the Middle East accept tattoos as a traditional practice and are reluctant to enforce the law against them. It's even been suggested by many that Fatima, the Prophet's daughter, was tattooed according to the customs of the day.

## Christian Tattoos

Tattoos depicting Christian devotion and faith have existed in the Middle East and Africa for nearly as long as Christianity itself. As early as 528 CE, Procopius of Gaza wrote about encountering Christians with crosses tattooed on their arms and shoulders. The acronym for Christ's name, INRI, as well as stylized pictures of fish and lambs, were also common tattoos during the sixth century, as both animals represented Christ—the fish being an acronym for Iesous Christos Theou Yios Soter, i.e., Jesus Christ, Son of God, Savior; while the lamb represented Christ as the Lamb of God. In the eighth century, Egyptian Coptic monks began tattooing the small, inner-wrist cross tattoos seen commonly on Coptic Christians today, which

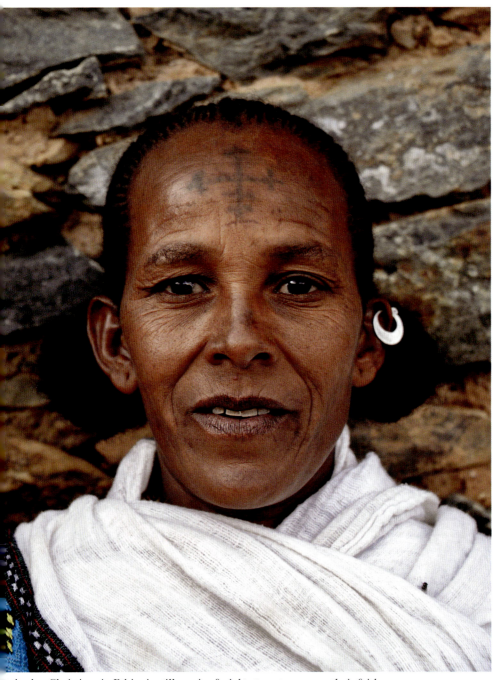

rthodox Christians in Ethiopia still receive facial tattoos to express their faith.

*Wikimedia Commons*

may also have been inspired by the crosses Ethiopian Christians tattooed on their faces and arms. Christian women in modern-day Ethiopia still wear crosses on their foreheads, as well as additional markings along their jawlines and neck.

In addition to being markers of faith, getting a tattoo was a common practice for pilgrims visiting the Holy Land. Christian pilgrimage tattoos were made by first stamping the pilgrim's arm or hand with a wooden stamp, then making the tattoo with a needle dipped in gunpowder over the inked mark. Today, pilgrims still get these tattoos to mark their visit to the Holy Land—however, modern tattoo machines and tattoo shops have replaced receiving a hand-poked tattoo administered at the side of the road.

## Northern Africa/The Maghreb

The Maghreb contains the North African countries of Morocco, Algeria, and Tunisia. The two main ethnic groups here, Arabs and Berbers, have tattoos, although the Berbers are significantly more tattooed than the Arabs, and, according to historical records, have always been more tattooed than any other people in this region. The Berbers are the original inhabitants of the region, and their name comes to us from the ancient Romans, who considered the nomadic people to be "barbarians." The Berbers call themselves Amazigh, but because of the long-ranging influence of the Romans that reaches even up to the present, the rest of the world still refers to them as Berbers.

All through the seventh to the thirteenth centuries CE, Arabs drove the Berbers into eastern Algeria and into the mountains of Morocco, where most of them still live. There are still Berbers who cling to their nomadic ways, scattered through the desert from Egypt to Senegal, traveling through the desert in long, winding camel caravans. Recently, the Berbers have seen a huge income boom from the tourist sector, as the idea of traveling Lawrence of Arabia–style through the desolation of the Sahara Desert to set up camp underneath the stars is something many people living in highly urbanized areas find immensely appealing, especially since these vacations come with musical entertainment, food, and often, commemorative tattooing from a traditional Berber tattooist.

Historical records show that the people of the Maghreb have a long association with tattooing, especially the lower classes. Like the ancient Greeks and Christianized Europe, the upper classes considered tattooing to be an instrument of control. Algerians used tattoos to identify their slaves, which

was a useful practice in the case of runaways, as it was immediately obvious which household the slave was running from. It was also used to mark soldiers and to identify deserters. In the fifth century, the king of the Vandals recruited Berbers to his army and had a cross tattooed on their foreheads, hands, or cheeks to distinguish them from the rest of his troops, which enraged their families back home, who did not consider their enlisted sons and husbands to be property the way the king of the Vandals apparently did. In the fourteenth century, Ibn Khaldun wrote that Governor Yezid of Ifrikia (now Tunisia) had Berber guards whose names were tattooed on their right hands, and the phrase "Yezid's guard" on the left.

Since the early 1800s, traditional tattoos are rarely seen in the Maghreb's urban centers. The tattooing that did exist in the cities was so heavily influenced by European and Asian motifs that past practices were almost entirely abandoned. By the turn of the twentieth century, for example, rifles, bicycles, and naked girls were popular tattoo motifs in Tunis, replacing the stylized dot and filigree patterns that had been popular for centuries before. However, while urban women of the Maghreb now prefer to use henna to mark themselves—or, if one can't afford henna, charcoal—there is one traditional tattoo that many of them continue to wear today. The *hammaqat*, or "the tattoo that drives men crazy," is located on the feet, which is the only part of the body that is allowed to be displayed in public throughout the Middle East and Northern Africa.

In the rural areas of Northern Africa, most tribes maintain the practice of facial tattooing. Up until the middle of the twentieth century, most Berber men and women were tattooed. Their tattoos were designed to enhance beauty, provide protection against the evil eye, or prevent illness. Magical tattoos were applied at a very early age to protect a child from disease and death, while beauty-enhancing and fertility tattoos were applied at the onset of puberty. Among Berber girls, a palm tree tattoo—drawn as a simple line from the bottom lip to the chin and sometimes surrounded by dots—was once considered one of the most beautiful tattoos a woman could have, while the ultimate symbol of beauty among southern Tunisian girls was the *foula*, an isosceles triangle with its apex on the bottom lip.

Besides decorative purposes, Maghrebian tattoos have always had a magical function, offering protections from the malevolent spirits of the desert. Young girls often had a small dot tattooed near the pubic region to ward off the evil eye, as the evil eye was believed to be able to enter a person in times of great duress, such as pregnancy or childbirth. Magical tattoos near the nose were applied for the same purpose, as were those by the mouth,

ear, and at the corners of the eye. Unborn children and babies were considered especially vulnerable to spirit possession and malevolence. A baby born to a family that had already lost a child was tattooed on the nose as a preventative measure.

The cross was considered the most effective defense against the evil eye because its energy would be diffused and scattered by the four points of the compass. For this reason, Moroccan women had a cross tattooed between their eyebrows, as women were considered especially susceptible to supernatural illnesses. Cross tattoos were also used to ease muscle pain, skin cancer, and impotence—however, therapeutic tattoos were only effective if made by a sharp knife with soot rubbed into the wound. In extreme cases, such as demonic possession, the sharp knife had to be dipped in either the blood of a murdered man or his murderer to render the tattoo effective.

## Southern Africa

For a very long time, European anthropologists were convinced that the darker-skinned indigenous peoples of Southern Africa didn't practice tattooing, as it was less likely to show up against their dark skin. However, there's evidence that tattooing in sub-Saharan Africa may date back as far as 84,000

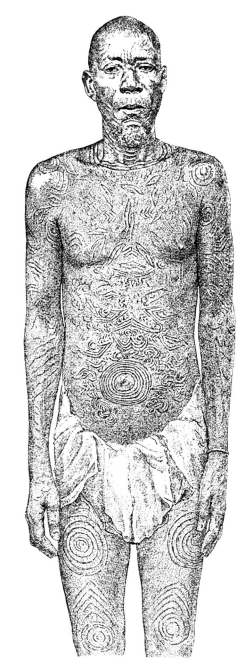

The Baluba of Central Africa were still practicing full-body tattooing at the end of the nineteenth century, when this was taken.

*Wikimedia Commons*

years; bone tools discovered at the Blombos Cave archeological site in present-day South Africa are believed to have been tattooing instruments. While many tattooing traditions in southern Africa have disappeared—mostly because colonialism, missionaries, and especially the transatlantic slave trade decimated entire groups of people and obliterated cultural practices that were thousands of years old—up until the nineteenth century, many tribal groups still tattooed themselves for a variety of reasons, both spiritual and decorative.

In the nineteenth century, Tigré women from the Eritrea region tattooed their entire bodies with beautiful patterns of stars, lines, circles, and crosses, as well as delicate rings around their fingers, using an iron

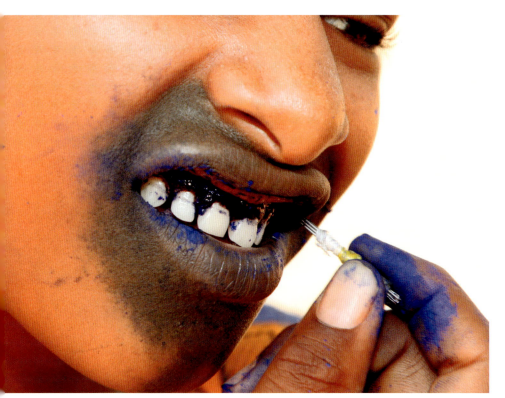

The Fula of Mali still practice mouth tattooing, resulting in a blue checkerboard or solid pattern on their gums.                                                                                    *Wikimedia Commons*

needle dipped in green vegetable dye. They also tattooed their gums either completely blue or in a checkerboard pattern. The Tigré claimed this dye was so powerful that it could even be seen on a person's skeleton many years after her death. Many tribes tattooed their gums to make their teeth stand out more, as well as filed them to points for an additional dramatic effect.

Today, the most extensive tattooing customs exist only among the nomadic tribes of northern Nigeria. There, the women of the Mossi, Fulania, and Zul decorate themselves in complicated geometric patterns. In Ethiopia, there are still members of the Tsamai and Kerre tribes that tattoo their arms, while the women of the Konso tribe tattoo simple patterns on their foreheads and breasts.

# Eastern Europe

## Russia, Siberia, Mongolia, and the Rest

A s in Western Europe and neighboring Asia, Eastern Europe and the very strict Eastern Orthodox Church viewed tattooing very unfavorably for millennia. Just a few passages away from the section of Leviticus most often appropriated by people to claim homosexuality is a crime against God also states, "Ye shall not make any cuttings in your flesh for the dead, nor print any marks upon: I am the Lord (19:28)." Even now, the Eastern Orthodox Church's official statement regarding members of the congregation who have tattoos is that they are "lukewarm, carnal, disobedient Christians."

Despite all of this, many famous Russians have had tattoos. Joseph Stalin had a tattoo of a skull on his chest—his American-raised granddaughter, Chrese Evans, is covered in tattoos and regularly posts pictures of herself on the Internet, especially when she acquires a new tattoo or piercing. While tattoos are still not socially acceptable in Russia, it's not illegal to have one, although the School of Russia and Asian Studies student handbook warns students visiting from other countries that "tattoos on the neck, face, or hands are primarily associated with those who have served in the army or those who have served prison sentences. Both of these groups can be rowdy and have a certain 'brotherhood' about them, meaning they may approach you if they see tattoos in these places. We suggest trying to keep tattoos covered when in public."

In 2016, after the Russian government decriminalized domestic violence, thirty-three-year-old tattoo artist Yevgeniya Zakhar posted an ad on her social media page offering to tattoo abused women for free after she heard about a Brazil tattoo artist already offering the service. Soon, she was flooded with requests—and got so stressed hearing her clients' stories of abuse that she had to limit her studio hours to one day a week. Since the ruling, she has transformed over one thousand women's injuries into butterflies and flowers for free, helping, in her own way, to put something that

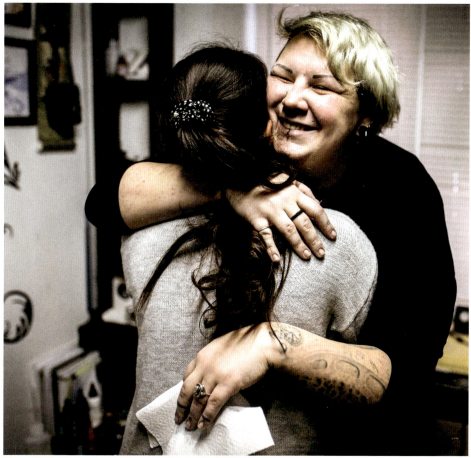

Since 2016, Yevgeniya Zakhar has been offering free cover-up tattoos to victims of domestic abuse in Russia to help them move past the painful moments in their lives.    *Google Images*

would have left an ugly scar for life a little bit further in the past. She says not one reported receiving help from police.

## The Pazyryk

All along the borders of present-day Russia, China, and Mongolia, the frozen tombs of the Pazyryk have revealed almost a dozen well-preserved ice mummies. All the bodies showed evidence of having their brains removed via a small hole in their skulls, which was filled up against with mink fur, while their chests had been carefully opened and sewn up again after the organs had been removed. Long, careful slits had been made along

their arms, legs, and backsides so that the major muscles could be removed and replaced with horsehair and sewn up again. While all of these measures may have helped during the short term to preserve the bodies for funerary purposes, the harsh conditions of a continuous Altai Republic winter were what really kept these Pazyryk corpses nearly intact for what turned out to be thousands of years.

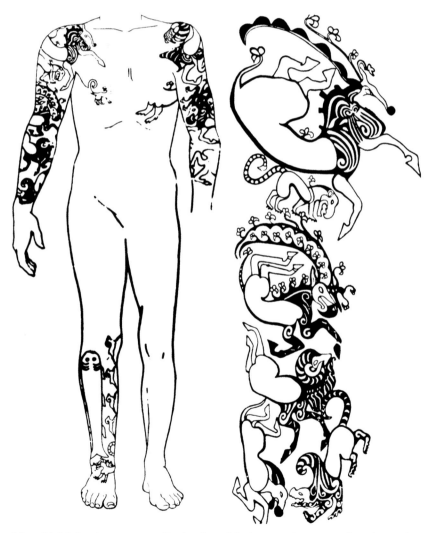

Many highly intricate tattoos of animals and fantasy creatures were found covering the body of the Pazyryk chief.                    *Wikimedia Commons*

The Pazyryk were a nomadic people who had domesticated the horse and the reindeer thousands of years ago, and belonged to a collective group known as the Sarmatians, or Scythians, a warrior culture made famous in literature by author Robert E. Howard in his *Conan the Barbarian* books. While we can only guess at generalities concerning Pazyryk culture, as they were a preliterate society and left no texts of their own behind, their tombs have revealed that they were incredibly skilled with a needle and thread, with saddles, blankets, and clothing embellished with amazing embroidery. The Scythians as a group were also well-known for their beautiful swords and their ability to use them viciously while on horseback—both men and women—which led many Greek scholars to claim they were descendants of the legendary Amazon warriors.

One of the first Pazyryk mummies was found in 1925, an elderly man with tattoos of animals all over his arms, chest, and lower legs. The 2,400-year-old tomb also contained jewelry, musical instruments, pipes, and beautifully embroidered fabrics from Persia and China, which the Pazyryks could only have obtained on journeys covering thousands of miles. There were also the bodies of several horses, all of which had had their major muscle groups removed and replaced with straw, just like the people had, and a young woman. Only the man in this first tomb was tattooed, which originally led archaeologists to suspect that only men received tattoos. While most of the man's tattoos were of animals and fantasy creatures, he also had a row of tiny circles tattooed down his spine, resembling the marks that five-thousand-year-old Ötzi had received for possibly therapeutic reasons.

In 1948, the Russian anthropologist Sergei Ivanovich Rudenko discovered another mummy when he was supervising the excavation of a group of Pazyryk tombs about 120 miles north of the Chinese border. The tombs found by Rudenko were in an almost perfect state of preservation, unlike most of the already excavated tombs, which had been ransacked by thieves and even the local country people over several thousand years. The tombs he found contained skeletons and intact bodies of horses and embalmed humans, together with a wealth of artifacts including embroidered saddles, riding gear, a carriage, rugs, clothing, jewelry, musical instruments, amulets, tools, and clay and bone pipes for smoking what turned out to be hashish, and more beautiful, fine fabrics from Persia and China, suggesting that trade between the far-removed cultures was a regular occurrence.

Rudenko's most remarkable discovery was finding the body of a tattooed Pazyryk chief. The man was thickset, powerfully built, and had died when he was perhaps thirty years old. Most of his body had completely

disintegrated, but the skin that remained was covered with clearly visible tattoos. What was left of the tattoos pointed to a man who had been covered with designs of interlocking animals, fantastic and real. The best preserved of these tattoos was a donkey, a mountain ram, two highly stylized deer with long, flower-tipped antlers, and an imaginary carnivore on his right arm. Two monsters resembling griffins decorated his chest, and on the left arm

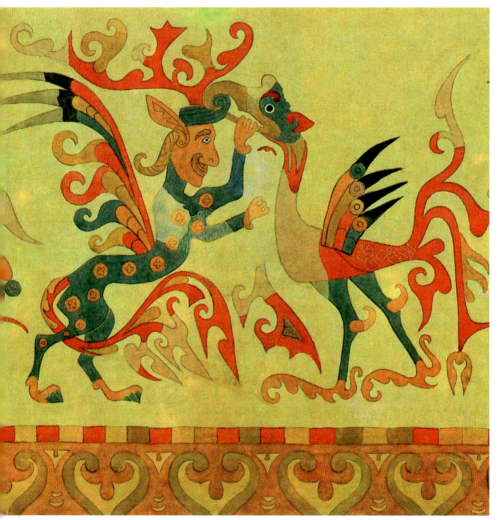

A scrap from a piece of carpet found in a Pazyryk grave, attesting to the artistic skill these people had with textiles.
*Wikimedia Commons*

were two partially obliterated deer and a mountain goat. On his right leg, a fish extended from the foot to the knee. A tattoo of a monstrous, unidentified, multi-limbed creature crawled over his right foot, while on the inside of the shin were four running rams that touched one another to form a single integrated design. The left leg was also tattooed, but the flesh was too damaged to identify the images. In addition, the chief's back was tattooed with a series of small circles in line with the spine, similar to the possibly therapeutic tattoos of the first mummy found.

In 1993, another heavily tattooed Pazyryk mummy was found—but this time, it was of a young woman, nicknamed "Ledi" (the Russian word for "lady") by the archaeologists who found her. She had been buried in a voluminous yellow silk blouse, a long, crimson woolen skirt, and white felt stockings made of marten fur, and a three-foot-tall headdress made of human hair and animal felt. She also had one tiny gold earring in one ear. While most of her clothing could have been from a local source, the fabric of the silk blouse had to have come from China, as China was still guarding its secret of silk production from the rest of the world at that time. While most of Ledi's flesh had disappeared with time, on one shoulder could be seen a tattoo of an elk whose gigantic antlers terminated in tiny flowers. She was also buried with many beautiful and expensive objects, including gilded ornaments, dishes, a hairbrush, a pot containing marijuana, and a hand mirror of polished metal with deer carved along the wooden handle and back. Six horses wearing ornate reindeer masks, including branching reindeer antlers, and elaborate harnesses were also buried with her, leading archaeologists to believe that status, and not gender, was the reason for the tattooing on the two mummies.

This theory finds confirmation in the writings of the Greek historian and explorer Herodotus from 450 BCE, who stated that among the Scythians, "tattoos were a mark of nobility, and not to have them was testimony of low birth." Many other Pazyryk tombs have been excavated, a few with relatively intact mummies, but only Ledi, the first mummy, and another mummy of a younger man have been found with tattoos. According to another Greek historian named Xenophon, a neighboring Scythian group called the Mossynoeci also showed status by being "drawn over and the front part tattooed in colors." In these same writings, he also left a gruesome insight into the true purpose of the removal of the muscles from the arms, thighs, and buttocks of the mummies—according to him, Scythians would mix this removed material with horsemeat, grind it up, and consume it during their funerary rites.

Examination of the tattoos has shown that the incredibly ornate and sophisticated designs were created by pricking the skin with inked needles, rather than the skin-stitching technique associated with the indigenous peoples who still practice traditional tattooing in the region today. The tattoos also resemble those found on mummies and in illustrations from Southeast Asia of the same period, specifically, Myanmar and Thailand, and suggest some connection to the region, either in trade or extended contact. Archeological evidence confirms that since the Pazyryk had regular enough contact with Chinese and the Persians to engage in regular trade with them, it's entirely possible that some of the people they came in contact with copied Pazyryk tattoos out of appreciation for the style. It's also entirely possible that the Pazyryks learned their tattooing techniques from the peoples they encountered during their trade ventures in Asia and Southeast Asia.

Like many nomadic peoples of antiquity and even today, it's likely that Pazyryks may have been animists, and believed that tattoos gave them the special powers belonging to the animals and magical creatures pictured on their skin. We do know that among the artifacts found in the burial sites were little bags of human hair and fingernail clippings, which suggest that the owners of the bag either kept their own hair and fingernail clippings close to prevent someone else from having power over them, or that the bags contained the hair and fingernails of another person ostensibly under their control, much like practitioners of Vodou and Santeria do to this day.

## Thracians

Herodotus tells us that for the Thracians, tattoos were greatly admired and "tattooing among them marks noble birth, and the want of it, low birth." According to Herodotus, Thracians tattooed themselves to excess, to the point where the tattoos of neighboring tribes are even referred to as "Thracian marks." As with the Pazyryks, it was possible to decipher one's social status in the community by their tattoos, or lack thereof. Both men and women were tattooed, and several beautiful Thracian vases from the fifth century BCE depict men and women with tattoos of animals on their arms and legs.

German archaeologist Konrad Zimmerman discovered physical evidence for tattooing in over forty painted vases dating from the fourth century BCE. Zimmerman theorized that, according to the depictions of Orpheus's murder on these vases, Thracian women had originally tattooed themselves to commemorate their victory over Orpheus, and that these

tattoos served to remind Thracian husbands that Orpheus's fate awaited them if they stepped out of line.

This theory, of course, would only really be valid if Orpheus, the lute player who descended into Hades to recover his deceased wife, Eurydice, was a real person and not just a legend. A much more plausible explanation comes to us from the Greek historian Athenaeus, who wrote that after invading Thrace, the Scythians attempted to humiliate some of the local women by tattooing them with blue dots. In defiance of this act of public disgrace, the women elaborated the existing tattoos and turned the irritating blue dots into beautiful, decorative designs that could be worn with pride and not shame. Even so, the fact that generations of Thracian women apparently continued to wear tattoos for decorative purposes brings even that well-established theory into question.

After the first century BCE, the Thracians became subjects of the Roman Empire and the tradition of decorative tattooing gradually declined, as it did with other groups assimilated into the Roman Empire or those converted to Christianity.

Chuchki tattoos were skin-stitched in the same way that their relatives' in Alaska were.

*Wikimedia Commons*

## Siberia

Not surprisingly, Siberians, like the Inuit and other indigenous peoples in the Arctic Circle, practiced skin-stitching tattoos. As Siberia and the St. Lawrence Islanders raided one another on a fairly routine basis, often kidnapping women to either marry or exchange for prisoners from previous raids, traditions like skin-stitching were kept alive on both sides of the Bering Strait despite missionary intervention.

The Chukchi, who lived in northern Siberia in relative isolation for over a thousand years, had the most extensive and complicated tattoos of any known indigenous Siberians. At age nine or ten, girls were tattooed for the first time with two lines running from their forehead to the tip of their nose, which was designed to distinguish men from women in the afterworld. This first series of tattoos was especially important, as prepubescent boys and girls can be almost indistinguishable from one another, and if one was to pass away before reaching puberty, you wouldn't want your gender to be the first thing to be questioned when entering the afterworld. At puberty, girls received additional tattoos on their chins, arms, hands, and cheeks, with the greatest detail being in the cheek tattoos, which consisted of patterns resembling branching reindeer antlers.

This 1850 painting of a Tungus man clearly shows his facial tattoos. *Wikimedia Commons*

Chukchi men received tattoos in recognition of great acts of bravery, usually involving killing a member of a hostile tribe or for catching a whale. Men received a small dot on top of their wrist or in their armpit for every enemy or whale they killed—polar explorer William Hulme Hooper reported in 1853 that some men had armpits so filled with these "kill marks" that they appeared solid black from a distance.

Girls from the eastern Siberian Tungus tribe were not tattooed on their chins but instead had three decorative lines arcing from the corner of their mouths to the corner of their eyes. A neighboring tribe, the Yakut, had short, straight

lines on their chins and cheeks that were similar to those of other eastern Siberian people. Women of the Koriak tribe also had decorative facial tattoos, but theirs also had a religious function. Many Koriak tattoos functioned as amulets or talismans that warded off malevolent forces, or were applied locally for the treatment of acute pain.

In western Siberia, women of the Ostiak tribe tattooed the back of their hands, forearms, and thighs. Ostiak men tattooed their personal mark on their wrists, which they also used as a signature, much as a specific segment of the *moko* facial tattoos of the Maori of New Zealand also served as a signature. Another tribe, the Samoyede, tattooed young girls with rows of black circles inside their elbows to protect them from a variety of feminine maladies, while older men and women alike had tattoos of reindeer antlers and other animal motifs on their cheeks.

## The Balkans

Up until the twentieth century, it was customary in Bosnia and Albania for young girls to be tattooed in church on Catholic holidays. An elderly woman, often a nomadic "gypsy," would tattoo religious symbols on their hands, arms, and sometimes their shoulders. These symbols usually consisted of a cross or elaborate figures made of multiple interlinking crosses of various sizes, or sometimes, just a single cross on one arm. Men were rarely tattooed, but if they were, it was usually only a cross around their index finger or a cross on the upper arm.

Ethnographers believe that there are several reasons why Bosnian and Albanian Catholics practiced tattooing. One major reason is there has been in religious split in the region since the seventh century, when the Balkans became the official geographic split between Christian

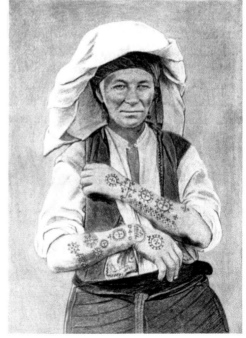

Drawn in 1910, this picture of a Bosnian woman has arms covered in the traditional tattoos of her day.    *Wikimedia Commons*

Europe and the Islamic Levant. Many Balkans converted to Islam after the Turks invaded the region in the fifteenth century, and it's believed that the remaining Christians wanted to emphasize their status as Christians within the now-Islamic country by wearing a tattoo of the cross. Another interpretation is that Christians were compelled by the Ottoman Turks to be tattooed with a cross to identify them as Christians within the kingdom.

A third explanation is that, since many of the present inhabitants of the Balkans are descendants of the nomadic Slavic tribes who reached the area in the sixth century, they may have brought their elaborate tattooing traditions with them from Asia and just incorporated Christian symbolism into the tattoos centuries later. Considering that the cross symbol is a common motif in the nearby Middle East as a ward against the evil eye, it's very possible that the cross tattoo was already present in the community as a pagan symbol but was simply adapted to suit the purpose of Christianity and Islam.

# Western Europe and the Ancient Mediterranean Coast

## From Ancient Greece to Victorian England

The history of tattooing in Western Europe has been a dynamic, continuously evolving one, changing in acceptance and relevance as empires rose and fell, through the cultural exchanges always brought by both conquest and trade, and the dramatic changes in religious and academic beliefs. Some of the earliest evidence of tattooing in the world has been found in Europe, and, despite the often-repeated concept that European tattoos faded out of existence completely at some point in the historical record, new research continues to reveal new evidence that at some place, some time, tattooing traditions have always existed in Europe, continued in an unbroken chain from antiquity. In fact, French explorer Charles Pierre Claret de Fleurieu's book *A Voyage Round the World (1791)* claimed that tattooing in modern Europe was not only common, but common from antiquity. "We should be wrong to suppose that tattooing is peculiar to nations half-savage; we see it practiced by civilized Europeans," wrote de Fleurieu. "From time immortal, the sailor of the Mediterranean, the Catalans, French, Italians, and Maltese have known this custom, and the means of drawing on their skin, indelible figures of crucifixes, Madonnas, or of writing on it their own name and that of their mistress."

## Ötzi

The earliest physical evidence of tattooing ever found on the Eurasian continent was that of the body of Ötzi the Iceman, an ice mummy found in

the Alpine Oetz valley, right on the border of Austria and Italy. Preserved much like the Pazyryk mummies of the Russian steppes, Ötzi's body was completely encased in ice for over 5,200 years, and was only found when an avalanche revealed his location to hikers in 1991. Unlike the Pazyryk mummies, Ötzi's resting place seems to have never thawed out or even been disturbed once during the entire time he was frozen, as almost all the skin of his desiccated body was found to be completely intact.

Despite his relatively old age (forty-something), Ötzi seems to have had a myriad of health problems, both genetic and age-related—he lacked both of his wisdom teeth and his lower set of ribs; he had a caddish gap, or diastema, between his front teeth; and some researchers have speculated that he may be been sterile. He also had hardened arteries, was infected with intestinal worms, suffered from gallstones, and had a toe compromised by frostbite. There's even a good chance he was murdered up in the mountains, as his body was found with a "fresh" arrow wound in one shoulder and a large crack in the back of his skull that was either caused by falling and hitting his head, or being clubbed to death. His body was found with his mostly intact clothing and shoes, a bow with arrows, a bronze flint ax, and flint for making fire. Along with the evidence of tattooing, Ötzi's remains gave a glimpse of a culture sophisticated enough to create all of these implements, while recent advances in DNA technology have shown that he was of Western European descent—and he still has living relatives in the Tyrol region.

Most of Ötzi's tattoos were a combination of crosses, dotted lines, solid lines, and individual dots. The dots were made with a pointed object, but the lines were made by cutting, and may have a medicinal purpose, as most of the tattoos coincide with signs of arthritis on his wrists, ankles, knees, and along both sides of his spinal column. However, many researchers believe that instead of ink, the marks were created accidentally when a traditional healer made incisions in Ötzi skin and inserted medicinal herbs into the wound. The herbs were then burned with heated medical instruments, and the charred residue blackened the resulting the scars. An examination of Ötzi's skin tissue revealed that the scars do contain carbon particles that could have come from charred plant fiber.

Overall, Ötzi has been discovered to have a total of sixty-one individual tattoos on his body, and he could have even more—the most recent-discovered tattoo, a series of lines on his rib cage, was found in 2015 when researchers rephotographed his body with a camera lens designed to capture light outside the visible spectrum. The tattoos on his rib cage were a

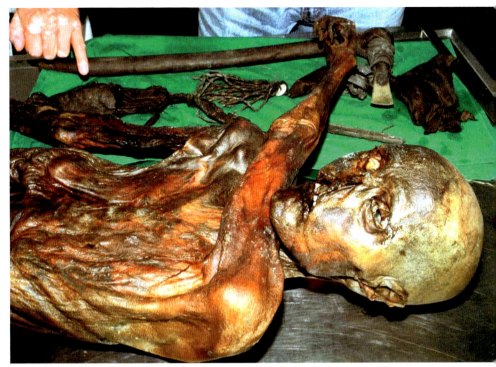

At over five thousand years old, Ötzi is the oldest Western European mummy found so far.
*Wikimedia Commons*

surprise to the researchers, because all the other tattoos on Ötzi's body were located on joints and known acupuncture points—however, the fact that Ötzi lacked his bottom set of ribs may have something to do with why his rib cage was tattooed.

The problem with finding and studying mummies like Ötzi is that because the only reason they survived as mummies was their preservation by the surrounding ice and extreme cold, any variations to the temperature they're kept in will cause them to start rapidly deteriorating. While Ötzi's remains were relatively intact due to the extreme care that's been taken of his corpse, there have been a couple of scares over the past two decades since his finding where decomposition has set in and emergency measures have had to be taken.

Outside of infrequent mummies, archaeologists in Europe have discovered what they believe to be tattooing implements from as far back as the Upper Paleolithic (10,000 BCE to 38,000 BCE). These are almost always clay dishes, red ochre, and sharp bone tools shaped like needles. A complete

"set" of these tools dating from twelve thousand years ago have been found in France's Grotte du Mas-d'Azil caves. In these same caches, archeologists have found small human figurines engraved with abstract patterns of dots, lines, and geometric shapes. Images of people decorated with four horizontal lines on both sides of their noses have been found on prehistoric stone pillars in France, while clay Cucuteni figures from the Romanian Danube region dated to 5000 BC show traces of illustrations that could be tattoos.

## Ancient Greece and Rome

To the ancient Greeks and Romans, tattoos were something relegated mostly to the uncivilized tribal people they referred to collectively as "barbarians," which was pretty much anyone except them. The Greeks in particular never wholeheartedly adopted the practice of decorative tattooing, and almost exclusively used them for punitive purposes. Plato wrote extensively about using tattooing as punishment for a variety of crimes against society, and believed that individuals guilty of sacrilege should be forcibly tattooed and banished entirely from the Republic.

However, in the fifth century BCE, Persians introduced the Greeks to an alternative use for tattoos—the permanent marking of slaves as property. According to Herodotus, in 512 BCE King Darius led the Persians into Thrace, and after the battle, tattooed letters on the foreheads of all of their prisoners of war. He also noted that all of their slaves and convicts were similarly tattooed, but all had different words and letters on their foreheads determined by the nature of their ownership or crime. One famous example of this was when Athenians defeated their neighbors the Samians in battle, they tattooed all the soldiers with an owl, the emblem of Athens. However, the next time they encountered one another in battle, the Samians defeated the Athenians and tattooed their prisoners with a Samian warship. Considering how often the Greek states went to war against one another, one can only wonder how many tattoos a soldier had inflicted on him before he was finally allowed to retire.

By the middle of the sixth century BCE, Greeks had begun to tattoo their slaves' faces as a matter of custom, making it impossible for any of them to run away. Ironically, these same slaves received yet another tattoo when they'd finally earned their freedom—it's possible that the Greeks believed they were doing these poor souls a favor by inscribing them with an additional mark that cancelled out their original slave tattoo. The original word for this type of tattoo was *stigma*, which, in ancient Greek, meant "the

markings on the snake," but soon came to denote a mark of shame. The one time period in Greek history when tattooing was not associated with crime, shame, or conscription was during Ptolemaic times, when a dynasty of Macedonian Greek monarchs ruled Egypt. Ptolemy IV (221–205 BCE) was said to have been tattooed with ivy leaves to symbolize his devotion to Dionysus, Greek god of wine and the patron deity of the royal house at that time. This fashion was also briefly adopted by Roman soldiers and spread across the Roman Empire until the emergence of Christianity, when tattoos were felt to "disfigure that made in God's image" and so were banned by the Emperor Constantine (CE 306–373).

Ancient Romans also practiced formal military tattooing. Vegetius, writing in the fourth century, noted that legionnaires and auxiliaries in the Roman army "should not be tattooed with the pin-pricks of the official mark as soon as he has been selected, but first be thoroughly tested in exercises so that it may be established whether he is truly fitted for so much effort," suggesting that the full military tattoo mark was considered an important badge of honor, and not just there to mark potential deserters. It was probably also done this way so that applicants to the army felt they had gladly earned the tattoo that would mark them as soldiers for most of the rest of their life, instead of it being the punitive tattoo of a conscripted soldier.

The Romans also tattooed the foreheads of their slaves, as well as gladiators and prisoners—aside from marking one's allegiance to a military unit, tattoos were generally awarded as marks of shame, and not honor. The power to tattoo someone against his or her will was the power to violate that person, and to remind them of that violation for the rest of his or her life. In the first century BCE, Emperor Caligula famously used tattoos to humiliate elite members of his court who displeased him, ordering their faces be tattooed before being sent to work in the mines. He also tattooed gladiators as public property, and condemned early Christians to be tattooed and sent to work in the mines along with the disgraced members of his court. Somewhat paradoxically, since you would think they'd be rewarded for this action and not further inscribed, slaves were marked when they were either freed, or when they'd finally paid their taxes in full.

In the third century CE, Emperor Constantine banned the tattooing of faces, as the Scriptures specifically forbade one man to mutilate another man's face. However, this didn't outlaw tattooing itself—it just meant that now soldiers and gladiators were only tattooed on their calves or hands instead of on their faces. In the sixth century CE, new, often conscripted recruits to Justinian's army received several dots on their hands, making it

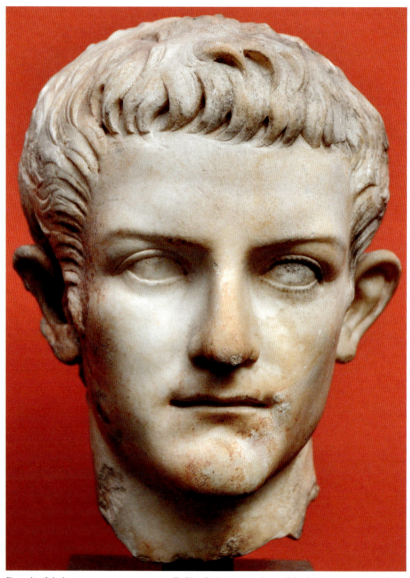

Despite his innocent appearance, Caligula is remembered by history as one of the most sadistic of the Roman emperors.                          *Wikimedia Commons*

easy to identify deserters. And, perhaps in an homage to the ancient Roman tradition of tattooing criminals, in the ninth century, Emperor Theophilus punished two brothers from the monastery of St. Sabas for the crime of venerating religious idols by having them severely beaten and their faces tattooed with twelve iambic lines describing their crimes. Somewhat

ironically, the brothers eventually became Saints Theodore and Theophanes the Graptos (or the Inscribed), canonized simply because they could now express their faith without speaking.

## The British Isles

Roman records of the third and fourth centuries CE tell about a people they called the Picts of ancient Britain. We're not entirely sure what these people called themselves, as the name *Pict* is a Roman word meaning "painted people," and derived from the stories that they possibly tattooed themselves and painted their bodies blue for conflicts to both frighten their enemies and to disguise their numbers in battle. Another group from the same area, the Britons, also received their name from the Romans, as *Briton* means "painted in various colors" in Latin.

Roman accounts of these ancient peoples suggest they may have been tattooed as a mark of high status, with "divers shapes of beasts" tattooed on their bodies. When Julius Caesar invaded southern Brittany in 55 BCE, he wrote that the Britons colored their bodies blue look more menacing on the battlefield—more recent historians have speculated that they also dyed their bodies to disguise their numbers and to camouflage themselves entirely in the low light of evening and early morning attacks. Chemical analysis of some of the bog bodies dredged from peat pits in Ireland, dating from between the first to the fifth centuri es CE, have revealed an unnaturally high amount of copper residue in their skin, which suggests that powdered copper, which turns greenish blue when it oxidizes, may have also been an ingredient in the blue body paint of the Britons.

Some of the most famous images we have of the Picts are those painted by sixteenth-century artist John White, who was a thousand years too late to have ever actually seen a Pict. The animal- and astrological-themed tattoos he drew on his subjects were very elaborate, sophisticated, and rendered in a variety of colors that would have been absolutely impossible for a tattoo artist to have made with just a single hand-powered needle and the limited selection of indelible inks available at the time.

A more reliable historical source discussing tattooing among the British Isles—specifically, among the Scots and the Picts—comes from a text by the 45Greek historian Herodian, a civil servant in the Roman government in the second century CE. He wrote that the Caledonians of Britannia walked around completely naked except for a few gold and iron ornaments, and drew "figures of animals or symbols on their skin by pressing a hot iron onto

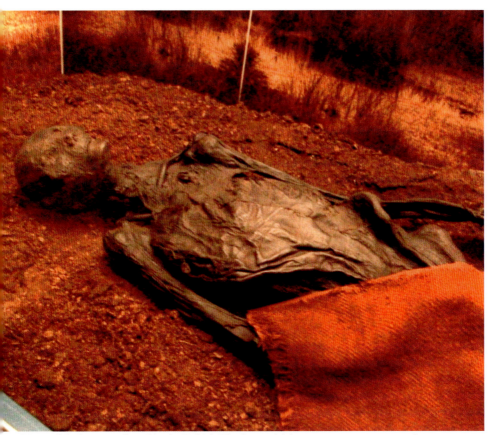

Many of the bog men found in the British Isles have a high copper content, suggesting copper was used to create their famous blue paint.                          *Wikimedia Commons*

their limbs, causing great pain, and over this they run the sap of a plant." The sap of the woad plant was already used by the Britons as a temporary blue dye, so it's possible that it was also used to color tattoos as well.

As Herodian never actually visited the British Isles, it's likely that his accounts were entirely secondhand or even thirdhand. It's also very unlikely that the people of the British Isles walked around completely naked in an environment that vacillated from cold and windy to rainy, and where the native plant life included Scottish thistles and brambles and would have deterred most people from abstaining from wearing shoes or pants. Also, the procedure he described sounds more like branding than tattooing, and it's unlikely that ornate tattoos such as the ones he described could result from rubbing any sort of colorant into a fresh brand.

The second textual source describing tattooing in the British Isles is that of a poem written in the fifth century CE by the Roman poet Claudius. In 402, he wrote a poem about the defeat of the Scots and the Picts by the Romans, in which he mentions seeing ". . . on the bodies of the dying Picts/ crude images cut with iron."

In the seventh century, Bishop Isidore of Seville wrote about seeing tattooing in Britannia. Though no one knows if he saw the tattoos firsthand or if he was merely reporting what someone else told him, he gave a very accurate description of the Picts and their tattoos. According to him, the Picts created their tattoos by rubbing the sap of local plants into their freshly pricked skin, and that the Pict elite distinguished themselves from the rest of the population by these elaborate designs. Isidore also claimed that the Scots tattooed themselves by a similar process.

Solid information regarding the tattooing practices among the Gauls, Britons, Celts, Picts, and other "uncivilized" peoples of the Isles is scarce, and most of the prints made in the nineteenth century supposedly based on historical accounts are extremely fanciful. Of all the figurative artwork left behind by the Celts, Picts, and Britons themselves, there is not a single piece of stonework, metalwork, or tapestry that depicts anything that looks like a tattooed human. This doesn't mean it didn't exist—all it means is that we haven't found any solid evidence for it yet.

What we do know is that as pagan Europe converted to Christianity, tattooing—except for tattoos with religious meaning, such as those received by pilgrims—was banned all over the Continent. In his official decree, Pope Hadrian I wrote, "Religious tattoos will bring spiritual rewards, but other tattoos defile God's creation." It's obvious from the wording of this decree that tattooing was

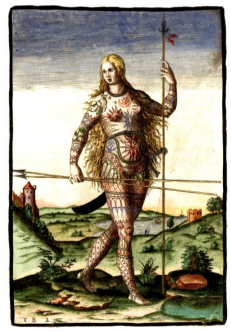

Theodor de Bry drew many fanciful depictions of the Picts nearly a thousand years after the fact, such as this 1588 depiction of a Pict woman and her tattoos.    *Wikimedia Commons*

still being practiced throughout Europe in the eighth century CE, because otherwise, there wouldn't have been any reason to create an official ban.

While tattooing was discouraged among mainstream Christian Europe, inside the hallowed halls of the Church itself, tattooing was alive and well.

Dominican Heinrich Seuse, among other mortifications, carved a Christogram on his chest, shown here bleeding through to the outside of his clothes.    *Wikimedia Commons*

Along with self-flagellation, barbed girdles, and horsehair shirts, penitent tattooing was very commonly used by members of the clergy and especially the priesthood to show their devotion to God. In the fourteenth century, the Dominican friar Heinrich Seuse tattooed a "Christogram" on his chest as a sign of his incredible devotion to Jesus. Some of his other devotions to Christ included wearing an undergarment studded with 150 brass nails and constructing a very uncomfortable door to sleep on as well as a large cross with thirty protruding needles to sleep with.

## Victorian England

During the nineteenth century, tattooing flourished in England like nowhere else in the Western world. This was due in part to the tradition of tattooing in the British Navy, which became commonplace after Captain Cook's first voyage to the South Seas. Many men, especially from the lower classes, as well as boys as young as twelve were lured by the prospect of steady employment and possible adventure to sign up with the crews of the numerous oceangoing vessels constantly traveling between British ports to the New World, Africa, and Asia. Little did these green crew members realize that they'd be trapped on board a ship for months at a time with little to do than keep an eye out for possible ocean obstructions, other ships, and the very minimal maintenance that a ship at sea actually needs. Some sailors used this time to mend fishing nets or their own clothing, while others were drawn to the irresistible lure of crafting macramé covers for glass bottles and fishing weights. However, the greatest way to spend all of that extra dead time on a ship was apparently tattooing, or being tattooed, as nearly every sailor who came back with some new design to commemorate their voyage. By the middle of the eighteenth century, most British ports had at least one professional tattoo artist in residence, and many of these artists accompanied ships when they left port to continue tattooing the sailors on board, as well as teach one or two enterprising young sailors on board the secrets of tattooing itself.

The first professional British tattooist on record was D. W. Purdy, who established a shop in North London around 1870. The only existing record of Purdy's work is a booklet published toward the end of his career, titled *Tattooing: how to tattoo, what to use, etc.* Purdy apparently drew all of his designs freehand without the aid of stencils, and was very proud about being able to do so, for in his book, he admonishes: "Before you commence to tattoo any individual you must be able to sketch well, as it is a very

George Burchett working on one of the many high-class women who depended on him for house calls.

*Library of Congress*

Edith Burchett, George Burchett's lovely and patient wife, displaying some of the many tattoos George gave her over the years.    *Library of Congress*

difficult matter to sketch onto a person's or on any other part of the body; you will have a good deal of rubbing out to do before you get the figure drawn correctly." So far as suitable subjects for tattooing, he suggested such ambitious projects as portraits of sweethearts, the Tower Bridge, the houses of Parliament, and Imperial Institute, and British battleships. Considering that the book is one-half angry lecture and one-half impossible challenge, it's possible that he wrote it to dissuade, rather than persuade or encourage, budding tattoo artists.

One of the most famous British tattoo artists of the late nineteenth century was Thomas Riley, and part of the reason he was so famous was because he had a serious edge over all over British tattooists. His cousin Samuel O'Reilly was responsible for inventing and patenting the first tattoo machine, and shared his new invention with his cousin before anyone else, making Tom Riley the first British tattoo artist with access to an electric tattoo machine. Riley very quickly rose to the top of his profession, due both to his skill as an artist and his flair for showmanship. One of his most famous publicity stunts involved tattooing the entire body of a pure white Indian water buffalo at the Paris Hippodrome in 1904. His performance lasted three weeks and was widely covered by the local and international presses. Later, the poor animal was returned to India, where it was supposed, by the British presses, to have been worshipped by Indians for the rest of its colorful life.

Riley's greatest rival was a man named Sutherland Macdonald, who, like Riley, had learned the art of poke-method tattooing while in the British Army. In 1890, he also bought himself a tattoo machine from O'Reilly and opened a fashionable London studio, with the goal of establishing himself as a respectable professional. To this end, he dressed in a formal black suit with tails and wore a top hat and sometimes a monocle while he worked. He cultivated a very dignified stance and called himself a "tattooist" rather than the common-use "tattooer." Macdonald also advanced his career by heavily courting journalists—often, with the offer of a free tattoo—and was the subject of many flattering newspaper and magazine articles, including by London's *The Strand*, which called his work "the very finest tattooing the world has ever seen." In Paris, *L'Illustration* referred to him as "the Michelangelo of tattooing."

However, neither of these artists ever achieved the status of George Burchett. Burchett started his career as a tattoo artist at the age of eleven, when he began giving his friends at school tattoos with soot and darning needles. While his clients were pleased with his work, their parents were not, and he was expelled from school. By the time he was thirteen, he had enlisted in the Royal Navy, where he made friends with an older sailor who took him in as an apprentice for his side business as the ship's tattoo artist.

During his twelve years in the Navy, Burchett made the acquaintance of and was tattooed by Hori Chiyo, the much-sought-after Japanese tattoo artist who had tattooed the Duke of Clarence and the Duke of York. Burchett was fascinated with the detail and artistic skill exhibited by Japanese and Burmese tattooists, and was determined to bring that level of skill and

quality to his own work. When he retired from the Navy at twenty-eight, he opened a tattoo studio in London and embarked on a career that eventually earned him the title "King of Tattooists."

During his remarkable career, Burchett developed one of the largest tattoo practices in the world and employed numerous assistants, including his brothers and his sons, who ended up running three different London studios under the Burchett name. He's also credited for pioneering permanent makeup, which made him very popular among many upper-class women and Hollywood starlets of the day. He was the subject of many newspaper and magazine articles, with a clientele that included King Alfonso of Spain, King Frederick IX of Denmark, King George V of England, as well as his wife, Edith—whom he covered from neck to ankles in tattoos—and the ex-convict J. P. Van Dyn, whom Burchett fondly referred to as "The World's Worst Man." He was known as a hard worker and an enthusiastic promoter of tattoo culture, and continued his nearly round-the-clock schedule until 1953, when he unexpectedly collapsed and died at the age of eighty-one.

# Japanese Tattoos

## Irezumi Art, from Woodblock Prints to Tattoos

T he earliest evidence of tattooing in Japan can be found in the form of clay figurines that have faces painted or engraved to represent what are believed to be tattoo marks. The oldest figurines of this kind have been found in tombs dating back as far as 5000 BCE, and are believed to have served as stand-ins for living individuals who symbolically accompanied the dead on their journey to the afterlife. For centuries, the Ainu women of Hokkaido tattooed the backs of their hands, their arms, and the area around their mouths. The tattoos covering the area around their mouths turned up at the corners, signifying that they were married. The Ainu, who came from the mainland more than twelve thousand years ago, practiced exclusively female tattooing for most of their history. Even today, there are still a handful of older women who can be found with their traditional facial tattoos.

The first written record of Japanese tattooing is found in a Chinese dynastic history from 297 CE. According to the text, Japanese men "young and old, all tattoo their faces and decorate their bodies with designs." Japanese tattooing from these texts is usually written about in a negative context, as the Chinese of this period already considered tattooing a sign of barbarism and, like most of Europe at this time, used it only for punishment.

By the third century CE, traditional tattoos that covered large parts of the body, like the back, were being worn by Japanese men, and were mostly hidden under clothing. Smaller tattoos, called *horimono*, were also popular at this time, but were generally applied to more discreet parts of the body that could be hidden by clothing like the larger ones. Perhaps because the only tattoos Japanese men received voluntarily were intimate ones that could be hidden by everyday clothing, when the government began to use tattooing as a punitive measure, they were always applied to the face or hands.

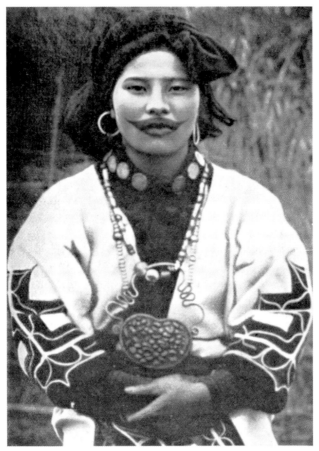

Ainu women tattooed their mouths after marriage.

*Wikimedia Commons*

By the fifth century CE, tattoos were being used solely to mark criminals as a form of punishment and not to celebrate one's personal status. Most tattoos spelled out words like *thief* and *deserter* and were prominently applied to one's face or hands. The first written account of tattooing as punishment in eighth-century Japan reads, "The Emperor summoned before him Hamako, Muraji of Azumi, and commanded him saying: You have plotted to rebel and overthrow the state. This offense is punishable by death. I shall, however, confer great mercy on you by remitting the death penalty and sentence you to be tattooed."

Just like in Rome, Greece, and Christian Europe, tattooing was now being used as a form of social control. After receiving a punitive tattoo, even

strangers would avoid talking to you for fear of guilt by association. Their friends and family would be afraid of letting them back into their home, and even their parents and children would disavow their presence. A tattoo was essentially a sentence of exile, even if one didn't actually leave one's country. This very public type of punitive marking was an effective way of controlling the population. More than a thousand transgressions were punished with tattoos under this system, although, of course, members of the upper classes could avoid this by paying a fine. The other four punishments were amputating the nose, or feet, castration, or the death penalty, and often, a criminal would be allowed to choose which of the four he or she preferred.

## Edo Period

It's during the Edo period of Japan (1603–1868) that the amazing, artistic creations involving balanced nature scenes, brilliant koi, seascapes, and heroic figures that we think of as the "Japanese tattoo" truly came into being. During this culturally and politically unique time in Japanese history, social conditions were such that the basis of the Japanese tattoo was formed. Many of the images and techniques developed during these centuries persist in the modern tattoos of today.

In 1720, the tattooing of criminals became the official punishment for most crimes, replacing the amputation of the nose and the ears. Murder was punished by death, but those convicted of extortion, fraud, or theft had a black band tattooed on the upper or lower arm, or had a character tattooed on their forehead. In a country where privilege and social status was based almost exclusively on birthright, offenders from the upper classes could easily buy their way out of the humiliation of having a punitive tattoo condemn them to lives of public disgrace. On the other hand, criminals from the lower classes could not afford to avoid getting tattooed, and since there were such a wide range of offenses that could result in a tattoo, the cities of Japan slowly began to develop a significant visible population of "criminals." Tattooing criminals was continued until 1870, when it was abolished by the new Meiji government of the Japanese emperor.

Concurrent with this, however, criminals began covering their punitive tattoos with larger decorative patterns, although they still would have been recognized as criminals by other Japanese citizens simply because they had tattoos. This visible punishment created a new class of outcasts that had no place in society and nowhere to go. Many of these outlaws were *ronin*, or masterless *samurai* warriors. With nowhere to go and a knack for vicious,

trained combat, they had no alternative than to begin organizing in gangs. These men formed the roots of *yakuza*—the organized criminals in Japan in the twentieth century, famous for the elaborate, full-body tattoos we associate with Japanese tattoos today. Like samurai, the *yakuza* prided themselves on being able to endure pain and privation without flinching. And what better way to show off how much pain one can withstand than a tattoo that covers most or all of one's body? A tattoo was also evidence of one's lifelong commitment to a group, and because it was also illegal, it marked them as outlaws for the rest of their lives.

While tattoos never became socially acceptable in Japan, they did become popular. In 1603, Japan closed itself off almost entirely from the outside world to preserve its culture and combat what was perceived as a growing threat from Spanish and Portuguese Catholicism. For the next two and a half centuries, Japan's culture and arts flourished in relative isolation and under the careful watch of the government, although contact and trade with the outside world was not completely eliminated. The art of creating woodblock prints (*ukiyo-e,* or "floating world culture") was perfected during this time, making the beautiful, elaborate works composed by popular Japanese poster artists inexpensive to reproduce and distribute. These prints were all made by printing one color from a complete design at a time from woodblock prints, much as silk-screened prints are made.

The biggest reason for the popularity of *ukiyo-e,* however, was its accessibility to the working classes, simply because many copies of a single piece of art could be made at a time, as opposed to an original painting of which no copies were made. On average, the price of a print would run no higher than a bowl of noodles. Another reason for the appeal of *ukiyo-e* was that unlike the work of traditional court artisans, who rarely saw any of the world outside of the insular environment of the palace, *ukiyo-e* artists were themselves working-class individuals. Their work depicted the world with which they were familiar, and portrayed popular subjects such as the working man's daily life, political satires, landscapes, and erotica (*shunga*).

Even more popular subjects were the visual images *ukiyo-e* artists created to accompany popular folklore, ghost stories, and historical figures and heroes. The artwork produced in this vein was uniformly concerned with capturing the spirit behind the imagination of the average citizen, while simultaneously maintaining a high aesthetic standard. The style and subject matter of these prints led to the Japanese style of tattoo. Pictorial tattoos flourished in Japan's underground in the eighteenth century, especially in the area around Tokyo. It was here that Kabuki theater, Buraku, and Sumo

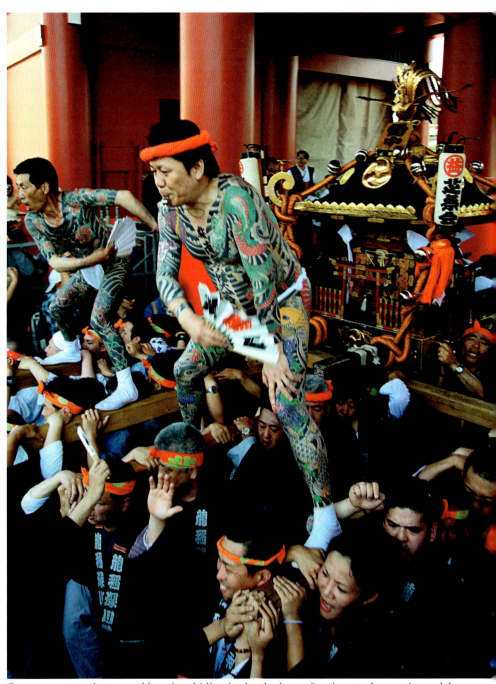

Contemporary *yakuza* spend less time hiding in the shadows of society, and more time celebrating their place in modern Japanese society, as in festivals like the Sanja Matsuri (Three Shrines Festival).                                                                                   *Wikimedia Commons*

Tsukioka Yoshitoshi's paintings portrayed many people of the lower classes, including this 1888 painting of a Japanese prostitute being tattooed.
*Wikimedia Commons*

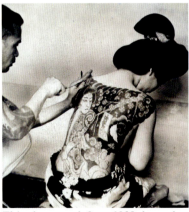

This photograph from 1932 shows that even after the end of the Edo period, tattoos were still something that Japanese prostitutes endured to attract clients.          *Library of Congress*

wrestling gained popularity, and the heady appeal of Japan's cultural center drew in artists, writers, and publishers, as well as the exotic, often-tattooed geishas who serviced these mostly male professionals.

In 1827, the *ukiyo-e* artist Kuniyoshi Utagawa published a series of prints based escapades from the fourteenth-century's *Shui-Hi-Chuan*, a Chinese novel about 108 "honorable bandits." Kuniyoshi's prints depicted the novel's heroes in colorful, full-body tattoos—tattoos that gave each of the book's characters supernatural powers. His popular art series inadvertently inspired fans of the artwork and book to seek similar tattoos of their own. When the government banned colorful kimonos as an excessive luxury around the same time, it only made these tattoos even more popular. Many men replaced their elaborately designed kimonos with even more elaborate tattoos that covered their backs, chests, and the upper parts of their arms and legs.

Little is known of Kuniyoshi himself, other than vague descriptions left by friends and family members of his warmth and great imagination. One of the most revealing reports of his character is found in a police report from 1853, where Kuniyoshi had been charged with drawing seditious political cartoons. The police investigator reported, "He appears vulgar, but he is large-minded. He accepts any order from a publisher, if he likes him,

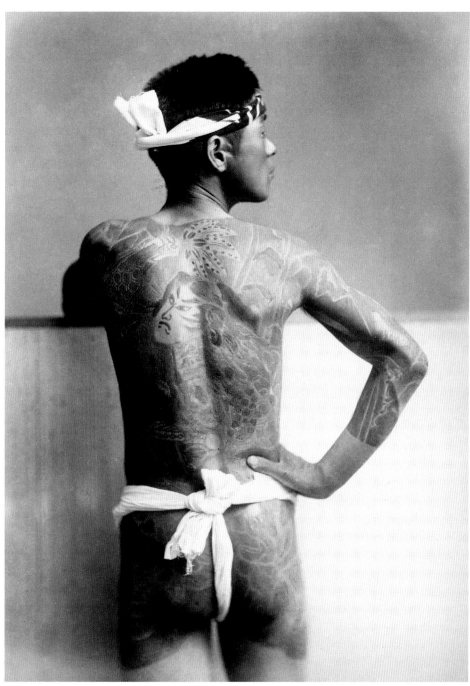

By the 1890s, Japanese tattoos had been elevated to an art form unlike anywhere else in the world.

*Wikimedia Commons*

regardless of the money that is offered, but refuses it if he is not pleased with him, no matter how much he is willing to pay."

Tattooing (called *irezumi*, which roughly means "to put ink in"), which had been quietly gaining popularity within the culture despite government condemnation, was now flourishing as a practice. Though the images chosen often varied, the most popular were those of samurai warriors, dragons, and tigers. Many tattoo designs were copied directly from the *ukiyo-e* prints, and several prominent *ukiyo-e* artists were heavily involved in tattoo art. The natural outgrowth of this trend was the collaboration between *ukiyo-e* print artists, tattooists, and tattoo aficionados. Not only Kuniyoshi, but also his students, were now designing tattoos in conjunction with artistic prints. As the popularity of tattoos heightened, *ukiyo-e* artists began designing prints that would simultaneously function as tattoo designs, and many prints designed without this double utility in mind were nonetheless well-suited for use as tattoo designs.

The vast majority of tattooed individuals during the Edo period were part of the lower, working classes, including firefighters, carpenters, and laborers, who were most commonly tattooed with images of great warriors from history and from legend. The men receiving these warrior tattoos were themselves estranged from any literal experience of the "heroics" of these often-fictional warriors, but desperately wanted to be these heroes. By tattooing the images of these warriors on their backs, these men could appropriate fragments of the warrior identity for themselves. Eighteenth-century Japanese firefighter brigades, for example, were composed of heavily tattooed men who would often strip down to their waists before approaching a blaze to reveal the heroic tattoos emblazoned on their backs, as well as to provide ease of movement when fighting the fire. Considering the lack of fire-retardant fabrics beyond silk, which was prohibitively expensive for the lower classes to wear, wearing nothing at all was probably the safest bet when approaching a fire anyway.

## Meiji Restoration

Kuniyoshi was the last of the great *ukiyo-e* artists. After his death in 1861, the once-mighty Tokugawa regime that had ruled Japan for over 250 years crumbled as a result of internal conflict and external pressures. During the 1850s, the government had opened up Japan's ports and ended centuries of near-isolation, which inevitably led to the collapse of the shogun-ruled

Contemporary tattooist Dan Sinnes has his own take on *shunga*, adding horrific elements to his otherwise erotic pieces. *Dan Sinnes*

government. An American consulate very quickly set up in Tokyo, and a European colony was established in Yokohama.

As a result of the sudden access to the rest of the world, Japanese art and culture was revolutionized at every level. The traditional styles of *ukiyo-e* suddenly seemed campy and old-fashioned to even the basest Japanese art connoisseur, and even Kabuki theater was all but abandoned. Many *ukiyo-e* artists tried to teach themselves the techniques of perspective, shadowing, and three-dimensional modeling that hallmarked Western art of the time, but only a few managed to adapt to the new demands of art connoisseurs.

However, visitors from Europe were stunned at the beauty and quality of Japanese art, especially tattoo art. Even despite the explorations of the South Pacific islands and the Americas, most Europeans had not seen tattoos much more sophisticated than the heavy, rigidly dictated lines of the Maori *moko*. Japanese tattoo artists were immediately in high demand, and wealthy Europeans and American traveled to Japan to be tattooed by Yoshisuki Horitoyo, one of the most famous Japanese tattoo artists at the end of the nineteenth century. Some of Horitoyo's clients included Nicolas II of Russia, Prince Georg of Greece, and King Edward VII of England, as well as dozens of wealthy socialites.

Japanese tattoo masters were world-renowned for their work, even though tattooing was still illegal for Japanese citizens and only foreigners could be legally tattooed by the Japanese masters. Some of the great tattoo masters established studios in Yokohama and did a brisk business tattooing foreign sailors and dignitaries. These tattoo artists also continued to tattoo Japanese clients illegally, but after the middle of the nineteenth century, their themes and techniques remained unchanged, limited to the traditional Japanese repertoire of legendary heroes, religious motifs, symbolic animals, clouds, flowers, and waves. Consequently, Japanese men who wanted an "exotic" tattoo would hold out for a Western tattoo artist to work on them, for the same reason that Europeans came to Japanese tattoo artists for an "exotic" tattoo.

While other tattoo artists in other cultures of the time—including Europe and the Americas—used only simple, or even primitive tools, the Japanese masters used a sophisticated set of instruments with varying numbers and groupings of needles. A Japanese master's set of tattoo tools could consist of fifty different instruments, including handgrips with shafts ending in between one and thirty needles. A shaft with no more than two or three needles was used for outlining, while color-filling and shading

Nicholas II (far right) sits with his family for a portrait in 1910, the Chinese dragon he received in Japan many years before barely visible on his right forearm.          *Wikimedia Commons*

required the use of many needles, often staggered in the same way that needle configurations for tattoo machines are set up today.

The traditional Japanese tattoo differs from Western tattoos in that it consists of a single major design that covers the back and extends onto the arms, legs, and chests. Such a design is not chosen casually, but represents a major commitment of time, money, and emotional energy, by both the client and the artist. Each design is associated with an attribute such as courage, loyalty, devotion, or obligation, and by being tattooed, individuals symbolically make these virtues part of themselves.

The use of color is also characteristic of traditional Japanese tattoos. The five basic colors were black, red, green, blue, and yellow, while additional colors, such as brown, were made by mixing colors from the basic color palette. White face powder, which contained a small amount of lead, was only rarely used, and the tattoos made with white ink were only visible when the skin was reddened from stress, exercise, a hot bath, or perhaps when the body attempted to rid itself of dangerous lead paint.

Japanese tattoos were true art, with such care taken in the rendering of the tattoos that they would have looked as good hanging on a stretched wall canvas as they did on a human body. In fact, some Japanese men made a small fortune selling their tattooed bodies to European museums. A museum "sponsoring" a tattoo could claim the skin of the bearer immediately upon his death to preserve and display it. While most of these skins are not on display anymore, it is possible, by appointment, to view the collection of preserved tattoo skins at the Pathology Department of Tokyo University, which houses the largest collection of tattooed human skin in the world.

# Chinese Tattoos

## From Punitive to Decorative Tattoos

T he barren desert of China's southern Tarim Basin has been the source of some of the ancient world's most mysterious tattooed mummies. Of the dozens of mummies that have been found, perfectly preserved in the frigid, incredibly dry air for thousands of years, the best-known one belongs to a woman from 1000 to 600 BCE.

The woman, who is believed to have been a sacrifice before being buried in a necropolis outside the modern village of Zaghunluq, had light brown, straight hair with white streaks in it that had been braided and tied with red wool string. Her body was covered with charcoal and soot tattoos received well before death, and included moons on her eyelids, ovals on her forehead, and a decorative scroll pattern on her left hand, wrist, and fingers. It's believed that the tattoos on her eyelids may have been received postmortem, or in a drugged stated just prior to being sacrificed, as this is an incredibly sensitive and difficult area to tattoo no matter how stoic the patient. Many other mummies of both genders found in this region also have bold, geometric tattoos on their hands, forearms, and faces, but this woman is believed to have an elevated social status because of the complexity of her body art.

Curiously, DNA evidence shows that this entire series of mummies have Indo-European origins, despite being located in the heart of Asia. Although the culture to which these mummies belonged has not been identified, the similarity of their tattoos to those of other Eurasian mummies possibly identify them as part of the tattooing tradition that began with Ötzi some five thousand years ago and the Pazyryks of Siberia from the fifth century BCE. Considering there's evidence that Pazyryks may have traveled as far from their homes in Eastern Europe to Burma/Myanmar, China, and even Persia for trading or diplomatic purposes, there's a chance that these mummies belonged to a group of Eastern Europeans who were either stranded in the region due to some environmental or political catastrophe, or just

decided on their own to stay in the area rather than continue the thousands of miles back home.

Chinese writers may have documented these people when they were still living—the first-century poet Wang Bo wrote about tattooed people in central Asia in the first century CE. Texts as far back as the third century BCE tell of the tattooed Yue who lived south of the Yangtze River. The tattoos were usually described in positive terms due to their power to thwart evil presences. The poet Zuo Si wrote in 300 CE that "Warriors with tattooed foreheads/Soldiers with stippled bodies/Are as gorgeously adorned as the curly dragon." Other accounts of the Yue say they wore tattoos of mythical beasts to protect themselves from dragons and sea monsters while fishing. Again, considering that the Pazyryks famously tattooed themselves with mythical animals and violent, nightmarish monsters from the world around them, it's highly possible that there may be a connection between the legendary Yue people and the Indo-European mummies found in the Tarim Basin.

Like much of the world, the history of tattooing in China has been one of contradiction, dependent on the cultural climate and attitude. Ethnic groups in China historically used tattoos to show social status, or to show to which tribe a person belonged. In other cases, as with the Siberians and Alaskan Inuit, indigenous women from the hundreds of scattered, unique tribes throughout China tattooed themselves to make themselves unappealing to rival tribes prone to kidnapping raids, and, if kidnapped, to make themselves identifiable to their families if and when they were rescued during a subsequent raid.

For many centuries, mainstream Chinese society regarded tattoos as something distasteful that only criminals and rural, uneducated peasants did. By 500 BCE, most Chinese had begun to follow the teachings of Confucius, who believed that the human body was a gift from one's parents and ancestors, and therefore should not be maimed or marked. Educated Chinese of the day considered tattooing to be "barbaric," just as their likewise-civilized Western European counterparts, the Greeks and Romans, did.

However, just like the Greeks and Romans, the Chinese also used tattoos to mark slaves and criminals. Farmers that were forced to join the army also received tattoos so that they could not escape and run back to their villages. Upper-class Chinese tattooed their concubines and house servants—not only to show ownership, but also to punish and humiliate a servant who had offended his or her master. For the punishment of infidelity, a concubine

The Yue Fei Temple in China, built in the twelfth century, features many statues portraying aspects of General Yue Fei's life, including this one in which he is being tattooed by his mother.

*Wikimedia Commons*

could be punished by having her eyebrows cut from her face and the flayed skin beneath filled with pigment so that she would have a permanent reminder of her crime. There was also a very good chance that the severity of the cutting would lead to an infection bad enough that, if not properly treated, could result in the concubine's death.

A punitive tattoo was usually forcibly applied to the hands or face, where they couldn't be easily hidden. China has had a long history of being especially brutal to criminals, with major crimes being punished with floggings, amputation of the nose, ears, eyebrows, or testicles, and death sentences consisting of chopping convicted men or women to pieces while they were still alive. Tattoos were generally used to punish small crimes, and considering the frightening alternatives, receiving a tattoo for punishment was probably a shameful yet acceptable consequence for a crime. A minor thief may have had a small ring tattooed discreetly behind one ear. A man convicted of adultery would be tattooed on the forehead, with additional tattoos added to the first for multiple infractions.

However, once a man was tattooed, he was forced to either join the army or be banished, as those with facial tattoos who showed themselves in the city risked punishment of amputation, castration, or death. Even after loyal service to the army, a tattooed soldier, or criminal-turned-soldier, found a return to normal society impossible because of the physical consequences to himself and possibly his family. Soldiers who had been captured during battle were often additionally tattooed with humiliating texts on their foreheads outlining their defeat, making sure that shame would be brought on their family should they try to return home. This punishment was especially poignant in the case of rural farmers who had been unexpectedly rounded up and conscripted by the Chinese government, as their families would often not welcome them back home after whichever war they'd fought because of the humiliation literally written all over their faces. Once a man joined the army, he was often there for life. If a man left the service, the only real alternative for him was to serve as a mercenary for a local warlord, which often led to him committing even more damning atrocities than he'd been asked to perform under the service of the emperor.

One major consequence of tattooing so many conscripted farmers, petty criminals, and soldiers was that tattoos began to lose much of their stigma. Former war-weary soldiers began to acknowledge one another in public not because they'd served together, but because they could each identify with the social isolation that a tattoo brought with it. Soldiers began adding their own texts and images to the tattoos given to them by

the government. Petty criminals did the same, turning the punitive marks into art. Soon, it was impossible to tell why someone had been tattooed to begin with, and soldiers and convicts began to associate with one another without questioning or caring about what the original tattoo had meant. In the 1960s, Communist leader Mao Zedong outlawed tattoos altogether as part of his campaign to unify China, specifically designed to force-integrate the individual tribes still clinging to their "backward" traditions in rural China, but especially those of the neighboring lands taken over by China. Even now, members of the Chinese military are not allowed to have tattoos, and many private businesses will not hire you if you have a tattoo.

Not surprising, traditional tattoos in China are close to dying out, although certain indigenous tribes have managed to cling to their traditions with a ferocity that even Mao couldn't stamp out. In the late 1990s, the China Association of Tattoo Artists began holding tattoo conventions, including the Shanghai International Art Festival of Tattoos, to showcase both modern and traditional Chinese tattoo styles and techniques. One of the most notable exhibits at their events has been to bring some of the elderly women from the Dulong tribe—one of the smallest ethnic groups in China and isolated from mainland China for thousands of years before Mao—to leave their village for the first time ever and come to Shanghai to show off their tattoos.

## Tribal Tattooing

While traveling from East Bengal to Burma during the thirteenth century, the Venetian explorer Marco Polo wrote extensively about tribes he'd encountered whose entire bodies had been "pricked" with images of birds and animals. Considering the region he was passing through and the images he described, it's very possible that he was writing about the Dai people, who originally lived in the deep south of Yunnan since ancient times, but have almost all completely relocated to Laos and Thailand—they're still listed as one of the fifty-six ethnic groups that make up China's indigenous population.

Among the Dai, both men and women are tattooed. A woman's tattoos on her hands, arms, and face are there specifically for enhancing her beauty, while a man's tattoos on his back, chest, and biceps are there to highlight the muscles in his body and advertise his strength. Dai women are generally tattooed on the backs of their hands, on their arms, or have a small dot tattooed between their eyebrows.

One of the 108 honorable bandits from the Chinese novel *Shui-Hi-Chuan*.

*Wikimedia Commons*

Traditionally, when a Dai boy turned twelve, his father would pay a tattooist to apply images of flowers, animals, geometric designs, and characters from the Dai alphabet on his chest, back legs, and arms, and, more recently, images inspired by Buddhism. Dai girls received their first tattoos around the age of five, and continued to receive tattoos to mark significant events in their lives, especially those of marriage and childbirth.

Tattooing among the Dulong (or Drung) people has existed since the Ming Dynasty over six hundred years ago. Anthropologists believe that Dulong women began tattooing their faces to make themselves unappealing to neighboring tribes prone to raiding their villages for slave-brides, and especially to make them unappealing to the men of the armies of mainland China during the Ming Dynasty's attempts at expansion throughout the continent. The tattoos became a defining mark of the tribe, and girls continued to receive facial tattoos as part of their puberty rites up until the 1960s, when facial tattooing was outlawed universally in China. Today, fewer than a couple dozen women with the traditional facial tattoos still live in China's Yunnan Province. Girls among the Dulong received their first tattoo around age twelve or thirteen—generally around the time they hit puberty—to show they had reached sexual maturity. Lines were drawn around their mouths, on their cheeks, and in between the eyebrows, all of which come together to create a stylized butterfly.

Tattooing also has a long-standing tradition among the Li people of Hainan Island, although since the Mao ban on facial tattoos, hardly anyone on Hainan sports the traditional facial tattoos of the Li people save a few elderly women. Like with many indigenous groups in Asia, tattooing is mostly reserved for women, with men having only a few small wrist tattoos

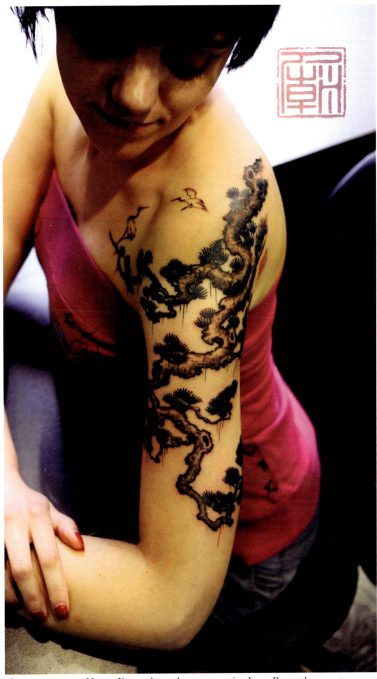

Contemporary Hong Kong–based tattoo artist Joey Pang draws on many traditional Chinese images for her work.

*Joey Pang*

for medicinal purposes. A Li girl who reaches maturity is first tattooed on the nape of the neck, her throat, and originally, on the face. Over the next three years, the girl would continue to have her arms and legs tattooed until she was determined to be of marrying age.

Traditionally, when a young Li woman is engaged, her hands are tattooed, and before the ban on facial tattoos, her future husband would tattoo the signs of his family on her face on the evening before her wedding. Family tattoos differed greatly among the different Li tribes, and could be easily used to differentiate between a woman of one tribe and another.

# India and Southeast Asia

## Ancient Artistry

Tattooing has been practiced in the regions making up Southeast Asia and India for thousands of years. Up until the past century, tattoo artists in Burma (now Myanmar) were considered among some of the best in the world, and may have influenced tattoo artists as far away as the Pazyryk Scythians in Eastern Europe and the nomadic tattooists of Persia.

Everything from colonialism to changes in religion to military occupation to a concerted effort within the individual countries to claim their heritage and destiny itself has helped shape the history and culture of this region, and unfortunately, traditional tattooing has suffered under these changes. In some of these countries, tattooing was declared illegal for so long that when it was finally made legal again, there were no more, or at least, very few, tattoo artists who knew how to revive these nations' tattoo traditions.

Unlike the Western world, and especially in Southeast Asia, religion is at the very bottom of the list of culprits to blame for the decline of traditional tattooing. Buddhism, unlike Confucianism, has never outlawed tattoos, and, in fact, Buddhist monks are almost single-handedly responsible for these traditions surviving at all. Buddhist temples have continued to offer a variety of magical tattoos—even adapting so far as to offer magical tattoos made in "invisible ink"—to pilgrims throughout the decades of political unrest that plagued many of these countries during the nineteenth and twentieth centuries.

## Thailand

While many tourists think getting a tattoo in Thailand is an essential part of the cultural experience and an almost required souvenir, the government of Thailand officially opposes tattooing of any kind—at least for residents of Thailand. People who apply for government jobs must show their bare chests and arms to prove that they're not tattooed, even though many highly qualified applicants may come from rural areas where tattoos are perfectly acceptable. Because tattoos are important to temple monks, pilgrims, and many of the indigenous people of the region, many temples have begun offering "invisible" tattoos—that is, tattoos made by traditional methods using sesame oil instead of pigmented ink. These invisible tattoos are accompanied by the same ceremonies as those done with permanent ink, and impart the same amount of luck and magical powers as the visible ones. For as long as perhaps a full week, the tattoo is visible as a pattern of faint abrasions on the skin, but once the skin has healed, there's rarely even any scarring on the site.

The belief in the magical powers of tattoos has made them an important part of Thai culture for thousands of years. A Buddhist Sak Yant, or *yantra*, is believed to be magic and bestow mystical powers, protection, or good luck, and is prevalent throughout Thailand, Laos, and Cambodia. *Yantra* symbols represent Buddha's sacred teachings, and are composed of pictures of animals, gods, and divine words—often a combination of all three. It's believed that, depending on the type of tattoo received, the different types of *yantra* may make wearers either more eloquent, protect them from evil and hardship, or invoke fear in those around them. This last *yantra* is the most powerful of the three, and only confers its powers to bearers who observe certain rules and taboos, such as abstaining from certain foods.

Tattooing is a highly ceremonial process among Buddhist monks, who have to go through an extensive formal training period before being allowed to tattoo another person. The tattoos themselves are made by dipping a six-foot-long "sword" (actually a long, very sharp pole called a *khem sak*) into ink and require serious concentration and practiced dexterity to render correctly. Sometimes, another monk may assist the monk doing the tattooing by helping guide this tremendously long and sharp tattoo pole to the skin of the person receiving the tattoo—however, this is only done the first couple of times a monk tattoos another human, and the more experienced monks can carefully and slowly give a Sak Yant tattoo all on their own. The process of receiving a tattoo is accompanied by special rituals to activate its magic powers, and many times, if people survive brushes

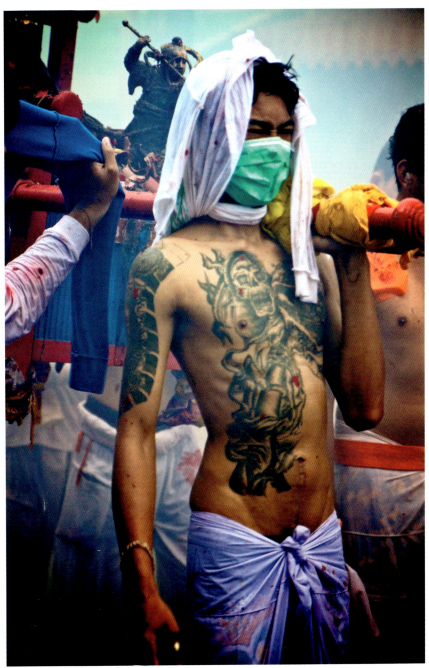

Although discouraged by the government, tattoos in Thailand are still a common sight, such as here, during the 2003 Phuket Vegetarian Festival.    *Wikimedia Commons*

with death, they often give credit to the protective powers of their tattoos. Since the power of a *yantra* decreases with time, Sak Yant masters hold a Wai Khru celebration every year to "recharge" their devotees' *yantra*. The more powerful a *yantra* is, the quicker its potency wears off, and therefore, to keep it at full strength, it must be "recharged" much more regularly than the less powerful ones. Coincidentally, the more powerful a *yantra* is, the more expensive it is, too.

## Myanmar (Former Burma)

Before the 1960s, when the socialist government of Myanmar, inspired by the Maoists of nearby China, banned the practice of tattooing, the indigenous women of the Chin Province of Myanmar tattooed their faces, with each woman having her own individual design. These designs were done strictly for personal ornamentation and to enhance a woman's natural beauty, although some anthropologists believe that the practice of facial tattooing here was, as in other parts of Asia, to make a woman unattractive and therefore less likely to be kidnapped by a neighboring tribe.

Historically, long before the colonization efforts of the French and British Empire, Burmese men were also known for their fantastic tattoos, which were of a higher standard of art than almost anywhere else in the world. Burmese tattoos were characterized by their beautiful, artistic designs and highly detailed execution. Motifs of animals, geometric patterns, prayers, tigers, and dragons regularly appeared on a man's back, thighs, or backside, and even manifested occasionally as a full-body tattoo, all of which spoke of his status in the community and his qualities and virtues as a man. An especially popular tattoo among young Burmese men was that of an image of *belu*, a devil or evil spirit that symbolized fertility, aggression, and brute force—basic manly attributes. Animals and devils were always surrounded by an oval outline of letters from the Burmese alphabet, sometimes forming a secret message or prayer. Sometimes, the animals themselves were formed entirely out of Burmese script.

After the 1960s and up until just recently, pictures of tattoos weren't even printed in newspapers or magazines published in Myanmar. All tattoos on pictured subjects had to be digitally "removed" before they were allowed to go to print. Even so, there were plenty of people coming in and out of the country with tattoos, and sometimes, Myanmar celebrities left the country and returned with a tattoo. In 2007, Myanmar rap star G-Tone caused great controversy when he returned to perform in his native country and pulled

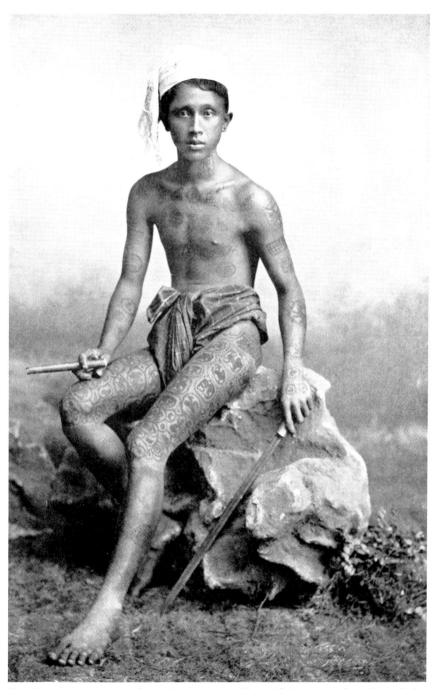

The Burmese were known for their intricate and beautiful tattoo work up through the late nineteenth century.    *Wikimedia Commons*

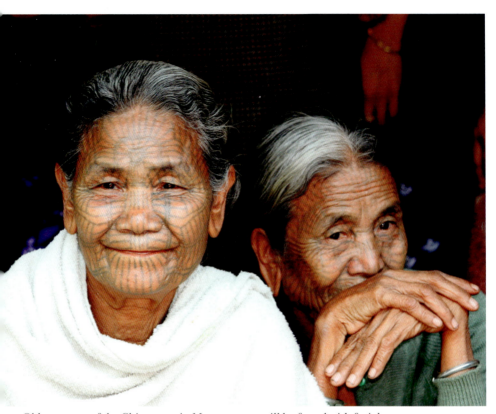

Older women of the Chin group in Myanmar can still be found with facial tattoos.

*Wikimedia Commons*

up his shirt onstage to show the tattoo on his back, which depicted a large pair of hands pressed together in prayer, clasping a string of prayer beads. Police believed he was showing solidarity for the thousands of monks who had been arrested during the Saffron Revolution earlier that year and immediately arrested him. Because of the international attention paid to G-Tone and Myanmar in general at the time, his jail sentence was commuted and he was simply banned from performing in Myanmar for the next six months.

In 2011, a group of retired generals were elected to government amid much controversy and international consternation. However, these retired generals completely surprised everyone when they began supporting the country's democratic movements, dismantled the previous government's draconian censorship laws, and allowed unfettered access to the Internet. Myanmar's youth were suddenly exposed to foreign cultures on a dramatic

new scale. Today, even though the government still officially opposes tattoos, legal tattoo parlors offering both modern and traditional tattooing methods have opened all over the country, reinvigorating an art form that was once revered the known world over.

## Vietnam

According to an ancient Vietnamese legend, there once was a tribe of fishermen and seafarers who lived in Southeast Asia. Each day, when these fishermen went out in their boats, at least one member of their group was killed by a giant fish, a poisonous snake, or a crocodile, or whole groups of them were drowned by unexpected bad weather. Their king took this as a sign that they had somehow angered the regional water spirits and ordered his subjects to tattoo their bodies with images of sea monsters, dragons, snakes, and crocodiles, in the hopes that the disturbed spirits would then leave his people in peace.

The fishermen in the story were the Giao-Chi—established before 1000 BCE and believed to be the ancestors of the present people of Vietnam—and the king, Hung Vuong, named his kingdom Van Lang, which means "Land of the Tattooed People." The king also ordered his fishermen to shape and paint their boats so that they looked like giant fish and dragons, something that the people of the region still do today. Migrant communities of Vietnamese have brought this tradition with them to the United States as well, and many major cities celebrate Vietnamese dragon festivals with food, parades, and, of course, dragon boat races.

Within the Van Lang Empire, the markings on men's legs and chests developed over time to represent symbols of power and nobility, and not simply to appease an angry water spirit. Kings and noblemen especially had dragons tattooed on their thighs and backs, right up until the end of the thirteenth century CE, when King Tran-Anh Tong, influenced by Confucianism, abolished tattooing.

## Taiwan

As in mainland China and on the neighboring island of Hainan, tattooing on the island of Taiwan has been around since ancient times. According to seventh-century CE Chinese writings, Taiwanese women tattooed their hands with images of insects and snakes, which possibly served as charms against the bites of these creatures when the wearer was working with water

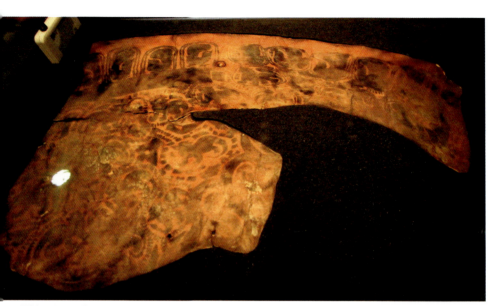

This piece of preserved skin found on a mummy in Laos shows that some of the same tattoo designs have existed throughout Southeast Asia for hundreds, if not thousands, of years.

*Wikimedia Commons*

or grass as the tattoos of the Giao-Chi protected their wearer from the dangerous creatures lurking in the water. Tattooing was customary on Taiwan (then Formosa) until Europeans arrived in the 1600s, followed by the Chinese, who finally conquered the island and incorporated it into the Chinese Empire. The practice gradually faded away around this point, and only the isolated mountain tribes kept up their tattooing traditions. In the nineteenth century, Japan took over Taiwan, and in 1914, began actively deterring all forms of body modification, severely punishing any found deviations of the law.

Even so, the Atayal, Saisiat, Paiwan, Rukai, and Puyuma tribes continued to practice their tattooing traditions in secret until well into the twentieth century. Their tattoos celebrated a child's initiation into adulthood, signs of courage and skill among warriors, and to ensure that the deceased could enter into the afterworld. Tattooing in Taiwanese tribes generally started around puberty, but a boy who had not taken an enemy's head in combat could be tattooed much earlier. Parents determined the exact date their child would receive his or her first tattoo by having a shaman interpret their dreams or by the behavior of birds, especially migratory ones.

Nature was frequently the inspiration for tattoos, such as representations of people, celestial bodies, and animal markings. Strict taboos were

enforced before and during the procedure, which required the recipient to follow a strict diet and exercise regimen and as well as proscribed sexual activities and status. Girls were never tattooed while they were menstruating, and pregnant women were not allowed anywhere near the tattooing sessions. Breaching those taboos could cause the designs to fade and lose their power and significance, which would render them impotent and require additional, painful tattooing sessions to restore their power. Special tattoos among the men of the Atayal and Rukai related to headhunting, combat, status, and authority.

Forehead tattoos were common, but chin tattoos were reserved for a man who had taken an enemy's head in battle. If a warrior had taken the heads of more than five of his enemies, he could also tattoo his chest and hands. Only the most accomplished warriors were allowed to tattoo their children with signs that indicated their father's bravery and battle prowess. Even after the Japanese banned headhunting at the end of the nineteenth century, it was possible for young men to still acquire the coveted status-enhancing tattoos of a headhunter by buying the rights to a design from a veteran headhunter. If the headhunter refused to sell the rights, the tattoo could still be earned by wrestling a bear or a wild boar to death.

Women among the Taiwanese tribes also wore tattoos to indicate status. Very skilled weavers among the Atayal were allowed to have their cheeks tattooed, and tattoos around the mouth indicated their marriage status. Women of almost all of the tribes also were tattooed in similar patterns of bands around both wrists and geometric patterns all along the fingers of both hands.

## Philippines

An indigenous people known as the Ibaloi once mummified their honored dead and laid them to rest in hollowed logs in the caves around what is now the Filipino municipality of Kabayan. In life, these ancient people had won the right to be covered in spectacular tattoos depicting geometric shapes as well as animals such as lizards, snakes, scorpions, and centipedes. According to nineteenth-century ethnographic accounts, Ibaloi headhunting warriors revered these creatures as "omen animals," and the sight of one before a raid could make or break the entire enterprise. After successfully taking the head of an enemy in battle, a warrior would have these magical animals permanently inked on his skin. Some Kabayan mummies also feature less fearsome tattoos, such as circles on their wrists thought to be

Many Filipinos today have been reviving the tattooing traditions of their pre-colonial past.

*Wikimedia Commons*

solar discs, or zigzagging lines variously interpreted as lightning or stepped rice fields. Today, thousands of people tracing their descent to the ancient Ibaloi wear designs on their skin modeled after those of their ancestors.

In 1532, Portuguese explorer Ferdinand Magellan discovered the four-hundred-plus island archipelago of the Philippines. The ship's journals reported that inhabitants of many of the islands tattooed themselves with a variety of patterns, with the practice apparently being so widespread among the residents of the Visayan islands of the Philippines that the Spanish named the inhabitants *Pintados*, or "Painted Ones."

The most famous tattooed person to come from the Philippines was a fully tattooed man named Prince Giolo, who came from the island of Mindanao to London in 1691. He was a slave whose owners went to great pains to promote his public appearances, including having two full-length portraits engraved and published as illustrations for an elegantly printed pamphlet that introduced him as "Giolo, the Famous Painted Prince."

Prince Giolo apparently had no desire to go to London, especially since he'd be leaving most of his family behind on the island, but his owners had told him that he would be paid enough for his public appearance that he would be able to buy his freedom and return home. However, the long trip overseas proved fatal to Giolo, and he died of smallpox soon after arriving in England. This was a great disappointment for his owner, the adventurer and buccaneer William Dampier, who had hoped the Prince would live long enough to make them rich. Dampier had acquired Prince Giolo from a ship's officer named William Moody, who had bought the Painted Prince— as he was billed—and his mother, who had also died during the trip, from a Spanish colonist who sold the pair to Moody.

Many more attempts were made to bring the heavily tattooed natives from the Philippines to England to exhibit around Europe both for royalty and as part of less-reputable traveling sideshows. Nearly all of them died either before reaching European ports or soon after landing in Europe, having no natural resistance to either the diseases that were so prevalent in Europe at the time or the unclean air and water of post–Industrial Age Europe. Every single man, woman, and child had their tattooed skin flayed from their bodies, tanned, and, barring any problems with the flaying or tanning, sent to England to be displayed at the British Museum. At one point, the British Museum had so many tattooed skins in their collections that they stacked them up against a wall in a back room and displayed only a fraction of the very best ones for museum attendees.

This Bontoc warrior from the Philippines wears tattoos representative of many people of the region prior to the twentieth century. *Wikimedia Commons*

Most Europeans were as shocked by the customs of the natives as Christopher Columbus has been when he'd first encountered the peoples of the New World. The men of the Philippines were tattooed all over their bodies, with wooden and metal pins piercing their genitals—in the case of the tribal leader, this pin was usually gold. The Spanish were especially shocked by the appearance of the natives, and many believed the Devil had personally taught the Filipinos these practices. Jesuit missionaries quickly began work to eradicate all body modification practices on the islands—as the seventeenth-century Jesuit priest Father Francisco Ignacio Alcina said, "With holy water, we have washed clean the ugly countenance and eradicated this superfluous and barbaric custom."

However, despite their best efforts to civilize the Filipinos, the indigenous people stubbornly refused to abandon the practices that were so deeply rooted in their culture. Genital piercing was never fully abandoned for one specific reason: Filipinos believed that genital piercing in men and women greatly enhanced sexual pleasure, and a woman would often show no interest in a man who wasn't pierced. They stubbornly and steadfastly clung to what they could of their tattooing traditions for similar reasons: a man without tattoos was considered a coward and unworthy of a wife, for if he couldn't handle something as innocuous as a tattoo needle, he certainly couldn't endure the agony inflicted by an enemy's spears, and would not be able to protect his family if attacked.

Unlike most other indigenous peoples of the world, only adult Filipinos received tattoos. Most men didn't get their first tattoo until they were twenty, and then, almost all of a man's tattoos were applied at once. Symmetrical patterns were applied to the chest, back, arms, and legs, while the very bravest men were tattooed on their eyelids and lips. The reward for enduring the additional eyelid and lip tattoos was higher status and increased appeal to women, which was worth it to some despite the fact that these tattoos sometimes proved fatal. Many women were only tattooed on their hands and wrists, with patterns resembling flowers and braids. Women's tattoos were specifically designed to enhance their beauty and could take on any configuration that each individual woman believed most attractive and likely to catch her a husband.

Even after Catholicism took hold in the Philippines, tattoos were still commonly practiced among the converted. Filipino shamans would tattoo spells in Latin to offer the wearer protection from misfortune and evil, while the shamans themselves were tattooed—also in Latin—and were believed to control supernatural forces through these spells. Because many

of the original Catholic prayers/spells were very lengthy when written out in Latin, the shaman would often just tattoo the first letter of each word on the recipient, with crosses marking the beginning and ending of the prayer.

## India

Up until the mid-twentieth century, almost every girl in India had a tattoo. Everyone from the mountain people in northeastern India to the Tamils in the south used tattoos to enhance a girl's beauty. They were like permanent jewelry—and, in fact, the Halba from central India say that "tattoos are the only jewels a girl can take to her grave." Although the custom is slowly disappearing due to the rapid encroachment of Western civilization and modern technology, there are still tribes that practice tattooing. The women of the

Indigenous peoples in the mountains and countryside of India still practice tattooing to express their cultural heritage.                                                  *Wikimedia Commons*

Across spread: Just a sampling of the many stamps used by Indian tattoo artists today, displayed at a street fair for passersby to choose from.                                    *Wikimedia Commons*

Kutch and Ribari in western India still decorate themselves with beautiful tattoos, as their ancestors did, as do those in the eastern provinces of Bengal and Orissa. Specialists called *keluri* tattoo girls on their neck, face, arms, and hands at street festivals or during village feasts, and even in the heavily populated urban areas, women with books of traditional designs can still be seen seated at tables or even on the ground at street bazaars, willing to tattoo anyone for a price. In some overpopulated slums, some mothers tattoo their children for identification purposes, in case they're lost in the crowd or kidnapped.

There are two distinctive tattoo cultures in India, the largest belonging to the Hindus and their caste system, while the other belongs to the animist mountain tribes who live in northeastern India, which include the Naga, the Aka, the Nisi, the Abor, the Apatani, and the Ao. Hindu tattoos reflect the subordinate position of women in society, and are designed to emphasize a woman's beauty as well as announce her fertility and provide magical protection for her during courtship, pregnancy, and birth. Among the animists, tattoos are used to emphasize a man's prowess as a warrior and particularly his success as a headhunter. Since the outlawing of headhunting, many of these tattooing traditions have declined sharply, although it is still practiced by women, whose tattoos symbolize fertility, beauty, and solidarity within the tribe.

Although the caste system in India is less prevalent than it used to be, it still has a strong hold on Indian culture and society, especially in the poorer rural areas. In fact, the concept of caste is still so strongly ingrained in Indian society as a whole that even the relatively new Islamic population of India has its own caste system. The animist mountain tribes are considered "untouchables" by both the city-dwelling Hindus and Muslims, who rarely interact with the isolated tribes. Many symbols of happiness and protection are associated with Hindu tattoos: lotus blossoms, fish, peacocks, triangles, and swastikas. In Bengal, priests from the Brahman caste refuse to accept even a drink of water from a girl without a lotus blossom tattooed on her forehead. Depictions of snakes, scorpions, bees, and spiders offer protection to women against the bites and stings of these creatures, while a line tattooed between or above the eyebrows offers the same protection against evil that the small red chalk dot many people associate with Indian women.

Traditionally, all tattooing in India was done by women of lower-caste nomadic tribes, such as gypsies. If no such woman was present, the only other option was to remain without a tattoo or to ask an older woman in the village to do it, usually the wife of the village wizard. Gypsy tattooists

were always fantastically decorated with tattoos and served as a walking billboard of what they could offer their potential customers, although it's hard to believed that they were able to complete all of tattoos on their bodies themselves. The tattoos of the gypsy women from Andhra Pradesh were so finely detailed that they reportedly looked as though they were covered in flowers. Women of all castes would invite these tattooists into their homes to work on them, and even the Muslims of the Tamil region would allow these "untouchables" in for a tattooing session.

Despite these relatively friendly interactions, however, the nomadic tribes these women belonged to had a bad reputation, which they possibly earned, and were even considered by some to be "a caste of thieves." This reputation often led to families refusing to pay a tattooist for her services—or even allowing her to leave—until all valuables in the house were accounted for, which was probably very humiliating for the poor woman who had been asked to work for hours on her clients' tattoos. Today, most tattooing is done by women who set up shop in the many street bazaars and festivals in town, and only rarely by nomadic people going from village to village in search of clients.

# Oceana Tattoos

## Hawaii, New Zealand, Tahiti, and Beyond

Tattooing has been practiced in Oceana by a related group of people called the Polynesians for at least 3,200 years. The Polynesians were a seafaring culture who populated the islands of the Pacific Ocean over the course of thousands of years, most significantly, New Zealand, Tahiti, Samoa, Tonga, Easter Island, the Cook Islands, and the Hawaiian Islands, but their descendants can be scattered all over the region on even some of the most remote, tiny islands of the Pacific. Somehow, this amazing group of nomadic explorers managed to find even the tiniest, most isolated islands in the middle of the Pacific, through following the paths of migratory birds and recognizing current patterns, successfully spreading their culture throughout the far-flung islands of the Pacific. There's even physical evidence that they may have even reached the Americas long before Columbus—when the Spanish arrived in South America, chickens, a creature with roots in the jungles of China, were already a staple in Aztec food, while DNA has revealed that "native" pigs in Central America have a genetic link to the ones Polynesians brought with them on nearly every voyage.

So far as we know, all Polynesian people practice tattooing, although the patterns and placement of the tattoos varies greatly. For example, the people of the Cook Islands mostly tattoo their stomachs and legs, while Samoans traditionally only tattoo their lower bodies—their *pe'a*, or tattoos, are applied so extensively and densely over their bodies that sometimes people died during the tattooing process itself or during healing. Tahitians favored tattoos that covered their buttocks, while the Maori of New Zealand are famous for their facial tattoos.

Unlike the inhabitants of many other parts of the world, Polynesians did not spend their days struggling to obtain the bare necessities of life in a hostile environment. Except for Easter Island, nearly every island they settled

on could easily support their population. They also packed wisely on every voyage they made—along with chickens and pigs, their boats were stocked with staple crops such as breadfruit that they immediately planted wherever they settled. Because of this, they were able to develop sophisticated arts and crafts, simply because they had the extra time on their hands. Everything

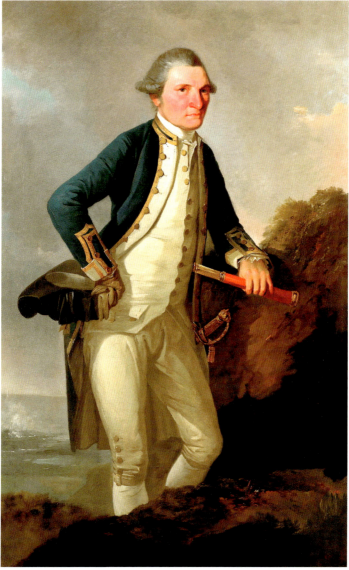

Captain James Cook and his crew on the *Endeavor* discovered many cultures that had long been isolated from the rest of the world.

*Google Art Project*

they made was made with great skill and fantastically decorated: canoes, bowls, war clubs, and even simple farming tools. Even their tattoos were far more sophisticated than those of most other peoples of the world. Tattooing was a natural part of their life and art, and an extension of the artwork that covered everything they owned.

Before Captain James Cook and his ship, the *Endeavor,* made his 1769 voyage to the South Pacific, Europeans had no standardized word to describe tattoos or even the process of tattooing. Even the word *tattoo* is based on the Polynesian word *tatau,* meaning "to knock or strike." When Cook landed on Tahiti, he and his crew were met by the heavily tattooed Polynesians inhabitants, whose customs both attracted and repelled the Europeans. The ship's naturalist, Joseph Banks, wrote, "What can be a sufficient inducement to suffer so much pain is difficult to say; not one Indian (though I have asked hundreds) would ever give me the least reason for it, although possibly superstition may have something to do with it; nothing else in my opinion could be a sufficient cause for so apparently absurd a custom."

Banks was a wealthy young man with a taste for adventure, fostered by his love of Victorian novels and culture. He was also a passionate amateur naturalist who, while neglecting his studies at Oxford, began an invaluable natural history collection that included skeletons, insects, pressed plants, minerals, and taxidermic animals that was ultimately acquired by the Natural History Museum of London, where it may still be seen today. At twenty-three, Banks had impressed enough of the scientific community of London that he became the youngest member ever inducted into the Royal Society.

In 1767, the Royal Society chose Captain James Cook to lead a voyage of exploration to the South Pacific. Cook, who was little known outside of naval circles, was a man of working-class origins who had risen through the ranks by making a reputation for himself as an outstanding navigator and cartographer. For the voyage, Cook was promoted to the rank of lieutenant and charged with two missions: the first, to sail to Tahiti, from which he was to observe the transit of Venus when it passed between the earth and the sun for mapmaking purposes, and second, to see if a fabled Southern existed that could provide new sources of colonial wealth, as the Spanish discovery of the Americas had done. He was therefore ordered to bring back detailed descriptions of the plants, minerals, and other natural resources in any lands he might visit, and for this, he needed a naturalist.

Joseph Banks was the youngest member ever inducted into the British Royal Society, and the perfect choice to be the *Endeavor*'s naturalist.                    *Google Art Project*

When Joseph Banks learned of the proposed voyage, he energetically promoted himself for the position of ship's naturalist. Because of his outstanding record as a collector and also, no doubt, influenced by the ten thousand pounds he had donated to help finance the expedition, the Royal Society was easily persuaded that Banks was the man best qualified for the post. Banks brought with him Sydney Parkinson, one of the most talented scientific illustrators of his day despite being in his early twenties.

Sydney Parkinson made careful, accurate drawings of the tattoos of the people Cook encountered during his South Pacific voyages, and even got tattooed himself while in New Zealand, much to Banks's consternation. Parkinson's greatest strength as an artist was his willingness to completely immerse himself in an environment, and for him, the cultures he depicted

were part of that environment. The open-minded, cheerful young artist managed to endear himself to numerous peoples during Cook's voyage, and the sensitivity of his portraits reflects the passion and respect he had for his subjects.

Parkinson also took very careful notes of the tools and the processes involved in tattooing itself, which have been invaluable to historians ever since. Enough of Cook's crewmen were seduced by both the beauty of the natives' tattoos and culture that many of them endured the pain of receiving traditional tattoos of their own before leaving, and more than one crewman had to be forcibly dragged away from the island—and the Tahitian women they had married in secret.

After traveling to Tahiti, New Zealand, and Australia, with brief stops on some other small islands along the way for provisions, the *Endeavor* headed home by way of the Cape of Good Hope. During the voyage back to England, twenty-six-year-old Sydney Parkinson died after a protracted battle with malaria and dysentery. The many exquisite drawings he had made of the plants, animals, and people Cook's crew had encountered during their thirty months at sea had established him firmly as one of the great scientific illustrators of the eighteenth century, and his work is still considered some of the finest representations of the era. He was the first European artist to set foot on Tahiti and New Zealand, the first to paint portraits of the Tahitians and the Maori and their tattoos, and the first European artist to paint the Australian landscape and natives. Had he lived, he would have been able to spend the rest of his distinguished career resting on these accomplishments alone.

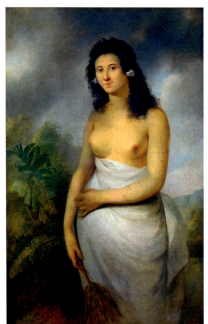

The delicate tattoos on the arms and hands of Tahitian princess Poedua can be seen in this painting by John Webber.
*Wikimedia Commons*

After his return to England, Banks was much in demand as a guest at fashionable dinner parties, where he thrilled giddy British socialites with his romanticized tales of stormy seas, cannibals,

headhunters, and exotic islands. His newfound status in the Royal Society eventually led him to being presented to King George III, with whom he shared a common interest in natural history and botany. In 1772, King George appointed Banks the director of the Royal Gardens at Kew, and in 1778, Banks was elected president of the Royal Society—a position that he held for over forty years.

The very young and very talented Sydney Parkinson was personally hired by Joseph Banks to illustrate the peoples, plants, and animals encountered by Captain Cook and the *Endeavor*.                    *Google Art Project*

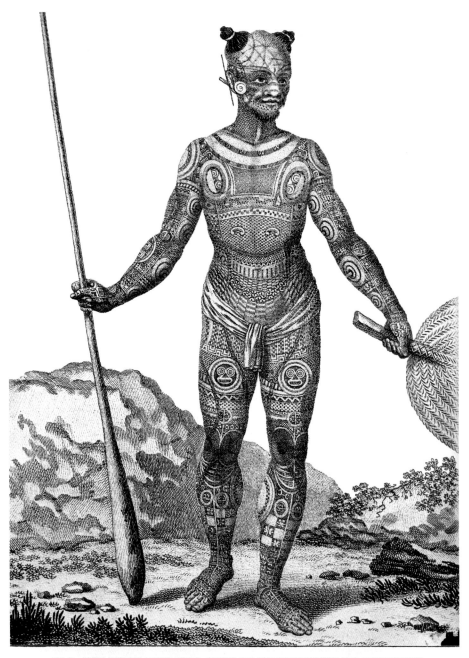

Abb. 84. ALTER KRIEGER LANGSDORFFS. BLUETE DER SCHACHORNAMENTIK UND KUPPENMUSTER.
1804. Kupfer X. 8/5 d. Orig. Vgl. S. 141.

This 1804 drawing of a Marquesan and his incredible tattoos by Alter Krieger showcases the great skill of the Marquesan tattoo artists.    *Wikimedia Commons*

Sadly, the main reason for the disappearance of so many of the tattooing traditions that Captain Cook's voyage encountered was precisely this sort of contact with European explorers, which ultimately meant the ending of their near-total isolation from the rest of the world. After centuries, and even millennia, of being the preeminent culture in their own little corners of the world, these indigenous populations were quickly overcome by the dominant European seafaring nations. Europeans quickly introduced their own value systems, based on Christian beliefs that utterly conflicted with those of the Pacific Islanders. They also brought their own diseases, both airborne and sexually transmitted, which decimated many of the isolated island populations, especially groups such as the Marquesans, whose population was significantly reduced almost immediately after first contact. And even though many of these sailors returned to Europe with tattoos and stories that piqued the imagination of the people back home, most Europeans still considered the practice unsavory and outlandish. It could not have escaped the natives that many of the adventurers found the tattoos of the native women distracting and unappealing, and to a society that had, up to that point, considered themselves the pinnacle of sophistication, this must have been a serious blow to their egos. In some cases, the only European observers to ever see and record genuine tribal tattoos were the ones who made first contact.

## Tahiti

After landing on the island of Tahiti, Banks was soon to become an invaluable member of Cook's crew by the way he was able to strike up friendships easily with the Tahitians, through the mutual trust he built up through his openness, natural curiosity, and fascination with their customs and way of life. During the three months that Cook's ship stayed on Tahiti, Banks wrote extensively about partaking in native orgies and dances, and wrote the first European description of surfing.

Of the Tahitians, Joseph Banks wrote, "Some have ill designed figures of men, birds or dogs but they more generally have this figure 'Z' either simply, as the woman are generally marked with it, on every joint of their fingers and toes and often round the outside of their feet, or in different figures of it as square, circles, crescents, etc. which both sexes have on their arms and legs. . . . Their faces are, in general, left without any marks."

He also wrote in detail about seeing a young woman receiving her first tattoo, saying:

. . . It proved as I have always suspected a most painful one. It was done with a large instrument about 2 inches long containing about 30 teeth, every stroke of this hundreds of which were made in a minute drew blood. The patient bore this for about one quarter of an hour with most stoical resolution; by that time however the pain began to operate too strongly to be peaceably endured, she began to complain and soon burst out into loud lamentations and would fain have persuaded the operator to cease; she was however held down by two women who sometimes scolded, sometimes beat, and at others coaxed her.

Sadly, by the time Charles Darwin and his *Beagle* reached Tahiti in 1845, only older Tahitians still had the traditional "sock" tattoo that was widespread among men when Cook's ship had made first contact a century before.

## New Zealand

In 1769, Cook, who was searching for the southern continent, Australia, discovered a small group of islands that hadn't had visitors from Europe for a decade. Cook, who was badly in need of food and other supplies, attempted to trade with the natives, but the fierce Maori warriors—who, unlike other South Sea Islanders, had encountered Europeans before and apparently didn't like them very much—rejected his overtures. In the resulting dispute between the crew and the natives, one of the Maori warriors was killed, and for some unknown reason, Cook's men dragged the body on board for further investigation.

Joseph Banks, upon examining the man, noted in his journal that "he was a middle-sized man tattooed on the face and on one cheek only in spiral lines very regularly formed; he was covered with a fine cloth of a manufacture totally new to us; his hair was tied in a knot on the top of his head; his complexion brown, but not very dark." Joseph Banks was once again the first European to write about a people's tribal tattoos, and a short while later, he also became the first European to acquire a perfectly preserved and tattooed Maori head for his personal collection, inspiring a fad that swept through Victorian England quickly with unforeseen consequences.

As the *Endeavor* cautiously continued around New Zealand, the British crew was able to establish more harmonious relationships with the other Maori groups they encountered. Banks had the opportunity to study and write in detail about Maori facial tattooing, or *moko*, and Sydney Parkinson drew the first portraits of tattooed Maori tribesmen. Parkinson also made

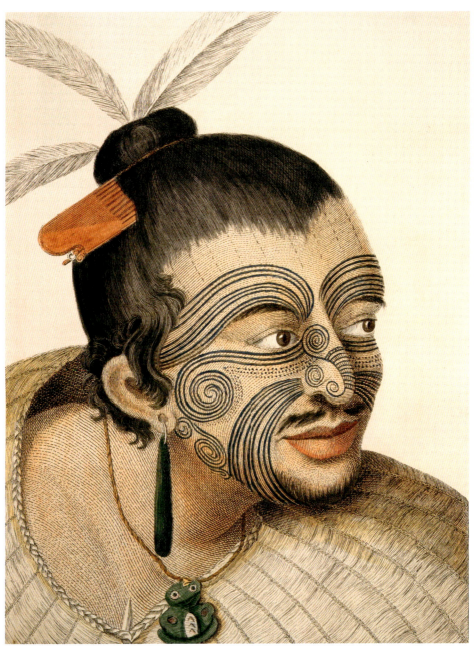

Sydney Parkinson faithfully rendered illustrations of the Maori and other peoples encountered during the voyage of the *Endeavor*. The openness he had for the many cultures they encountered shows in the respectful way he rendered all his portraits of indigenous peoples.

*Wikimedia Commons*

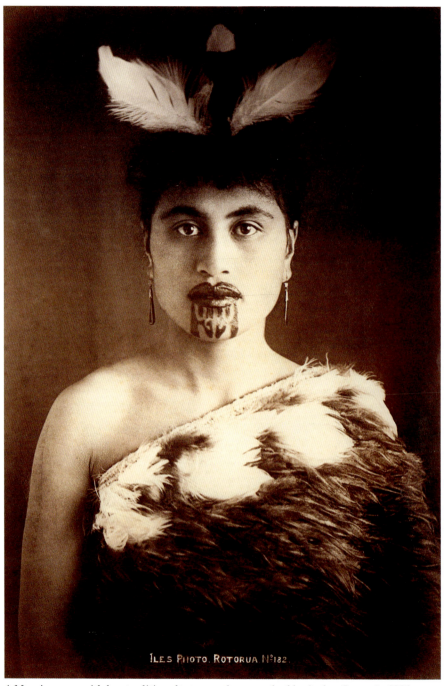

A Maori woman with her traditional tattoos, photographed by Arthur James in 1900.
*Wikimedia Commons*

drawings of the Maori tattooing instruments, which he described the use of in detail and even submitted to a Maori tattooing session to accompany the other tattoos he'd gathered along his trip.

Both genders of the Maori of New Zealand are tattooed, although traditionally, the men are much more tattooed than women. A *moko* describes a man's personal and family history, with different parts of the face referring to different types of information. The center of a man's forehead told an observer his rank in his community, while the area around his eyebrows reflected his status. The tattoos on his cheek told of his specific profession or trade, while the space under his nose bore his individual signature, which could be used to bind agreements. The tattoos on his chin spoke of his prominence or reputation, while the tattoos along his jawline gave his birth status. Although Maori women were also tattooed on their faces, the markings tended to be concentrated around the nose and lips. Years after Cook's visit, Charles Darwin wrote that when Christian missionaries tried to stop the procedure, the women maintained that tattoos around their mouths and chins prevented the skin from becoming wrinkled and kept them looking young; this practice apparently continued all the way up into the 1970s.

When someone with a *moko* died, his head would often be preserved by the man's family, to be kept in an ornately carved wooden box and brought out only for ceremonial purposes. To preserve the heads, first, the eyes and brain were removed, and the sockets, ears, nostrils, and mouth were sealed with flax fiber and tree gum. The head was carefully boiled or steamed to melt and seal the gum, then smoked over an open fire and dried in the sun for several days. When it was completely dried out, it was treated with shark oil to keep the skin from cracking. The finished result was a *mokomōkai*, which was a slightly shrunken, beautifully tattooed head. The heads of important enemies were also preserved this way, and were considered war trophies. During diplomatic relations between tribes, these heads would be exchanged as a condition of the peace, with each *mokomōkai* being returned to his family and tribe.

As gruesome as it sounds, Europeans were probably even more fascinated by these tattooed heads than they were the living men with the tattoos, and sailors began trading with the Maori for their *mokomōkai*—specifically, they traded guns and ammunition. From 1807 to 1842, over three thousand battles were fought between warring Maori tribes, and the tribes with guns had a distinct advantage over the ones without. This gave rise to a period of New Zealand history called the Musket Wars. Back in England,

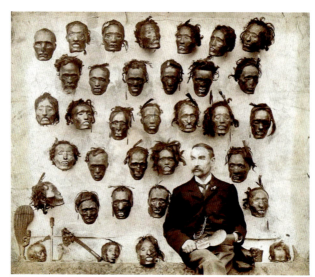

Victorians considered a *mokomōkai* one of the greatest acqui-
sitions for one's collection of curios—pictured is merchant
Horatio Goron Robley with his own collection of *mokomōkai*.
*Wikimedia Commons*

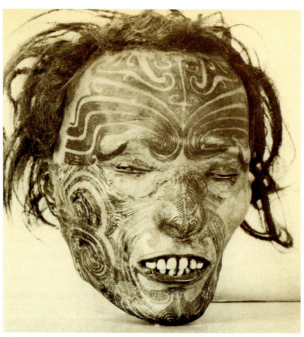

The Maori collected the tattooed heads of their enemies,
preserved them, and kept them as good luck charms and to
exchange for the heads of their own ancestors, likewise kept
by their ancestors.                      *Wikimedia Commons*

*mokomōkai* became commercial trade items that could be sold as curios, artworks, and as museum specimens that fetched high prices in Europe and America. During the Victorian era, where high-class society held mummy-unwrapping parties and even smoked mummy wrappings and dried mummy parts because of their alleged hallucinogenic properties, a tattooed Maori head was a coveted keepsake.

The Maori demand for firearms grew so great that tribes began carrying out raids on their neighbors just to get their heads. They also tattooed slaves and prisoners and even a few unlucky Europeans with meaningless motifs in order to have more heads to trade for guns. There were even reported cases of *moko* "farms," where living, tattooed prisoners were held for Europeans to come and view to pick out the ones whose heads they wanted. Finally, in 1831, the governor of New South Wales banned any further trade of heads out of New Zealand, and by 1840, New Zealand was officially a British colony.

Since the 1980s, an effort has been by the New Zealand government and the Te Papa Museum to repatriate the mokomōkai, now referred to as toi moko to indicate their status as ancestors, from international collections. Of the six hundred confirmed Maori heads believed to be in museum collections, a little under half have been returned to the Maori. One of the largest collections remaining outside of New Zealand is in the American Museum of Natural History in New York, where the heads are hermetically sealed and not available for public viewing.

## Samoa

French explorers were the first Europeans to set foot on the island of Samoa in 1787, although the island had been seen from a distance by other ships as early as 1722. The first written observations of the native Samoans were that "the men have their thighs painted or tattooed in such a way that one would think them clothes, although they were almost naked." When missionaries came to Samoa a few years later, one of the first things they tried to completely abolish, predictably, was tattooing. After all, as one missionary wrote, "Tattooing is among the works of darkness and is abandoned wherever Christianity is received."

Ironically, considering the missionaries' opinion of Samoan culture, the Samoans were intrigued by Christianity and considered it just one more thing to incorporate into their existing culture. Just as they did for other indigenous peoples, such as those in Africa and South America, many

elements of Christianity integrated easily into an existing religious structure, such as the concept of the Virgin Mary and the cavalcade of saints that accompanied pre-Vatican II Catholicism. The Samoans did not, however, intend for Christianity and Christian morals to *replace* their culture—they were more interested in picking through the dogma and adding bits and pieces to their existing culture, and tattooing was one aspect of their culture they were very reluctant to let go of. Even though Samoans willingly attended church services and took sacrament on Sunday, they were not willing to give up tattooing, and because of this attitude, tattooing in Samoa was never completely abandoned as it had been in much of the rest of Oceana.

According to Samoan oral tradition, the origin of the Samoan tattoo was brought to the Samoa islands by two sisters, Taema and Tilafaiga, who came ashore with the tools and knowledge of tattooing. The tale proclaimed that the two sisters sang a song as they swam, chanting that only women would be tattooed, but as they neared the beach shores, the song mistakenly became reversed, indicating that only the men would be tattooed. One of the Samoan chiefs decided to allow the women to tattoo him, and soon, the art of tattoo became a family tradition that spread throughout the culture.

For young Samoan men, tattooing was a rite of passage from boyhood to maturity. A young man who was not tattooed was not considered an adult. Without tattoos, he couldn't get married, couldn't speak in the presence of other adult men, and was required to perform menial tasks with the other children. Samoan males who lack tattoos are colloquially referred to as *telefua* or *telenoa*, literally "naked." Those who begin the tattooing ordeal, but do not complete it due to the pain, were called *pe'a mutu*—and it was a mark of shame.

Traditional Samoan tattoos can only be given to a person by a tattoo master, who makes the tattoo marks with a piece of bone carved into a sharp comb attached to a wooden stick. Soot is collected from burning candlenuts and mixed with water, which results in a very dark, thick ink. *Pe'a* is the traditional tattoo design for men that spans from the waist to the knee. The design is very intricate with a series of lines, curves, geometric shapes, and patterns. Each section denotes a special meaning to the person's character, his family, and culture, covering a man from mid-back, down the sides and flanks, to the knees. The geometric patterns are based on ancient designs, and often denote rank and status—the traditional canoe tattoo, for example, stretches all the way across a man's mid-back. Even the most sensitive parts of a man's body, including the penis and the skin around the anus, are given specific tattoos.

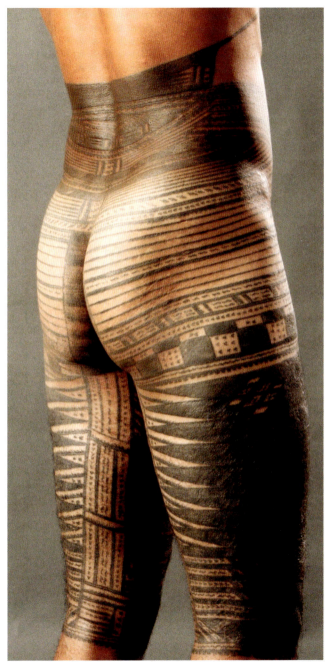

The Samoan *pe'a* covers almost all of a man's trouser area, cutting off just below the knees. *Wikimedia Commons*

The women of Samoa also get tattoos. The *malu* is a simpler and more delicate design than the *pe'a*. They span from the upper thighs to below the knees and are often only seen when women display their *malu* during traditional dances. Many Europeans considered them to be some of the most alluring and beautiful tattoos seen among any women of the Oceanic islands.

In 1990, a village on Savai'i, an island in Samoa, made having a tattoo a requirement for all adult men; since then, Samoan immigrants living in other countries have gotten traditional tattoos to express their heritage. Also, while many tourists do go to Samoa to get their own Samoan tattoos, many master tattooists refuse to tattoo clients who can't show a direct lineage to Samoa. Some legislators are even considering making it illegal for non-Samoans to receive a traditional tattoo, with heavy fines proposed for any island tattooist giving a non-Samoan these tattoos.

## Marshall Islands

On the Marshall Islands, tattoo imagery came directly from the ocean environment of the natives. Considering that the waters surrounding the archipelago are now home to the world's largest shark sanctuary, it's no surprise that some of the reoccurring tattoo motifs were based on bite marks of various sizes, shark teeth, fish scales, and sea shells. Some of the inhabitants of the islands were so heavily and elaborately tattooed all over their bodies that they were described as "dressed in a suit of chains, resembling a medieval knight." Both men and women were tattooed during specific rites of passage, although, as with most Polynesian groups, the men were much more heavily tattooed than the women. Unlike many Polynesian groups, Marshall Islanders even tattooed their fingers and genitals, leaving no part of their bodies untouched by the needle.

While traditional tattooing has not existed on the Marshall Islands since the turn of the twentieth century due to heavy missionary and European intervention and influence, detailed descriptions of Marshallese tattooing do exist. The first European to touch upon the atolls of the Marshall Islands and leave a written account of the trip was the Spanish explorer Alvaro de Saavedra, who arrived in October of 1529 on a return voyage from the Philippines to Mexico. Saavedra encountered a northwestern atoll of the Marshall Islands, possibly Ujelang. A brief encounter with the heavily tattooed natives seems to have impressed the Spaniard and his crew so much that they named the entire island group "Los Pintados," meaning "the painted."

A more detailed narrative stems from the accounts of the Russian Exploring Expedition under the command of Captain Otto von Kotzebue, who visited the northeastern Marshall Islands from 1816 to 1817 and again in 1824. Adalbert von Chamisso, a German naturalist on the expedition, even desperately ventured to obtain a tattoo himself, but could not find a Marshallese tattooist willing to give a foreigner a tattoo. In his eyes, "tattooing neither covers nor disfigures the body, but rather blends in with it in graceful adornment and seems to enhance its beauty." The expedition's artist, Choris, drew several sketchbooks' worth of illustrations on the islanders, their tattoos, and various aspects of their culture. But after Kotzebue's expedition left, little ethnographic work was done in the Marshall Islands for over half a century.

Following his two-month sojourn in the Marshall Islands in 1897, Augustin Krämer wrote an academic paper on tattooing in the Marshall Islands, as well as other neighboring islands in Oceana, and included tattooing in a monograph on his trip, published in 1906. In 1910, Kramer again visited the Marshall Islands with the German South Sea Expedition, and in 1938, published all his collected ethnographic material together with Hans Nevermann as part of a multivolume series. In his collection, Krämer stated that Marshall Island tattoos are called *eo*, which meant the drawing of lines in general, but also referred to the lines of the Blue-striped or Regal Angelfish, which lived in the waters off the coasts of the islands. The Regal Angelfish was, for the Marshallese, the apex of perfect symmetry existing in nature, and served as an example for their tattoos. Marshallese tattoos were executed in a systematic manner and none of the motifs or patterns were of accidental creation.

Sadly, by the mid-1800s, the Marshall Islanders were completely overrun by German industrialists who conscripted the locals to work as field laborers, and soon after, dedicated German missionaries came to spread Christianity and the joys of the civilized world through the little atoll. The islands fell under the care of the United States in the 1940s, and became a testing site for nuclear bombs and radiation studies from 1946 through 1958.

## Melanesia

A legend in Papua New Guinea states that once upon a time, tattooing was completely painless. One day, however, a woman who was tattooing a girl accidentally passed gas, making the girl and her friends laugh. The woman took their laughter as a sign of disrespect and from then on, she only used

thorny twigs for tattooing, which hurt a lot. Because of this, no one was to ever laugh at the tattooist again, or any other tattooist from then on.

Scarification and body painting was practiced much more than tattooing in the thousands of islands that make up Melanesia, as native Melanesians are darker-skinned than those of Polynesian descent—it's now believed that seafaring Melanesians came to the islands directly from the continent of Africa anywhere between forty thousand to sixty-five thousand years ago. However, Melanesians did tattoo themselves for both decorative and spiritual purposes, especially the women. Most often, the tattoos were a combination of abstract designs and pictures of fish, birds, and the sun and moon. Birds were an especially common tattoo and were believed to connect the wearer to the spirit world, as birds were believed to be related to spirits and ghosts because of their ability to fly.

While men had very few tattoos or were only decorated with scars, tattoos were an obligation for all women. Without a tattoo, a woman could not get married, and if she did manage to land a suitor, her family wouldn't be paid a fair bride price. The higher a girl's father's rank, the more tattoos she

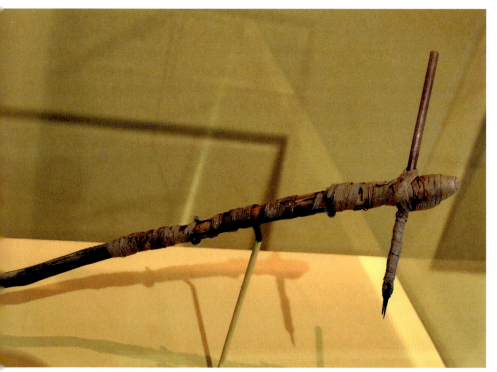

The traditional Melanesian tattooing instrument is the *boare tifá*—note the sharp thorns at the end used to make the punctures.                                           *Wikimedia Commons*

was entitled to, and if she married a man with "Big Man" status, she would receive additional tattoos after her wedding as well to commemorate her exceptional position of status within the tribe.

The most extensive tattooing in Melanesia was done on Papua New Guinea. As in most tattooing traditions, bearing the pain of a traditional tattoo, which is still performed using a *boare tifá*, a tattooing tool made from a sharp thorn dipped in a variety of ceremonial antiseptics, is an important part of the process of being tattooed. Traditionally, all women were required to be tattooed before getting married, beginning with a few small tattoos on their arms when they were five or six and culminating in a series of tattoos that covered their chin, nose, stomach, shoulder, back, buttocks, and naval by the time they reached puberty. After marriage, they received additional tattoos on their chest, and continue to get tattooed for the rest of their lives to mark significant events, such as childbirth and mourning the death of a family member.

According to anthropologists, the facial patterns of these tattoos are most likely inspired by the plumage of the Raggiana bird of paradise, which is a relatively ordinary-looking bird until it reaches maturity, upon which it develops brilliant, distinctive patterns all over its face and body. The reason they believe this tradition was inspired by birds is because so many other rituals and traditions on Papua New Guinea are inspired by birds, whose migratory patterns have alerted the islanders for thousands of years about everything from changing weather patterns to the passage of time to impending disasters.

The role of the tattoo artist is one of the most important in Papua New Guinea. When a young woman's elders decide she's reached maturity and is ready for her tattoos, they deliver her to one of the tribe's tattooists, generally an older woman who comes from a long line of tribal tattoo artists that may go back a staggering one hundred generations or more. Being a tattoo artist carries great responsibility—she's not only responsible for making the tattoos themselves, but also for caring for the young woman she's just worked on for the duration of her healing period. Each series of tattoos can take up to two months to execute and completely heal, depending on the size and location of the tattoo and the age of the girl, so the tattoo artist essentially takes on the role of full-time nursemaid or surrogate mother for the young woman on and off throughout her life. From beginning to end, the process of acquiring these tattoos is shrouded in mystery, and is performed completely inside the tattoo artist's hut with only one family member allowed to assist in holding the girl steady; no one else permitted to

see the girl or her tattoos until each phase of the artwork is complete. Girls are not allowed to make a sound during the process, either, as their silence is supposed to be indicative of how they'll be able to deal with childbirth later in life.

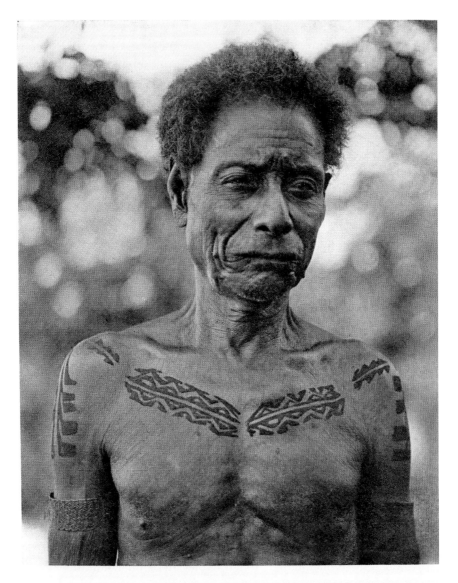

## Tattoo assumed by homicide

This Melanesian man from 1910 received his tattoos to commemorate taking the heads of his enemies.                                                          *Wikimedia Commons*

Men also receive tattoos, although much smaller and more localized. Most of their tattoos are of a medical nature, and are used to relieve joint pain and problems with the heart and, occasionally, impotence. Other tattoos are given to mark great achievements, such as leading a trade excursion with another island or killing an enemy.

Today, with many families moving to the major cities in Papua New Guinea and New Guinea for work and education, many of these tattooing traditions have been reduced or completely abandoned. As with much of the rest of the world, girls have the choice between getting a facial tattoo and settling to a life of marriage and child-raising, or getting an education and choosing a career in the city or anywhere else in the world.

Fiji is the only island in Melanesia where tattooing is entirely restricted to women, and it was traditional for all girls who lacked tattoos to be the first to see the beautiful patterns revealed when the scabs were removed from newly tattooed girls, possibly to stimulate their desire to have their own tattoos through sheer peer pressure. Fijian girls were tattooed with designs that symbolized the tasks they would perform throughout their lives and after death. Tattoos were so important to marking a woman's status that a woman could not serve food to any high-ranking man in the tribe, even if he were her husband or father, without having her fingers tattooed first.

## Borneo

Borneo is one of the few places in the world where traditional tribal tattooing is still practiced today, just as it has been for thousands of years. Until recently, many of the inland tribes had little contact with the outside world, and as a result, they have preserved many aspects of their traditional ways of life. Borneo's tattoo traditions have managed to endure a great many periods of colonialism, occupation, war, and other "civilizing" forces, partly because its rugged geography of lush rain forests and impenetrable mountains and cliffs have offered a level of isolation to its native population despite the island's being split between the sometimes adversarial nations of Indonesia and Malaysia.

Borneo was largely unknown to the Western world until the British arrived in the mid-nineteenth century. Before the arrival of the British, tribal warfare was endemic, with the purpose of the wars not for property or territory, but to acquire enemy heads, which were skinned and dried over a fire and hung from the longhouse rafters. The skulls were believed to be a source of spiritual energy that would bring prosperity and good luck

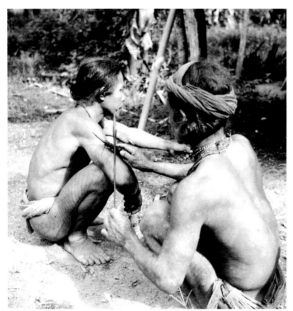

In 1938, natives of Borneo were still widely practicing traditional tattooing.                    *Wikimedia Commons*

to the tribe that had taken them. They were kept warm, protected from the rain, and treated with great respect. Only elders were allowed to touch them.

For over a century, the British rulers of Borneo tried to put an end to the tribal warfare, which was originally met with some success. But with the end of tribal warfare, headhunting entered a decadent period, with heads being collected by pretty much anyone who couldn't run away from a Borneo headhunter fast enough. Defenseless old people, solitary travelers, people who had fallen asleep in the forest, and even people on their deathbeds or fresh corpses were in danger of having their heads removed to be hung from the longhouse of a neighboring tribe. The British attempts to outlaw headhunting were fairly ineffectual, as the sheer size of Borneo thwarted their efforts at policing the native peoples. As the third largest island in the world, Borneo covers an area five times bigger than England and Wales. The terrain is a mix of steep hills, cliffs, mountains, and rain forests, and flat plateaus, there are very few roads that penetrate the jungle heart of the island.

While there are dozens of completely distinct indigenous tribes living on the island of Borneo, most are collectively lumped by the governments of Malaysia and Indonesia as *orang asli*/Original People (Malaysia) or Dayaks (Indonesia). The term "Dayak" is applied to a variety of indigenous native tribes that officially include the Ibans, Kayan, Kenyahs, and many others, with over 140 spoken dialects separating the tribes from one another. While many of the tribes have individual traditions that belong only to them, there are some common traditions that link them together involving tattoos and religion. Almost universally, all groups on Borneo tattoo their hands. In life, this is a sign of high status, while in death, a hand tattoo lights the person's

way and guides their soul to the River of the Dead. The spirit guarding the river looks for this tattoo first thing, and will only let souls cross over to the afterlife if they have it. A warrior who has died in battle has a special life of comfort waiting for him in the afterlife, but if he doesn't have his identifying hand tattoo, his soul will be drowned in the River of the Dead for maggots to eat.

Among all the people of Borneo, tattoos were first applied as designs stamped onto the skin with heavily inked, carved, porous wooden blocks, after which the tattooist would pierce the outline with thorn or bone, forcing the wet ink left by the block into the skin. These blocks come in the shape of flowers, leaves, animals, stars, insects, and sea creatures, and were often traded back and forth among tattoo artists so that many people ended up with the same tattoos. Sometimes, during trading excursions between tribes, tattoo artists of different tribes would trade their blocks with one another and bring home entirely new designs. In this way, tattoo art and design became a cultural exchange between tribes all over Borneo. One subset of the Dayak, the Iban, has always adopted the tattooing styles and motifs of the people they've encountered. Traditional tattoos of dogs and stars have, over the years, been replaced or mixed with images of airplanes, helicopters, and American eagles.

Traditionally, because women didn't travel as widely as the men did, the tattoos of girls and women were more strictly associated with tribal affiliation. Women received their first tattoos around age ten, and continued to receive them for the next three to four years. A woman needed to receive all her tattoos before becoming pregnant to insure her safety during birth and to ensure her child's safety.

## Hawaii

Hawaii is one of the very last places the Polynesians reached during their era of exploration, and, ironically, also the last island that Captain James Cook ever reached—on his third voyage of exploration commissioned by the Royal Society, he was killed during a skirmish with the native Hawaiians. He was fifty-one years old.

The Hawaiian Islands were completely uninhabited by humans until 400–600 AD. A second group of Polynesians from Tahiti came to Hawaii around 1000 AD and conquered the first, who had lived in total isolation from the rest of the world for centuries. Although the Tahitians didn't slaughter the natives, they reduced them to commoners, calling them

*menehune* (an insult meaning "people of small status") and imposed their own political system and customs on them.

When Captain Cook came to Hawaii in 1778, he was the first European to ever land on its shores. After his relatively peaceful relations with other Pacific Island culture—with the exception of the Maori of New Zealand—he was startled to find such a warlike people with such a rigid system of hierarchy in the middle of nowhere, where the chances of confronting an enemy seemed next to nonexistent. Another thing noticed about the Hawaiians was that only people of significant social significance were tattooed, unlike other Oceanic societies, where nearly everyone had one or more tattoos, often for pure decoration. He also noted that Hawaiian tattoos were much less elaborate and less artistically constructed than those of many other similar cultures.

Strangely enough, by the middle of the nineteenth century, tattoos were actually more popular and common among the Hawaiians than they had been before Cook's visit. The tattoos had also become much more elaborate, and contained foreign imagery, including European animals and objects such as goats and cannons. However, the old tattoos still had some of their original power and meaning and were reserved for specific classes of Hawaiians. Some offered a ruler magical protection, while a warrior's tattoos protected him in battle. Many tattoos were also received as part of a mourning ritual. Often, a woman would get her late husband's name tattooed on her tongue—an especially grueling process—as a physical expression of her emotional pain and grief.

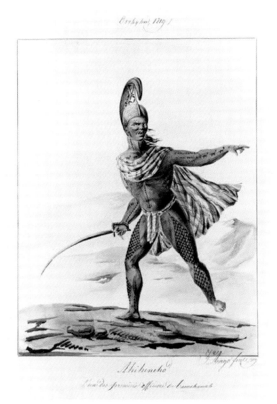

Ahiheneho, one of the First Officers of Kamehameha, was a member of the Hawaiian ruling class during Cook's time.    *Wikimedia Commons*

In 1887, and under force, King David Kalakaua signed the 1887 Constitution of the Kingdom of Hawaii, which limited the power of the royal family and established a constitutional monarchy much like Britain's. However, the main purpose of the constitution, also referred to as "the Bayonet Constitution," was to transfer power from the royal family to an elite class of American, European, and native Hawaiian landowners. When Kalakaua died in 1891, his sister, Lili'uokalani, succeeded him on the throne and attempted to restore the monarchy's power. American and European residents, in opposition to the queen, solicited protection from the United States, who literally sent in the Marines and put the queen under house arrest. Queen Lili'uokalani was officially deposed on January 14, 1893, and in 1898, the chain of islands was annexed into the United States.

# North America and the Arctic Circle

## A Forgotten History

The first recorded observations of tattooing among the native peoples of North America was made by Dr. Diego Alvarez Chanca, a physician who accompanied Christopher Columbus on his second trip to the Americas in 1493. In a letter to the Council of Seville, he noted that the inhabitants of an island in the Lesser Antilles "paint their heads with crosses and a hundred thousands different devices, each according to his fancy; which they do with sharpened reeds." Almost a hundred years later, in 1539, the conquistador Hernando de Soto's chroniclers wrote that the Tula of modern-day Arkansas "prick their faces with flint needles, especially the lips, inside and out, and color them black, thereby making themselves extremely and abominably ugly."

One problem that historians have with trying to separate fact from fantasy in regard to so many early Europeans' descriptions of tattoos is that many artists took great liberties when re-creating their subjects' tattoos. Some of the most problematic depictions come from the engravings of the sixteenth-century Flemish artist Theodore de Bry, who famously also captured his impressions of what the indigenous Britons of Europe must have looked like over a thousand years before his time, covering their bodies with impossible tattoos and carrying completely anachronistic weaponry. De Bry never actually visited the New World himself, but instead based his engravings on the verbal descriptions and sketches of the explorers Jacques le Moyne de Morgues and John White. Modern historians have noted that many of his engravings have North American Indians in costumes and holding weapons from South American Indians, or even European farm tools and clothes. Also, as most of the early sketches and engravings made during those first encounters don't have distinguishing captions, it's impossible to tell whether the subjects were covered in tattoos or just body paint.

However, these engravings were the basis of Europeans' impression of the New World's inhabitants for hundreds of years.

Most nineteenth-century scholars took absolutely no interest in North American native tattooing. In 1909, ethnologist A. T. Sinclair noted with dismay that "one of the great difficulties in treating our subject is that details, or even mention, are so often absent when the practice must have been common. Even the slightest hint

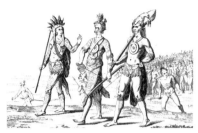

The Timucua were among the now-extinct tribes that Columbus encountered when he landed in the Americas.
*Wikimedia Commons*

of something is sometimes of value." Sinclair dedicated a good part of his academic career surveying the records of tattooing in each geographical region of North America, but in many cases, only came up with fragmentary one-liners that suggested that tattooing must have been practiced all over the continent.

## The Arctic

In 1972, the complete hut and mummy of an elderly Inuit woman was accidentally uncovered on the southeast cape of Alaska. The woman, who had apparently died of asphyxiation when her hut collapsed on her around 400 CE, had tattooed lines and dots all over her right forearm, with a heart-shaped image on the back of her right hand. Her left arm was also tattooed, almost covered with multiple-flanged heart shapes connected by vertical and horizontal lines. Ten years later, Albert Dekin and Raymond Newell found the remains of a five-hundred-year-old Inupiat settlement near Point Barrow, also in Alaska. Two well-preserved adult women with tattoos similar to the much older mummy's were found, as well as several children without tattoos.

Ethnographically, tattooing was practiced by all people characterized as Eskimos and was most common among women. While there are a multitude of localized references to tattooing practices in the Arctic, the first was probably recorded by Sir Martin Frobisher in 1576. Frobisher's account describes the Eskimos he encountered in the bay that now bears his name: "The women are marked on the face with blewe streekes down the cheekes and round about the eies. . . . Also, some of their women race [scratch or

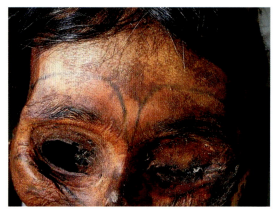

This mummified Inuit woman, like many other mummies found frozen in Alaska, was found with tattoos similar to the skin-stitched tattoos of contemporary indigenous people of the Arctic Circle.    *Google Images*

pierce] their faces proportionally, as chinne, cheekes, and forehead, and the wristes of their hands, whereupon they lay a colour, which continueth dark azurine."

Traditional indigenous tattoos of the Arctic region are not poked into the skin with repeated thrusts of an ink-dipped needle, but are actually stitched into the skin. In this process, a piece of ink sinew is threaded through a needle and pulled through the skin to make a straight, unbroken line. When an Inuit girl reached maturity, three vertical lines were skin-stitched on both cheeks, which was believed to induce fertility and protect them from illnesses and child-stealing evil spirits. The Salish of the Thompson River region of Canada also practiced skin-stitching, although they often endured these tattoos for decorative purposes and to show courage and strength. And while the peoples of the Aleutian Islands used medicinal tattooing for complaints in their joints, the Russian priest Veniaminov wrote around 1830 that Unangan women from Unalaska Island (Alaska) wore skin-stitched tattoos across their faces and bodies because "the pretty ones and also the daughters of famous and rich ancestors and fathers, endeavored in their tattooings to show the accomplishments of their progenitors, as for instance, how many enemies, or powerful animals, that ancestor killed."

As a rule, skin-stitched tattoos were performed by elderly women by almost all Arctic peoples, as they generally had had years of experience sewing parkas, pants, and boots out of animal skin. Tattooing needles were traditionally made from slivers of bone, as that was the most durable

substance available to indigenous peoples of the region, but as trade routes opened with Europeans, bone needles began to be replaced with steel needles. The ink was made from the collected soot of seal oil lamps and mixed with urine, which was smeared thickly over a thread of reindeer sinew prior to tattooing. Most of the tattoos were done freehand, depending on the skill of the tattoo artist. Urine was also poured on the tattoo and around the outside of the house of the person tattooed, with the belief that urine would repel evil spirits and protect the tattoo. Because of the antibacterial properties of ammonia in urine, it probably was very helpful in keeping a new tattoo from being infected. Superstition played a great role in *why* someone would get tattooed as well—one Inuit legend stated that after death, the gods used the skulls of women who lacked tattoos as drip trays to catch candle wax, which was apparently incentive enough for girls to look forward to getting their first skin-stitching.

A typical nineteenth-century account, provided by William Gilder, illustrates the tattooing process among the Central Eskimo living near Daly Bay, a branch of the great Hudson Bay:

"The wife has her face tattooed with lamp-black and is regarded as a matron in society. The method of tattooing is to pass a needle under the skin, and as soon as it is withdrawn its course is followed by a thin piece of pine stick dipped in oil and rubbed in the soot from the bottom of a kettle. The forehead is decorated with a letter V in double

Contemporary tattoo artist Colin Dale demonstrates traditional Inuit skin-stitching on himself, learned while growing up in Canada.

*Claire Artemyz*

Two Eskimo women and their children pose for a picture in 1938 on King's Island, Alaska.
*Wikimedia Commons*

lines, the angle very acute, passing down between the eyes almost to
the bridge of the nose, and sloping gracefully to the right and left
before reaching the roots of the hair. Each cheek is adorned with an
egg-shaped pattern, commencing near the wing of the nose and
sloping upward toward the corner of the eye; these lines are also
double. The most ornamented part, however, is the chin, which
receives a gridiron pattern; the lines double from the edge of the
lower lip, and reaching to the throat toward the corners of the mouth,
sloping outward to the angle of the lower jaw."

There seems to have been no widely distributed tattoo design among
the indigenous peoples of the Arctic, although chin stripes on women were
more commonly found than any other. Receiving a chin stripe tattoo was a
sign of social maturity, a signal to men that a woman had reached puberty.
Chin stripes also served to protect women during enemy raids. During the
frequent battles between Siberians and Alaskans, the only way to tell the

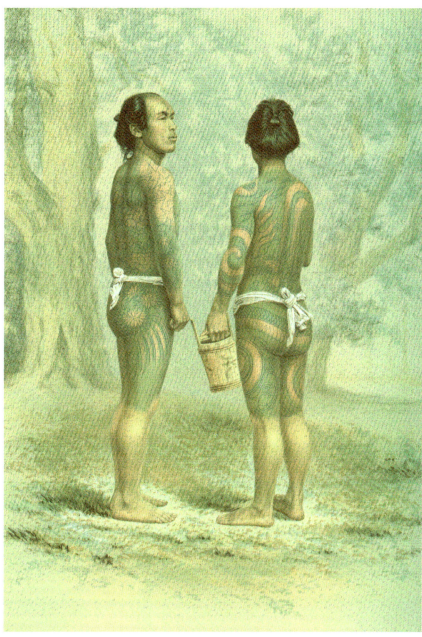

This 1883 painting depicts a pair of Eskimo men from an unidentified tribal group.
*Wikimedia Commons*

difference between a man in a parka and a woman in a parka was a woman's chin stripes. Since women were considered a valuable commodity, the chin stripes would save them from being killed in battle—however, it also made them easy targets when it came to capturing them as slaves.

With the introduction of Europeans to the Americas, however, the practice of tattooing began to be quickly phased out through a missionary ban, intermarriage with European traders, and modernity in general. The practice of skin-stitching had almost completely disappeared until the discovery of the tattooed mummy in the 1970s. The mummy, combined with a new generation's interest in traditional culture, rekindled an interest in the precolonial history of the Arctic. Today, the practice of skin-stitching is once against alive among many young Iñupiaq, Inuit, and Yup'ik women, with tattooing workshops and seminars held all over Alaska, Canada, and even Greenland.

## United States

Some of the best descriptions of American Indian tattooing come to us from eighteenth-century naturalists who worked in the Southeast. Mark Catesby, an Englishman who traveled down the East Coast from Virginia to South Carolina from 1722 to 1725, wrote of the Cherokees he encountered, "Their war captains and men of distinction have usually the portrait of a serpent, or other animal on their naked bodies; this is done by puncture and a black powder conveyed under the skin. These figures are esteemed not only as ornamental, but serve to distinguish the warriors, making them more known and dreaded by their enemies."

Another naturalist, William Bartram, wrote in his book *Observations on the Creek and Cherokee Indians*, of the Creek/Muscogee Indians:

> But the most beautiful painting now to be found among the Muscogee is on the skin and bodies of their ancient chiefs, which is of a blueish, lead, or indigo color. It is the breast, trunk, muscular or flesh part of the arms and thighs, and sometimes almost every part of the surface of the body, that is thus beautifully depicted or written over with hieroglyphics: commonly the sun, moon, and planets occupy the breast; zones or belts of beautiful fanciful scrolls wings round the trunk of the body, thighs, arms and legs, dividing the body into many fields or tables, which are ornamented or filled up with innumerable figures, as representations of animals of the chase, a sketch of a landscape . . . and a thousand other fancies. These paintings are admirably well executed, and seen to be inimitable. They are

performed by exceedingly fine punctures, and seem like *messotino*, or very ingenious impressions from the best educated engravings.

English settlers in the Jamestown area also wrote extensively about tattooing among the local Algonquin. In 1593, Captain John Smith—best remembered for his marriage to Pocahontas—wrote that the natives of Virginia and Florida had "their legs, hands, breasts and faces cunningly embroidered with diverse marks, such as beasts and serpents, artificially wrought into their flesh with black spots." In the seventeenth century, Colonel Percy wrote, "The women kinde in this Countrey doth pounce and race their bodies, legges, thighes, armes, and faces with a sharpe Iron, which makes a stampe in curious knots, and drawes the proportion of Fowles, Fish, or Beasts; then, with paintings of sundry lively colours, they rub it into the stampe which will never be taken away, because it is dried into the flesh where it is sered." From most of these accounts, it appears the Algonquin combined branding and "pouncing," or tattooing, to make most of their body adornment. As the Algonquin also have a history of body painting for adornment, it's hard to know how many of these markings were temporary paintings for ceremonial purposes or actual permanent tattoos. Also, because the word *tattoo* hadn't yet entered the lexicon, the words *stamps*, *pouncings*, *prickings*, and *paintings* were used fairly interchangeably.

In 1615, the French explorer Gabriel Sagard-Théodat wrote that the Huron "take the bone of a bird or a fish which they sharpen like a razor, and use it to engrave or decorate their bodies by making many punctures as we would engrave a copper plate with a burin. During this process they exhibit the most admirable courage and patience. They certainly feel the pain, for they are not insensible, but they remain motionless and mute while their companions wipe away the blood that runs from the incisions. Subsequently they rub a black color or powder into the cuts in order that the engraved figures will remain for life and never be effaced, in much the same manner as the marks which one sees on the arms of pilgrims returning from Jerusalem."

Other French explorers, especially Jesuit missionaries, made similar observations of all the native tribes they encountered. The Jesuits eventually sent back all their notes to Paris, where the Church compiled them in a series of volumes titled *Jesuit Relations*.

One of the best examples of Native American tattooing comes from an oil painting of the Mohawk chief Sa Ga Yeath Qua Pieth Tow by English artist John Verelst. Sa Ga Yeath Qua Pieth Tow was one of four Mohawk chiefs who visited London in 1710 as part of a delegation led by Peter

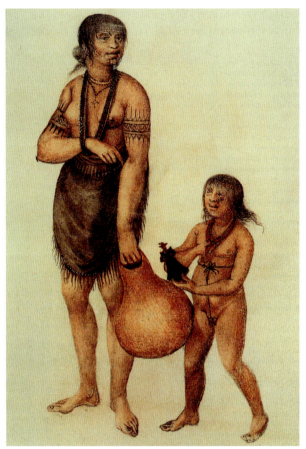

John White painted this picture of a tattooed North Carolina Algonquin woman and her child in 1585.

*Wikimedia Commons*

Schuyler, a member of the New York Indian Commission. Schuyler hoped to persuade Queen Anne to assist the British colonists in their conflict with the French in Canada. Schuyler had the chiefs make speeches in which they promised that their own people would assist the British troops. The mission was successful, and the queen was persuaded by the eloquence of the Mohawks to send the expedition.

As with Captain Cook's own crew many years later, many European explorers deserted their European companions to not only live with the Native American groups, but fully take on their traditions. When the explorer Rene-Robert Cavelier, Sieur de La Salle was murdered in 1687 by his crew while searching for the mouth of the Mississippi River, several of

the Frenchmen who made up his crew found a new home with the Cenis (Hasinai) tribe of the Caddo Indians. Military officer Henri Joutel, met up with the Cenis and wrote of the Frenchmen the tribe had adopted: "They have so perfectly injured themselves to the Customs of the Natives, that they were become meer Savages. They were naked, their Faces and French Bodies with Figures wrought on them, like the rest."

Several other members of the La Salle expedition were captured by the Hasinai and Karankawa Indians, including brothers Pierre and Jean-Baptiste Talon. In 1690, Father Damian Massanet and Alonso de Leon ransomed the brothers from their captors and took them back to Spain, where they were extensively questioned about their experiences on the Gulf Coast. "The savages first marked [the Talons] on the face, the hands, the arms, and in several other places on their bodies as they do on themselves, with several bizarre black blacks, which they make with charcoal of walnut wood, crushed and soaked in water," reported de Leon to the Church back in Europe. "Then they insert this mixture between the flesh and the skin, making incisions with strong, sharp thorns, which cause them to suffer great pain. . . . These marks still show, despite a hundred remedies that the Spaniards applied to try to erase them."

In nearby Georgia, the Yuchi Indians also practiced a combination of body painting and tattooing. The German explorer Philip Georg Friedrich von Reck wrote in 1736 of Yuchi tattooing, "The figures on their chest are pricked in with a needle or other pointed instrument, until they bleed, and in them they sprinkle fine powder or charcoal dust, which mixes in the blood, remains in the skin, and appears blue-black." Von Reck made many detailed sketches and watercolors of the Yuchi Indians, which are today archived at the Royal Library in Copenhagen and can be viewed through their Web page Die Kongelige Bibliotek. Von Reck refers to tattoos as "burns" throughout his descriptions; however, from the process he describes and the sketches themselves, we can be fairly certain that the marks decorating his subjects are tattoos. The vertical lines tattooed on the chests of some of his subjects are similar to those of a tribe of Creek Indians from the Georgia region, the Yamacraw. The leader of the Yamacraw, Tomochichi, visited London with the explorer James Oglethorpe in 1734 as part of a Native American delegation, during which time he had his formal portrait painted by William Verelst.

In Tennessee, the Overhill tribe of the Cherokee were noted for having adapted their tattooing methods to the influx of Europeans into the area. Iron needles were now used for tattoos, having a much finer and more

durable point to work with than a bone, shell, or wooden needle, while gunpowder was the choice medium for tattooing, as the fine powder both made nice, dark marks and relatively little infection when embedded in the skin.

In the area destined to become Alabama, the eighteenth-century explorer and trader James Adair wrote of the Chickasaws, "the blue marks over their breasts and arms [are] . . . as legible as our alphabetical characters are to us." Adair asserted that these "wild hieroglyphics" were used in order to "register" their bearers "among the brave." The implications for one's status, if tattooed, were profound. Signs of achievement, tattoos could also single out captives taken in war for particular torture. Adair suggested that fighters taken captive who were "pretty far advanced in life, as well as in war-gradations, always atone for the blood they spilt, by the tortures of the fire," arguing that it was by their tattoos that an individual's war history was known.

Such risks, however, were outweighed by the prestige the "hieroglyphics" carried within one's own community, leading some, Adair wrote, to give themselves tattoos without having first performed the deeds necessary to earn them. "The Chikkasah . . . erazed [*sic*] any false marks their warriors proudly and privately gave themselves—in order to engage them to give real proofs of their martial virtue," Adair commented. In a public shaming, the perpetrators were "degraded . . . by stretching the marked parts, and rubbing them with the juice of green corn, which in a great degree took out the impression."

Tattooing was practiced by almost every tribe in the lower Mississippi Valley. Jean-François Benjamin Demont de Montigny, a soldier in the Natchez Revolt of 1729, wrote of the Natchezes' tattoos, "The greatest ornament of all these savages of both sexes consist in certain figures of suns, serpents, or other things, which they carry pictured on their bodies in the manner of the ancient Britons."

By the early nineteenth century, missionaries, with the encouragement of the US government, had made it their duty to convert the dwindling Native American populations and eventually assimilate them completely. The decline of Native traditions during the mid-nineteenth century is especially evident in paintings done by such notable artists as George Catlin, Thomas McKenney, and Karl Bodmer—in almost all cases, any body adornment in the portraits is temporary paint only.

Some groups managed to hold on to their tattooing traditions longer than others, however. Of the Great Plains Indians, the Osage had some of the most elaborate tattooing traditions, and many Osage women were

The outline of a traditional chin tattoo is barely visible in this photograph of a Mohave woman from 1903.
*Library of Congress*

still receiving traditional tattoos well into the twentieth century. While the Osage men were mostly tattooed on their chests and throats, Osage women were tattooed all over their bodies, depending on their status in the tribe. A full-body tattoo was both time-consuming and expensive to receive, so a woman's financial worth was equal to the number of tattoos on her body and reflected the importance and wealth of her family to a potential suitor. The Iowa also continued their tattooing well into modern times, with both men and women receiving tattoos on their chests, hands, and foreheads.

In the mid-1700s, the French explorer Jean Bernard Bossu stayed with the Osage Indians for several months in the area that is now Alabama. According to his book *Travels in the Interior of North America, 1751–1762*, the Osages tattooed a deer on his thigh. This tattoo, they said, meant that he was their brother and that as he traveled among the tribes that were allies to the Osage, he could show them his tattoo and be welcomed.

According to Bossu, getting a tattoo one hadn't earned was a serious crime among the Osage. While he was staying with them, a man who was trying to impress a woman got a tomahawk tattoo, signifying he had traveled and fought with a war party—even though he hadn't. The tribal leaders said they would cut it off his body, since he hadn't earned it—according to Bossu, he felt sorry for the man and used a technique unknown to the tribe to remove the tattoo without pain, applying a mixture of opium and a blistering agent made from insects.

Another ethnographer, James G. Swan, wrote in 1878 about the tattoos of the Haida, a Northwest coast people, who allowed him to copy their tattoo designs for his book *Tattoo Marks of the Haida*. The Haida, who were renowned through the region for their elaborate wood carvings and ceremonial masks, told him that the animals motifs represented family crests and totem marks. However, the designs were so stylized that he could not identify the individual animals, even though, of course, the Haida could recognize them. Everyone he asked could tell the difference between and identify the images of all the different creatures in the tattoos, but, being an outsider, they would not explain to him what the symbols meant.

Native North American tattooing was frequently associated with religious and magical practices. It was also used as a symbolic rite of passage at puberty ceremonies, and as a distinguishing mark that would enable the spirit to overcome obstacles on its journey after death. Such an obstacle might be an apparition that blocked the spirit's path and demanded to see a specific tattoo design as evidence of a spirit's right to enter the afterworld—similar to practices and beliefs of the natives of Borneo, who also

believed that an identifying tattoo was necessary to pass successfully into the afterlife. An example of such tattooing is found among the Sioux, who believed that after death, the spirit of a warrior mounts a ghostly horse and sets forth on its journey to the "Many Lodges" of the afterlife. Along the way, the spirit of the warrior will meet an old woman who blocks his way and demands to see his tattoos. If he has none, she sends him back and condemns him to return to the world of the living as a wandering ghost.

Many native tribes also practiced therapeutic tattooing. The Ojibwa, for instance, tattooed the temples, forehead, and cheeks of those suffering from headaches and toothaches, as these maladies were believed to be caused

This 1899 photo shows the traditional facial tattooing practiced among the Maricopa Indians until the early twentieth century.

*Wikimedia Commons*

by malevolent spirits. Songs and dances accompanied the tattooing ritual, designed to help exorcize the patient's demons.

Tattoos were also awarded to warriors who had distinguished themselves on the battlefield. The Reverend John Heckwelder wrote in 1742 about an aged Lenape warrior:

> [T]he man, who was then at an advanced age, had a most striking appearance, and could not be viewed without astonishment. Besides that his body was full of scars, where he had been struck and pierced by the arrows of the enemy, there was not a spot to be seen, on that part that was exposed to view, but what was tattooed over with some drawing relative to his achievements, so that the whole together struck the beholder with amazement and terror. On his whole face, neck, shoulders, arms, thighs, and legs, as well as on his breast and neck, were represented scenes of the various actions and engagements he had been in; in short, the whole of his history was there deposited, which was well known to those of his nation, and was such that all who heard it thought it could never be surpassed by man.

# South America

## Ancient Practices in the Face of Missionary Influence

**B**efore Europeans had set foot on what would become Latin America, Central and South America had vibrant tattoo cultures. The very oldest known piece of tattooed skin found anywhere in the world was discovered in present-day Chile on the upper lip of a Chinchorro mummy from 6000 BCE. This moustache-like tattoo is thought to be part of a tattooed cosmetic tradition, used purely for decoration. In 2006, an elaborately tattooed mummy of a young Moche woman was found buried deep inside a mud-brick pyramid in El Brujo, Peru. Her hands were covered in stylized designs that may have represented stars or even spiders, while the backs of her arms and legs were tattooed with snakes. A large bird was tattooed on one shoulder, and from the array of weapons and funerary objects found buried with her, she appears to have been an important person in society. The Moche were a warlike people who predated and possibly became the Inca, along with the Nazca and the Chimú of the region. Tattoos on a female Chiribaya mummy from 1000 BCE feature a combination of therapeutic and ornamental motifs with simple overlapping circles on her neck and

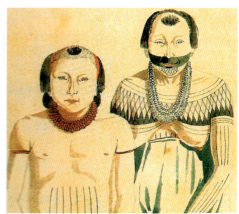

The Munduruku Indians still sometimes practice the facial tattooing of their ancestors, as in this painting by Hércules Florence in 1828.
*Wikimedia Commons*

upper back, while more elaborate tattoos on her hands and arms depict animal and nature motifs.

While the arid climate of the Peruvian desert is ideal for mummifying corpses—and hundreds of mummies have been found in Peru exactly because of this—the process isn't perfect, and often, only a skeleton dressed in clothing is left of a person who died a thousand years before. However, the pottery that's been found in the area, often buried with these bodies, has provided wonderful insight into the tattooing practices of these long-vanished peoples. Nazca terracotta figures from 100 to 700 AD depict women with elaborate tattoos of flowers and animals all over their lower backs, thighs, shoulders, and pubic regions, while the Mochica left behind figurines of men with fierce-looking facial tattoos and grid patterns completely covering their chests. Pre-Columbian Inca burial sites have been found with similar clay figurines and face vessels, as well as a few mummies with just enough skin left on them to offer a tantalizing glimpse of an ancient art form that disappeared within a century of European contact.

For more than one thousand years, a culture flourished in what are now the western Mexican states of Jalisco, Nayarit, and parts of Colima. Most of what we know about the culture comes from artifacts taken from shaft tombs—usually by tomb raiders—including examples of heavily tattooed hollow ceramic figurines. Some scholars believe the figurines depict gods, while Christopher Beekman of the University of Colorado Denver suspects that they may in fact represent the people with whom they were buried. Certainly, the designs were intended to communicate identity and status, particularly considering that the figurines appear to have been used in ceremonial contexts, and set up in residential areas to be seen and visited. According to Beekman, it is notable that the tattooing occurs prominently around the mouth, which may refer, as it does in Classic Maya society, to the breath of life or the capacity of polished speech of these individuals.

## First Contact

When Hernán Cortés arrived in southern Mexico from Spain in 1519, he and his crew were horrified to discover that the natives not only worshipped devils in the form of statues and idols, but also had somehow managed to imprint indelible images of these idols on their skin. Spain had been so firmly under the thumb of the Catholic Church for so long that most explorers were oblivious to the concept of tattoos, and immediately assumed

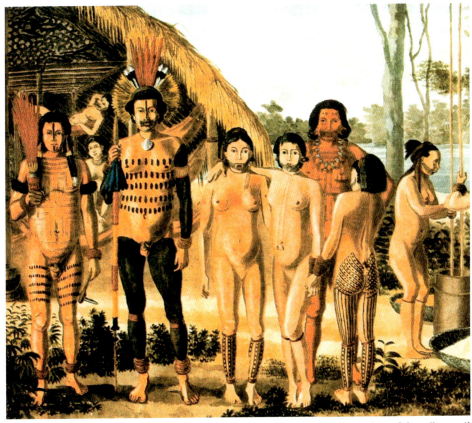

The Apiaká Indians of the Mato Grosso region of Brazil tattooed both genders of the tribe until the late nineteenth century.                    *Wikimedia Commons*

that the markings of the people they had just encountered were the mark of Satan.

He also learned that two fellow compatriots had beat him to the New World—a Catholic priest named Geronimo de Aguilar and a man named Gonzalo Guerrero. Both men had been shipwrecked eight years before and had been taken in by the Mayan as guests. Somehow, de Aguilar had managed to hold on to his faith during his harrowing adventures. He kept track of the days on a homemade Christian calendar, said his prayers, and resolutely maintained his chastity despite many provocations and the temptation of native women. The Mayans were very impressed with this display of self-control, to the point that the ruler of the Chetumal eventually made de Aguilar the official Guardian of the Royal Wives. When de Aguilar saw the Spaniards for the first time, he thanked God, wept, fell to his knees, and

asked if it was Wednesday. He had apparently kept track of the Christian seven-day week for eight years.

Because de Aguilar had mastered the Mayan language and knew much about Mayan culture, Cortés "rescued" him and used him as an interpreter and advisor. De Aguilar accompanied Cortés throughout his invasion of Mexico. He proved to be an invaluable asset when Cortés attempted negotiations with Montezuma. Guerrero, however, had gone so far as to convert to the Mayan religion and marry the daughter of a local noble. He demonstrated a great talent for warfare and even gave the Mayans information about Spanish battle techniques to help them fight against the conquistadors. After proposing and organizing a successful attack on the Spanish ships of the Cordoba expedition, he was made Chief Military Commander. However, the sheer numbers of the Spanish invaders ended up completely overwhelming the Mayan warriors, and in 1535, Guerrero was killed along with dozens of Mayan warriors.

The tattooing styles of the peoples of Central and parts of South America—the Zapotec, Huaxtec, Totonac, Itza, Maya, and Inca—were almost all awarded to men to indicate their status, with some variations. Itza warriors tattooed their entire bodies, including their faces, while Mayans tattooed their entire bodies but considered facial tattoos taboo. The exception for this was to mark a person as a criminal, at which point the offender would be tattooed publicly from chin to both ears. In Nicaragua and Costa Rica, only those of noble blood were tattooed, although slaves of Nicaraguan nobles were tattooed with ownership symbols, as were the slaves of the Cuna and San Blais peoples in the Panama region.

Offshore, the Arawak Taino on Haiti also practiced tattooing, as did the coastal Arawak of northwestern South America. The Spanish who encountered them noted that they first made an impression design with a wooden stamp dipped in paint, while the tattoo itself was made with the sharpened end of a reed, much like the ones the Kayan of Indonesia use today. Most of their designs were either complex geometric patterns or fantastic plants and animals. Their neighbors, the Carib, were a warlike people who tattooed themselves prior to eating their captured male prisoners, but also used tattooing as part of a young person's initiation into adulthood. Arawak girls were given broad lines around their mouths or small, hook-shaped marks in the corner of the mouth, while Arawak boys had wide patches tattooed around their mouths that were extended up as they grew older, until they reached their cheekbones and sometimes went all the way up to their eyes. Both the Arawak and the Carib were still tattooing themselves

up into the 1850s, but had almost completely abandoned the practice by the twentieth century.

## The Missionaries

With the influx of Spanish missionaries into Central and South America, most tattooing completely disappeared within a few generations. One of the best-known crusaders against tattooing was the Franciscan Diego de Landa, who made it his life's work to eradicate tattooing practices among

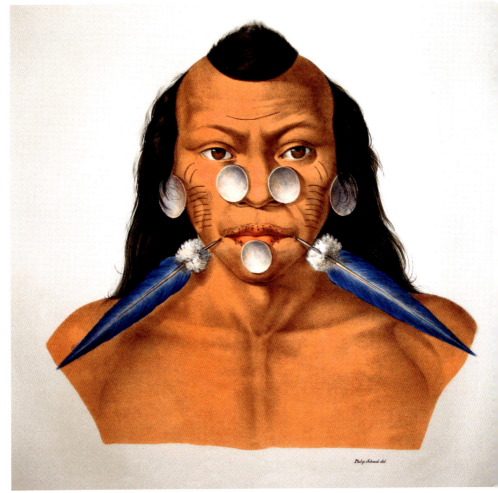

This 1823 portrait of an Amazonian warrior by Johann Baptist von Spix shows both tattooing and body piercing were practiced by this unnamed tribe. *Wikimedia Commons*

the "heathens." In 1549, he was granted permission from Spain to conduct his own New World Inquisition, and went all over Central America converting, destroying heathen iconography, and severely punishing any natives he found still clinging to their traditions of tattooing and piercing in secret.

In all, de Landa ordered the torture of over 4,500 suspected idolaters. Thirty committed suicide to avoid torture, and countless others were crippled for life. The few who survived the torture but refused to confess were tried by a court of the Inquisition and publicly burned. De Landa observed with apparent satisfaction that "in general, they all showed sincere repentance and a willingness to be good Christians."

The Mayans especially were penalized for their beliefs, and were forced to ransack their own temples and tombs, and to deliver up to the Inquisition the bones of their ancestors, together with any "false" idols and "demonic" statues. These were all destroyed in a solemn ceremony presided over by de Landa, who also confiscated and burned thousands of manuscripts in which the Mayans had recorded their history, art, mythology, science, astronomy, and medicine, all in the name of God. He wrote, "The Mayans use certain glyphs or letters in which they wrote down their ancient history and sciences in the books . . . we found a great number of these books in Indian characters and because they contained nothing but superstition and the Devil's falsehoods, we burned them all; and this they felt most bitterly and it caused them great grief."

## The Amazon

Despite the crusades of de Landa and other zealous missionaries, some indigenous groups managed to hold on to their tattooing traditions well into the present. The Sumo, Paya, and Mosquito peoples of Nicaragua still tattoo geometric designs on their faces, arms, and chests. The Costa Rican Bribri cut lines into their skin and fill them with boiling resin to make raised, colored scars, while the Pano tribe in the Amazon still bear a variety of facial tattoos that both signify their tribal status and are designed to enhance their beauty.

Because of the relative inaccessibility of the Amazon rain forest, many of the peoples who made the Amazon their home were spared European contact until well into the eighteenth century. Ironically, the missionaries who were the first to contact many of these tribes were also the ones who worked the hardest to preserve these natives' ways of life and protect them

from fortune hunters and colonists, and even negotiated treaties between European governments and the Amazon peoples, as with the Portuguese government and the headhunting Mundurucú. Compared to their predecessors, these missionaries made comparatively half-hearted attempts at conversion of the natives—one eighteenth-century missionary, Father Martin Dobrizhoffer, was appalled by the tattooing practices of the Abipón of Paraguay, but instead of forcibly eradicating the practice, he managed to convince the natives to also tattoo crosses on their foreheads as part of their tribal markings.

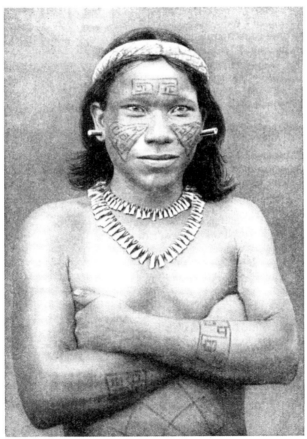

In 1922, this man, the sole remaining member of his still-unidentified tribe, was found living in the Amazon rain forest.
*Wikimedia Commons*

# Henna Tattoos, Temporary Tattoos, and Body Paint

## The Not-Permanent Ink

While many people consider a tattoo to be the ultimate permanent accessory, there are plenty of fans of tattoo art out there who are terrified of the idea of going under the needle to get the body art they want, or simply aren't sure they can get attached to any one piece of art enough that they'd want to wear it for life. Luckily, there are plenty of options out there for getting a beautiful tattoo for a short-term period—beyond having someone draw on you with a set of semipermanent magic markers.

While most peoples have practiced tattooing at some point in their history, people have also spent just as much time and energy over the course of human history giving themselves nonpermanent decorations. In "primitive" cultures, body paint is often used to celebrate rites of passage and group celebrations as much, or perhaps even more, than tattooing, while people ranging from the Celtic and Teutonic groups in Europe to the many indigenous peoples in the Americas all famously used some sort of body paint before going off to battle.

### Henna

Henna is a plant that grows all over the Middle East and has been used as a dye for thousands of years. Henna "tattoos" are made when the leaves of the plant are dried and crushed into a powder, then mixed with water to create a thick paste. This paste can be used on your hair to add a red or burgundy semipermanent tinge to it, carefully applied to your skin to create semi-permanent patterns, or even used as a natural nail polish. On

your skin, it can last anywhere from a few days to a few weeks, while it may last even longer on your hair and nails, where it's absorbed much more fully. Henna appears orangey on lighter skin and hair colors and redder on darker skin and hair colors, and stains thicker skin areas better than thinner skin areas, which is why henna is more traditionally used on the palms and on the soles of the feet.

The art of henna, or *mehndi* in Hindi and Urdu, has been practiced for at least nine thousand years in Pakistan, India, Africa, and the area of the Middle East that was once the Persian Empire. Because henna has natural cooling properties, people of the desert from antiquity have made henna into a paste and soaked their palms and the soles of their feet in it to cool their bodies. It also works as a natural sunscreen, and was used as such by the ancient Egyptians as well as many desert-dwelling civilizations to the present day. Henna has also been used to dye fabrics including silk, wool, and especially leather, as its chemical properties can help protect the surface of leather from the elements. Another contemporary way of using henna is as shoe or boot polish (if you're wearing naturally colored leather footwear, that is), as it can very effectively cover up scuff marks on leather and doesn't wash off.

In addition to its dyeing and cooling properties, henna has medicinal value. A plaster made of henna works like an antiperspirant in that it tightens pores—of course, it stains your skin red as it does so—while the same plaster's antibacterial characteristics helps reduce halitosis—again, dyeing your gums orangey red in the process. It is used as a coagulant for open wounds, and a poultice made with henna leaves can soothe burns and eczema. Henna is also known to work internally against diarrhea, and is used traditionally, to unknown effect, to combat leprosy, smallpox, jaundice, and certain cancers. Henna mixed with vinegar is reportedly good for relieving headaches.

Henna's inherent soothing properties are also part of why *mehndi* is traditionally drawn on the palms of the hands. Since the palms contain numerous nerve ending, when henna is applied to the area, it helps relax the system, calming the recipient. Traditionally, it's used for special occasions like holidays, as well as birthdays and weddings in Africa, Pakistan, India, and the Middle East, which can all be very stressful events.

Somewhat ironically, considering that today, a permanent tattoo costs much more than a henna tattoo, only wealthy Indian women traditionally received henna tattoos to celebrate their weddings, while lower-caste women who could not afford a henna drawing received a permanent tattoo

instead. Traditional *mehndi* includes pictures of lotus blossoms, peacocks, and foliage in both the bride's and groom's hands, and, in the case of the bride, the hidden name of her new husband. Part of the wedding night ceremony includes the groom trying to find his name in his new wife's palm, and sometimes, consummation of the marriage isn't even allowed to begin until he does find his name.

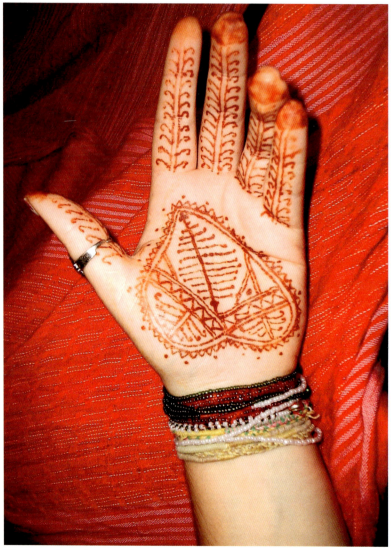

The heart-shape is a traditional Berber henna design.          *Wikimedia Commons*

The longer you leave the henna paste on your skin, the darker the resulting design, and the longer the design lasts. It's a common belief among Hindu women in India that the darker the imprint left on the bride's palms, the more her mother-in-law will love her. This belief may have been contrived to make the bride sit very patiently for many hours for the paste to dry and yield a good imprint. A bride is not expected to perform any household work until her wedding *mehndi* has faded, which was also a very probable incentive to sit still long enough to ensure a long-lasting imprint.

In Morocco, brides do not usually cohabitate with their in-laws. However, seven months after the wedding, the new Moroccan bride visits her in-laws, who rejoice in her visit and offer her many gifts, while henna decorations are applied to her hands in celebration of the event. When she returns one year later, the henna marking is again made on her palms as a symbol of stability—the ritual is repeated until she is pregnant with her first child.

A Moroccan woman in the seventh month of pregnancy may seek out a well-respected henna practitioner called a *hannaya* to paint certain symbols on her ankle, which will then be encircled by a corresponding amulet. The henna and the amulet are meant to protect both the mother and child through birth. One the baby is born and the umbilical cord is severed, a plaster of henna, water, and flour is placed on the newborn's belly button to ensure beauty and wealth, and, of course, to prevent a nasty infection.

Among the nomadic Berbers, ancestors of the first inhabitants of the Moroccan region, it is common for a bride's hair to be lacquered with henna paste on her wedding day. This is done by, according to tradition, "a woman who is happy," who informs the new bride in a ritualistic singsong fashion that she is being painted with the "plant of happiness" so that she will be able to rule happily as the lady of the house. Throughout the region, when a man is being sent off to war, he has his wife apply henna to the palm of his right hand for protection and to remind him of her love. The hope is that he will return home before the paste has completely faded from his palm—that is, within a couple of weeks.

In death, too, henna is used throughout the Middle East and India. For example, when a man dies, his head is sprinkled with henna, while the hands and feet of a deceased woman are painted with henna to ensure her happiness on the other side. It is also customary for the family and friends of the departed to dip their hands in henna paste at a funeral. This is supposed to help them overcome their grief and to surrender to the divine will that is responsible for their loved one's passing.

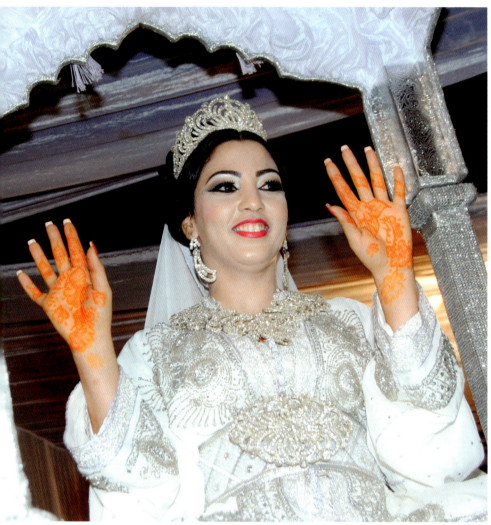

No Moroccan bride would be complete without her exquisite henna tattoos.    *Wikimedia Commons*

In Morocco as well as India, men do not usually participate in henna rituals and ceremonies until they've passed away. For the most part, it is considered a feminine art form embraced by all facets of social classes of women—except for widows, who are strongly discouraged from sharing in henna traditions. A North African widow cannot use henna for four months after the death of her husband. In India, a widow may never touch henna, because henna is considered an enjoyable social activity, and once a woman's husband dies, she is no longer supposed to have any fun. In this respect,

widows are also never invited to any social functions except funerals, and a new bride should never look at or be seen by a widow because it is considered bad luck.

A skilled henna artist can manipulate the henna paste and stain to create complex patterns within a range of colors from orange to red and brown to near black. When the paste is left on longer, and heat is either applied to the area under a hair dryer or just on a particularly hot day, the stains are darker, and retain their vivid color longer. Sometimes a short stay in a sauna can also make the colors set darker. Paste made from plants that were harvested after periods of extreme drought or high heat, such as the end of summer or early fall, have been found to have exceptionally strong dye content.

The fresher the henna powder you use, the better, but all henna stains to some degree. Generally, when you buy henna powder at a store, look for an expiration or "packed by" date to find the freshest powder, or if no date is available, usually the greener the powder, the fresher it is. Henna mixed with lemon juice and essential oils, applied, wrapped and left on overnight can create a henna stain that is almost black.

Sometimes, you'll come across little cone-shaped tubes in the store, of something called "black henna." This is actually not henna at all, but a textile dye called paraphenylenediamine (PPD) that the FDA has only approved for hair dye in the United States—PPD is not legal for cosmetic purposes at all in Canada and much of Europe. Research has linked PPD to a range of health problems including allergic reactions, chronic inflammatory reactions, and late-onset allergic reactions similar to allergic reactions to clothing and hairdressing dyes. It can also potentially cause liver and kidney damage, as the poison can remain unnoticed in your system for a long time after you apply PPD to your skin. If

Black henna tattoos can cause serious skin irritation and blistering, and even permanent scarring.    *Wikimedia Commons*

A henna ceremony is an important enough occasion to require a woman to have her own pillow and lacy mitts to protect the design.                    *Wikimedia Commons*

you want a nice, dark henna tattoo, just use regular henna and be very, very patient.

## Other Semipermanent Stains

Many ancient Roman manuscripts mention the color and character of Briton body painting, as stated in the translation from Latin: *"All the Britons dye their bodies with woad (vitrum), which produces a blue color, and this gives them a more terrifying appearance in battle."* Unfortunately, as this tradition was broken for at least twelve centuries and no written record exists on pre-Christian Celtic body art, we may never be certain what it looked like or how it was done. Analyses of male bog bodies found in peat pits around Ireland have shown them to have a high copper content in their skin, which suggests that perhaps powdered and oxidized copper lent itself to the blue coloring as well.

In the Amazon, many tribes use the fruit of the Genipa tree to create the ink used in their traditional body paintings. The juice of the fruit is clear and colorless when first applied to the skin, but over a period of twelve hours, turns an opaque, blue-black color. Because it's such a strong stain, Amazonians use twigs or leaves to apply the paint to avoid accidentally staining their hands, because even when first applied, it will not come off easily with just vigorous scrubbing and water. Amazonian tribes have varying methods for preparing their paint, techniques that have been passed down through generations over thousands of years. Its medicinal properties are well documented, chief among them the ability to ward off insects, treat bronchitis, and protect from sunburn. Babies especially are often stained black from head to toe to keep away the biting insects.

## Body Paint

While almost every group of people in the world has had some form of tattooing, for those with darker skin, a tattoo just doesn't make the impact that it does on much lighter skin. Because of this, many peoples of Africa and Oceania practice scarification and simple tattoos to make permanent marks, and elaborate body paints for semipermanent ones.

The Surma of southwest Ethiopia are considered by their neighbors to be among the masters of body paint, using their entire bodies as a canvas—men, women, and children alike. Every morning during the courtship season, this incredibly isolated tribe goes to the riverbanks to scrape chalk, which they mix with water to create an opaque white paint. They use this paint in one of two ways: either by covering their bodies with chalk and scratching designs out when it's dried to expose the dark skin underneath, or by using a paintbrush made of a reed or grass stem to paint intricate floral designs all over their bodies. The only taboo regarding painting is that the lower legs must be left bare, but this is purely for aesthetic reasons—any paint below the knee would smear anyway while walking through the tall grasses of the region and ruin the overall design.

The Surma consider body painting to be an essential part of every child's education. It teaches girls how to attract future partners, and it teaches boys how to decorate themselves to enhance their musculature and highlight their masculinity. Children of both sexes generally start learning body painting when they're four years old, and practice painting on one another up through adulthood. Often, children and especially adolescents paint matching designs on one another to show that they're friends.

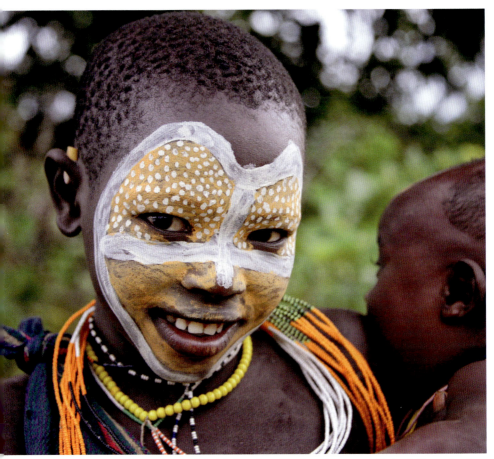

The Surma decorate themselves with brightly colored body paint on a daily basis from the time they're small children.                                                                *Wikimedia Commons*

A neighboring tribe of the Surma, the Karo, are renowned for their remarkably colorful body paint, which encompasses all the colors available in the natural world around them. The tribe of scarcely three thousand remaining members make their paints from pulverized bright-yellow mineral rock, white chalk, bright red paint from pulverized iron ore, and black paint from charcoal; even more colors are created by mixing this naturally occurring palette together. The patterns themselves aren't as complicated as those of the Surma, but are simple designs of spots and geometric patterns laid on top of brightly contrasting color fields and outlined multiple times. Every day, they wash off the designs of the day before and repaint themselves in either the same design, or with a

completely different design. They also paint bright strips of color in their hair with the different clays.

In South Sudan, the pastoralist Dinka cover themselves with white ash every day to both protect themselves from insects and as a mark of beauty—their unique body painting is inspired by the pure white, long-horned cattle they've lived beside for thousands of years. Dinka men also bleach their hair red and add white ash to it to make it match their skin. The Victorian explorers who first discovered the Dinka called them the "gentle ghostly giants of Africa" both because of their bleached appearance and because most Dinka stand between 6′6″ and 7′6″.

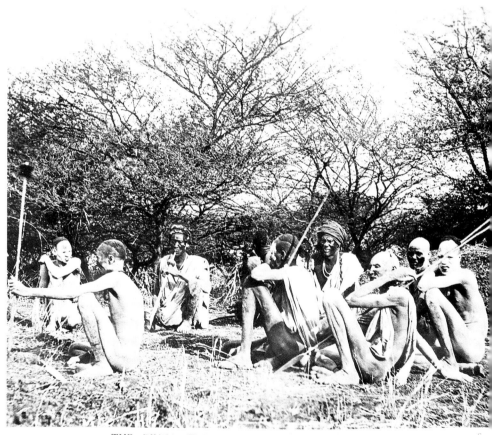

THE DINKA TRIBE, BAHR-EL-GHAZAL

Dinka tribesmen, painted white with ash, relax together in this photograph from 1910.

*Wikimedia Commons*

Olng'esher is a Maasai ceremony that marks a man's passage from being a warrior to becoming a tribal elder.                                    *Wikimedia Commons*

Farther south, in Kenya and Tanzania, the Maasai use exclusively bright red body paint, made from pulverized rocks with high iron content, animal fat, and pleasant-smelling herbs and plants. Red symbolizes the blood of cattle and the Maasai's inseparable relationship with their herd. The paint is used in their hair and on their bodies, and when a warrior shaves his head to symbolize reaching the Maasai version of retirement, he paints his bald head bright red as well. While some Maasai use their fingertips to smear large patterns on their faces and bodies, others use reeds and grass bundles to paint incredibly detailed geometric patterns on their skin, especially around their eyes.

The Tuareg of North Africa, or the Blue Men of the Desert, may be the best-known nomadic tribe to the world outside of Africa, as they've been depicted in so many movies about Africa because of their bright-blue skin, including the Mark Harmon vehicle *Tuareg: The Desert Warrior*. While this blue dye is a defining characteristic of the tribe, the Tuareg don't actually color their skin—instead, the dye in the indigo cloth of their veils and robes isn't permanently set, and turns everything it touches blue.

The Tuareg do use body paint in many of their ceremonies, however; ironically, none of it is blue. During wedding ceremonies, Tuareg brides cover their hands in intricate henna patterns, paint their lips, eyes, and eyebrows black, and draw patterns with red ochre on their faces. Unlike most other Muslims, the Tuareg men keep their heads and faces covered in

public, while the women leave their heads and faces uncovered and wear their long, beautiful hair in thick braids down to their backs.

In Papua New Guinea, while all the women are covered in elaborate tattoos, men's tattoos are almost nonexistent. Instead, during times of intertribal conflict, the men go to great lengths to decorate themselves with body paint and feathers. Men of the Huli tribe paint their faces with intricate and individuated patterns of red, yellow, orange, and white, and top it all off with gigantic headdresses made of flowers, feathers, bird skulls, and foliage. The men of the neighboring Kalam tribe also employ face paint

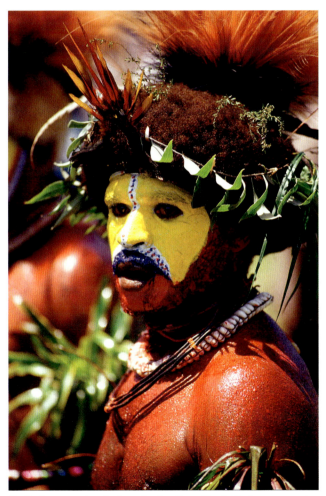

Huli wigmen paint their entire bodies with chalk for ceremonies and wear wigs made of human hair, plant material, and feathers.
*Wikimedia Commons*

during ceremonies, with each man wearing relatively the same pattern of red cheek circles and a wide swath of red outlined in white following the bridge of the nose.

In the Melanesian island of Vanuatu, the Ni-Vanuatan use white chalk paint in all their ceremonies, which range from beautiful, geometric face painting during intertribal "friendship ceremonies" to covering their bodies in white, lithe stripes during their prewar Snake Ceremonies. Most Ni-Vanuatans belong to cargo cults, which means that they believe that wealth can be gained by participating in religious ceremonies—similar to the Prosperity Theology churches in the United States and in the Philippines.

In the Jayawijaya mountains of Indonesia, the Yali—perhaps best known by *National Geographic* readers for their fantastic, two-foot-long penis gourds—cover themselves from head to foot in white ash and chalk for ceremonial purposes. Another regional tribe, the Dani, also use body paint, but not as extensively—the Dani paint white chalk spots or tiny star patterns all over their bodies, paint white "trousers" on their legs, and occasionally outline their eyes in white. The two tribes of former headhunters used to have an incredibly combative relationship, but since the outlawing of headhunting and the oppressive encroachment of the modern world on their territory, the two former enemy tribes now come together for ceremonies and competitive games.

## Temporary Tattoos

Some of the earliest temporary tattoos were actually flash tattoo transfer sheets used by real tattoo artists. In the 1940s, monochrome sheets of nautical tattoos were made available to kids for "a penny a sheet," with instructions to "moisten the skin and press the pictures down" to transfer the tattoos. If you didn't want the picture on your skin and wanted it on a piece of clothing instead, you could simply iron the design onto a shirt, hankie, or apron instead, much like the quilt and embroidery transfer designs of the day. The designs were very messy in an inexpert hand, but if you were careful, you could amaze your friends with an anchor or a sailor tattoo on your arm at school the next day—and if your mother saw it before you left for school, a good scrubbing took most of it off.

By the 1950s, temporary tattoos had made their way into bubblegum packages as well, printed on paper with vegetable dyes that often bled onto the enclosed gum. In the 1960s and up through the 1970s, Cracker Jack

Temporary tattoos are a safe and easy way for kids of all ages to enjoy having a tattoo for a day or two.                                                                    *Wikimedia Commons*

began enclosing entire booklets of tiny multicolored tattoos in their boxes as the prize, proving to be one of their most popular prizes of all time, even though they were notoriously messy to apply and often left smeary blue and green streaks on kids' fingers and clothing. People still collect and trade the little Cracker Jack tattoo booklets of anchors, skull and crossbones, octopuses, Uncle Sam, and other mostly nautical themes, and even today, Cracker Jack very occasionally surprises and delights a consumer with one of their tattoo books.

In 1996, Edward A. Biggs of International Designs, Inc., patented the first commercially available waterslide decal tattoos, which completely transformed temporary tattoos. With a waterslide tattoo, a highly detailed piece of art is printed onto a thin plastic sheet and covered with a water-soluble piece of paper treated with adhesive. Once the plastic layer is peeled off, the design is transferred to the side with the adhesive. When someone puts the paper, design-side down, against his or her skin and wets the paper, the

adhesive on the paper is dissolved and the tattoo design is transferred to the skin. Because the design is made of such a thin, flexible layer of plastic ink, it looks, moves, and feels almost like a real tattoo.

Waterslide tattoos have proven to be so popular that you can even find them in grocery store bubblegum machines and as kids' prizes in dentists' and doctors' offices. Recent adaptations to the original design include adding glitter and foil accents to the designs, creating beautiful metallic temporary tattoos that would be impossible to re-create as an actual tattoo. They're cheap enough to manufacture that books of waterslide tattoos can usually be bought for a couple of dollars, with each book containing dozens of tattoos of varying sizes. Specially treated blank paper can be found in craft stores as well, so that anyone with a design idea and a laser or inkjet printer can make his or her own waterslide tattoos for a couple of bucks a sheet.

## Biotech Tattoos

Recently, several companies have begun releasing temporary tattoos that are as functional as they are visually appealing. Makeup company L'Oréal now sells a temporary tattoo that monitors your UV exposure, sending information about your sun exposure directly to your cell phone. Researchers at medical company MC10 are working on a silicone diagnostic sensor that can be worn like a Band-Aid to monitor your body's hydration, activity, and even your temperature. UC San Diego is developing a temporary tattoo that will work as a battery to charge your mobile devices and runs off your body's sweat.

Perhaps most exciting of all, MIT has developed a metallic temporary tattoo called DuoSkin that is fully interactive with your mobile devices, and can display and even store information on your skin. You can conceivably set your house up to be run by your DuoSkin tattoos—at the very least, you can turn your lights and radio on and off by touchpoints on your tattoos—just like you can with your cell phone. It's also very pretty, made of gold leaf that can be augmented with working LED lights that run off the salt of your sweat, and many of the designs resemble jewelry more than functional devices.

# Circus Performers

## Tattooed Men and Women

The popularity of tattoos during the last half of the nineteenth century and the first half of the twentieth century owed much to the popularity of the circus. There was almost always work to be found for a tattooed man or woman at the circus, and when circuses prospered, circus performers, and tattoo artists, prospered as well. When a circus went bankrupt, the tattooed men and women employed as performers found themselves out of work. However, because there were so many traveling circuses and dime-store museums during this period, it didn't take the enterprising tattooed performer long to find work again.

For over seventy years, every major circus employed one or two to several dozen completely tattooed people. Some were exhibited in sideshows, other performed traditional circus acts such as juggling, tightrope walking and various acrobatics, fire breathing, sword swallowing, and equestrian vaulting. Rival circuses competed with one another for the services of the most elaborately tattooed show people and the most outlandish acts and paid them handsome salaries. Many of the old-time tattoo artists made most of their money while traveling with circuses during the spring and summer, returning to their shops and homes in the winter. The circus served as a showcase where tattoo artists could attract customers by exhibiting their work to a paying public, and in many cases, the only surviving records of the great early tattoo masterpieces have come down to us in the form of photos and posters of performers that were used for publicity.

The love affair between the circus and tattooing began in 1804, when the Russian explorer Georg H. von Langsdorff visited the Marquesas Islands. There, he met Jean Baptiste Cabri, a French deserter who had lived for many years among the indigenous people of the islands. During his time on the island, Cabri had been extensively tattooed by traditional tattooists and had even married a Marquesan woman who bore him several children, all of whom he left behind to return to Europe with Langsdorff.

Langsdorff brought Cabri back to Russia, where Cabri enjoyed a brief but successful theater career in Moscow and St. Petersburg—much of his performance revolved around relating his "harrowing" adventures on the Marquesas, complete with dramatic pantomime, culminating in him ripping his clothes off to reveal his extensive tattoos. After he had worn out the Russian theater circuit, he took his show on the road and toured the rest of Europe, where he was examined by distinguished physicians and exhibited to royalty, all of whom were thrilled to hear his well-worn speeches about his time on the Marquesas. But within a few years, his career went into decline. During the last years of his life, he was forced to compete with trained dogs and other popular amusement in country fairs. He died in 1822, poor and forgotten, in his birthplace of Valenciennes, France.

The first Englishman to work the theater circuit as a tattooed man was John Rutherford. In 1828, an account of his amazing adventures among the Maoris of New Zealand appeared in the popular press. It was reported that he had been captured and held prisoner for ten years. Shortly after his capture, he was forcibly tattooed by two priests who performed the four-hour ceremony in the presence of the entire tribe. During the process, he lost consciousness, and had to spend several weeks convalescing.

After his recovery, Rutherford was adopted by the tribe, promoted to the rank of chief, and treated with great respect. The Maori offered him over sixty girls to choose from, and told he could take as many as he wanted for his wife. He prudently chose only two, both of whom were, amazingly enough, daughters of the chief, immediately making him next in line to rule the Maori. During his years with the Maori, he participated in warfare, headhunting, and other tribal activities.

In 1826, Rutherford was rescued by an American ship that took him to Hawaii, where he made good use of his time by quickly marrying yet another native princess. After a year in Hawaii he made his way back to England, where he joined a traveling circus, and he related his colorful tales of adventure and intrigue to enraptured crowds.

## P. T. Barnum

Possibly the world's greatest showman, if not of all time then definitely of his time, Phineas T. Barnum is credited with organizing the first sideshow of unusual individuals who were, in his words, "mysterious deviations from nature's usual course." They were exhibited at Barnum's American Museum,

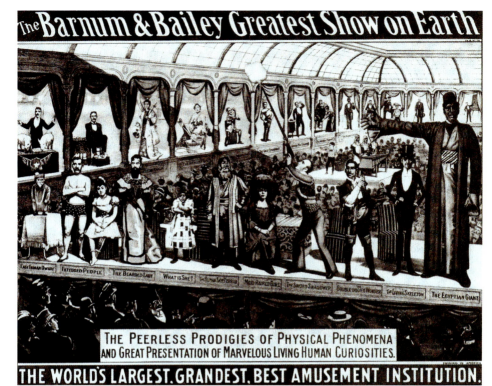

P. T. Barnum and his Peerless Prodigies of Physical Phenomena included two "tattooed people," pictured on the far left.

*Library of Congress*

which opened in 1841 in New York and soon became one of the largest and most profitable attractions in the city.

Patrons of Barnum's American Museum were treated to a hodgepodge of entertainments, such as exotic animals, scientific lectures, magic shows, melodramas, and human curiosities that included Siamese twins, dwarves, bearded ladies, albinos, snake charmers, sword swallowers, geeks, fire breathers, contortionists, gypsies, fat people, skinny people, and cannibals. Some of the displays were real deviations from the norm, while others were fake. Some of the performers even performed as two or three separate acts at various times to make the exhibits seem even more inclusive than they actually were, but all were introduced with preposterous stories about their exotic origins and adventures, and especially how they had narrowly escaped from their harrowing lives to end up at P. T. Barnum's museum.

In 1842, P. T. Barnum hired James D. O'Connell to become the first tattooed man exhibited at a circus in the United States. O'Connell had been tattooed in the Caroline Islands, where he had lived among the natives for several years. After leaving the islands, O'Connell made his way back to the United States, where, in 1834, he published an account of his adventures in *Eleven Years in New Holland and the Caroline Islands*. For two decades, O'Connell performed as an actor, dancer, and acrobat in circuses and vaudeville theaters throughout the United States.

O'Connell was wildly popular in the circus, where he entertained his audiences with tall tales of adventure like those told by Cabri and Rutherford. According to him, savages on the island of Ponape in the Caroline Islands had captured him and forced him to submit to tattooing at the hands of a series of voluptuous virgins. He discovered, to his great distress, that island custom obliged him to marry the last of the

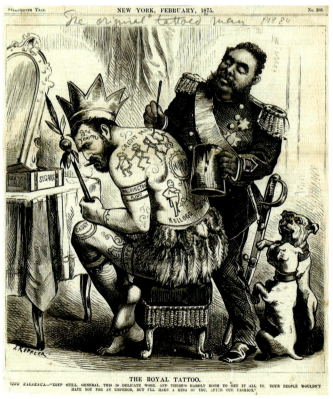

This Joseph Keppler piece is a commentary on how a man could make people think he was a king in a sideshow act if he just received enough tribal tattoos.            *Wikimedia Commons*

maidens who tattooed him—who was, of course, a princess, which made O'Connell the islanders' chief. A theatrical playbill from 1837 advertised O'Connell playing himself in a melodrama based on his adventures in the South Seas.

In 1869, the country was revolutionized when the east and west coasts of the United States were connected by railroad for the very first time. Traditionally, circuses had moved in horse-drawn wagons over unpaved roads, advancing slowly from one small town to the next. In contrast, train travel suddenly made it possible to move large numbers of people and animals, and heavy equipment between major cities in a just few days with relatively little effort. As a result, profits increased dramatically, as did the wages for people employed by the circus, which created even more competition between circuses, as whoever could offer the best deal to performers got the best acts. The circus entered an era of growth and prosperity that resulted in employment opportunities for many tattooed people and the artists who tattooed them.

In 1871, Barnum joined with two established circuses to form the largest circus in the world: P. T. Barnum's Great Traveling Exposition. It included a museum, a menagerie, and over thirty human curiosities. There was no tattooed man in Barnum's traveling circus when it first opened, but the position was filled two years later when Barnum met Constantine, aka Captain Constentenus.

The elaborately tattooed Captain Constentenus had a back story that sounded a lot like a combination of Cabri's and Rutherford's stories. He claimed that he had been taken prisoner, suffered torture by tattooing, married a native princess, and escaped to travel through Africa and Asia— apparently, this sequence was the natural course of events with all encounters involving the indigenous peoples of the South Pacific—where he had one remarkable adventure after another. He claimed to be "the greatest rascal and thief in the world, and always much admired by the ladies."

As the skeptical circus patron may have guessed, especially one who had heard the same story before from other similarly tattooed persons, a lot of Constantine's tale was exaggeration. Constantine was originally from Greece and had spent some years in Burma, where he had himself voluntarily tattooed by the highly skilled tattooists there with the intention of going into show business. His success was due not to his fanciful stories, but to the fact that he was more elaborately and artistically tattooed than his rivals. The artistry and craftsmanship of Constantine's designs, which consisted of beautiful renditions of monkeys, flowers, trees, birds, and a

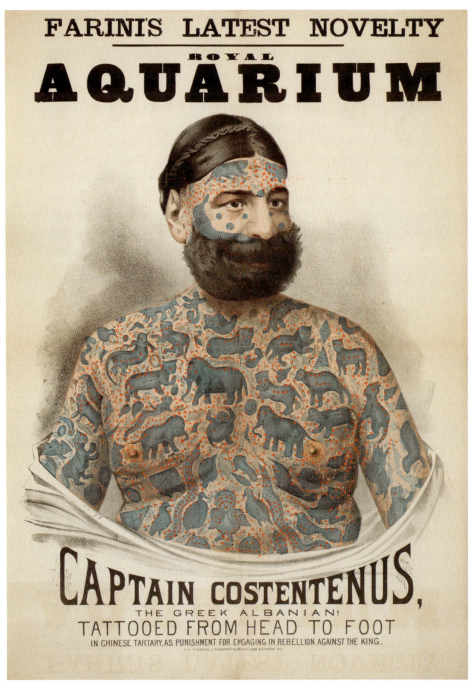

Captain Constentus (Constantine) was one of P. T. Barnum's greatest attractions during the heyday of the sideshow act. *Wikimedia Commons*

variety of unidentifiable fanciful creatures, as well as the ornate script of the Burmese people, far surpassed anything that had ever been seen in Europe up to that point, and were not anything like the geometric patterns and heavy black lines that earmarked the work of Polynesian tattoo artists.

## The Great Omi

The most famous tattooed man of the early twentieth century was Horace Ridler, who worked under the stage name of "The Great Omi." In 1927, he walked into tattooist George Burchett's office and asked to be tattooed all over, including his face, with inch-wide zebra stripes. After over 150 hours under Burchett's needle, Ridler also went and had his teeth filed down to sharp points, had his septum pierced so that he could insert an ivory tusk through his nostrils, and had his earlobes pierced and stretched until the holes were more than an inch in diameter.

Fans of Omi might have been surprised to know that the man who had done all these things to himself had come from a relatively boring background, as the youngest son of a very ordinary family who lived in the countryside just outside of London. Ridler grew up in an upper-middle-class environment, went to a private school, and had a private tutor by the name of Joe Green, who also worked in the family's stables as a groom. Green had been a circus clown during his youth, and when he wasn't tending the horses or helping Horace with his homework, he would perform his former circus act for young Horace with the Ridlers' horses, which involved acrobatics and juggling while on horseback. His stories apparently painted such a wonderful picture for the young man that they sent the boy down the long road that would eventually transform him into The Great Omi.

The Great Omi became one of the most well-known freaks in the history of the circus, and enjoyed a successful career until his retirement in 1950. Wisely, he had chosen to retire when he was still a star of the traveling circus, instead of as a washed-up, broken carnival sideshow attraction as so many of his associates did. He and his wife moved to a small village in Sussex, England, and lived the remainder of their years in a caravan in the woods near the village. The local people gradually became used to Horace Ridler's weekly visits to town to pick up fan mail at the post office and provisions at the grocery store, where he would try to minimize his outlandish appearance by wearing a scarf and hat. He died in 1969 at the age of seventy-seven.

## Painless Jack Tryon

Painless Jack Tryon, also known as "Three Star Jack," was often billed as the "World's Most Handsomely Tattooed Man." A fantastically attractive man, Jack was tattooed from his neck to his feet, with some of the work contributed by tattoo luminaries such as Charles Wagner and Lew Alberts, while most tattoos on his body inked by himself.

While there aren't any records of where Jack learned the art of tattooing, what is known is that he was already making a name for himself as a tattooist by 1910. A man of many talents, Jack also worked the performing circuit as a magician, tightrope walker, and a fire-eater. His wife also worked in the circus, as a snake handler on her own and as Jack's partner in many of his acts. He also worked as the tent master, or "boss canvasman," as it was called then—on railroad shows, making sure the circus tents were set up properly and wouldn't blow down or away during inclement weather.

In the 1940s, Painless Jack left the circus completely and set up a tattoo shop in San Antonio, Texas, where most of his clients were servicemen from the nearby Air Force base.

## Irene Woodward

Most historians point to Irene Woodward as the first tattooed lady to appear in a circus act, but there are others who claim that her main competition, Nora Hildebrandt, was actually the first. The two women both appeared on the US sideshow circuit roughly around the early 1880s.

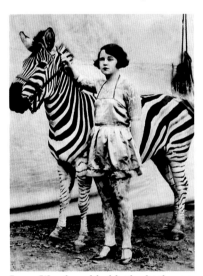

Irene Woodward holds the hotly contested title of First Tattooed Lady of the Circus.    *Library of Congress*

Irene claimed to have grown up in the American West with her brother and father, who was a former sailor. According to her official brochure, "Facts Relating to Miss Irene Woodward, the Only Tattooed Lady," her father tattooed her to pass the time in the lonely cabin they shared. Irene was delighted by his work, and convinced her father to continue until nearly her entire body was covered in tattoos. Supposedly, when her father died in a Ute raid in 1879, the Utes were so frightened by her elaborate tattoos that they released both her and her brother from captivity unharmed.

Irene Woodward was born Ida Levina Lisk in 1857 to a shoemaker and his wife, and grew up in a series of lower-class alley apartments in Philadelphia. Her mother had five other children after Irene, but only one—her brother—survived. Inspired after seeing Captain Constentenus perform with the Barnum & Bailey Circus in Denver, she traveled to New York City in 1882 to be tattooed.

During the course of her tattooing, she received a completely random, unconnected series of tattoos that eventually covered her entire body. She had a circle of flowers around her neck, while on her left arm was a hive of worker bees over the phrases "Never Despair" and "Nothing Without Labor," a tattoo of the Goddess of Liberty, angels, stars, and the moon. Her left arm featured a harp enclosed in a shamrock juxtaposed with the patriotic image of an American eagle with the phrase "I Live and Die for Those I Love." However, just the fact that she was a woman with so many tattoos would have distracted any discerning viewer from the fact that she was basically a walking flash tattoo catalog.

Dime museum owner George B. Bunnell knew a sideshow jackpot when he saw one. He hired Irene to work as one of the first performing tattooed ladies at his curiosity-filled museum, Bunnell's Dime Museum, in New York City. Her 1882 debut at the Sinclair House down the street from the museum made the *New York Times* and signaled the beginning of the end of the tattooed man act that had dominated sideshows and museums over the previous fifty years. The tattooed lady both scandalized and intrigued the public—here was a woman covered in blue- and red-inked designs that most people only saw on sailors or hoodlums. She wore an immodest costume to show off her tattoos, yet really revealed only her decorated knees and elbows to the curious

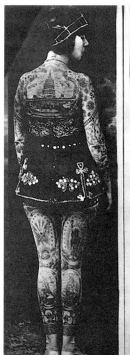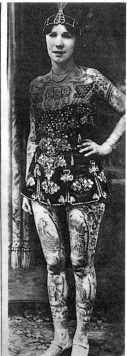

The tiny and childlike May Vandermark performed as a tattooed woman with P. T. Barnum's circus for several years.        *Library of Congress*

public, leaving the rest of her body to the imagination of her easily titil-lated audience.

Irene was reported by the papers that wrote about her as being dignified and even a little shy at having so many strangers staring at her. As she told her backstory to audiences, they were captivated by its danger and pain, and the idea that the only reason she'd survived her capture by Indians was because of the tattoos her loving father had allegedly given her during all those lonely days and nights out on the prairie.

Irene spent her early career at a series of dime museums in New York and beyond. From Bunnell's, she moved on to the Globe Dime Museum in the Bowery. In the Midwest, she performed at Sackett's in St. Louis, Missouri, the Milwaukee Dime Museum in Wisconsin, and then back to Philadelphia. She also picked up her first agent and future husband, George E. Sterling, who, going against tradition, took her surname after marriage to become George E. Woodward.

In 1884, Irene found work with the Great Forepaugh Show, where she worked for the next few years with only a brief interruption for the birth of her son, George Woodward Jr. After the Forepaugh Show closed in 1889, both she and George Sr. got jobs with P. T. Barnum's Greatest Show on Earth, with her as the attraction and him selling tickets and managing the money. For the next fifteen years, the two of them traveled around Europe, both with P. T. Barnum's show and Pawnee Bill's Wild West Show. She also appeared on many stages as a solo act, presenting herself before many European heads of state as well as the Munich Anthropological Society and Berlin Anthropological Society. In addition to her performances, life-size wax figures of Irene's body were created for display in over thirty-eight European wax museums to remain for audiences to view for years to come. In 1915, at the age of fifty-eight, Irene passed away from uterine cancer.

## Nora Hildebrandt

Nora Hildebrandt's debut was also with Bunnell's Dime Museum in New York, on March 1, 1882. Her story was, of course, tragic. She claimed to have been born in Australia in 1860, but following several family tragedies, she came to New York at the age of five, "friendless and alone." In 1878, her father, a tattoo artist, sent for her from Salt Lake City, Utah, so they could travel together through the Wild West.

At some point during their travels, they were attacked by the Lakota (Sioux), and Sitting Bull forced her father to tattoo her for a full year before

the poor man decided he couldn't torture his daughter anymore and defiantly broke all his tattoo needles. He was, of course, killed for this, but Nora was rescued by the famous cavalryman General George Crook. The pain of tattooing had left Nora completely blind, so Crook took her to Denver and left her at the hospital with no hope of recovery. However, while she was recuperating, circus owner Adam Forepaugh and sideshow manager W. K. Leary happened across her and funded her return trip to New York to live out her days under the care of her remaining family. Miraculously, she was completely cured of her blindness before even reaching New York, and Forepaugh offered her a job in his circus.

The little that's known of Nora's actual life is much different from that in the pamphlet, of course. She was born in London, England, around 1857, and most likely immigrated to the United States as a domestic servant, as many young European women of her time did. Along the way, she met tattooist Martin Hildebrandt, and asked him to tattoo her entire body in 1882. They had a common-law marriage, and she took his name. Their marital status was so secret, and their age difference was so great, that many

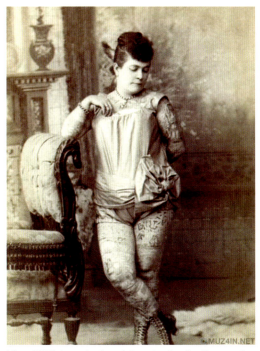

Nora Hildebrandt also claimed to be the first professional "tattooed lady" in the United States.
*Library of Congress*

people thought Martin was actually her father, a supposition she did little to discourage.

After a short stint at Bunnell's Dime Museum, she began traveling around the Americas and Europe with various circuses. During her first trip to Mexico, Nora was billed as "Mexico's Great Sensation." She performed before Mexico's president Manuel Gonzalez and his family, as well as former president Porfirio Díaz. Nora was showered with gifts in Mexico, including a mustang pony with a saddle and bridle from President Gonzalez, diamond earrings from his son, as well as a gentle pet tiger. She also caught yellow fever, but recovered enough to continue her tour.

As her popularity grew, her tenuous relationship with Martin disintegrated, and she finally disposed of him by having him committed to an insane asylum in 1885, claiming he was her abusive stepfather instead of her husband. By December of that year, she was working at a dime museum in the Bowery once more, claiming "preeminence over all tattooed ladies" and making sure everyone knew she was a "living art gallery, wearing a better wardrobe and more diamonds than all other curiosities combined." She claimed to wear diamonds worth $5,000 at her shows, which probably made security at the little museum she worked at very nervous.

In 1888, Nora received an offer to travel to Berlin and Paris, where she met her future husband, a heavily tattooed barber named Jacob Gunther. Technically, it was the first marriage for both of them, since Nora's relationship to Martin had never been recognized in the eyes of the law, especially after she'd had him civilly committed as her stepfather. Jacob and Nora celebrated their first anniversary by signing a joint contract with Hagar and Henshaw's sideshow to travel with Barnum & Bailey. Jacob had taken his wife's surname, and performed in the show as Jacob Hildebrandt, tattooed man. The couple continued to travel and work together until 1893, when Nora died suddenly of unknown causes at the age of thirty-six. Jacob Hildebrandt went back to being Jacob Gunther, barber, and lived out the rest of his life quietly in Brooklyn, New York.

## Frank and Emma de Burgh

Frank de Burgh and his wife Emma were a fully tattooed husband and wife exhibit. Their first known appearance was with the Sells Brothers Circus in 1885, when the two of them were married, with great fanfare, under the big top in Burlington, Iowa. Along with the usual patriotic symbols and tattoo motifs, Frank and Emma displayed tattoos that showed the newlyweds'

bond and devotion to each other. Frank wore a beautiful scroll inscribed with the words "Forget Me Not," held up by a pretty young woman with the name "Emma" scrawled underneath her. Emma bore the names "Frank" and "Emma" in prominent view. They are best known, however, for their religious themes, with both Frank and Emma exhibiting exquisite biblical scenes as part of their gallery of tattoos.

Frank's back was covered from shoulder to shoulder with the Mount Calvary crucifixion scene. Emma's back displayed an even more impressive reproduction of Leonardo da Vinci's *Last Supper*, meticulously done down to the most minute detail by Samuel O'Reilly. Unfortunately, Emma lost popularity as she grew older and gained weight, and while Frank drew appreciative crowds during their 1893 European tour, many of those in Emma's crowds had come specifically to pass judgment. The two of them went on to travel through the Americas and then to Europe with various circuses, until their marriage ended in 1898. Emma continued to perform on her own for a few more years before retiring.

First-generation tattooed ladies were usually completely tattooed, or at least tattooed in enough places that Victorians considered them scandalous. Their legs, arms, chests, and backs were covered in crudely inked designs, and they wore skimpy dresses to show themselves off for the audiences. Due to a lack of visual evidence, however, it's unknown if the majority of women had tattoos on their breasts, bottoms, or torsos—the places their costumes covered. Emma de Burgh, however, left behind a single nude photo that points to her having a large clock face with Roman numerals tattooed on her stomach, as well as garlands of leaves and flowers on her breasts and all along her bikini line. Victorian morality for women during the nineteenth century demanded adherence to a strict dress code, but tattooed women needed to display as much inked flesh as possible to attract curious circusgoers. This made them both fascinating and forbidden to the men of the era, and, most likely, added complication to the personal lives of the tattooed women themselves.

## Modern Exhibits

While tattooed men and women in sideshows have fallen out of favor, tattooed people in art shows and exhibits have grown to fill their place. Art collectors have approached well-known tattoo artists and their clients to offer them money for their tattooed skins—sometimes, to be part of a traveling

live exhibit; sometimes, the purchase involves a postmortem collection; and sometimes, it involves a commitment before and after the "artwork's" death.

Belgian artist Wim Delvoye has been selling tattooed pigskins to art collectors around the world for the past decade. He cares for his tattooed pigs on his farm in Germany until they die of old age, upon which time collectors can bid on the skin. While the work may seem controversial, pigs have been marked with ID tattoos for over a hundred years on commercials farms around the world, and, most likely, not under the sterile, fully sedated condition that Delvoye tattoos his pigs. The pigs are living works of art,

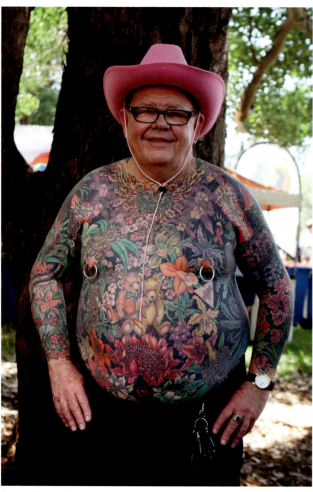

Australian and occasional sideshow act Geoff Ostling is currently seeking a postmortem purchaser for his elaborately tattooed skin.
*Wikimedia Commons*

covered with flowers, angels, knights on horseback, and themes from the natural world.

In 2006, Delvoye sought out a human canvas for his work. German tattoo shop owner Tim Steiner answered the call, and by 2008, after many tattooing sessions spread out over several years, the two of them had found a collector for his skin, titled "TIM"—to be collected posthumously, of course. As part of the deal with TIM's future owner, Rik Reinking, Steiner had to exhibit the tattoo by sitting topless in a gallery at least three times a year for ten years. His first exhibition took place in Zurich in June 2006, when the tattoo was still a work-in-progress, while the last exhibition in 2016 involved a whole year at the Museum of Old and New Art (Mona) in Hobart, Tasmania, sitting near-motionless on a display stand for five hours a day, six days a week.

In 2014, the International London Tattoo Convention featured an exhibit called The Human Gallery, in which people posed inside intricately designed shadow boxes set behind ornate gold frames so that only their tattooed body parts could be seen. Viewers of the exhibit were treated to the sight of living, disembodied tattooed heads staring back at them from inside the ornate gold frames, as well as tattooed arms, legs, and even posteriors that would emerge from the frames as if to greet them as they walked around the gallery space.

In early 2016, the Victoria Art League's Point of Origin gallery in Texas debuted its first tattoo exhibit. While many of the exhibits in the show were inked on living skin, the collection also included the paper sketches that the tattoo artists had used to create the designs used in the tattoos, to show visitors to the exhibit the evolution from a sketch on transfer paper to a fully formed tattoo.

Every year, as tattoos have gained appreciation in the art world, more museums have begun to feature exhibits of living people tattooed by experimental and fine artists in the field. And as more tattoo artists gain recognition in the art world, no doubt, more art collectors will be drawn to lay claim to these unique pieces, increasing the possibility that someday, many museums around the world will have these human canvases hanging on their walls in public collections as well.

# Prison Tattoos

## The Story Behind Bars

In 1886, French professor of forensic medicine Alexandre Lacassagne extensively researched tattoos among groups of criminals, prostitutes, and other convicts. Lacassagne discovered that many prisoners in associated "brotherhoods" had nearly the exact same tattoo in roughly the same part of their body, essentially discovering the identifying tattoos of the first known prison gangs. He also noted that some types of tattoos were associated with certain body parts as well—obscene tattoos were usually found on the buttocks and lower abdomen of a prisoner, while tattoos of national heroes or saints were usually tattooed on the chest. One incarcerated soldier he studied had a general's uniform tattooed over his entire body, while another had an admiral's uniform. Whether either soldier had attained these ranks while in service was not noted, but either way, the idea of a soldier languishing behind bars wearing a uniform that could not be taken away from him no matter what is a poignant image.

More than a third of the Italian criminals examined by Lacassagne had religious tattoos, many of which were acquired in the sacred town of Loreto, Italy, where even today, thousands of pilgrims visit each year, acquiring tattoos while there to commemorate the journey. Tattooed inscriptions were also common among the convicts, often expressing feelings of rage, vengeance, or anarchist sympathies. Many criminals were also inscribed with expressions of self-loathing, such as "Born under a bad sign."

These French penal tattoos were all very simply and crudely rendered, created in the near dark by a handheld sharpened wire dipped in homemade ink, made by mixing urine and soot together. The first tattoo many inmates ever received was a single dot on all four fingers, which indicated that the bearer had been to prison. A star or a sailor on a crucifix represented a conviction by a naval court-martial, while the face of a woman on a rose meant that the wearer had had a bad, often violent, experience with a woman. Three dots at the base of the thumb meant "Death to the

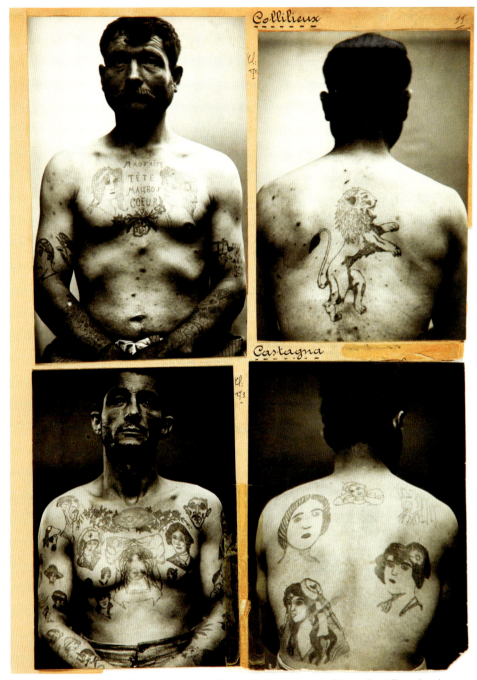

Pictured are two of the subjects studied by Alexander Lacassagne in his work on French prisoners.
*Library of Congress*

Police" (*Mort aux vaches*), and was usually worn by prisoners who considered themselves revolutionaries or political prisoners. Often, political prisoners also had images of the Church tattooed on their bodies—the ultimate pre-revolutionary subject.

The French prostitutes and female convicts Lacassagne studied had much subtler, and much less obscene, tattoos than their male counterparts did. Their tattoos were usually located in parts of their bodies easily hidden by clothing, such as their upper arms, shoulders, or between their breasts. Most of the women had tattoos of their husbands or lovers on their bodies, and while many women used a cigarette to burn off the name of an ex-lover in order to replace it with a new name, some left the names of all their lovers on their bodies and just tattooed a new name in a new spot to commemorate the new relationship. One woman Lacassagne studied had the names of thirty men very carefully tattooed in a very tiny hand in the space between her breasts. Other prostitutes studied had the name of their pimp tattooed on their bodies as a sign of their "relationship," as many prostitutes today do.

Italian criminologist Cesare Lombroso helped encourage the stigma attached to tattooing when, in 1896, he warned people to avoid tattooing at all costs, noting that "when the attempt is made to introduce it into the respectable world, we feel a genuine disgust, if not for those who practice it, for those who suggest it and who must have something atavistic and savage in their hearts." Lombroso, a professor of psychiatry and criminology at the University of Turin, invented the theory that criminals are throwbacks to a more primitive and impulsive type of man in whom the passions are predominant and moral qualities underdeveloped. In his 1876 book, *L'Uomo Deliquente,* he considered tattooing so significant to the criminal mindset that he devoted an entire chapter to tattoos, their known meanings, and case studies of criminals he'd interviewed about their tattoos. He examined over five thousand criminals and found that ten percent of the adults in his study were tattooed. He listed and categorized hundreds of tattoo designs that, he asserted, would be of great significance in the analysis of the criminal mind. Examples of things to watch out for were: mottoes expressing disrespect for authority or the desire for revenge; obscene words and images; any tattoos on the penis, which signified that a man was particularly deviant and mentally deficient; tattoos signifying membership in a criminal organization; and coded messages buried in tattoos. He recommended that prison authorities should keep track of and make a recording of any inmate's tattoos, especially any tattoos received while behind bars.

While Lombroso's moral outrage and judgment regarding tattooing led to many future misconceptions in criminology, the one good thing about his study was that in his work, he created and published the first statistical records of the frequency of tattooing and designs among Italian convicts. Because tattoo designs change so frequently behind bars, depending on political climate, changing perceptions of what's classified as a crime, and even the technology and equipment available to prisoners, his book is the only visual collection existing of the tattoos that were common at the time of its publication. He's also credited as being the first author to publish reproductions of nineteenth-century European tattoos.

Criminologists weren't the only academics writing damning treatises about tattoos. In his 1908 book, *Ornament and Crime*, Austrian architect Adolf Loos condemned tattooing on civilized men, claiming, "The Modern man who tattoos himself is a criminal or a degenerate. Tattooed men who are not behind bars are either latent criminals or degenerate aristocrats. If someone who is tattooed dies in freedom, then he does so a few years before he would have committed murder."

For some inmates, getting a tattoo is something one does to simply mark off the passage of time or to just pass the time itself, while to others, a tattoo represents membership in a gang or a bond formed with other inmates. Still other tattoos represent the crimes one has committed to get in prison in the first place—sometimes, in the case of truly heinous crimes, such as rape, murder, or pedophilia, these tattoos are forcibly applied behind bars to inform other prisoners of an inmate's crimes. In the nineteenth century, prisoners being transported to Australia from England often gave one another tattoos of biblical scripture to make fun of the establishment that had exiled them from the country of their birth. In these cases, tattoos represented a statement of government injustice, and a way to keep one's spirits up during banishment.

Today, tattooing in most prisons is illegal, as it's usually performed under unsanitary circumstances and can increase the risk of blood-borne pathogens being spread through the prison. Many times, tattoo ink is made from burnt rubber and urine, ballpoint pen ink, and other substances that can cause horrendous infections in the recipient. To counter this, Canada has begun to set up professional tattoo shops in their prisons, which conform to the same health code standards that exist in shops outside of prisons. The in-prison tattoo shops, staffed by both professionals and inmates, also serve as an educational outlet for prisoners wishing to learn how to become tattoo artists. Some prisons even invite celebrity tattoo artists to

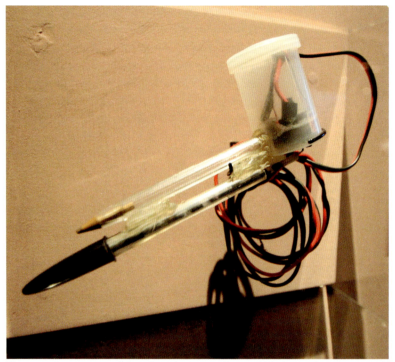

Homemade tattoo machines in prison are often cobbled together from small engines, such as an electric toothbrush motor, and a couple of ink pens.
*Wikimedia Commons*

come and teach workshops inside the prison, sharing new techniques and technologies from the outside world with the prison community.

## Russian Prison Tattoos

While tattooing is explicitly condemned in Russian prisons—although with the gradual acceptance of tattoos in society, this is less of a crime now than it was in the past—to not have a tattoo while incarcerated means that you, as a prisoner, have no status. During the Communist regime of the USSR, prisoners, political or otherwise, would use tattoos to express their distaste for the system that incarcerated them, to protest government control, to show solidarity for a political cause, and to pass secret messages along from one incarcerated group to another. Often, when these tattoos were discovered by prison authorities, the inmate would be hauled off to see the prison doctor to get the tattoo forcibly removed, usually by cutting or burning the tattooed skin off completely.

Still, tattoo culture has managed to flourish spectacularly in the world behind bars. Movies like David Cronenberg's *Eastern Promises* have offered cinema audiences a glimpse into the significance and hidden language of Russian prison tattoos. While many tattoos found in Russian prisons are completely unique to the individual wearers, there are some specific motifs that can be found throughout the system, meaning the same thing on each person. For example, a cat tattoo always means that the prisoner was a thief—multiple cats means that prisoner was part of a gang of thieves. A star tattoo measures how long a person has been in prison, with each point on the star representing one year. Shackles tattooed on the ankles means a prisoner has already been incarcerated for five years. Barbed wire tattooed on the forehead means a prisoner has been convicted and is serving a life sentence, while the tattoo of a skull is only worn by murderers.

## United States Prison Tattoos

While there are hundreds and hundreds of gangs in prisons around the country, the three major gangs that officially link most of the prison communities together are the Aryan Brotherhood, the Black Guerilla Family (BGF) and the Mexican Mafia. Each of these gangs have official tattoos related to them, and often, it's these tattoos that immediately alert a police officer in the outside world that he or she's dealing with an ex-convict. Inside the prisons, guards have been trained to keep members of specific gangs separate from one another, which can help maintain relative calm within the prison population, but also sometimes results in gang members feeling emboldened because they're surrounded by other members of their behind-bars community. Because of the work of Lombroso and Lacassagne, most prisons keep an up-to-date record of convict tattoos and their meanings, as well as notes on any events that create new tattoos and what these changes might mean to the environment of a prison population.

Members of the Aryan Brotherhood often have tattoos of a shield or crest with an "A" and "B" on it, or a heart pierced with two swords with "A" and "B" on the heart. However, the true tattoo for this organization is a shamrock with the number "6" on each of the three leaves, representing the number of the beast with the letters "AB" underneath. Because the Aryan Brotherhood is a gang originally created behind bars, only members who have served prison time are allowed to wear tattoos announcing membership.

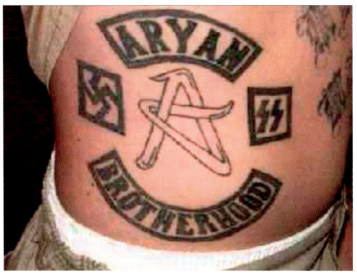

Here are just a couple of the tattoos typically found on members of the
Aryan Brotherhood.                              *Wikimedia Commons*

A related criminal organization is the Family Affiliated Irish Mafia
(FAIM).

This group also wears a shamrock tattoo, signifying their affiliation with
the Aryan Brotherhood—however, only members who have received permis-
sion from the Aryan Brotherhood are allowed to have a shamrock tattoo.

The Black Guerrilla Family (BGF) is a major black prison gang founded
in 1966 by Black Panther member George Jackson while he was in the San
Quentin State Prison. BGF was associated with a number of anti-establish-
ment groups, including the Black Liberation Army, Symbionese Liberation
Army, and Weather Underground. All African-American prisoners fall
under the automatic authority and protection of the BGF in prison.

BGF members receive a variety of tattoos according to their crimes, but
the most common tattoo of the faction is that of a dragon attacking a prison
gun tower. BGF commonly use different versions of a dragon surrounding
a prison tower and holding a correctional officer in its clutches. Another
common motif is that of a pair of crossed machetes, or rifles, and the letters
"BGF," as well as the tattoo "276," which corresponds numerically with the
letters "BGF" in the alphabet.

The initials "EME" located anywhere on a convict's body is the universal
tattoo for a member of the Mexican Mafia. The Mexican Mafia was formed
in the 1950s by a group of Hispanic youth offenders from various Los

Angeles barrio gangs at Deuel Vocational Institution (DVI), where the worst offenders of the California Youth Authority were sent. When the founder of the Mexican Mafia, Luis "Huero Buff" Flores, aged out of the juvenile detention system and went on to serve time at San Quentin, he continued the terror tactics that had made the Mexican Mafia the most powerful criminal youth organization in Los Angeles. By the 1990s, the Mexican Mafia had branches in prisons all over California and Texas.

Aside from EME, a "13" surrounded by dots is a common tattoo among members of the Mexican Mafia. The three dots can represent prison, hospital, and cemetery, which are associated with the gang lifestyle. Another much more elaborate tattoo is that of a black handprint, known as "The Black Hand of Death."

# Gang Tattoos

## Street Ink

**B**ecause tattoos have been associated in so many cultures with criminal behavior and the prison system, it's no surprise that most criminal gangs throughout the world have specific tattoos either given to them during initiation, to mark rites of passage, or to communicate groupthink or belief systems. Just as with tribal groups that get specific tattoos to demonstrate family ties, place of origin, or loyalties, some gang tattoos are used purely for identification purposes. These types of tattoos are especially helpful for correctional officers and law enforcement, as, in the United States and elsewhere, knowing which gangs can coexist in small quarters and which cannot is essential to keeping the peace.

The following are just a few of the most common tattoos found among some of the more heavily tattooed gangs out there. Some more recognizable gangs, such as the Crips and the Bloods, aren't mentioned here as they don't generally include tattooing as a sign of membership or an initiation rite, while other gangs aren't mentioned because they don't have a standard, recognizable tattoo motif among members.

of your tattoo, and then they refer you to a clinic with a prepaid or heavily discounted voucher to cover the service.

Here are just a few organizations that offer free tattoo removal to the formerly incarcerated, former gang members, and survivors of human trafficking. Aside from the following nonprofit organizations, many city and county police departments also offer a similar referral and voucher service for former gang members.

- Fresh Start Tattoo Removal: freshstarttattooremoval.org
- The Youth Removal Project: fadefast.com/youth-removal
- Homeboy Industries: homeboyindustries.org

# Sailor Ink

## Ink on the High Seas

n the 1890s, American socialite Ward McAllister said about tattoos, "It is certainly the most vulgar and barbarous habit the eccentric mind of fashion ever invented. It may do for an illiterate seaman, but hardly for an aristocrat." Ironically, and obviously unbeknown to him, King Edward VII of England had received a tattoo nearly thirty years before, while King George VII had had a dragon tattooed on his arm in 1882. Lady Randolph Churchill, the mother of the future prime minister Winston Churchill, reportedly had a snake tattooed around her wrist in her youth that she kept covered throughout her adult life by wearing heavy bracelets and long sleeves or gloves whenever photographed, while King Alfonso of Spain, King Frederick IX of Denmark, and Emperor Wilhelm II of Germany also had tattoos. Tattoos were not just something sailors received—plenty of royal personalities of the day, and before, had been parading around with them, either out in the open or in secret.

Just like today, the difference between a good tattoo and a bad tattoo had to do with money as much as personal taste. Royalty and wealthy socialites sought out the best tattooists and had them brought to their house to tattoo them in the comfort of their living rooms, or jumped on a ship to visit far-off Japan to get tattooed by a tattoo master with a background as a serious artist. Meanwhile, sailors got most of their tattoos from other sailors learning to tattoo, especially as fewer ships made stops in the South Seas Islands, where Europeans' love of tattooing had first begun. The quality of these tattoos was much poorer among the lower classes than those of the upper classes as the sailors performing the tattoos were not the highly trained artists that the South Sea Islanders or the Japanese were. However, despite the poor quality, the custom spread fast at sea, where older men would prick an anchor or some other nautical symbol into a younger sailor's arm either by request or as an initiation to a life on board. Such distinguishing marks, names, signs, or symbols were not only popular because they made each

man feel he had become an accepted member of the ship's community, but also because they were both superstitiously enhanced with strange qualities and they served as identification in case of drowning or disaster.

Certain tattoos became traditional among European and early American sailors and were received for good luck before a voyage. A rooster tattooed on one foot and a pig on the other was supposed to protect a sailor from falling overboard and drowning, with the reasoning being that neither animal could swim, so neither animal would try to leave a ship. A tattoo of a swallow would ensure a sailor would return home safely, after the swallows of Capistrano that returned to the same roosts year after year. Swallow tattoos were also used to mark how many voyages and miles a sailor had made during his life. One swallow meant a sailor had traveled a full five thousand miles, while another swallow was added for each additional five hundred miles. A tattoo of a turtle meant that the sailor had crossed the equator, while an anchor tattoo meant he had sailed the Atlantic Ocean.

From the 1760s, European ships' crew lists and surveys of dock workers recorded the tattoos of hundreds of individuals, including tattooed names, initials, and crosses, as well as a wealth of individual pictorial tattoos. These

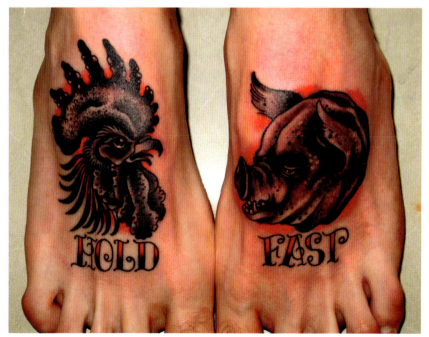

Many sailors believed that a tattoo of a rooster on one foot and a pig on the other would keep a man from drowning, as rendered here by contemporary tattooist Dan Sinne.

*Dan Sinne*

books served as a handy reference manual for ship captains who were looking to fill out their crew, and needed to know whether the young man with the skull tattoo looking for work on their ship was wanted for mutiny by another crew, or was known to be a hardworking mate. In the days before telephones and handy letters of reference, even two or three words stating that a person was a reliable deckhand in a published ship roster was valuable to captain and crew alike.

One of the earliest such rosters, the Description Books for dockyard workers at Deptford, England, contains such notes as "shipwright John Hoxton has St. George mark'd on his right arm" while carpenters William Henry and Thomas Towning both had their initials tattooed on their hands, "Markd WH" on right hand" and "Markd TT rt hand" respectively. One of the most famous of these lists came from William Bligh after the 1789 mutiny on his ship HMS *Bounty*. His "Description List of the Pirates" provides many descriptions of tattoos, many of which were clearly received in or inspired during a trip to the South Pacific, but many with obviously Western origins. In one example, Bligh described seventeen-year-old shipman Peter Heywood as being "very much tatowed. On his right leg tatowed the three legs of the Isle of Man, as upon the coin." Many of the surviving crew members listed in this registry were eventually rounded up and hung for crimes against the Empire for their mutinous behavior, while others simply disappeared, possibly forced to seek work either in other countries, where there was no registry that identified them as criminals, or in other occupations altogether.

Fifty years later, the British government finally organized a formal registry of crew lists in printed and widely distributed Description Books, which had columns specifically allocated for the recording of tattoos as a means of surveillance and identification. Many ship's captains carried these lists with them when they traveled and distributed them among the captains they met at foreign ports to ensure the safety of rival ships and their crews as well.

## The United States

Tattooing was brought to New York by sailors, who used hand needles to while away the boredom of shipboard life, as well as to initiate sailors into the fraternity. New York City's most famous tattoo was undoubtedly the red star on the forearm of Rowland H. Macy, the founder of the department store, a souvenir of his whaling days. It remains the Macy's department store insignia.

One of the first professional American tattoo artists was C. H. Fellowes, whose design book and tattooing instruments were discovered in 1966 by a Rhode Island antique dealer and are now in the collection of the Mystic Seaport Museum in Connecticut. Fellowes left no other record of his life or art, other than what was in his book. A thorough search of nineteenth-century business directories failed to reveal his name, and it's probably that he was either a ship's tattoo artist, or followed the fleet and came aboard to tattoo sailors whenever and wherever they docked. At the time, this would have been a much more profitable way to conduct a tattoo business than simply sitting in one's shop and waiting for customers to walk in off the street.

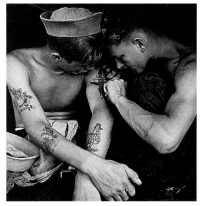

Many sailors, like this one getting tattooed in 1944, picked up tattoos during their travels like some people do souvenirs.    *Wikimedia Commons*

Fellowes's book contained over a hundred designs in red and black, many of which were ambitious compositions featuring religious, patriotic, and nautical themes. Among these are those that would have been of special interest to US Navy veterans, as they commemorated specific naval engagements that occurred during the Civil War and the Spanish-American War. One of the great naval battles of the Civil War is illustrated in a drawing that shows the northern warship *Kearsarge* with guns blazing as a Southern vessel, the *Alabama*, sinks in flames. According to contemporary accounts, the crew and the officers of the *Kearsarge* had stars tattooed on their foreheads to celebrate their victory over the *Alabama*, which took place on June 19, 1864. The presence of Fellowes's rendition of the battle in his book suggests that while there were definitely customers who were interested in commemorating the battle in tattoo form, most people wanted that tattoo drawn as a ship on a discreet spot on their body, instead of getting a star on their own foreheads as the original crew had.

Another ambitious composition shows the battleship *Maine* sinking. A banner above the ship bears the words "Remember the *Maine*," and superimposed on the ship is a portrait of her commander, Charles D. Sigsbee. The sinking of the *Maine* occurred in the harbor of Havana, Cuba, in 1898, and marked the beginning of the Spanish-American War.

The bust of Admiral William Thomas Sampson, commander of the fleet that blockaded Spanish warships in the harbor of Santiago de Cuba,

is the subject of another of Fellowes's drawings. Two other designs portray the USS *Iowa*, one of the battleships that participated in the final defeat of the Spanish Navy. Yet another depicts the USS *Hartford*, which was known to many nineteenth-century naval men as a flagship during the Civil War and later enjoyed a long and honorable service as a US Navy training ship.

Several tattoo artists found employment in Washington, DC, during the Civil War. The best known of these artists was Martin Hildebrandt, a German immigrant whose career began in 1846. In addition to working in DC, he traveled extensively during the war and was so well known that he was welcomed by both Union and Confederate soldiers, who would let him set up shop in their camps, where he was kept busy tattooing military insignias and the names of sweethearts.

In 1870, Hildebrandt established the very first tattoo studio in the United States, on Oak Street in New York City. This section of New York

Students of the Seamen's Institute getting art lessons as part of the WPA Federal Art Project job retraining for military veterans.                    *Wikimedia Commons*

was considered one of the city's worst slums, but it was close enough to the James Slip and a ferry landing that a steady stream of sailors shipping out were able to find his studio. At the time, he charged between fifty cents and $2.50 for a tattoo from a collection of designs that included a young lady intertwined with a flag from any nation, the Crucifixion, ballerinas, Masonic and Odd Fellows symbols, the hand of good fellowship, and a variety of standard sailor symbols. He claimed in an 1876 interview that he had "marked thousands of sailors and soldiers."

Hildebrandt worked at this location for over twenty years and tattooed some of the first completely covered circus attractions, including Irene Woodward, Annie Boyle (later Howard), and his common-law wife, Nora. In 1885, he was arrested for disorderly conduct, and Nora had him charged with insanity and sent him away to spend the rest of his life in an insane asylum.

Photographer Dorothea Lange caught this candid shot of an unemployed lumber worker and former military man, who probably had his Social Security number tattooed on his arm in case his body couldn't be otherwise identified during the war.                    *Library of Congress*

# Tattooed Makeup

## Practical Applications

W hen most people think of tattoos, they usually envision big, splashy, colorful creations designed to make a statement. However, many tattoos are so innocuous that you wouldn't even know they were there. Since the 1930s, women from all walks of life, all over the world, have been getting their day-to-day makeup tattooed on their eyes, lips, and cheeks, saving them from having to worry about reapplying their makeup through the day.

New York tattooist Charles Wagner is generally credited with being the first in the business to offer cosmetic tattoos, but London tattoo artist George Burchett, known as the King of Tattooists, is credited with developing early cosmetic tattooing with such techniques as filling in eyebrows, coloring lips, and rouging cheeks. Burchett offered this service almost exclusively to upper-upper-class English women, and accordingly, he charged much more for tattooing makeup on clients than he would if he was simply giving them a more traditional tattoo. He often worked on these ladies in the privacy of their homes, rather than have them come to his tattoo studio, as many of the starlets he worked on required confidentiality from him as well as a gentle hand. However, according to his memoirs, beauty salons had already been essentially tattooing clients without their knowledge for years, rubbing vegetable dyes into lightly abraded skin to add color to their cheeks and lips. Since Burchett used a tattoo machine instead of relying on surface abrasions, however, his cosmetic makeup likely lasted much longer than the quick jobs at the beauty salons.

In 1979, tattoo artist Pati Pavlik began offering permanent makeup in her studio at Laguna Beach, California, and by 1985, about two-thirds of Pati's tattooing work was cosmetic. For having ushered in the mainstreaming of permanent cosmetics across America, she is fondly named the "Mother of Permanent Makeup." This recognizes her work as a tattoo artist, her efforts at advancing legislation to make sure that cosmetic tattooing was

safe and properly regulated, and the classes on cosmetic tattooing she offered within the field. In 1989, she formed the National Cosmetic Tattooing Association, which focuses on scientific data associated with permanent cosmetics.

## Benefits of Permanent Cosmetics

Permanent eyeliner, lipstick, and other permanent cosmetics eliminate the need to use makeup. For people with allergies to some of the chemicals commonly used in commercially produced cosmetics, tattooed makeup is an effective option. Permanent eyeliner allows people to swim, shower, or

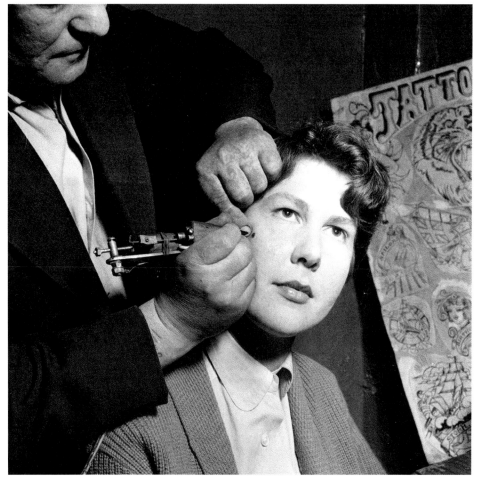

A tattoo artist paints a permanent beauty spot onto the cheek of a female client at his workshop in Copenhagen, a common procedure in the 1950s.        *Library of Congress*

exercise without having makeup smudges, which is why it's become one of the most popular cosmetic procedures in Hollywood, with celebrities such as Madonna, Angelina Jolie, Elizabeth Taylor, Little Richard, and Nicolas Cage touting its effectiveness.

Another common purpose of cosmetic tattooing is to help a person recover after reconstructive surgery. A skilled artist can blend discolored scar tissue into the surrounding skin after surgery or an accident, and nipples can be visually reconstructed after a full mastectomy, using a combination of tattooing and a small silicone implant. Since a good part of recovering from a physical trauma is learning to live with the physical

Pop star Madonna is one of many celebrities who have had their makeup permanently applied.                    *Wikimedia Commons*

aftermath, most insurance companies now offer some coverage for cosmetic tattooing, especially in the case of areola reconstruction.

Up until fairly recently, permanent cosmetics were applied using the same coil-driven style of tattoo machine as those used on the rest of the body, which, combined with the cumbersome weight and size of the machine as well as the overall noise made these sessions undoubtedly traumatizing. In 1970, however, a new type of tattoo machine, designed specifically for tattooing permanent makeup, was invented in Taiwan, and soon made its way to North America. The new machine, still in use today, is the pen-style tattoo machine, which looks and feel just like a pen and is fitted with a single needle.

While the pen-style machine is popular among tattoo artists because it is easy to use and relatively silent, it does not deliver the same quality tattoos that the coil-driven machines do. The ink is often deposited so close to the surface of the skin that the tattoo fades away almost completely in three years, and frequent touch-ups are often required. Because of this shortcoming, some cosmetologists have begun promoting their services as "semipermanent tattoos," so that customers will know in advance that they're going to have to go back under the needle again in a few years to keep their tattoos looking nice and dark.

Recently, the digitally controlled computerized tattoo machine entered the North American market from Germany. This machine has a more reliable and stronger power source than pen-style tattoo machines, but retain the easy-to-manipulate pen shape and virtually noiseless operation that made pen-style machines popular in the first place. The needle depth is automatically controlled by preset buttons, so that tattoos for reconstructive purposes, such as areola procedures, are set at a depth that ensure their permanency, while presets for eyelids and lips adjust accordingly to minimize tissue damage while creating a strong, steady, permanent line.

## Risks Involved with Tattooed Makeup

There's an old adage that says that if you're considering getting a vasectomy, always choose a doctor who has performed at least a thousand vasectomies. The same thing goes

This woman has had microblading, or a tattooed eyebrow procedure, done.
*Wikimedia Commons*

for finding a tattoo artist or cosmetologist who specializes in tattooed makeup. Before you let someone work on your face or especially anywhere near your eyes, check your tattoo artist's credentials carefully. Ask to speak with former clients. Ask to see before-and-after photographs. To avoid infections and ensure professional results, it is important to work with a licensed aesthetician, ideally one recommended by a cosmetic surgeon. Make sure everyone in the office uses sterile gloves and sterilized equipment when working on you.

Another important consideration is knowing whether your body will accept or reject the ink used by the tattoo artist, as not all tattoo artists use the same brand or quality of ink. Just because you've gotten a tattoo before by a different artist, it doesn't mean that you won't have an allergic reaction to a different brand of ink. Again, since the FDA really only takes the time to look into a product after enough people have had allergic reactions (or worse), it's up to you to make sure the tattoo artist performs a patch test of the ink that will be used in the procedure. Most will, but be ready to say something if this is not automatically offered. After all, you wouldn't want to have an unpleasant infection near your eyes or on your lips that would require further medical attention.

The technician applying your permanent makeup should be wearing gloves and operate with sterile equipment.                    *Wikimedia Commons*

Because the skin on your eyelid is thinner than on any other part of your body, eyeliner tattooing is the biggest challenge tattoo for any tattoo artist. There is hardly any subcutaneous fat within the eyelid, particularly near the lid margin, so selecting the precise needle depth is especially important to prevent damage to the eye. An inexperienced tattoo artist can easily overwork an eyelid to the point that damage to the eyeball itself can occur, as well as cause damage to the tear ducts or leave excessive bruising. When you leave the office after your tattoo, you should have minimal bruising, redness, and tenderness to mark the occasion—not blindness, blocked or excessively leaking tear ducts, or a black eye.

Since there are so many blood vessels in the delicate, thin skin around the eyes, a condition known as "pigment migration" can occur, in which the tattoo ink spreads out through the surrounding skin of the original tattoo, resulting in runny lines around your eyes that resemble smeared eyeliner or mascara. This usually happens soon after being tattooed, but it can take several months to manifest. When this happens, depending on the amount of migration, the tattooed eyeliner line or lines can be made a little thicker to correct the mistake, the original tattoo can be removed entirely via laser surgery and redone at a later date, or the client can choose to leave the tattoo alone entirely to let it fade over time, then come in and get it corrected at a later date. Most tattoo specialists prefer clients take the third option, as the first option can result in even more pigment migration, while the second can result in damage to the client's cornea and permanently damage the hair follicles of the eyelashes.

## Safety Concerns

Because the FDA considers tattoo ink a cosmetic product, the same safety rules apply to tattoo inks that do to regular makeup, even though one goes inside your body and the other stays on the surface of the skin. The pigments used in the inks are color additives, which are subject to premarket approval under the Federal Food, Drug, and Cosmetic Act. However, because of other competing public health priorities, such as those related to food and medicine, the FDA has not exercised much authority or even done significant study on the color additives used in tattoo inks. Also, even though a number of color additives are approved for use in cosmetics, none of them is actually approved for injection into the skin, and using an unapproved color additive in a tattoo ink makes the ink adulterated and can cause anything from different absorption rates into the skin to clotting and

This woman has had her lip color and eyeliner tattooed on.
*Wikimedia Commons*

color-bleeding. Many pigments used in tattoo inks are not approved for skin contact at all. Some are plastic- or rubber-based industrial grade pigments that are suitable for printers' ink or automobile paint, and can cause severe allergic reactions in many people.

In 2003, the FDA became aware of more than 150 reports of adverse reactions in consumers to certain permanent makeup ink shades, and it is possible that the actual number of women affected was greater. The inks associated with this outbreak were voluntarily recalled by the company that marketed them in 2004. In the spring of 2012, the FDA again received reports of infections from contaminated inks, resulting in their recall and market withdrawal. In 2014, tattoo kits, mostly purchased online through eBay and Amazon, were removed from the market after reports of severe microbial infections caused by use of the ink surfaced, all of which had been traced back to a single manufacturer in China.

# Tattoo Schools

## Where They Learn to Do It

The title of this chapter may be a little misleading, because you don't necessarily have to go to school or get a degree in anything to become a tattoo artist. In fact, many successful tattoo artists have never taken an institutional class on tattooing. Many very good tattoo artists learned how to do everything on their own, by just picking up a tattoo machine and experimenting on oranges, synthetic tattoo skin, or even themselves.

However, no decent tattoo artist isn't first and foremost an artist. Many tattoo artists have gotten advanced degrees in other art fields, such as graphic or fine arts. Somehow, these artists found their way into a tattoo studio and learned to translate their artistic vision onto skin. It's essentially impossible to be a good tattoo artist, or really, any type of artist, if you don't first and foremost have an appreciation for art and have some vague grasp of artistic concepts and art history.

With the popularity of tattoos both on and off the reality show TV circuit, many people have recently been drawn to tattooing as a potential career. Reality shows make it look like a significant part of a tattoo artist's day consists of hanging out with rock stars and other cool people and quickly drawing up a tattoo on clients when they come in—especially since most tattoo reality shows' episodes only last an hour at the most, and the majority of detailed tattoos take hours and hours to complete, and completing the tattoo may sometimes need to be spread out over several months. It's almost impossible to sit down and create the amazing tattoos you see on these shows, from beginning to end, in the time it takes for an episode to run its course.

Because of this, and many other misconceptions about the work and dedication that goes into becoming a successful tattoo artist, many people think that buying a cheap tattoo kit on eBay and practicing on their friends is all they need to become a successful tattoo artist, and never acquire the skills necessary to compete in this highly competitive business.

## Getting Started

When you're trying to become a professional artist, every single spare moment you have is an opportunity to work on your skills. As an artist, you should have a sketchbook with you at all times, full of your original work. Don't worry if it isn't a book full of perfect sketches—if you fill the book with pictures and you hate everything in it, put it aside and start another book. Like anything, art becomes good by practicing. Even mediocre artists can become proficient if they practice enough. Spare time at work and at home should be used to come up with new designs, and improvements on old ones. Free time at home should be spent improving your technical skills as a visual artist. Just like any visual artist in any other field, a tattoo artist should be familiar with art history, technique, and critique, and spend lots of time reading books about art and going to museums. You don't have to have a degree to be an artist, but anyone who thinks professional artists don't have some sort of art education—which definitely includes being self-educated—is in for a rude surprise. Outside of a university setting, there are plenty of community college or community education art classes where you can get additional teacher-guided art instruction at an incredibly reasonable price. All of this adds up to what you really need to improve your skill as an artist: practice, practice, practice.

While you're doing all this drawing and studying, start looking at your work with a critical eye. When you come up with a piece that you think is really good and really showcases your personal style or skill, save it. Keep working, and keep saving all your best work, until you have a nice stack of artwork that represents your talent and artistic vision. Then, go through that stack one more time and pull out the best of the best. This remaining collection of artwork—shoot for twenty or thirty outstanding pieces—will be your portfolio, which you'll take around with you when you try to get work in a tattoo studio. When you arrange your portfolio, put your very best pieces in the beginning and at the end, as those are the two places that'll get the most attention during even the most cursory thumb-through.

## Apprenticeships

Many professional tattoo artists got their start in the field as an apprentice to another tattoo artist, and today, it's generally the accepted path to becoming a professional. An apprenticeship is basically an internship: you get to do all the things the master tattoo artist is too busy to do, or not interested in doing him- or herself—you make coffee for clients, sweep out the shop, order supplies, and, after you've proven yourself capable, sterilize and

maintain the tattooing equipment. Unfortunately, even though this feels like a job, and you may work enough hours that you're pretty sure it is a job, you're not going to get paid for your apprenticeship. In fact, it's common for a novice to pay up to $5,000 during an apprenticeship for the pleasure of carrying bloody Kleenexes and Band-Aids out to the trash. If you luck out and get a free apprenticeship, you usually also have to sign a contract agreeing to work a certain number of hours at the tattoo shop after your apprenticeship is completed, before moving on to another shop or starting your own business.

A word of warning: when you start looking for apprenticeships, make sure you find a parlor run by a reputable owner who will teach you real skills, and not just someone who's padding his or her bank account by selling apprenticeships. Just like an employer's going to check your references when you apply for a job, you should always check an employer's references as well. Find professionals who apprenticed at the tattoo shop you're interviewing with, or find other current apprentices and ask them about their experience with the shop. If you feel comfortable doing so, ask those you're interviewing with if they can offer you any references themselves. This may seem a daunting thing to do with a potential employer, but this is your life, and there's nothing wrong with taking initiative in your career as early as possible.

Once you are an apprentice, you will learn many skills from your teacher, most of them having nothing to do with actual drawing. You will learn how to safely clean your equipment, how to operate a tattoo machine, how to adjust your power supply, how to protect yourself and your clients from disease, and, last but not least, how to correctly apply a tattoo. This can take many months to learn completely. And while many of the responsibilities given to you during your apprenticeship may seem incredibly boring and pointless, to someone who actually wants to become a tattoo artist, it's a very practical, hands-on education. When you're sweeping out the shop, you're learning the importance to keeping your own workspace clean and sterile. When you're making coffee for or conversing with clients, you're learning how to deal with people and make them comfortable in a space that might be your own someday. And, of course, you're watching the tattoo artist work his or her magic while you do your "menial" work.

You can buy yourself a tattoo machine off of eBay. Ask the person you're apprenticing with to recommend a machine and model—and start practicing tattooing on your own at home, either on orange skins—a long-standing tradition among tattoo artists—or on sheets of synthetic tattoo skin that can be bought off of eBay or Amazon relatively inexpensively. Sometimes, these sheets come pre-inked with flash designs so you can practice tracing the designs with your tattoo machine, or you can order blank sheets and practice

working with a blank canvas, and even make your own stencils on a transfer machine to transfer to the skin. And then, of course, practice, practice, practice. Learn to make nice and steady lines, and the difference between the various needle groups and what each one does. This way, when the tattoo artist you're apprenticing for asks if you'd like to try tattooing on a human for the first time, you won't gulp and say, "No, not yet!" Instead, you can confidently take the tattoo machine and say, "Sure, I'll try!"

There are some tattoo artists out there who discourage buying your own machine and working outside the studio. The reasoning is that, if you're practicing on your own before the owner of the studio you're apprenticing for has decided you're ready, you're going to learn a lot of bad habits that he or she will just have to break you of. If you're concerned that this will be the reaction to your practicing on your own, bring it up to the person you're apprenticing with; or, if you're pretty sure the reaction is going to be a negative one but you still want to learn how to use a tattoo machine on your own,

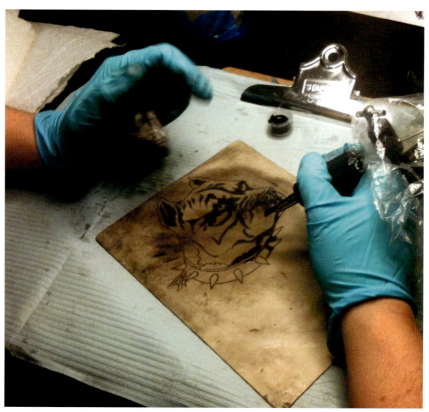

Part of your apprenticeship involves learning to tattoo on a piece of natural pigskin or synthetic practice skin.                    *Wikimedia Commons*

there are lots of how-to books on tattooing techniques that you can pick up that can help point you in the right direction, as well as let you know what sort of bad habits you should avoid.

There's no formal graduation from an apprenticeship. Generally, the teacher decides when you are ready to venture off on your own as an artist. Sometimes, the teacher and student will sign a contract at the beginning of the apprenticeship, and the terms will vary. But as long as you are not under contract to continue for a certain length of time or prevented from working for a competing shop, you can decide to stretch your wings when you feel you have learned all you can from your teacher. No matter how long you apprentice or how long you tattoo, you never know it all. There is always more to learn, new techniques to adopt, new ways to enhance what has already been done. Never be satisfied with mediocrity, and never allow yourself to become egotistical. This is an incredibly competitive field, and the moment you allow yourself to get sloppy is the moment someone's going to lure all your clients away.

## Certification

The tattoo licensing process functions on a county-based level, and as such, obtaining one can vary greatly even within the same state. For instance, the state of Wisconsin requires every county to accept only licensed tattoo artists, but the application for this license only requires that an individual apply for the license and send in a fee. In Denver County in Colorado, applicants are required to submit proof of Blood-borne Pathogens certification along with their fee, while neighboring Jefferson County doesn't require a tattoo license at all, only that the shop where an artist works practice OSHA standards and pass the annual inspection. In still other counties, a CPR certification is also needed to obtain a tattoo license in addition to all of the above. Make sure you have all the proper certification needed before you start your tattoo career, and if you move to another county or work in a shop is a different county, make sure you know exactly what you need to avoid being fined or closed down entirely. County regulations can change at any time, too, so check your state's website on a regular basis to ensure you and your shop are still up to code.

## Finding Work

Once you finish your apprenticeship and certification training, you need to find a place to work. Some new tattoo artists are contractually required to stay at the tattoo shop they apprenticed at for a specific period, while others

choose to stay at their first shop because they're comfortable with the shop and the owner.

Generally, like at most hair and beauty salons, a tattoo artist isn't paid anything by the owner of the shop. All income is earned from actually tattooing, so your reputation as an artist is directly linked to your income. Also, at almost any tattoo parlor, you are renting the tattoo space and chair in the shop by the hour (which usually amounts to a fifty-fifty split between the tattoo artist and the shop owner for each client tattooed), which means you're sharing the space with other artists and their clients. If you have a regular client load, you can usually make a deal with the owner to rent the space and chair exclusively for a weekly or monthly rate. There's no real set rate for how much a studio space is going to cost you, except that it's dependent on both the region and the reputation of the shop itself.

## Formal Education Programs

It doesn't take long for most aspiring tattoo artists to discover that getting an apprenticeship at a reputable tattoo shop is incredibly competitive and difficult. Luckily, there is another option: there are formal education programs that can teach you everything you'd learn in an apprenticeship. The downside of a formal education program is that because it's a classroom setting, you'll have less one-on-one tutorship than what an in-shop apprenticeship would offer you. Here are just a few of the many programs currently out there, and what you can expect from enrolling in a program.

The Academy of Responsible Tattooing (www.tattooschool-art.com) is one of the best-known tattoo trade schools in the country, with locations throughout the United States. They offer both one-day workshops as well as a five-hundred-hour program designed to look and simulate the experience of a tattoo apprenticeship. During an ART workshop, aspiring tattoo artists learn the ropes of working in a tattoo shop, including the proper sanitation techniques, ways to prevent cross-contamination, how to use and clean a tattoo machine, and how to make stencils. Attendees who complete the full workshop are then eligible to apply to a tattoo apprenticeship with ART's Professional Craftsman Program, which consists of 420 hours of training and assisting, plus 80 hours of professional development. During your time at ART, the history of tattooing is covered, as well as drawing techniques, shop management, machine maintenance and functionality, portfolio building, certification and sanitation practices, preparation for city and state licenses, and the execution of at least twenty tattoos on clients of your solicitation under professional supervision in a safe environment. There are options for

full-time students and part-time, with a monthly payment plan available for students who can't cover the entire (roughly $5,000) bill up front.

Austin's School of Spa Technology (www.austin.edu) may sound more like a beauty college than a school for learning how to tattoo, but it has an incredible tattoo program. Students learn artistic technique and art history, receive help from instructors in putting together a portfolio, and earn their Bloodborne Pathogens certification. Students are also taught how to start their own tattoo business and how to build a relationship with clients. The total cost of the program, including tattoo equipment, is under $4,000, making it one of the more affordable academic programs available.

Master Tattoo Institute (www.mastertattooinstitute.com) is a well-known and popular tattooing school in the tattoo hub of Miami. The program considers itself cutting-edge and backs up that bold talk by combining an experienced and talented faculty with some of the best resources for students available. The school also has a comprehensive curriculum designed to not only educate students on the skill-specific aspects of body art, but also give students a solid grounding in general artistic strategy and knowledge. The programs are cost-effective and offer a diverse set of skills and experiences. The school has been around for more than fifty years, which should tell you all you need to know about its prestige and success. Some of the required

Here's a glimpse of a typical classroom setup of most tattoo schools—this one's from the Academy of Responsible Tattooing (ART). *Google Images*

course load includes classes in color mixing and theory, tattooing safety practices, making your own stencils, using Photoshop to create and develop tattoos, and troubleshooting for and maintaining your tattoo equipment. It costs approximately $6,000 to complete the basic 160-hour program, and an additional $8,000 for the 240-hour advanced tattoo course.

# The Machines

## The Mechanics of Tattooing

It wasn't long ago that buying a tattoo machine was a fairly complicated affair. Up until the 1950s, there were only a few distribution companies that sold tattoo machines, and shipping and handling time could take up to over a month to get from one coast to another. Many tattoo artists had a side business manufacturing and selling tattoo machines based on the designs of Samuel O'Reilly and Charles Wagner, but this required having a fair amount of technical skill, and for many, it was just easier to order a premade machine and wait for its eventual delivery.

With society's gradual acceptance of tattoos, and especially the creation of the Internet, it's become amazingly easy to have a complete tattoo kit delivered right to your door for under $40, with higher-end machines running up to several hundred dollars. Many tattoo artists today still make their own tattoo machines, and even sell them to other tattoo artists. Many tattoo artists, such as Kat Von D, famously have collections of machines that other tattoo artists have made just for them.

Most professional tattoo artists stick to using the high-end machines, which run at a consistent speed, need much less regular adjusting of tension and have fewer problems with basic wiring, and are purportedly easier to handle. However, if you have some basic knowledge of electronics—very basic, because most tattoo machines are not particularly complicated—you can get away with using a cheap machine so long as you routinely check the tension, make sure all the contacts line up the way they should, and keep an eye out for wiring problems between the machine, power source, and the foot pedal. There is the risk, when you order cheap machines on eBay or another source, that the metal of the machine is of poor quality and will either snap under tension or rust even with minimal exposure to moisture, so you'll want to keep an eye out for any oxidation or signs of metal fatigue, such as tiny metal flakes coming off the moving parts of the machine during use. Keeping your equipment clean and oiled properly can help extend the life of even a bottom-end machine. It is recommended, however, that when you're buying tattoo needles, try to stick to products made in and sold in the

United States, even though they cost more. There have been problems in the past with Chinese manufacturers selling needles with an unacceptably high lead content in them, and since this is the one part of the tattoo machine that actually goes into your body, it's worth it to spend a couple bucks more for safety's sake.

## Thomas Edison

While some people credit Thomas Edison with inventing the tattoo machine, his 1876 patent was actually for the Electric Pen. The Electric Pen was not technically a writing instrument but part of a document duplicating system, or stencil maker, something desperately needed in the days before mimeograph machines and photocopiers. The Electric Pen was a small, handheld, high-speed rotary motor that punched holes through a paper with a single needle fast enough that a person could "write" with it, making clean enough perforations that ink could then be rolled over the stencil and transferred onto paper innumerable times. While the Electric Pen sold relatively well, it mostly did so on concept and not performance. The Pen was bulky and difficult to control, and often ruined more stencils than it made.

However, the next year, Edison completely redesigned his first invention and came up with the Autographic Printing Pen (US Patent Number 180, 857). The Autographic Printing Pen was a small machine with two electromagnetic coils and a flexible reed that vibrated over these coils to create the reciprocating motion needed to make the stencil. The biggest difference between the two inventions was the engine itself—the coil engine was smaller, lighter, and more powerful than the rotary engine, and the added length of the "pen" body of the Autographic Printing Pen made it possible for a person to hold it like a regular pen, rendering it much easier to write.

## The First Machines

In 1875, tattoo artist Samuel O'Reilly opened a tattoo studio in the Chinatown area of the Bowery, just five years after Martin Hildebrandt opened the first tattoo studio in the United States. It was an ideal location. The Bowery was located at the future crux of the Second and Third Avenue elevated trains, and already boasted a wide variety of entertainment such as gambling halls, burlesque theaters, saloons, shooting galleries, houses of ill repute, and dime museums. Thousands of people passed through Chatham Square every day, and among them were many who stopped to get a tattoo from O'Reilly.

At this time, tattooing instruments were sets of needles attached to a wooden handle, not much different or improved from the handheld

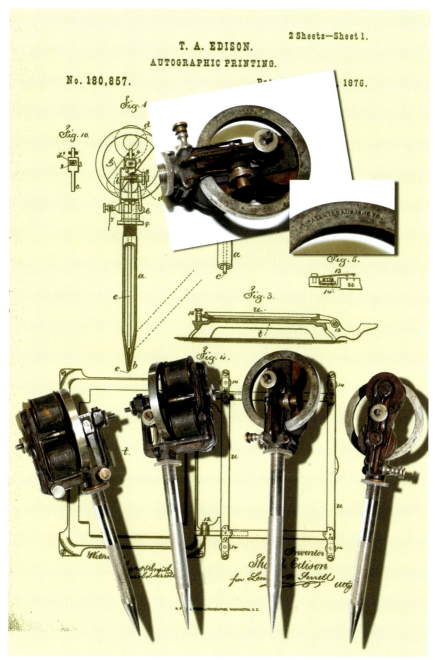

Thomas Edison's Autographic Stencil Pen is considered by many to be the official inspiration for the tattoo machines that followed it. *Google Images*

instruments used by Egyptian tattoo artists from four thousand years before. Most tattoo artists had several of these tools for doing different types of detail and outlining, although admittedly, they were not as varied as the very specific tattooing tools used by the Japanese masters. The tattoo artist dipped the needles in ink and moved his hand up and down rhythmically, puncturing the skin two or three times per second. The technique required great manual dexterity and could be perfected only after years of practice, and even then, it was a painstakingly slow process that required great patience and skill.

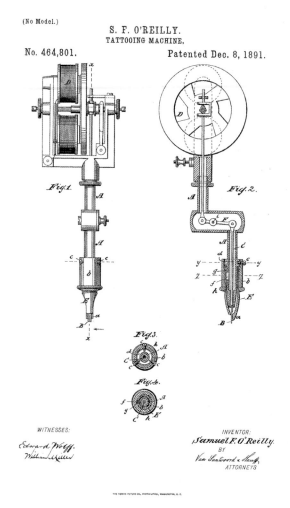

Samuel O'Reilly is credited with inventing the first patented tattoo machine.                                                    *Wikimedia Commons*

In addition to being a competent artist, O'Reilly was a mechanic and technician. Early in his career he began working on a machine to speed up the tattooing process. He reasoned that if the needles could be moved up and down automatically in a handheld machine, the artist could tattoo as fast as he could draw. O'Reilly was especially inspired by Thomas Edison's Autographic Print Pen, and in 1891, he took Edison's Pen, added multiple needles and an ink reservoir, and submitted it to the US Patent Office. He was awarded US Patent Number 464,801 for the first patented tattoo machine. O'Reilly's tattoo machine worked by using a hollow needle that filled with permanent ink, like a fountain pen. An electric motor powered the needle in and out of the skin at a rate of up to fifty punctures per second. The tattoo needle inserted a small drop of ink below the surface of the skin each time. The original machine patent allowed for different sized needles that delivered varying amounts of ink—a very design-focused consideration.

His tattoo machine revolutionized tattooing, and O'Reilly made a small fortune from both royalties and on-site sales of his machine as well as from customers who flocked to his studio, believing his tattoos would be faster—which they definitely were—and therefore less painful to acquire than through previous methods. His prestige was such that he was invited to travel to Philadelphia and other major cities, where he made house calls and tattooed wealthy ladies and gentlemen who did not care to be seen frequenting his Bowery tattoo studio.

O'Reilly died of a fall in 1908, but a student of his, Charlie Wagner, took over his shop and continued there until his own death in 1953, during which time, he made enough significant improvements on O'Reilly's mechanical design that he received several of his own patents. He started a mail-order business and sold his new machine to aspiring tattoo artists across the country, along with ink and design sheets. Wagner, perhaps the most publicized tattooist of his era, once said that next to covering up names of customers' former girlfriends, his greatest source of income was a 1908 naval order forbidding sailors to wear obscene tattoos; he was kept busy tattooing clothes on the naked girls that had been inked on impulsive would-be enlistees.

During World War II, Wagner was arraigned in New York's Magistrate's Court on a charge of violating the Sanitary Code. He told the judge he was too busy to sterilize his needles because he was doing essential war work: tattooing clothes on naked women so that more men could join the Navy. Because these were the days before the danger of blood-borne pathogens was well known, he was only fined ten dollars (approximately $102 in today's exchange rate) and told to clean up his needles.

Wagner introduced many new innovations during his career, including being the first American tattoo artist to offer permanent makeup to women,

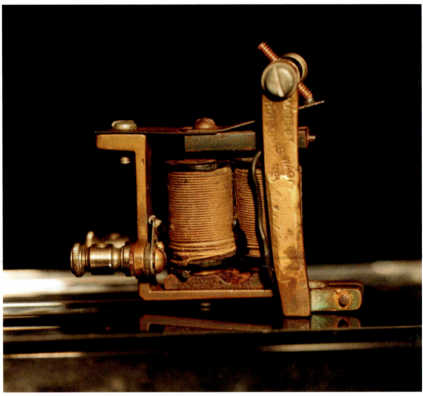

Charles Wagner's patented design was very similar to modern tattoo machines.

*Google Images*

as well as the concept of tattooing dogs and horses so that they could be identified in case of theft. He experiments with various methods of chemical tattoo removal, as well as offering therapeutic tattooing for rheumatism and joint pain. In a 1926 interview with *Collier's Weekly* magazine, he estimated that there were two thousand amateur and professional tattoo artists in the United States who were now using his machines and copying his flash designs.

In 1929, Percy Waters patented a tattoo machine with two electromagnetic coils set parallel with the frame, a spark shield, and an on/off switch, closely resembling the tattoo machines of today. Another important modification included a needle set up for cutting plastic stencils, which was very popular among tattoo artists who also created stencils for sale. Waters, a successful tattoo artist in Detroit, Michigan, also ran a tattoo supply company for nearly thirty years. Aside from selling his and other manufacturers' tattoo equipment, he produced stencils of classic flash sets featuring nautical motifs, scantily clad women, and generic shapes that could be filled with script.

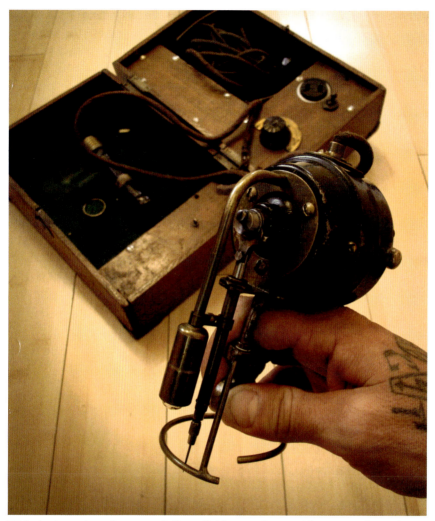

With the invention of commercially available tattooing machines, many home inventors took it upon themselves to build their own versions, such as this homemade tattoo machine from the 1900s. *Wikimedia Commons*

In 1979, a patent for a new tattoo machine design was registered to Carol Nightingale. Nightingale's machine included full adjustability of coils, back spring mount and contact screw, leaf springs of different lengths for different types of work, and an angled armature bar that did away with the bend in the front spring. This machine made it possible for lines to be made darker or lighter, allowing for tattoo artists to create minor shading in their creations. It also allowed for better control over the speed, depth, and pressure of the needle, and was lighter than previous models and easier for artists to work

with for longer periods of time. Finally, in 2008, the US Patent Office issued Patent Number 7,340,980 to Luigi Conti Vecchi for the newest, most modern version of the tattoo machine: "light and compact . . . improves the diffusion of the coloring liquid on the skin, simplifies the tasks of the operator, reduces the pain caused by the piercing action and increases safety [by] . . . avoiding the formation of cheloids caused by poor healing."

## Distribution and Catalog Sales

Tattooist, supplier, and even manufacturer Joseph Verba ran a tattoo supply catalog business out of his screen printing business in Cleveland, Ohio, in the 1930s. For $20—the modern equivalent of roughly $275—you could order his complete tattoo package, which consisted of two tattoo machines, a stick of black India ink, and a set of red, green, yellow, and brown pigment. For just $5 (or $69 now), you could order a tattoo machine designed by Verba himself: "built of brass, nickel plated, extra heavy high polished framed, magnet coils of Swedish rod iron steel, wound with fine double cotton covered wire and carefully tested to give you the proper current and vibration . . . My machines will operate on AC or DC current, with proper rheostat and is guaranteed to do fine art work."

As an artist himself, Verba also offered sheets of hand-drawn and painted flash created by himself as well as other artists. He also provided everything you needed to make your tattoo studio look professional from Day 1, including photographs of tattooed strangers to hang on your wall to give the illusion of having been in business for a while.

## Needle Configurations

While many older tattoo machines only had the capacity to use a single type of needle—generally, a single relatively thick needle, good for making straight lines and very basic coloring—modern tattoo machines have the capacity to use a variety of needles, combined with varying setting speeds, designed for shading, blending, and heavy and thin outlines. The four defining qualities of a tattoo needle are needle diameter, needle count, needle configuration, and needle taper. Each type of needle is assigned a specific number that is used almost universally by tattoo needle manufacturers, although there can be variations when dealing with tattoo supply countries outside of the United States.

When people refers to "a tattoo needle," they're almost always talking about a group of several small needles, or sharps, welded to a needle bar.

These needles work together to cover a larger area of skin than a single needle ever could. Each needle has a specific diameter number attached to it, with the most common being 0.20mm (#6), 0.25mm (#8), 0.30mm (#10), and 0.35mm (#12), and 0.40mm (#13). The smaller the needle diameter, the smaller the dot the needle makes, so a #6 can make extremely fine lines while a #13 makes the heaviest lines. The most popular diameter for tattoo needles overall is a #12, and #10 is the most popular size for lining.

The next defining property of a tattoo needle is the number of needles that are grouped together at the point of the needle bar, which is referred to as the needle count or number of "points." There can be as little as one needle at the point of the needle bar and as many as one hundred. Typical needle counts are 01 (one needle), 03 (three needles), 04 (four needles), 05 (five needles), 07 (seven needles), 08 (eight needles), 09 (nine needles),

Many tattoo artists prefer to design their own machines and needles for use in their studios, such as this 1978 collection of needles once owned by tattooist Manfred Kohrs. *Wikimedia Commons*

11 (eleven needles), 14 (fourteen needles), and 18 (eighteen needles), although these are far from the only options. The next two numbers following the needle diameter in a tattoo needle code indicate the needle count. So in the case of tattoo needle product number 1204RL, you're looking at a group of four #12-diameter tattoo needles (#12 + 04 needles).

The needle configuration—the last part of the product number—indicates how the needles are grouped together. The letters that come after the needle diameter number and the needle count number in a traditional tattoo needle code indicate the needle configuration. For instance, "RL" at the end stands for a "Round Liner" needle configuration, meaning that the needles are grouped in a circle. The most common needle configurations are Round Shader (RS), Round Liner (RL), Flat (F), Magnum or Weaved Magnum (M1), Curved Magnum (M1C), and Stacked Magnum (M2). Each needle configuration is used for a specific type of or part of a tattoo. Round liner needles are used for lining, while round shaders are used for shading. Flats are used for areas with geometric shapes and shading. Weaved magnums are used for shading, blending, and coloring large areas. Stacked magnums are used for shading, blending, and coloring tighter large areas, and curved magnums are used for shading, blending, and coloring large areas with less impact to the skin.

# Tattoo Art

## Where Does It Come From?

The most popular designs in traditional American tattooing evolved from the efforts of many artists who traded, copied, swiped, and improved on one another's work. In this way, they developed a set of symbols that were inspired by the spirit of the times, and especially by the experiences of soldiers and sailors during World War I and II. Many of these designs represented courage, patriotism, defiance of death, and longing for family and the loved ones left behind.

Today, only a few very talented tattoo artists work completely freehand on a client, and historically, very few ever have. Tattoo artists all over the world had been using wood blocks and felt pads and other methods to transfer tattoo designs onto skin for thousands of years, making sure the design is perfect before starting the actual tattooing. It only makes sense, because with this art form, mistakes are hard to correct.

Since the nineteenth century, tattoo artists have used either stencils or transfers to lay out their work before starting the process of tattooing. Even if an artist is making a completely individual design for a client, the design is printed on paper first for a client's approval, followed by a stencil on transfer paper that can be resized, if necessary, and repositioned numerous times to find the perfect spot on the client's skin before any tattooing takes place.

### Tattoo Stencils

In 1856, chemist Alexander Parkes patented the first plastic that could be heated and easily reshaped, a combination of cellulose and camphor that we know as acetate. Because there is no patent on register for tattoo stencils themselves, no one knows who first took acetate, scratched a design into it, sprinkled a little charcoal into the etching, and made the first tattoo transfer. With the introduction of stencils came the introduction of flash tattoos, those quick-and-easy tattoo designs that you see hanging up on the wall of every tattoo parlor. Because the plastic was very thin, it was flexible enough to follow the contour of a client's body; however, because it was so thin and

fragile, the design scratched into it could be only a rudimentary outline, so the tattoo artist using the stencil still had to have to skill as an artist to make a decent tattoo. Also, the acetate was highly flammable with a low melting point, and many tattoo studios were not set up to store acetate the way film studios, which handled and stored chemically related celluloid film, were able to. One can only imagine how many expensive stencils were accidentally destroyed, or caused related fire damage on their own, due to improper storage in those tiny tattoo studios.

Despite being very thin and fragile, acetate stencils were not easy to cut, and doing so was often left up to the apprentices in the shop. A heavy sewing needle or a 78 rpm record needle would be placed in a pin vice and that would be used to cut a scratch deep enough in the acetate to hold a layer of chalk or charcoal dust. Stencils also offered an easy way for tattooists to exchange designs. Once the stencil was cut you could lay a piece of tracing paper over the etched side, rub a pencil lead over the tracing paper, and a copy of the design would appear, just like with a gravestone rubbing or when trying to figure out the last message on a notepad. These ribbings could then be mailed to friends in the business. This is one way that designs were

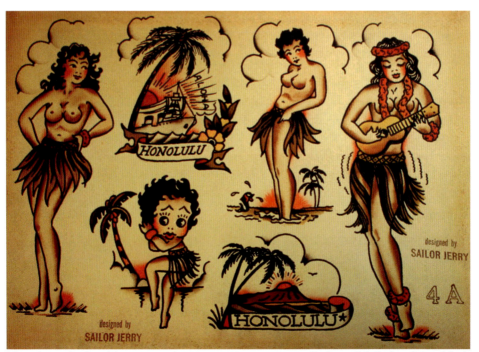

Many times, the first thing you see when you step into a tattoo studio is a wall full of traditional flash tattoos, like these designed by Sailor Jerry in the 1950s.          *Wikimedia Commons*

circulated around the world before the use of magazines, conventions, and the Internet.

Albert Morton Kurzman—aka "Lew the Jew" Alberts—is considered by many to be the inventor of the flash tattoo. Before serving in the Spanish-American War in the Philippines, Alberts studied drawing and metalworking in high school, and even worked briefly as a wallpaper designer. He received several tattoos from fellow servicemen during the war, and learned the art of tattooing enough to make a career out of it. When he returned from the Philippines, he set up a tattoo shop in New York, where he both tattooed clients and designed and sold tattoo machines. His biggest business, however, was designing and selling thousands of designs through the mail and in his shop for other tattoo artists to buy for their own use. With the invention of the tattoo machine, tattoo shops were springing up all over the country, run by tattooists who were technically proficient, but incapable of creating their own original artwork—armed with an envelope of plastic stencils from Alberts's studio and other flash tattoo artists, even a mediocre tattoo artist could run a successful tattoo studio.

## Transfers

Acetate stencils were not the only method for transferring tattoo designs to a client's skin. Another process was to make a transfer, by placing transparent rice paper over the design to be used in the tattoo, which would be traced with a hectograph pencil. The design would then be flipped over onto the client's skin and gently rubbed until the image was fully transferred, where it could then be traced over and filled in by the tattoo machine. The downside of this process was the transferred image would always be in reverse, so putting words or names in the transferred tattoo required the extra step of writing the words out first, then flipping the paper over and tracing the image coming through the backside of the paper onto the rice paper to be used for the transfer. Another downside to a rice paper transfer was its fragile nature—if it got even a little bit wet, it would start dissolving almost instantly. The transfer could usually only be used once. However, the designs applied via this transfer method generally came across much stronger and cleaner than those from using an acetate stencil, and were the preferred method for tattoo artists who did custom work, which was usually a one-of-a-kind piece anyway.

In 1950, the Thermofax machine was released as an office copier, a slightly better copier than the mimeograph machine had been. To make a copy, a thin sheet of heat-sensitive copy paper was placed on the original document and exposed to infrared energy. Wherever the image on the

original paper contained carbon, the image absorbed the infrared energy, and the heated image then transferred the heat to the heat-sensitive paper, producing a copy of the original.

The downside of the Thermofax machine was that it could only make one copy at a time, and often, because of the level of heat involved in the process, both the original and the copy were sometimes scorched, making it undesirable for formal business use. The Thermofax was eventually replaced by more efficient photocopiers, but as it faded out of office use, it gained a wide audience in the tattoo business, and was a fixture in most tattoo artists' studios by the 1980s.

A tattoo artist armed with a Thermofax machine can make a photocopy of a piece of art directly onto a piece of heat-sensitive transfer paper. That transfer can then be directly applied to a client's treated skin, leaving a clear, strong copy of the artwork on the skin for the tattoo artist. This process has revolutionized tattoo art, as an artist who labors to come up with a piece of original art no longer has to redraw that artwork in order to make a transfer. Customers can also bring pieces of their own original artwork in with them and have tattoo artists make transfer copies of the art on their Thermofax machines. This has added a new level of customization to getting a tattoo.

## Flash Tattoos

Flash tattoo are those sheets of designs usually on display when you first walk into a traditional tattoo studio. They may also be found in big books sitting on the counter for you to look through while you wait to be seen by the tattoo artist, or, more recently, accessible via the Internet from the comfort of your home.

Flash tattoos are considered work-for-hire pieces, in that the artist sells all his or her rights to the tattoo design to have it included in a collection of other flash tattoos. Designing and selling flash tattoo designs is one way that tattoo artists have been able to continue to make money as artists when tattooing work is slow. It's also a great way to make money off all the hundreds of doodles and sketches most artists accumulate during the process of coming up with a really good, original piece.

Flash designs are usually packaged in books or catalogues containing several hundred designs, or even as subscription-based software packages containing thousands of designs. Today, tattoo artists can walk clients through thousands of flash images on their computers, have clients pick out designs, print them out, and make transfers with Thermofax machines, right in the office.

## Custom Images and Original Art

Many times, customers come into a studio with pieces of artwork that they want as tattoos. If customers have come up with the artwork themselves, there's usually no legal issue in turning it into a tattoo, but if it's another artist's work, tattoo artists should make sure, for their protection, that there aren't any copyright issues involved. Technically, as soon as an artist creates a work of art and shows it to one other person in a public space—including a grocery store—it is legally protected by copyright. Although copyright laws vary from country to country, generally the duration of copyright is seventy to seventy-five years after the death of the artist. After this time, the work is no longer under copyright and can be reproduced without additional clearance or fees. Any piece of art created by a living artist or an artist deceased fewer than seventy years may be subject to copyright laws. Technically, artists or their representatives must be contacted for copyright clearance and they are entitled to royalties.

In *Anderson v. Hermosa Beach*, the US Court of Appeals for the Ninth Circuit held that tattoos are considered a form of creative expression. The court ruled that since tattoos are more akin to speech than conduct, a tattoo copied from a copyrighted artwork would be infringement. Technically, the tattoo artist who copied the work would be a direct infringer, and the person getting tattooed would have contributory liability.

While most artists aren't willing to take someone to court for getting a painting or a drawing of theirs turned into a tattoo—and, in fact, most artists are generally fairly flattered that someone would want to wear one of their illustrations on their body forever and ever—it's a good idea to contact artists first to get their permission before going under the needle and risking any legal complications. This really isn't that big a deal—most artists today have a website with

Many times, customers come in wanting tattoos based on pieces of existing art, like this one by Roll & Roll Hall of Famer poster artist Emek.

contact information on it, and all you have to do is shoot them an e-mail requesting the use of their work. Often, if they give you their approval, they'll want you to send them a photograph of the finished tattoo so that they can see how good (or bad) a job the tattoo artist did with their work. Many times, tattoo artists work closely with print-bound artists—just like the Japanese *irezumi* artists did with the *ukiyo-e* artists in Japan—and often, artists can point you in the direction of a tattoo artist best suited to render their work on your flesh.

The most well-known legal case of tattoo copyright infringement was that of Victor Whitmill, the designer and tattoo artist of Mike Tyson's infamous face tattoo. He accused Warner Bros. of copyright infringement when a very similar tribal tattoo was used upon Ed Helms's character in the film *The Hangover Part II*. The case highlighted that tattoo artists' claims are perceived to have legitimate foundations, with Warner Bros. agreeing to settle outside court. Although the terms of the deal were undisclosed, copyright holders are legally able to receive statutory damages of between $750 and $30,000. Most recently, tattoo copyright infringement has been put into the spotlight by popular NFL player Colin Kaepernick due to his Yahoo! Fantasy Sports ad. It displays his chest tattoos for most of the ad, causing concern as to whether he, and in turn the NFL Players Association (NFLPA), are breaching copyright laws. To date, all cases relating to tattoo copyright have been settled outside court, meaning there is no legal precedent to work from, making it a potential legal minefield for many public figures with tattoos.

# Photochromatic/ UV Tattoos

## Glow in the Dark, Invisible by Day

One of the more exciting recent trends in tattoo technology has been the invention of the photochromatic tattoo, which are also known as UV tattoos, black light tattoos, or glow-in-the-dark tattoos. A photochromatic tattoo is one that is almost completely invisible until it's exposed to ultraviolet radiation, such as a black light in a nightclub. Just like getting a handstamp that only shows when UV light is shined on it, these tattoos disappear in regular light, making then wonderfully appealing to people who want a big, dramatic tattoo but don't want to worry about limiting their career opportunities because of it. It's almost like having a secret tattoo. You can potentially even get one on your face, and, barring any residual scarring or puffiness, no one would ever know you had it unless they looked really close. Also, just like a UV-activated handstamp, the fluorescent colors of photochromatic tattoos glow spectacularly under a UV light, which, if you frequent places that use UV/black lights a lot, almost makes them more exciting than a regular tattoo.

### The Ink

There are several different kinds of glow-in-the-dark ink. One is incredibly bad for even the surface of your skin, while the others are about as harmless as typical tattoo ink. Phosphor-based inks contains phosphor. It is the oldest glow-in-the-dark ink, and it's also very dangerous to use on the skin and can cause burning and even severe blistering if applied in strong enough amounts. Phosphor, used for fertilizing crops since prehistory, was originally extracted by boiling down urine or by collecting bat guano from caves. In the 1800s, many islands in the Pacific were stripped of their guano reserves by Europeans who packed and sold it as fertilizer to farmers.

Because phosphorous was the thirteenth element discovered, and also due to its use in explosives, poisons, and nerve agents, many people refer to it as "the devil's element." It wasn't until phosphorus was used on an industrial scale that its incredible toxicity also became known. In the nineteenth century, it was used in early matches, and the proliferation of those matches poisoned many people—which, considering that at the time, the main source of it was bat feces, isn't really that surprising. When it became known that workers at the match factories were also getting ill, phosphorous became a regulated substance. Chemically manufactured phosphorous can still be found in many children's glow-in-the-dark toys and jewelry designs—however, the phosphorous itself is always encased in a safer material, such as plastic, and in toys marked as not suitable for children who still stick things in their mouths.

You can usually tell what contains phosphor based on one little premise: whether it needs a light present to glow or not. If, after exposure to light, it can continue to glow on its own in a completely dark room, it is unhealthy and contains phosphor. If it's a tattoo ink that glows on its own, then you definitely do not want that in your body. If it only glows under a UV/black light bulb, then it's probably UV-based and safe.

The ink of a UV tattoo is so specialized that a separate patent (US 6470891 B2) has been awarded to it, unlike almost any other tattoo ink. The ink itself is a mixture of a nonpigmented (clear) carrier base with one or more photochromic compounds suspended in it. This mixture is completely colorless until exposed to ultraviolet radiation, which activates the photochromic elements, making the tattoo glow. The tattoo instantly becomes invisible again the moment the UV light is removed.

UV tattoos are applied the same way as a regular tattoo—with one commonsense exception. During the application of UV tattoos, tattoo artists must use UV bulbs so that they can see what they're doing. This is likely important for customers, too, so that they know they're actually getting the tattoos they wanted, and not some nightmarish creations that will get them laughed out of the first nightclub they walk into wearing a tank top.

## Safety Concerns

UV-light inks are as safe for your skin as any other kind of ink. Again, the FDA does not officially review any kind of ink, but the mechanics behind UV-light inks are not phenomenal, and they don't involve some crazy chemical trickery. Instead, they simply harness a color that our eyes can't see. When white light hits something, part of it is absorbed, and another part is reflected back, and the color that is reflected is the part we actually see. UV inks are

UV tattoos are almost like secret tattoos in that without UV exposure, they're practically invisible.

ultraviolet-colored and are outside of our range of vision. However, when UV-light hits a tattoo with ink designed specifically to reflect UV-light, the light's energy weakens just enough to make the tattoo reflect a visible color. It appears brilliant blue to us because it only excites the blue receptors in our eyes—to see a real violet color, your receptors would need to see something that reflects blue and red, but not green. Many animals and especially insects, such as bees, can see colors within the UV spectrum just fine, and technically would be able to see your tattoo even though you can't.

Because UV tattoos are still a relatively recent invention—and, again, because the FDA only nominally regulates tattoo inks—physicians still don't know the long-term effects of the chemicals used in the ink. One thing that has been noted is that over time, white and blue UV ink turns yellow with age, making a formerly invisible tattoo visible. This process is accelerated by sun exposure, which has an overall negative effect on tattoo inks in general. While a completely UV-ink-based tattoo looks fantastic when it's first inked, many tattoo artists recommend just using the UV inks to highlight a visible tattoo so that when yellowing does occur, you don't just have uneven blotches on your skin as the invisible tattoo ages. However, if you are going to get a tattoo that's a combination of visible and UV ink, make sure you get the visible ink design filled in first, as UV tattoos will look muddy and not glow as brightly if tattooed over with regular ink. The yellowing can be slowed significantly if a strong UV-blocking sunscreen is used on the tattoo anytime it might be exposed to sunlight.

# Tattoo Styles and Fonts

## Designing the Perfect Tattoo for You

With the evolution in technology and techniques in tattooing, a variety of different styles have emerged for tattoo artists to gravitate toward. Some tattoo artists prefer to do tattoos in the Sailor Jerry–era flash style, while some specialize in heavy-lined tribal tattoos. Out of respect for an artist and his or her work, it's a good idea to choose one who specializes in the type of tattoo you're looking for. Most tattoo artists have an online presence, and you can easily view their portfolios online before making an appointment.

There are three basic approaches to tattooing: flat, old school/traditional, and fine line. The first step in figuring out what kind of tattoo you want is to choose which technique or techniques (as some artists will incorporate more than one style) you want used in your tattoo.

### Flat

Flat tattoos are made of solid blocks of color with no shading or texturing of any sort. Most often, they're rendered in black ink, although there's no law that says you can't get a flat tattoo done in any color you want. Shapes and simple symbols are first tattooed in one thick outline and can be filled in or left as is. A recent adaptation of flat-style tattoos is blackwork, which takes its name from an elaborate style of Spanish embroidery that uses only black threads.

Some of the most common flat tattoos are tribal style, such as those epitomized by the Maori. While it may seem that these must be the simplest for an artist to give a client, there are many factors that go into a good, solid flat tattoo. It's important that all the ink of a flat tattoo goes into the skin at exactly the same depth, and that exactly the same ink (brand and/or color number) is used throughout the tattoo. If the depth, spacing, or speed of the

Colin Dale incorporates elements of flat-style tattooing into his traditionally inspired tattoos.

tattoo needle itself is applied differently during tattooing, you run the risk of a solid black tattoo fading into a spotted tattoo as the tattoo ages. Tattoos applied by traditional methods are intense, agonizing affairs that take days and days using instruments and techniques that have been passed down for hundreds or thousands of years. Given this, it stands to reason that it takes more than a novice with a tattoo machine to create an adequate flat tattoo.

Often, tattoo artists not familiar with the extensive work of inking a good, solid flat tattoo get impatient, hurried, bored, or disinterested when working large fields of solid black. They underestimate how long a "simple" tattoo will take to deliver and underbid themselves, only to realize that they needed much more time to adequately fill in the tattoo. To make up the deficit, they may "hurry up" to finish the job on time, so that the first part of the tattoo—the part done when the artist thought he or she had plenty of time—is done correctly, while the last part is uneven and may begin to fade unevenly not long after the tattoo heals. Another mistake many tattoo artists make when giving a flat tattoo is to try to use as large a tattoo needle group as they can, such as nine needles in a magnum configuration, which will cover a large area quickly, but will not give as dark and solid a tattoo as a smaller group of needles in a flat configuration. Many tattoo artists recommend no more than four points—which is, incidentally, roughly the same number of points and shape as the traditional tattooing equipment used by Polynesian tattoo masters when they created these ancient designs.

## Old School/Traditional

Traditional tattooing gets its name from the kind of tattoos artists of the Western world were creating in the late 1800s through the early half of the twentieth century, such as the anchors and pinup girls that sailors would get when shipped off to war. World War II–era Sailor Jerry's tattoos fall under this category, even though, at the time he was working, his were considered some of the most sophisticated out there. Traditional tattooing is based on clean, simple design and execution, filled in with solid blocks of color and minimal, if any, shading. Daggers, hearts, snakes, pinup girls, panthers, roses, skulls, and butterflies are all traditional motifs, although any image can be rendered in his style.

The advantages of getting a traditional-style tattoo is that the pieces really stand out due to the strong outlines, and they age really well. They can also be seen clearly from far away, while more sophisticated tattoos require a closer look to identify what the tattoo actually is. Because the lines are so simple, the pigment migration that happens with most tattoos over time is minimal

Roxx's beautiful blackwork tattoos invoke images of the embroidery style from which blackwork gets its name.

to almost invisible, unlike a tattoo with a lot of shading and colors, which may get muddy over time.

Again, though, just because a tattoo design looks simple, if the hand behind the needle is unskilled and uncoordinated you can end up with a crude piece of work. Rendering clean, simple lines requires just as much skill as a more complicated-looking piece of artwork.

## Black-and-Gray / Jailhouse Style / Fine Line

Don't let the name fool you—black-and-gray tattoos are some of the most sophisticated tattoos being done today, despite having their origins in the 1970s–1980s Southern California prison system. Consisting of only black ink and rendered with only one or two needles at a time, black-and-gray is made with lines thin and detailed enough to create lifelike portraits and realistic shading for three-dimensional objects.

Heavily influenced by black-and-gray is fine line tattooing—a style has opened the craft to serious artists and artistry. The defining hallmarks are thinner outlines, precise shading, and detailed designs. However, because

they are made by poking holes in your skin, the more complicated the design, the bigger the tattoo must be. Because of factors like pigment migration, which causes outlines to smear and become muddy no matter how good the artist, you absolutely cannot come in with a photograph and expect a realistic portrait to be rendered in a tiny block on your arm. In fact, celebrity tattooists such as Vincent Castiglia insist that potential clients come in for several initial consultations before being inked, to discuss such factors as how a tattoo will age. Many of these artists will allow you to view a computer simulation of the effects of time on the planned tattoo.

## Watercolor

Watercolor is the newest artistic movement in tattooing, and basically, it's a tattoo that looks like a watercolor. Many artists have created amazing tattoos of flowers, landscapes, re-creations of Japanese watercolor art, portraits, and even just "splotches" of different colored inks that look like someone scribbled, sprayed, and even wiped a paintbrush off on the wearer's skin.

The artist uses the same tattoo machine and ink that any other tattoo artist does, but allows the outline to blur and the colors to blend in with one another unevenly to create the effect that the tattoo is painted on the skin instead of painted into the skin. Since this is such a new style of tattoo, there's not much research on how it ages down the line, but possibly, some of the inks will fade, while others will bleed and blur into one another; however, since the tattoo doesn't have a strong outline to begin with, this might not be a problem at all. Often, watercolor tattoos are combined with a fine line tattoo to create a phenomenal piece of art.

## Fonts

One of the many reasons why printmaking and tattooing historically went hand in hand was because printmakers were some of the only people aware of all the different fonts in existence at various times—and the only ones who had easy access to the plastic stencils for these different fonts. It was very easy for a graphic artist who specialized in designing and printing signs to take those same plastic stencils and either use them to make lettering on tattoos himself, or lend them to a tattoo artist who wanted to offer more than tattoos that featured his own handwriting.

With the advent of the Internet, almost every font possible is now available for tattoo artists to use and customers to choose from. Many sites offer free downloads of fonts, while others offer font bundles that have additional capabilities of resizing the fonts and graphing them to fit a specific-sized

Nuno Costah's beautiful watercolor tattoos with elegantly blurred outlines look like they were painted right onto the skin.

space. Even now, a tattoo artist with a background in graphic arts can get away with "eyeballing" a font and knowing exactly what size lettering is needed for a tattoo, but a less experienced one might need to first lay out and size the lettering on an inexpensive graphics program, such as Adobe Photoshop or Microsoft Paint. It is very important that, just like any tattoo, the lettering is laid out on the skin first to make sure the artist doesn't run out of room.

# Your First Tattoo

## What to Expect

So you've finally reached the point where you are ready to get a tattoo. No "buts"—you've thought long and hard about it, you have an idea of what sort of design, or what specific design, you want, and you've even found a tattoo artist and studio you want to do the work. So what's next?

Many people reach this jumping-off point but never take the actual leap, because they don't know how to get from the point where they really want that tattoo to actually walking into a tattoo shop and getting that tattoo. Some people think that if they don't know the proper lingo or come in with a specific budget, they'll get treated poorly, like when you go into a cell phone store and just want to get a cheap flip phone.

The reality is that so long as you are up front with your tattoo artist about how much time, money, and experience you have in the matter, you'll be treated just fine, especially if it's your first tattoo. While you should never haggle over prices with your artist—because that's insulting to any artist— there's nothing wrong with explaining that you're on a budget so long as you're willing to take your artist's suggestions on designs within your price range. If you have an extremely low tolerance for pain, let the artist know, because most tattoo artists can give you a numbing agent before they even start tattooing—in fact, most will without even asking. Lastly, most tattoo artists are first and foremost artists, and when you walk out of their shop with your new tattoo, you're going to be a billboard for their work. So it's in their best interest for you to be comfortable in their chair, and happy with the results.

### The Layout of the Shop

Back in the days when tattoos were still a social taboo, there wasn't a lot of thought put into how to make a tattoo shop comfortable for new clients. Most people came in right off the street, and often, those walk-ins were made on an impulse. Much like a used car salesman, the goal of a tattoo artist in those times was to get someone in the chair as quickly as possible so that you could

do the tattoo, get paid, and move on to the new customer. Almost everything happened in the front room of what was often a converted beauty parlor, right in front of a big glass window so that everyone walking by could see the person getting tattooed. Because of this, many tattoo parlors became a favorite place for gawkers to stand around, watching the spectacle of a client getting tattooed.

These gawkers inadvertently served as a client referral service, as often, passersby would ask about what kind of tattoos people could get in that shop, and if getting a tattoo was really painful, or any questions about past clientele. If the kids standing around the storefront raved about movie stars coming in for tattoos, or some amazing piece that the artist did on a previous client, there was a good chance that those asking the questions might come in to get a tattoo themselves. As there were many restrictions against where tattoo shops could advertise their business, word of mouth was the most important marketing tool available to them.

As tattoos became more popular, and more "normal" people began to walk in through the door, the shops began to concentrate more on trying to make customers feel comfortable. A standard shop layout began to be almost universally adopted, which is still used today. Gone were the giant picture windows people could press their faces against to watch strangers get

Here's the view that would have greeted you in a 1950s tattoo parlor, when tattoo artists mostly just gave tattoos based on flash, as opposed to custom artwork.                    *Wikimedia Commons*

their butts tattooed, replaced by a view of a roomful of flash tattoo choices, a comfortable set of couches, and possibly a potted plant.

When you first walk into a tattoo parlor, you'll most likely find yourself in a room that looks a lot like a doctor's or a dentist's front room. While every shop's front room is different, depending on the owner and the vibe they're trying to set, basically, there should be a front desk with a receptionist, a chair or couch to sit in, and either a wall full of flash tattoos to look at or a portfolio of the tattoo artists' work, or both. Some studios have a flat-screened monitor set into the wall that cycles through some of the work done by the artist at that shop, as well as interviews with the tattoo artists themselves. If you can't immediately find a portfolio of the artist's personal work to look through, ask the receptionist—he or she probably has several books behind the register you can look through. Many tattoo parlors have all their flash and original work available to look up online—Instagram portfolios are especially popular right now—which is especially handy since the artist can resize and print the design you want much quicker than was possible in the past. Also, if there are multiple customers in the shop, an online portfolio makes it easy for multiple customers to look at an artist's work without having to fight over taking turns to look at a physical portfolio.

One thing to keep in mind when you first walk into a tattoo shop: if you're not comfortable, or made to feel comfortable, when you come into the shop, this probably isn't the place for you. If the front room of the shop looks dirty or unsanitary to you, turn around and leave. If you feel like you're already being treated disrespectfully the first few minutes in the store, turn around and leave. There are plenty of tattoo artists around, and there is no reason for your first time to leave you with an unpleasant memory. The one exception—as with all artists—is if the artist you've booked does impossibly amazing work and getting a tattoo from him or her is a once-in-a-lifetime experience. But even then, almost all professional artists want you to be happy with both the tattoo they give you and the experience of getting a tattoo from them. After all, word of mouth is still the most valuable advertising tool in the industry, and a happy customer will bring in more customers than an unhappy one.

Most shops will not allow customers to bring food, and definitely not pets inside with them, due to health regulations. Most will let you bring in a drink with a lid, though, and, in fact, will encourage you to drink water during your tattoo session so your body doesn't get overstressed or dehydrated. Almost all shops also have wireless Internet available for customers now as well, so if you have a long wait time ahead of you, you can play with your phone or laptop while you're waiting.

Just beyond the lobby are the tattoo stations, which is where you will be tattooed. Tattoo stations are set up differently from one shop to another.

Many tattoo artists have sketchbooks of original artwork already available for you to look through to pick your tattoo design, such as this one by Nuno Costah.

*Nuno Costah*

Some shops have individual rooms that each tattoo artist works out of so that they can close the door completely on the outside world while they work. In bigger cities, where real estate is at a premium, there may just be office cubicles separating the tattoo stations from one another. Other shops have a single open floor for tattoo artists to work on, where customers can see one another being tattooed and talk to one another while it's going on.

While the stations themselves may be set up differently, there are going to always be a few standard features. The first is that there will be a sink close by for the tattoo artist to have easy access to water, because no matter how tiny your tattoo is, you're probably going to bleed. Each tattoo artist will have his or her machines and needles laid out next to the tattoo chair or table, sterilized and organized just like a dentist's or doctor's tools. Because of the chance of contamination, do not touch the tattoo artist's tools, or really anything that's not yours. If there are magazines or books in the studio, those are safe to touch, but otherwise, keep your hands to yourself.

Sometimes the tattoo shop also has a drawing room in the back where the artists come up

with their original work. If you are at that studio because the artist specializes in original work, you'll probably be taken back here to see some of the drawings the artist has come up with when you commissioned the tattoo. They might be general sketches, with details on what colors the artist wants to use and how he or she wants to fill the sketches in, or it might be a full-blown artistic masterpiece, with little wiggle room for alteration. There's usually a printer and stencil machine back here as well, where your artist can print up a stencil of your tattoo, measure it against the area you want tattooed, and decide if it needs to be resized or it you're ready to go.

Since the 1980s, great care has been given to showcase a tattoo shop's sterilization area and sterilization practices. The lobby of most shops prominently displays their safety certifications from the health department and state, while the sterilization area will be well lit with carefully marked containers for needle disposal. Even if the shop apprentice has carefully sterilized everything before your visit, chances are your tattoo artist will make a good show of re-sterilizing everything in the ultrasonic cleaner in your presence. There's always a sink in the sterilization area, where the tattoo artist can clean the ink tubs used during your tattoo. Sometimes these tubs are disposed of altogether, simply because they're relatively inexpensive and the artist probably buys them by the case. Although the sink itself is also sterilized with a surface cleaner, it's a good idea to never use the sink in the sterilization area for any other purpose than to sterilize tattoo equipment. Even the people who work in the shop consider this sink off-limits to everything but washing off contaminated tattoo equipment.

An autoclave will be in this area, ready to sterilize all the used equipment except needles, which will be disposed of after your session. In this area are also the supplies needed to run the autoclave, such as autoclave bags and distilled water. You can usually find other cleaning supplies in this area as well, such as extra paper towels and antibacterial soap.

## Before You Get Your Tattoo: Prep Work

Because tattoos are permanent, you and your tattoo artist have a few steps to go through before the official tattooing begins. After you've approved the artwork your artist has come up with, or agreed on which flash tattoo you want, he or she will make a stencil of the art. This is done generally using a thermal stencil maker, which makes a heat-transferable copy of the design that can be applied directly to your skin. Stencils give artists a clear outline to work off as a guide, but they are usually just that—an outline. Most artists like to change the design and fill in details while they're working, so if the stencil only minimally looks like the elaborate design you and your artist

agreed on, don't panic—you're still getting the tattoo you asked for. By creating a stencil first, the client and artist can see how the design looks on your body before it's there permanently. Also, stencils are fully repositionable, so if you don't like it in the first place the artist puts it, it can be moved to another spot. Most tattoo studios have a photocopier or printer right next to the stencil maker, so if the artwork is too large or too small and needs to be resized, a new copy of the art can be made and a new stencil can be made from that.

Before the artist transfers the stencil to your skin, the area to be tattooed must be properly prepared. First, the artist scrubs your skin with a hospital-grade soap. Next, they have to shave the area, as hair harbors bacteria and may interfere with the transfer of the stencil. If you're getting your tattoo in a particularly hairy part of your body, be advised that the tattoo will not

Most tattoo artists can make a reasonably good stencil out of a photograph you bring in with you.                    *Wikimedia Commons*

The stencil has been removed, leaving a nice, purple outline for tattooist Greg Scott at Ancient Art to work with.

*Wikimedia Commons*

affect hair regrowth whatsoever. You may need to keep shaving that area in the future for your tattoo to stand out properly. The plus side is that if you're getting your head tattooed, and you get tired of having the tattoo, a few months' worth of hair growth should cover it up completely. Finally, the area is swabbed down with alcohol to disinfect the skin. This may sting a bit due to any razor nicks or burns, but if you can't handle a little alcohol sting, you probably shouldn't be getting a tattoo anyway.

At this point, the artist will usually have you stand up straight so that he or she can apply the stencil. Most of the time, you will be asked to stand with your hands hanging loosely by your sides to get one last appraisal of how the tattoo will look, as most people are going to see your tattoo when you're standing in this position, unless it's in an intimate area. For tattoos on the underside of your arm, you will be asked to sit straight with your arm out, perpendicular to your body. With a forearm tattoo, you'll be asked to sit or stand with your arm out straight. A lower leg or foot tattoo may entail standing on a chair or stool so that the tattoo artist isn't lying on the ground by your feet, trying to line up the design with your body. This is the point where you and the artist both have one last chance to double-check the design and make sure everything is the way you want it—all lines should be at the correct angle with your body and you should be absolutely pleased with the design. If there are words in the design, this is the time to make sure they are absolutely spelled correctly—if there's any doubt, check the dictionary.

After the stencil is finally applied to everyone's satisfaction and the backing paper is peeled off, you'll have to wait another five to ten minutes for the stencil to set before any tattooing even begins. This is to make sure the stencil doesn't smudge or come off completely while the artist is working, since part of his or her hand will inevitably rub against the stencil many times during the tattooing process. A lot of old-school tattoo artists use a stick of deodorant to help transfer the stencil to your skin, which doesn't dry satisfactorily and takes great skill as an artist to transfer successfully; most tattoo shops now use a liquid-based transfer solution that dries completely and leaves no tackiness or odor on the skin, and, most importantly, transfers a clean image.

Some tattoo artists prefer to draw their design on your skin, especially those who deal with the same flash tattoos over and over and can draw up a good pinup girl or flower-wrapped skull from sight in as little time as it takes to transfer a tattoo. Lettering is commonly drawn on freehand, as it's easier to gauge how letters will fit on your skin than to keep resizing font on a computer before creating a stencil. All artists have their own ways of doing things—your job as the client is to be patient, pay attention, and allow the artist to do whatever is needed to present the best possible tattoo. Again, if the tattoo includes writing, and the artist is drawing the words directly onto

the skin, make sure the spelling for everything is correct. Once the artist starts tattooing you, the last thing on his or her mind will be spellchecking.

## Getting Your Tattoo

Get comfortable, because you're going to be here a while. Depending on the endurance of you or your tattoo artist, as well as the size and complexity of the tattoo, the process could take anywhere from twenty minutes to many, many hours. Most tattoo artists prefer to do as much as they possibly can in a single session, because once they stop, they can't come back and work on your tattoo again until the first part of the tattoo heals, which can take several weeks. So you're going to want to find the most comfortable position possible to sit or lie in while you're being worked on, because you don't want to have

Get comfortable—you're going to be here for a while!    *Wikimedia Commons*

to worry about getting any muscle cramps while you're trying to stay as immobile as possible.

For most designs, there is a set process artists follow to ensure a quality tattoo. Most artists start by outlining the tattoo, either in ink or in water. A tattoo outlined in water is called "blood lining," in which the needle leaves an unlinked tattoo line on the skin in case the stencil gets wiped away. Portrait tattoos and watercolor-style tattoos usually involve more shading and color bleeding than a solid outline, so the first part involves drawing out a couple of solid lines from the tattoo, such as a nose or an eyelid or the outline of flower petals. It's very important not to flinch or twitch during this phase, because a squiggly outline will require the tattoo artist to do more touch-up

James Kern uses more contemporary equipment to create his science fiction–inspired tattoos.                                                                    *James Kern*

Colin Dale works with a variety of authentic traditional tattoo tools in his studio, including needles set into deer antlers.                                                                                    *Colin Dale*

than a straight one. If you have a really big tattoo, with a lot of solid detail, your entire first tattoo session might consist of just working on the outline.

After the outline is complete, the artist will start to work on the black shading. The black shading is done first as the contrast will make the color in a tattoo look very bright and intense. Also, without black shading, the tattoo will look faded more quickly than without it, especially years later. The same goes for black-and-gray tattoos. Without the black shading, the tattoo starts to look faded very quickly.

Once all the black is done, the artist can start applying the color. This is usually done in order from dark to light, so all the greens, blues, and purples will be tattooed in first, while warmer colors such as red, yellow, and orange will be applied later. The lightest or pastel colors will be tattooed last of all. The reason for this is because the dark colors can get into the lighter colors if

they're applied in a different order, and you can only keep the lightest colors pure if you put them on top of the dark colors.

After the tattoo is completely inked, the artist will give it a once-over to look for "holidays," which are blank spots in the tattoo. The artist will tattoo over any spots that have been overlooked so that you have a nice, solid tattoo. When you come back for a checkup after the tattoo has healed a few weeks later, the tattoo artist will again look for and cover up any holidays that might have occurred during the healing process.

# Proper Tattoo Shop Etiquette

## Dos and Don'ts for First Timers and Pros

W alking into a tattoo shop can be an intimidating experience, especially if it's your first time. You can get a lot of attitude from other customers if you don't fit their preconceptions of what a customer at that shop should be, and if you come into a high-end shop flat-footed, without researching the tattoo artists' individual styles or setting up an appointment, you may not be treated as gently as you'd like. While there are still plenty of tattoo shops that'll take walk-ins for flash tattoos, more and more tattoo shops are operated by real artists who take their work seriously, and want their work to be treated seriously by their potential clients. To make the whole experience more pleasant, there are just a few rules you should follow.

### Do Your Research

Before you even step into a tattoo shop, you should research the place and see what kind of art they turn out. In this wonderful age of Instagram and Facebook and the Internet in general, this just takes a couple of minutes of your time. Most tattoo shops have a Web page available with links to all the artists on staff, as well as recent examples of their work. You can get a pretty good idea from a few minutes' browsing on which artist to request to do the artwork you have in mind. If you come into a studio showing even a little bit of familiarity with an artist's work—you can even mention a few of the artist's pieces during your initial conversation with him or her—your relationship with your tattoo artist will be off to a great start.

You can also check out online reviews of the shop on Yelp, YellowPages, or your local publication's website to see if customers have lodged any

complaints regarding their treatment during the session, their satisfaction or dissatisfaction with their tattoos, and a general idea of what price range you can expect for your tattoo.

Back in the days before the Internet, this sort of research was accomplished by walking into a shop and looking through a giant folder of photographs of previous clients while a surly tattoo artist glared at you as if trying to decide whether you would eventually pick out and pay for a tattoo or just turn around and walk out of the store. If you weren't happy with the work done at that first shop, you had to physically walk into a second and possibly a third shop and go through the same process all over again. Now you can "visit" every tattoo shop in your vicinity without even leaving your living room—or being glared at by anything scarier than your cat.

## Be on Time

When you do finally get an appointment set up, make sure you show up promptly to your session—ten or fifteen minutes early is perfectly acceptable, too, and may even get you in the chair a few minutes early. Most tattoo artists have their entire day booked, so if you come in late, they're not going to get as much work done on you as they could have before they have to send you home to let the next scheduled client in. Also, you will probably still get charged for the time you were supposed to have spent in the chair. If you have to cancel your appointment, call the artist at least an hour ahead of time so that other arrangements can be made for your spot. Whatever you do, don't come in late and demand to get your full scheduled session. Not only will you upset the person working on you, but if your artist was to give you all that time, it would screw up every other appointment for the day.

Think of it as a doctor's appointment—sometimes, if you show up ten to fifteen minutes early, there's the possibility that the person who was scheduled right before you made a cancellation, and you can get into the chair that much faster, and might even get a little extra time.

## Be Sober

Don't believe all those crazy stories about people getting wasted and wandering into a tattoo shop for an instantly regrettable tattoo—if you're not a World War II sailor about to be shipped off to fight Nazis, no one's going to want to give you a tattoo when you're drunk.

There are many, many reasons for this. First, if you've altered your body chemistry at all through alcohol or drugs, it's going to affect the way your body reacts to pain. Those with a high tolerance for pain may suddenly find

themselves unable to deal with a tattoo needle while under the influence. Second, alcohol—especially large quantities of it—make your blood thinner, so you'll bleed a lot more during a tattoo session when you're drunk than when you're sober. Third, people who are under the influence in any way are unpredictable, and most tattoo artists don't relish the idea of having to protect themselves from flailing fists or chase someone around the shop while trying to work.

Last of all, and probably most important to most tattoo artists: if you come into their studio under the influence, somehow get a tattoo, and decide the next day that you were way too wasted the night before to have consented to your new tattoo, you might sue the artist. In these incredible litigious days, tattoo artists don't want to have to deal with something as stupid as being sued for working on an inebriated person. It's just not worth the trouble. So get a good night's sleep, eat a good breakfast, and come in stone-cold sober.

## Do Not Haggle

As Sailor Jerry once famously said, "Good tattoos aren't cheap, and cheap tattoos aren't good." Every artist in every field has, at one time or another, had to deal with someone who thinks that artists are in their field for the joy of creating art, and that money is a secondary consideration. This is absolutely not true. While artists usually do love their work, part of what sustains that love is being able to not have to work a side job as a secretary or plumber while they're also working as an artist.

The same goes for tattoo artists. When you go into a studio, you will usually get a rough estimate of how much a tattoo is going to cost you—this is the artist's hourly rate multiplied by how long he or she thinks the tattoo will take to complete. This is not a negotiable fee. Generally, the rate you're quoted will be on the high end, too, so that if there are any problems along the way, the artist won't have to come back to you mid-tattoo with a higher price than originally quoted, and if all goes well, you could possibly be surprised by a slightly lower bill.

The exception to this is the very high-end, prestigious tattoo shops owned by celebrity tattoo artists, and if you are lucky enough to get into one of those chairs, you already knew that money's no object.

## Find a Sitter

Getting a tattoo is a complicated-enough business that you don't want your artist to be distracted by kids running around the shop, bothering other customers, or insisting on making "Ew!" noises while you're getting your

tattoos. People who are used to babies crying and toddlers shrieking may be fine with your having your kids along, but chances are, your tattoo artist is not one of those people. Some counties have regulations in place that don't allow minors inside a tattoo shop at all, which means even babies aren't allowed through the door.

The exception is if you show up at a tattoo shop and small children are already there in a non-supervised playroom. Because of the changing demographics of clients, some tattoo shops have set up an area for your kids to hang out while you get worked on. However, this is not free daycare—if there's someone on hand watching your children, expect to be charged for it in some way, whether outright on your bill or via some hidden fee figured into the final cost. Otherwise, bring another adult along with you to keep an eye on the kids.

## Come in Clean

There are very few things as intimate as getting a tattoo, and some areas of your body are more intimate than others. Be considerate to the artist who's going to have his or her face inches from your armpit or butt crack. Also, even if your brain doesn't think it's any big deal, getting a tattoo is a stressful thing for your body to endure, and you may sweat more than normal because of natural physical reactions to stress. A good, strong antiperspirant can help, preferably one with as little scent as possible to avoid making the entire tattoo shop smell like baby powder or perfume.

## Dress Appropriately

Be sure to wear clothing that makes it easy for your tattoo artist to work on the part of the body you're getting tattooed. If you're getting your upper body tattooed, a short sleeve loose-fitting T-shirt should be easy enough to simply hike up or pull to the side to get to the area you want tattooed, and if you're getting your shoulder blade tattooed, wearing a bra with a V-back, such as a sports bra, will make it easy for the tattoo artist to work on without having to keep pushing your bra strap out of the way or ask you to remove it entirely.

If you're getting your lower body tattooed, loose-fitting shorts will make it easy for the artist to reach most areas without having you get completely undressed. Keep in mind that any area you're going to get tattooed will have to be shaved clean before the artist can even start working on you.

## Have Faith in Your Artist

By the time a tattoo artist starts working on you, you will have 1) chosen this artist because you like or her previous work, 2) read testimonials saying what a great artist he or she is, and 3) sat through at least one consultation regarding the proposed artwork as well as the placement of the artwork. So when the time comes to get your tattoo, don't be a backseat driver. Have faith, try to relax, and just let the artist work his or her magic. You'll be back in a couple of weeks anyway after the tattoo's healed for any final touch-up, so if you have a problem with the tattoo you get, that's the time to bring up any issues.

## Come Alone

It takes a long time to get a tattoo, and unless you've got friends who just like sitting around in the front room of a tattoo shop, reading magazines or playing around on their phones for hours, it's better to just come alone. Most tattoo artists do not like to work with someone standing by their elbow watching them or worse, offering advice, so if your friends come along, they're probably not going to be able to watch you get your tattoo. You're not going to be sedated in any way, either, so there's no reason to have someone drive you home from the session—you should be able to get yourself home without any problem.

## Turn Off Your Phone

Is there anything more annoying than having to stand behind someone at the checkout line or sitting next to someone on the bus who's talking loudly to a cell phone the whole time? Don't be that person while getting your tattoo—your tattoo artist doesn't want to have to hear about the important things you're thinking of doing, or how so-and-so got you really upset, etc. Besides, there's nothing wrong with engaging in small talk with the person who's leaving a permanent mark on your body. While some tattoo artists do like to work in relative silence, or while listening to music, many like to check in with you every few minutes to make sure you're doing okay, or to ask the sort of questions dentists are famous for, such as what you do for a living, if you have any pets or kids, etc. Again, being tattooed is an incredibly intimate activity, and there's no reason to shut out the person giving you the tattoo.

Another reason that you should just turn your phone off altogether is that you do need to stay relatively still while getting a tattoo, and picking up your phone to see who called or even answering it involves significant moving. So just shut your phone off entirely and return any important calls after your session is done.

Colin Dale not only works with unconventional tools when tattooing a client, but he also sometimes works his magic in a much more unconventional setting—i.e., outside, in a tent—than your average tattoo artist.                                                                *Colin Dale*

## Pregnancy and Illness

Anybody who's ever been pregnant knows what a crazy time it is. Your hormone levels are spiking, and your brain is loaded with one impulsive thought after another. If you have ever wanted a tattoo before being pregnant, you will almost definitely, at some point, be totally convinced that you absolutely need a tattoo to commemorate the new life growing inside of you.

Resist this urge. Again, your head might have no problem with your going under the needle, but your body will be convinced that you're under some kind of attack and react accordingly. Your stress levels will rise, your immune system will go into overdrive, and neither of these are good for your pregnancy. If you absolutely have to commemorate your pregnancy with art, find a good henna artist instead. Many henna artists actually specialize in pregnancy-themed designs based on various spiritual traditions, and if you

absolutely love the design your henna artist come up with, you can always get it redrawn as a permanent tattoo after your baby is born.

Be healthy when you go in to see your tattoo artist. Many state emphatically that they will not see a client who has a cold or feels sick in any way, specifically because they do not want to have a cold or pick up your drippy flu. After all, tattoo artists can only work if they themselves are healthy, as no client want to come into a studio where the artist is sick. If you pick up a bug before your scheduled session, contact the tattoo artist and reschedule. The artist will be very understanding and grateful you called.

# Choosing the Tattoo Location (Wisely)

## Blending In Versus Standing Out

With the growing acceptance of tattoos in most segments of society, many people who might never have dared getting a tattoo are now wearing them proudly. More and more characters in movies are portrayed with bad-ass tattoos, as well as real-life celebrities, making the idea even more appealing to young and old fans alike.

But the reality is that most people can't walk around with a giant lightning bolt bisecting their faces, or afford the looks of shock that come when taking off their coats at work to reveal tattooed sleeves or hands. Even with the acceptance of tattoos in many jobs and social circles, a discreet tattoo is still the best option for most people, just in case you have to change careers or make a good impression with someone outside your immediate group of acquaintances. Here are some of the more visible tattoos you may want to think twice before pursuing.

Sometimes, the best way to cover an injury or scar is with a beautiful tattoo. *Wikimedia Commons*

### Sleeve and Trouser Tattoos

As far as big, dramatic tattoos go, sleeve tattoos—tattoos that cover your arm from the shoulder to your wrist, or in the case of a half sleeve, either above or below your elbow to your wrist of shoulder—are particularly popular, as your arms and legs have much fewer pain receptors than the rest of your body. The fleshy parts of your arms and legs also bleed less than the less-

While some sleeve tattoos might make you look dangerous walking down the street, other sleeves—like this one by James Kern—are living art pieces that just beg to be shown off.    *James Kern*

fleshy parts of your body, such as your face and hands, making it a more pleasant experience for the tattoo artist as well.

Because a sleeve or a trouser tattoo can be such an intensive process, however, getting one can take many, many hours in the chair, and rarely is it done all at once. The more detailed your tattoo is, the longer it takes, too. Most people usually can't spend more than a couple of hours at a time being tattooed, and most tattoo artists can't spend more than a few hours at a time working on one. Since a new tattoo is basically an open wound, every time you reach a stopping point, the newly tattooed area needs time to heal, which is usually about two weeks. Tattoo artists can't work successfully around skin that hasn't healed yet, as the new ink may flake off if there's scabbing present, so when they stop for the day, they must wait the full two weeks to continue at whatever point they left off on your tattoo.

Most sleeve and trouser tattoos rarely start off as such. Generally, a person gets just one arm or leg tattoo, then adds onto the original design as time goes on and new ideas come up.

## Neck Tattoos

Despite being close to a lot of large arteries, getting a tattoo on the side of your neck or throat isn't much riskier than any other part of your body. However, it may be difficult to find a tattoo artist who will give you that tattoo, because it's considered a "game-changing" or a "job-killer" tattoo—the terminology differs from one tattoo artist to another. If you're someone with long hair, most artists won't give a second thought to giving you a tattoo on the back of your neck, but unless you come in already heavily inked, it can take some convincing to get a tattoo artist to work on any part of your neck that can't be covered easily by your hair. This isn't done completely out of concern for you and your welfare, either—the tattoo artist doesn't want to deal with you coming back to the shop with a lawsuit because no one warned you that you couldn't get a job with a giant butterfly tattooed on your throat.

In many parts of society, neck tattoos are associated with prisons, gangs, and criminal behavior in general. Unless you are now comfortably self-employed, a neck tattoo is an idea to put off for later, when you are.

## Face and Scalp Tattoos

Many people around you already have face and scalp tattoos, but you'd never know it. Tattooed cosmetics have been around for decades, with men and women alike getting permanent eyeliner, lip liner and lipstick, and cheek rouging in cosmetologist's offices. Recently, scalp tattoos have become popular among men with thinning hair or bald pates, retracing the original hairline and giving the appearance of fresh stubble coming in right below the surface of the scalp.

While these are all examples of face and scalp tattoos that go on unnoticed, many people have found themselves drawn to the more dramatic tribal tattoos of the Maori, as exhibited by professional boxer Mike Tyson. While there's no inherent health risk in getting your face tattooed, just like a neck tattoo, it's the first thing most people notice about you, and they will make assumptions. A tattoo on your face isn't easy to cover—unless, of course, it's in a place where your facial hair grows in thick and dark enough to cover it.

Conversely, the only way that a dramatic, non-cosmetic scalp tattoo can cause you problems is if you shave your head, which is why many people get a scalp tattoo in the first place. There's no evidence that getting a tattoo on your scalp impedes future hair growth, so if you need to cover it up for work or something else, just stop shaving your head and let your hair grow over the art. The biggest drawback to getting a scalp tattoo is that, because there's very

Some facial tattoos, unlike Rick "Zombie Boy" Genest's, are easier to hide than others.

*Wikimedia Commons*

little fatty or muscular tissue covering your skull, it's one of the more painful places to get tattooed, and tends to bleed easily and profusely.

## Hands and Feet

Perhaps because so many celebrities have gotten tattoos on their hands and feet lately, or, even more likely, with the acceptance of tattoo culture, being able to get a tattoo in such a visible place makes the idea so attractive, hand and foot tattoos are on the rise. There are, however, a few things to take into consideration before getting a tattoo on your farthest extremities.

If you change your mind and decide to get the tattoo removed, it takes more laser treatments to completely remove a tattoo on your hand or foot than pretty much anywhere else on your body, as the farther from your heart a tattoo is, the longer it takes for the tattoo ink to be broken up and reabsorbed into your body. If you have two identical tattoos located on your foot and shoulder, it may take twice as long to remove the tattoo on your foot as the one on your shoulder.

As far as pain goes, we all know how much it hurts to catch your toe on something or accidentally cut your finger in the kitchen. Hands and feet—especially fingers and toes—are full of nerve endings and are especially sensitive. Generally, a tattoo hurts more on areas where there is less fat or muscle padding, bringing the bones and tendons closer to the surface. This causes the vibrations of the tattoo machine to resonate through those parts, making the sensations more intense. They're also the termination points of many blood vessels, and therefore bleed easily and profusely. It was not long ago that many professional tattoo artists refused to tattoo hands and feet in their shops.

Another thing to consider is how much time you'll have to wait for your tattoo to heal properly. The skin regenerates faster on your feet, causing potential issues with ink migration and rejection during the healing process, which can cause your brand-new tattoo to either develop spots and fading early on or for the outlines to become blurred and messy. Another thing to consider is that a new tattoo needs to be treated like a fresh wound, left open to the air to heal. If you live in a cold climate and you get your tattoo in the wintertime, or need to wear closed-toed, tight-fitting shoes for work, it's going to be hard to keep your foot tattoo comfortably exposed for healing. Your tattoo artist may be able to give you some pointers on how to protect your tattoo and foot in these situations.

Hand tattoos are similar to foot tattoos in that they tend be more sensitive, more likely to lose ink during healing, and more prone to infection. Another thing to keep in mind is that there is still a large portion of our

society that looks down on hand tattoos, and there are few places on your body that are more visible than your hands. Many employers will not even consider a potential employee if they have tattoos that are not easily covered. While hand tattoos are more common in more blue-collar jobs, most people would not want to see a hand tattoo on their surgeon, attorney, or clergyman.

This foot tattoo, by Jessica Weichers, makes wearing any shoes except flip-flops an absolute drag.                                         *Jessica Weichers*

If your plans include a mainstream upscale career, they probably shouldn't include a hand tattoo.

## Places to Avoid

Everybody deals with pain differently, and what is excruciating to one person may be perfectly tolerable to another. Almost universally, the most painful places on your body to get tattooed are the nipples and genitals, the pits behind your elbows and knees, the area along the sternum and the bottom of your rib cage, and your armpits. Many tattoo parlors will not tattoo these areas at all—at least not without some proof of your superhero-like ability to withstand pain.

# The Care of Your Tattoo

## Protecting the Ink

A tattoo normally takes anywhere from one week to a full month to look fully healed, depending on the type, style, size, and placement. There's always the chance of infection when you make an opening in your skin such as a cut, scrape, a puncture, or a tattoo, and while a tattoo may not look like an open wound, it is and should be treated as such. If you don't care for your tattoo properly, it will get infected, just like any other type of wound. An infection can lead to swelling, unnecessary pain, and, in the most extreme circumstances, blood poisoning or even gangrene. When you leave the tattoo parlor, you should have a checklist of things to keep an eye on with your new tattoo, as well as either a tube of antibiotic or a list of supplies to pick up at the drugstore on the way home.

### Wash and Treat

If your tattoo artist put a bandage or gauze pad on the tattoo, leave it alone. Leave the bandage on for a minimum of two hours, but not overnight. Sometimes, the artist will cover your tattoo with plastic wrap—in that case, take the plastic wrap off as soon as possible and replace it with a regular bandage and topical antibiotic cream. You're actually better off having nothing at all on your tattoo than plastic wrap, as, with any other open sore, your tattooed skin does need to breathe in order to heal, and plastic wrap essentially suffocates the tattooed area and can lead to a really disgusting infection. If a tattoo artist uses paper towels and Scotch tape to cover your new tattoo, you may want to get a blood test afterward as well because this is not something a competent tattoo artist does.

When you remove the bandage the first couple of nights before bed, you need to carefully wash and dry the tattoo, using lukewarm water and a mild soap. Do not scrape or scratch the area—even if it's itchy—as it'll just lead to a longer healing time and possible scarring. Don't use a washcloth or anything

abrasive for the same reason. The tattoo will probably feel a little slimy to the touch, as your body has been producing extra white blood cells (pus) to heal the area. Carefully wash the tattoo until it doesn't feel slimy or sticky to the touch anymore, as the accumulation of dried pus can cause extra scabbing on top of the tattoo. If showering, be careful to not let the water beat directly on the tattoo, as it will hurt and irritate the skin further. In the tub, be careful to keep the tattoo above water as much as possible, as that will also hurt and irritate the skin. Irritating the skin in any way may cause the tattoo to heal unevenly and lead to additional scarring over the design.

After washing the tattoo, carefully pat it dry—don't rub—with a clean towel or paper towel. If the tattoo artist gave you a specific antibiotic to use on your tattoo, apply a fresh layer and bandage it up. Otherwise, put a layer of vitamin E–enriched, non-petroleum-based antibiotic cream on the tattoo and put a fresh bandage on it or wrap gauze around it (depending on the size of the tattoo). Neosporin is not recommended as it works too quickly and forces some of the new ink out of your body as it heals, resulting in a tattoo that's spotty or has significant color loss. You can also use a non-petroleum product such as Tattoo Goo Aftercare Salve, Hustle Butter, or Ink Fixx, all of which may be sold in the studio in which you get your tattoo done or easily found on Amazon or eBay. Most tattoo artists do recommend that whatever you use, it should be non-petroleum-based, as petroleum-based products can cause some of the tattoo inks to fade.

After that, keep it clean, and use ointment or a lotion that is dye- or fragrance-free—like Lubriderm, Aquaphor, or Eucerin—on the tattoo and the surrounding skin until it's completely healed. Apply a small bit three or four times a day, just enough to moisturize your skin and keep it clean. Don't cake it on, as your tattoo and skin need to breathe to heal properly and quickly. If the skin starts to look dried out, just put a little more on. Certain areas, like the back side of the knee, the bend of your arm at your elbow, or your fingers—anywhere the skin is very thick or stretchy—can be tough to heal. Your body is trying to form a scab and you are constantly bending that area and the tattoo/scab keeps cracking. At those points, it's better to use more lotion to keep it moisturized at all times.

Foot tattoos may have a greater chance of infection, especially if you live somewhere cold and need to wear socks and heavy shoes after getting your tattoo. Diligent care should be taken to protect your tattoo from becoming excessively dirty, including washing it multiple times during the day to keep it clean. Swelling can also be an issue, so, if possible, keep your foot elevated for much of the first few days and use an anti-inflammatory such as ibuprofen.

Just like a foot tattoo, a hand tattoo needs a little additional care. Gently wash the tattoo several times during the day, and keep the area wrapped in

a bandage or gauze to prevent dirt from getting into it. If your job includes wearing gloves, you will likely have to wash and wrap your tattoo every time you change your gloves until it's completely healed.

Don't be surprised if you need to get your hand or foot tattoo touched up after it heals (something most tattoo artists do for free after the healing time has passed), as it can be very difficult to get ink to stay put in areas such as the heel of your hand, the palm, and the sides of your fingers.

## Additional Considerations

Something you may not have thought of is that while you're healing, your body is rejecting the ink of your tattoo as foreign material. This isn't such a big deal during the daytime, when you have the tattoo bandaged up, but during the night, as it's recommended that you sleep with the tattoo completely unbandaged (just like any other minor wound that's healing), you're going to leave pus and excess ink on your sheets and blankets. Many people have woken up to find a perfect mirror-image of their tattoo staining their nice sheets. So for those first couple of nights, make sure you have cheap, clean cotton sheets on your bed. You can also cover your bed with a clean soft towel to sleep on.

When your tattoo develops scabs—as most develop a thin, white haze over the top of the tattoo near the end of the healing process—don't pick the scabs. Picking scabs results in scarring and can ruin your brand-new tattoo. The scabs will fall off on their own while you're cleaning the tattoo or in your sleep. If you can't stop yourself from picking, just keep it covered and moisturized during the daytime until it's completely healed. Or wear mittens.

The sun is probably a tattoo's single worst enemy. During the first month, you absolutely need to keep your new tattoo out of the sun to avoid additional scarring or uneven healing. Wear loose-fitting clothes to keep your tattoo out of the sun, or cover the tattoo with a gauze pad when outside. Once your tattoo is fully healed, continue to use a minimum 30 SPF sunscreen on the tattoo to keep it from fading. Use sunscreen at the tanning salon as well.

## Infections

The most important thing about after-tattoo care is knowing if and when your tattoo is infected. The chances of your tattoo getting a serious infection are rare—after all, a tattoo really isn't any more serious of a wound than a good rug burn or a surface scrape—but even those can get infected if not cared for properly.

One of the unpleasant side effects of an infection from a tattoo is a tattoo keloid.

*Wikimedia Commons*

Some of the infections you can get from a tattoo come from receiving the tattoo itself. If the person giving you a tattoo isn't doing it in a shop but is rather in his or her living room, there's a good chance the tattoo equipment hasn't been inspected by the health department or the artist hasn't attended a communicable disease certification course, something legally required of tattoo parlors in most states. Dirty needles and poorly maintained equipment—as you probably well know by now—can transmit everything from HIV and hepatitis to staph infections and other blood-borne pathogens. If you walk into a tattoo parlor and it's not spotless, turn around and walk out.

Just like any other wound, there are definite, telltale signs to let you know that your tattoo is infected. A tattoo doesn't heal any differently from any other wound. If it feels hot to the touch, or a red haze develops around the tattooed area two or three days after you get the tattoo, or if there's excessive scabbing, yellow or green pus, if it stinks, or if it continues to swell excessively beyond the initial swelling of the first day, call your tattoo artist or call your doctor. Even the pharmacist at your local drugstore can probably recommend something for you immediately.

# Tattoos in Literature and Film

## Tattooed Characters and Tattoo Themes

Since it isn't until the Victorian Age that we get the word *tattoo* from Captain Cook's encounters with the Polynesians, it's difficult to find Western literary references to tattoos before the 1700s. Phrases like *devil's marks* and *prickings* in early North American colonial literature could refer to tattoos—especially when referencing witches or Native Americans—but they could also refer to unusual birthmarks, instead.

However, from the eighteenth century on, plenty of colorful characters in classical literature were written with distinctive tattoos, from the criminals and Freemasons who peopled Sherlock Holmes penny dreadfuls to anything with a pirate or a sailor in it. Today, many characters in movies and comic books sport tattoos, but up until recently, a tattoo on a character was a glimpse into their unwritten backstory. As Jack London once said, "Show me a man with a tattoo, and I'll show you a man with an interesting past."

### Tattoos in Literature

Nowadays, we can imagine just about every cool or eccentric character in a novel has a tattoo, but up until recently, tattoos were mostly sported by shady characters and seamen. Herman Melville, who spent nearly a decade of his life working on merchant and whaling ships, had many characters in his stories who sported tattoos. His very first novel, *Typee: A Peep at Polynesian Life* (1846), was loosely based on his own monthlong experience of being held captive by cannibalistic natives on a South Pacific island. In the book, he wrote in great detail about the tattoos of both the men and women of the mythical island of Typee. At one point, it appears that the natives intend to absorb the narrator, Tommo, into their society, which would mean that he would receive the facial tattoos the men of the society all bear, which would separate him from traditional European society altogether. In fact, it's the fear of being

tattooed and permanently linked to the people of Typee that causes Tommo to flee from the island, leaving his beautiful native lover, Fayaway, behind.

In the book, Melville wrote extensively of the tattoos of the Polynesian Marquesas Islanders. "In beauty of form they surprised anything I had ever seen . . . Nearly every individual of their number might have been taken for a sculptor's model . . . I have seen boys in the Typee Valley of whose 'beautiful faces' and 'promising animation of countenance' no one who has not beheld them can form any adequate idea." Cook, in the account of his voyages, pronounced the Marquesans as by far the most splendid islanders in the South Seas. Stewart, the chaplain of the US ship *Vincennes*, expresses in more than one place his amazement at the surpassing loveliness of the women, and says that many of the Nukuheva damsels reminded him forcibly of the most celebrated beauties in his own land. Unfortunately, the beautiful Marquesans proved to be the least disease-resistant people of Oceana, and were almost

Herman Melville wrote many stories based on his time in the South Pacific.                    *Google Images*

immediately wiped out after first contact with Europeans. Only anecdotal evidence of their tattooing remains.

In Melville's better-known novel, 1851's *Moby-Dick*, the narrator, Ishmael, goes so far as to have the dimensions of the gigantic sperm whale that served as a temple for the people of Tranque tattooed on his arm, allegedly as a point of future reference. The other tattooed character in *Moby-Dick*, Queequeg, is covered from head to toe in tattoos, given to him by a Polynesian seer who had "written out on his body a complete theory of the heavens and the earth."

Robert Louis Stevenson's *Treasure Island* opens with a mysterious sea captain arrives at the Admiral Benbow Inn, his forearms covered in tattoos that all speak of adventure: "Here's luck," "A fair wind," and "Billy Bones his fancy," while on his shoulder is a rather prophetic sketch of a man hanging from the gallows.

In Victor Hugo's *Les Miserables*, ex-convict Jean Valjean proves his identity in court by accurately describing tattoos on two convicts whom he had known for many years while in prison. "Cochepaille, near the inside of your left elbow you have a date in blue letters which was tattooed with gunpowder," Jean Valjean says, addressing Cochepaille on the stand. "It is the date on which the Emperor [Napoleon] landed on Cannes: March first, 1815. Roll up your sleeve," upon which Cochepaille grins, rolls up his sleeve, and proves beyond a doubt that Hugo's protagonist is indeed Jean Valjean.

Along with sailors and pirates, tattooed characters were also often convicts. Henri Charrière's classic autobiographical novel, 1969's *Papillon*, takes its title from the main character's tattoo, a swallowtail butterfly on his chest. After he was wrongfully imprisoned on Devil's Island, the butterfly serves as a totem for the main character, a painful reminder that butterflies never do well in cages. Taking the convict tattoo to its extreme, Franz Kafka's 1914 short story "The Penal Colony" centers on a machine that tattoos each alleged criminal's crime on his skin before letting him die over the next twelve hours from his wounds.

More recently, Chris McKinney's gritty novel *The Tattoo* follows the story of Hawaii's seedy underworld. The book takes place almost entirely inside the walls of Halawa Prison, where the inmates' traditional tattoos have evolved to tell the darker stories of their owners. Reminiscent of Melville's *Typee*, Jill Ciment's 2005 novel, *The Tattoo Artist*, tells the story of a woman who has been marooned in the South Seas for thirty years, only to finally be rescued and returned to 1970s New York, where the tattoos that once helped her integrate into Ta'un'uu society now set her apart from her own.

From its early days, science fiction writers rightly decided that tattoos would eventually become commonplace. Science fiction of the 1950s and 1960s featured such characters as a woman with tattooed eyes in John

Berryman's "Modus Vivendi," and offworlders who have tattoos that identify which colony they belong to in J. F. Bone's "To Choke an Ocean." In Philip K. Dick's "The Golden Man," even a postapocalyptic world overrun by mutants still has fry cooks who wear white aprons and have tattooed wrists, and in Robert Ernest Gilbert's futuristic western "Thy Rocks and Rills," the main

In Victor Hugo's *Les Miserables*, ex-convict Jean Valjean proves his identity by describing the tattoos of his fellow convicts.                                        *Google Images*

character, Stonecypher, has a pair of crossed revolvers tattooed on the back of his right hand.

Ray Bradbury's 1951 *The Illustrated Man* is a collection of short stories that all revolve around a different tattoo on the Illustrated Man's body, with each tattoo coming to life as it's told. Tattoos are featured in Bradbury's other famous collection of short stories, *Something Wicked This Way Comes*, in which the carnival master, Mr. Dark, has a tattoo on his body for every person who has fallen under his control.

In Alfred Bester's *The Stars My Destination*, we meet a man driven to the brink of insanity after being abandoned by friends and crew to drift alone in space. The main character, Gully Foyle, has a face that is covered by a tattoo of a tiger mask, which he tries to remove with horrific results. Another lone survivor of a space colony, Robert Heinlein's Valentine Michael Smith from *Stranger in a Strange Land*, briefly joins a circus on Earth and befriends its tattooed lady, an "eternally-saved" member of the Fosterite Church of the New Revelation, who indirectly helps him craft his own religion.

Perhaps some of the most poignant writing about tattoos, however, can be found in poetry. In his elusive poem "Tattoo," Wallace Stevens writes, "The webs of your eyes/Are fastened/To the flesh and bones of you/As to rafters or grass." In the more accessible "Blackie the Electric Rembrandt," poet Thom Gunn writes about a young man getting his first tattoo: "We watch through the shop-front while/Blackie draws stars. . . . [he] leaves with a bandage on/his arm, under which gleam ten/stars, hanging in a blue thick/cluster. Now he is starlike."

Ray Bradbury's book *The Illustrated Man* featured a "narrator" whose tattoos become animated to tell a series of apocalyptic stories.                    *Google Images*

## Tattoos in Comic Strips and Comic Books

The tattooed earliest comic strip character would probably be Popeye, who debuted in 1929 with an iconic anchor tattoo that would be copied on little boys' biceps for decades to come. Presumably, Popeye's tattoo was perfectly acceptable to mothers of the era as he was both a sailor and he helped promote spinach-eating. Another tattooed sailor, this one in comic books, was the villain the Original Tattooed Man, who made his debut in a 1963 issue of *The Green Lantern*. Abel Tarrant, the Original Tattooed Man, had tattoos of various items and weapons that he could manifest at will simply by touching the tattoo needed for the job.

From the 1970s on, many of Marvel and DC Comics's heroes and villains were drawn with tattoos. Deathbird, Screaming Mimi, Bullseye, Zartan, Typhoid Mary, Doctor Manhattan, Hellblazer, several X-Men, the Punisher, and ancillary characters in *Conan* were all drawn with elaborate and often cumbersome tattoos that would probably make a regular alter-ego street appearance impossible without heavy makeup or a trench coat. Today, the facial and/or full-body tattoos of characters like Dagger, Psylocke, Hiro-Kala and even Rainbow Brite's cheek tattoo are considered perfectly *de rigueur*.

## Tattoos in Films

Few people who see *The Girl with the Dragon Tattoo* will forget the forced-tattoo scene between the title character and her abusive caseworker, or the dozens of self-inflicted tattoos covering Guy Pearce in *Memento*—however, some of the more powerful tattoos in movie history are some of the subtlest. For example, Robert Mitchum's tattooed hands in 1955's *The Night of the Hunter* have been copied many, many times (with "LOVE" on the left knuckles and "HATE" on the right), including in *The Rocky Horror Picture Show*. Jake and Elwood of *The Blues Brothers* have their names tattooed across their knuckles, while Ryan Gosling has the word "HAND" across the knuckles of his right hand in the movie *The Place Beyond the Pines*. And while it's not a film, but a TV show, it's worth mentioning here that *The A-Team*'s Mr. T had "Pity" and Fool" inscribed across the knuckles of his left and right hands.

In the 1966 Japanese film *Irezumi*, the title character is a prostitute who, after getting a spider tattoo, becomes a vicious killer. *Escape from New York* (1981) features Kurt Russell as "Snake," who has a tattoo of a cobra across his stomach with a tail that disappears somewhere below his waistband. Featuring one of the first large-scale tattoos on the major screen, 1986's *Manhunter* (remade in 2002 as *Red Dragon)* introduced serial killer Francis "The Tooth

Popeye inspired little boys and girls in the 1930s both to eat their spinach and possibly get tattoos.                                                                    *Google Images*

Fairy" Dollaryde, who has a gigantic tattoo of William Blake's "Red Dragon" across his back.

These days, it's hard *not* finding at least one character in a film with a hand tattoo or a tramp stamp or a tribal tattoo. But for more than the first half of the twentieth century, tattoos hinted that literary characters had something dark and dangerous in their past.

# Reality TV Meets Tattoos

## TV Shows Inspired by Tattoo Artists

There are two main types of reality shows based on tattoos. One type is a series based on really awful and regrettable tattoos being fixed and made beautiful, while the other type takes the viewer through the beginning to the end of creating a tattoo from scratch. A third, inadvertent type of reality show usually happens in either of these two setups—a drama based on the interaction between the tattoo artists, their families, and the customers. In some cases, the drama becomes the overwhelming focus of the reality show, and the tattoo show and the artists and their work become the background story, instead of the other way around. Ever since *Miami Ink*'s debut in 2005, dozens of reality shows featuring tattoo artists have been rolled out on a variety of themes. While a lot of tattoo artists in the field despise the idea of having a reality show based on an art form they've spent much of their lives mastering, most jump at the chance to show off their skills on the small screen.

### The Ink Series

*Miami Ink* premiered on TLC in 2005 and spun off into several national and international series. The show's considered by many to be the granddaddy of all the reality tattoo shows, and helped launch the careers of many of its participants. The show lasted for six seasons before being cancelled, filmed exclusively at 305 Ink tattoo shop, which later changed its name to Love Hate Tattoo. Each episode featured a series of different clients—many of them minor celebrities and alternative rock musicians—along with their motivations for choosing the tattoo they'd requested. In addition, there was some focus on the personal lives of the artists, which, at times, got uncomfortably complicated during some emotional clashes between the cast members.

Chris Garvey tattoos a client on the set of *Miami Ink*.
*Wikimedia Commons*

In 2007, *Miami Ink*'s first spin-off, *LA Ink*, premiered at Kat Von D's LA studio, High Voltage Tattoo, which, during one season, received the Guinness world record for most tattoos performed in a twenty-four-hour period. *LA Ink* was followed by 2011's *NY Ink*—set in *Miami Ink*'s Ami James's new tattoo studio, Wooster St. Social Club—*London Ink*, and *Madrid Ink*, all of which followed the same setup of *Miami Ink*, profiling customers and their reasons for being tattooed as well as the backstory and vision of the tattoo artists themselves. Of all of these spin-offs, *Miami Ink* was the only one that lasted longer than four seasons, with *London Ink* and *Madrid Ink* lasting only a single season apiece.

## Fix-It Shows

One of the longer-running fix-it tattoo shows was TLC's *America's Worst Tattoos*, which ran from 2012 to 2014. In this series, celebrity tattoo artists Megan Massacre—who made her television debut as part of the cast of *NY Ink*—and her crew took on some of the most disturbing tattoos brought in by clients and changed them into much-more-acceptable pieces of body art. Some of the episode premises included covering up clients' own youthful experiences with a tattoo machine on themselves; fixing a tattoo that only cost a client a six-pack of beer to get; X-rated tattoos; and many, many episodes based on fixing very poorly rendered tattoos in general. The strength of the show— outside of the amazing evolution of some really messy, seemingly unfixable tattoos—was the charisma of Megan Massacre herself and the considerate

way she and her crew related to the clients who came in the door, desperate for help.

In the same vein of *America's Worst Tattoos* was *Bad Ink*, which ran for a single season in 2013 on A+E. Featuring Dirk Vermin and Rob Ruckus of Pussykat Tattoo in Las Vegas, the show featured a variety of awful tattoos that customers desperately needed covered or fixed. One episode featured a woman who was convinced her newborn was terrified of her tattoo, while another was about two guys who actually wanted to make their existing tattoos even more awful and ridiculous. Many critics believe that part of the reason that the show was canceled after just one season was that too much focus was paid to the tattoo artists' musical side projects and personas.

## Competitions

Oxygen's *Best Ink* ran from 2012 to 2014, and was a show much in the vein of *Project Runway* and *Cupcake Wars*. In each season, a group of tattoo artists from around the United States competed in various judged and critiqued tattooing challenges, with the winner of the competition earning a $100,000 cash prize and a cover article in a well-known tattoo-related magazine. Also in 2012, Spike TV premiered its own competition, the long-running *Ink Master*, with musician Dave Navarro and tattoo artists Chris Núñez and Oliver Peck as judges, with some episodes incorporating a fourth guest judge, usually a well-known tattoo artist who has knowledge of or a reputation in the style of tattoo (such as new school, traditional, Japanese, portrait, black-and-gray, etc.) chosen for the week's elimination challenge. The final winner of the competition received the title of Ink Master, a cash prize of $100,000, and a feature in *Inked* magazine.

## Shop-Based Drama

One of the longest-running tattoo reality shows is VH1's *Black Ink Crew*. Premiering in January of 2013, the show follows the daily operations of Black Ink, an African-American-owned-and-operated tattoo shop in Harlem, New York. Part of the reason *Black Ink Crew* has been going so strong is that it has become more of a drama-fueled reality show than a tattoo-themed show, and the relationships and conflicts between the various cast members have kept audiences on the edges of their seats since Season 1. In fact, the show has proven so popular that a spin-off series, *Black Ink Crew: Chicago*, premiered in 2015, featuring the daily goings-on at another African-American-owned tattoo shop, Chicago's 9MAG.

A&E's *Epic Ink* only ran for one season in 2014, but it had enough of a devoted fan following that people apparently still call up Oregon-based Area-51 Tattoo to see if they can be tattooed for the show. *Epic Ink* featured the hyperrealistic tattoos that the shop calls "geek-chic," which are inspired by comic books, pop culture, and science fiction.

Dave Navarro was one of the judges on *Ink Master* during the show's run.

*Wikimedia Commons*

# Standard-Bearers and Rule-Breakers

## Innovators in the Field

There are tattoos, and then there are tattoos that are so amazing they simply put every other tattoo in the vicinity to shame. Just like every other area of the arts, there are true superstars that are creating pieces that are just beyond the abilities of your average tattoo artist. The realm of tattooing introduces an unexpected element into the equation of creating the perfect piece of art—the client him- or herself. A superior tattoo artist has to consider not only the design and whether it can be capably rendered into a tattoo, but also the client's body shape, the placement of the tattoo, whether the tattoo will augment or stand out against the wearer's body, and how the tattoo will age with the client.

Knowing that these fantastic artists exist creates a real dilemma for tattoo enthusiasts, too: should you get your first tattoo now at the tattoo shop down the street, or should you save up your cash for a future visit to a tattoo artist who will create a unique and beautiful piece unmistakable as anything but true art?

Whatever you decide to do, it never hurts to discover how really amazing a tattoo can look; if anything, this will give you something to measure your local artist's work against. Each of the following artists has received national and international recognition for their innovations in style and subject, and many of them are the only tattoo artists Hollywood's elite will even consider visiting.

In the past, this section of the book might have been broken up into two separate chapters—one featuring men, one featuring women. However, the only reason that the artists in this chapter were chosen for inclusion at all was because of the outstanding quality of their work, which has nothing to do with gender. So why separate them that way?

# Sailor Jerry (1911–1973)

Sailor Jerry, born Norman Keith Collins, is considered one of the most influential artists in the development of tattooing. Collins left home as a teenager to travel around the country, mostly by hitchhiking, train hopping, and just walking. He eventually landed in Chicago and hooked up with local tattoo legend Gib "Tatts" Thomas, who taught him to use a tattoo machine. When he joined the Navy a few years later, he got the chance to practice his skills on his crew members and at the ports where they stopped. At some of their stops, especially in the ports of Japan and in the South Seas, he met with other tattoo artists and learned new techniques from the masters. He also developed a lifelong love of ships, and eventually earned master's papers on every kind of vessel he could get tested for.

In the 1940s, Sailor Jerry opened a tattoo parlor in Honolulu, Hawaii, where he was soon considered by his contemporaries the greatest American tattooist of the time. Before Sailor Jerry, American tattooists used only three or four colors in their work. Sailor Jerry wanted to use additional colors, and searched for pigments, or mixtures of pigments, that could be used safely in tattoos. Every time he found a new color, he tested it on himself first to make sure it was safe for his clients, then shared the information with other tattooists he worked with. He also found new power sources for tattoo machines, made his own machines, and found new ways to arrange the needles to create basic shading and heavier outlines based on the needle configurations of the Japanese tattoo artists he'd encountered.

Sailor Jerry was also one of the very first tattoo artists to dispose of and replace his needles between clients, preventing many cases of blood poisoning via the transmission of pathogens between customers; he furthered his cause by using an autoclave to sterilize all his equipment. On the mainland, officials regularly shut down tattoo parlors because diseases were being transmitted from one client to the next by dirty tattoo needles. The practice of using disposable needles made tattooing safer for everyone by helping prevent the spread of infectious diseases, and soon, this became an expected practice at all tattoo parlors.

Before Sailor Jerry, most tattoo artists kept their tattooing secrets to themselves, to the point that if they sold flash sheets to other tattoo artists, they'd intentionally screw up part of the design so that an amateur artist not paying attention wouldn't know that the design was flawed. Sailor Jerry regularly took young tattoo artists under his wing and arranged for tattoo artists to get together on a regular basis to share techniques and information about handling customers and even preparing small business loan forms and filing taxes, creating the first interactive tattoo community in the United States.

## Don Ed Hardy (1945–present)

Don Ed Hardy got his start doing body art an early age—when he was twelve, he started a business drawing tattoo art on his classmates with a set of colored pencils. His work was so sophisticated—especially for someone so young—that he even got written up in the local newspaper. He and his partner, Lenny Jones, drew up an official-looking business license to hang up on their wall to make themselves seem more legitimate.

Hardy first apprenticed as a real tattoo artist with Sailor Jerry, and, through his association, was able to study tattooing in Japan in his late twenties with the Japanese classical tattoo master Horihide. After his stay in Japan, he began incorporating Japanese imagery and especially Japanese style in his work, including yakuza-inspired sleeves, full back and bodysuit tattoos, and trousers.

As an artist, he especially made his mark when he became the first tattoo artist to open a studio that strictly did commissioned, original pieces. After years of doing the same flash tattoos over and over, he wanted to use his artistic background to create completely unique pieces of "wearable art." In 1982, he and his wife formed Hardy Marks Publications and began releasing books about tattoos and other alternative art forms—specifically the series *Tattootime,* which brought Hardy's experience with and international knowledge of tattoos and their history to an eager US audience.

Although Hardy doesn't do tattoos anymore, he still creates canvas-based art for galleries around the world, and oversees and mentors artists at his San Francisco studio, Tattoo City. Since 2000, he's also partnered with various fashion designers who have licensed many of his tattoo designs for use in shoes for both men and women, purses, T-shirts, and jackets.

## Peter Aurisch (Germany)

peteraurisch.com/

Peter Aurisch's work draws heavily on the cubism and futurism styles that artists like Picasso made famous in the first half of the twentieth century. Figures are broken up into heavily outlined blocks with sharp angles where you would expect curves to be. Colors appear in unexpected but perfect places, like on the nose and ears of a black-and-white gorilla reduced to a prism of lines and angles, the single eye of an abstracted pillar of lobsters and crabs, or emanating in a golden spill from a lamp onto an otherwise-colorless open book. The location of his tattoo studio is kept a secret until a booking and a deposit are made, and he won't work on more than one client a day, despite the fact the requests for tattoos come to him from all over the world.

On his site, he invites potential clients to send him "a short and significant email. I only need your really rough idea, bodypart [*sic*] and a rough size, no long stories about meanings, your life and stuff." All his work is done freehand, and if you're lucky enough to book him, the first time you'll actually get to see what he's envisioned for your tattoo is the day you walk into his studio for the work to begin.

## Bang Bang (United States)

**www.bangbangforever.com**

Artist Keith (Bang Bang) McCurdy has been tattooing celebrities since 2007, starting when he first tattooed a Sanskrit phrase on pop star Rihanna's hip. His work has graced the skin of Justin Bieber, Chris Brown, Katy Perry, Chanel model Cara Delevingne, and many more. In return for his services, he's let all his celebrity clients leave a tattoo on him. His leg is a virtual gallery of celebrity tattoos: Chris Brown gave him a cartoon face doodle, while Rihanna drew a little red umbrella on his calf. Katy Perry drew a candy cane, and Justin Bieber tattooed a muscular mouse on him.

So far as his own work goes, Bang Bang creates phenomenal photorealistic cityscapes and portraits in black-and-white, as well as brightly colored cartoon strips and graffiti-style tattoos, while historic figures, wild animals, and literary figures all make their way into his creations. While some customers come in with a specific idea of what they want from him, most simply let him take their vague ideas and turn them into his amazing, magical, completely unique creations.

McCurdy's tattoo studio, Bang Bang NYC, features a crew of over a dozen fantastically talented artists who tattoo everything from geometric black-and-white abstractions and tiny minimalist tattoos to watercolor and realistic floral arrangements and trees.

## Yasmine Bergner (Israel)

**yasminebergner.com**

Yasmine Bergner bills herself as a "community tattoo artist," which means that she has, in part, adopted the ancient tradition of the nomadic female tattoo artists of the Middle East, offering her services to help enhance a group's identity. She considers everyone she tattoos to be a member of that group—whether these individuals know one another or not, they are connected by her beautiful dotwork tattoos that are immediately identifiable as her creations.

Her meticulously created, hand-tapped tattoos incorporate stars, geometric shapes, fractals, and designs inspired by ancient petroglyphs. While they're mostly rendered in black-and-white, she occasionally uses one or two accent colors, depending on the tattoo. A former art therapist, she feels her tattoos help her clients to embrace the emotional and spiritual connection between themselves and one another through their wearable art.

## George Bone (United Kingdom)

**George Bone Tattoos, georgebonetattoos.co.uk**

George Bone has been tattooing out of his world-famous tattoo studio for over forty years. A former holder of the *Guinness Book of World Records* title of "Britain's Most Tattooed Man," Bone's tattoos are heavily influenced by Japanese imagery. His original creations feature delicate flowers blooming on climbing vines or rippling, coiled dragons. While he does plenty of full-color tattoos, the ones that truly showcase his individual style are his full-body Japanese-style tattoos that use only black ink, or very minimal color.

## Paul Booth (United States)

**Last Rites Tattoo Theatre, www.lastritestattoo.tv**

Paul Booth has made a name for himself by creating some of the most artistically gruesome tattoos in the business. His original creations feature demons and severed veins, rabid animals, monsters, and zombies. Over the years, Booth has tattooed artists such as WWE's The Undertaker and bands Pantera, Slayer, Slipknot, Mudvayne, Lamb of God, and much more. In 2002, his recognizable style was seen on so many major metal bands that *Rolling Stone* magazine named him "the king of rock tattoos."

## Scott Campbell (United States)

**Saved Tattoo, savedtattoo.com**

Scott Campbell has a reputation throughout the world as being one of the most talented hands in the world of tattooing. As the co-owner of the legendary Saved Tattoo in Brooklyn, New York, his client list has included a long roster of celebrities including fashion designer Marc Jacobs, Heath Ledger, Josh Hartnett, Courtney Love, Orlando Bloom, Helena Christensen, and Penelope Cruz. In recent years, he has gained much acclaim from fine art communities worldwide for his work in mediums other than skin, including intricately carved sculptures made from US currency, a series of watercolor

paintings based on his experiences during a six-week stay in a maximum-security prison in Mexico City, and graphite drawings done on the insides of eggshells. He's also delved into the world of fashion as a designer for Louis Vuitton's SS11 menswear collection and has spent time in a Mexican prison teaching inmates how to build their own tattoo machines, which resulted in his "Things Get Better" show at the OHWOW Gallery in Los Angeles.

## Vincent Castiglia (United States)

vincentcastiglia.com/

Vincent Castiglia discovered tattooing while still attending art school, and by the time he was nineteen, he was already working on clients under the informal tutelage of Brooklyn tattoo artist Mike Perfetto. His work almost universally contains elements of the surreal and macabre, with strong, dark lines designed to age well with the client. His work is almost exclusively black-and-white, and all his tattoos are custom, original work.

Outside of tattooing, Castiglia has made a name for himself in the art world for his excruciatingly beautiful paintings rendered entirely out of his own blood, which he keeps in special non-coagulating vials in a refrigerator in his studio. He was the first American artist to receive a solo exhibition invitation at the HR Giger Museum, in Switzerland, and documentaries featuring his work have appeared on the National Geographic Channel (NatGeo), FOX

Vincent Castiglia images are a combination of stark beauty and borderline horror.                    *Vincent Castiglia*

News, CNBC, BBC, New York 1 News, Spike TV, the Discovery Channel, and the Science Channel. Recently, he painted a guitar for Slayer guitarist Gary Holt in Holt's own blood.

A tattoo consultation with Castiglia is a multipart process. During the initial consultations, Castiglia creates computer simulations of how proposed tattoos will look on his clients, and walk them through how aging and changes in weight will affect the tattoos, all of which are designed to make sure clients will want to keep these works of art on their bodies, and continue to be happy with them forever.

## Nuno Costah (Portugal)

**www.costah.net**

Nuno Costah's lively and playful works look like they stepped out of the pages of a gleefully demented children's book or a sugar-cereal-fueled Saturday morning cartoon show. His deceptively simple designs radiate happiness, with sharp, black outlines splashed with beautiful waves of bright colors that look as though they were rendered in chalk, watercolor, or colored pencil. His specialty is creating tattoos that he believes embody the spirit of his individual clients themselves.

Not surprisingly, he's also one of the better-known street artists in Portugal, where his cheerful cartoon murals (commissioned and otherwise) cover the sides of abandoned structures, bridges, and even on patrons' refrigerators.

## Colin Dale (Denmark)

**Skin & Bone, www.skinandbone.dk**

Colin Dale-Grandberg, born 1965 in Saskatoon, Saskatchewan, Canada, to a Scandinavian father and artisan mother, learned at a very early age the importance of art and culture. Colin's parents were foster parents to many native Indian children, so he was introduced to native culture, history, and art as a child, as well as the petroglyphs/pictographs of his native Canada and the *helleristninger* and rune stones of his Scandinavian ancestry.

Dale moved to Denmark in 1991, where he pursued a career as a graphic artist and medical illustrator before apprenticing with tattooist Erik Reime at his studio, Kunsten pa Kroppen. After several years of learning the basic skills of hand and machine tattooing, Dale began traveling and exchanging tattooing techniques with tattoo masters from Borneo, Samoa, and Tahiti. His research has helped to reintroduce the lost tattooing techniques of the

Nuno Costah incorporates bright, cheerful colors in his joyful, cartoonish creations.
*Nuno Costah*

Colin Dale's tattoos draw on both the traditions of his Danish heritage and the indigenous cultures he was exposed to during his Canadian upbringing.                    *Colin Dale*

Nordic, Native American, and Inuit cultures, while his work has been illustrated in various books, magazines, and documentary programs.

In 2010, he opened his own studio, Skin & Bone, where he almost exclusively works with hand-tapped, hand-poked, or hand-stitched designs, using custom-made bone tools designed to hold different configurations of needles as well as Inuit steel needles for skin-stitching. He's also mastered the mixing and using of natural pigments that many clients prefer to the commercially available plastic-based inks. Dale calls his work neo-Nordic, as it draws heavily on Scandinavian imagery, especially motifs and concepts from Viking legends.

## Mikael de Poissy (France)

**Mikael de Poissy Tatouage, www.tattoo.fr**

Mikael de Poissy is about as classically inspired as you can get. Most of his tattoos are based on the stained-glass heritage of France's gothic churches and cathedrals—as he points out on his website, 60 percent of the world's historic stained glass exists in France. With his bright use of colors and strong black lines, it's easy to look at some of the work he's done on clients and imagine that somehow, the sun is shining through the tattoos themselves.

While his tattoos are not as big as the original stained-glass pieces he very faithfully renders, they aren't small, and they are complete in detail. Most cover the entire span of a back, or the entire length of an arm or leg. But people who come to him for work are looking for big, bold pieces to celebrate their love of the subject matter, whether it be a sleeve depicting Joan of Arc or an entire back tattoo commemorating the murder of Thomas Beckett.

## Deno (United Kingdom)

**Seven Doors Tattoo, www.sevendoorstattoo.com**

Pablo Vasquez Gonzales, better known as Deno, creates tattoos that, at first glance, look like old-school traditional tattoos, with thick lines, minimal shading, and a limited palette of bright colors. However, the imagery is completely unlike anything you would have found during Sailor Jerry's time. Bloody skulls emerge from sea creatures' mouths, rhinoceroses bloom out of the center of bright-colored flowers, coffeepots turn into spiders, and ornately patterned sharks leap in front of a tropical sunset. Bright red and solid black play a prominent role in nearly all his surreal, fantastic designs, making his work even more impossible to ignore.

## Lionel Fahy (France)

**el.fahy.free.fr**

Lionel Fahy's work incorporates deceptively simple line drawings punctuated by unexpected color, creating tattoos that are stark and beautiful and fit each individual customer's body perfectly. His pieces mix odd combinations of fruit and flowers and animals and mythical creatures together, or just one simple motif drawn out beautifully along the length of an arm or a leg. His work distills concepts to a point of minimalist perfection, delivering the same impact that a tattoo filled with colors and lines and shading might.

While he might have many conversations with clients to come up with perfect tattoos for them, the tattoo session itself almost never lasts more than one day. By the time a client reaches the chair, both parties know exactly what they want and it's exactly the same vision. Fahy's clients come from all over the world for his tattoos, and they all go home with completely unique designs that will keep them happy for the rest of their lives.

## Elle Festin (United States)

**Spiritual Journey Tattoo, spiritualjourneytattoo.com**

Elle Festin is almost single-handedly responsible for the global resurgence of neo-tribal art. In the '90s, after years of research into and collecting reference material about traditional Filipino tribal culture, Festin and a group of like-minded friends formed the Mark of the Four Ways Tribe (*Tatak Ng Apat Na Alon*), with the aim of reviving the vibrant tattoo culture of the Philippines.

Festin's beautiful work, rendered entirely in strong, black lines, not only evokes the geometric patterns of traditional Filipino tattoos, but are also created the same way, by patiently and painstakingly hand-poking and hand-tapping. Over the years, he and his tattoo artist wife, Zei, have traveled to the Philippines many times to consult with the few remaining indigenous master tattoo artists there as well as to give classes to a new generation of tattoo artists eager to carry on this integral part of their culture.

## JonBoy (United States)

**West 4 Tattoo, www.west4tattoo.com**

JonBoy (Jonathan Valena) has tattooed celebrities all over the world, including Kendall Jenner, Justin Bieber, Zayn Malik, and Ireland Baldwin. He describes his work as "Coleman Style," which basically means the lines are

Much of Lionel Fahy's work draws on Cubist traditions, utilizing heavy lines and minimal colors.                                                                                      *Lionel Fahy*

strong, straight, and clean, creating very minimalist fine line tattoos that just look like they belong on the wearer. Many of his tattoos are very, very tiny, and range from miniscule writing in various languages, to paper airplanes and origami, and minimalist finger, toe, and ankle tattoos. According to recent interviews, his tattoos are designed to enhance the beauty of the person wearing them, and not distract from that natural beauty. Recently, multiple pieces of his were featured in an MSN.com article, "30 Tiny and Stunning Tattoos for Grown-Ups."

## Myles Karr (United States)

**Escapist Tattoo, www.escapisttattoo.com**

Myles Karr was a professional artist long before he taught himself to tattoo, and he brings the same level of beauty, wonder, and skill to his work as a tattooist that he does his canvas-bound artwork. The tattoo world hasn't been the same since. Most of his tattoos are based on his own surreal drawings that he keeps in his studio for customers to look through. His work's exquisite strangeness and beauty is on par with that of classic artists such as Hieronymus Bosch, Arthur Rackham, and John Neill, as well as Japanese anime. He only does original tattoos, so even if you bring him a piece of someone else's finished art that you want as a tattoo, he will probably alter it to make it fit his own (and yours, of course) aesthetic.

While he mostly operates out of his private tattoo studio, Escapist Tattoo, the high-demand tattoo artist can also be booked at a variety of other New York–area tattoo shops, including Three Kings Tattoo, Electric Anvil Tattoo, Hudson Valley Tattoo Co., as well as the Torchbearer in Rhode Island and Jersey City Tattoo Co. in New Jersey. He also occasionally does work out of Incognito Tattoo (Los Angeles) and Idle Hand Tattoo (San Francisco) in California and Scapegoat Tattoo in Oregon.

His advice to would-be tattooers? "I didn't have a formal apprenticeship and can only offer this advice: draw a lot, get tattooed as much as you can by the best tattooers you can find, don't expect anyone to go out of their way to help you, learn to take criticism, and don't give up. You get out of tattooing what you put into it."

## James Kern (United States)

**No Hope No Fear, www.nohopenofeartattoo.com**

James Kern creates gigantic, brilliant canvases on human skin that feature apocalyptic visions, vivid landscapes and underwater scenes, and portraits

James Kern creates bright, beautiful images with science fiction and sometimes apocalyptic themes.

*James Kern*

of stars, planets, and the outskirts of the galaxy. Science fiction concepts and imagery play a heavy part of much of his work, which uses bright colors, subtle and effective shading, and looks like it's stepped right out of the pages of the most exciting comic book ever. Because of the sheer complexity of his original designs, most of his pieces are big—sleeves and trousers, entire backs, or, for example, a giraffe that takes up three-quarters the length of a client's body.

Kern is well-known on the convention circuit for being both incredibly approachable to new tattoo artists and for leading numerous art seminars, from basic tattooing techniques to incorporating advanced techniques into his work.

## Little Swastika (Germany)

**www.little-swastika.com**

Marc Reidmann, aka Little Swastika, is part tattoo artist, part performance artist. His work incorporates multiple bodies in a design, whether it's four people who, standing next to one another, spell out the word "Love" in a tattoo filled with geometric shapes that continue from one body to the next, or a single tattooed body that is actually part of a larger piece of street graffiti. His larger pieces incorporate as many as ten people in a single design, with each individual tattoo beautiful and striking enough to stand on its own as well as in the whole composition. His work invokes textile patterns and textures, or graffiti art splashed across a wall of flesh, with bright splashes of color that look as though they were spray-painted directly onto the skin, or scribbled on with a wax crayon.

Reidmann's nom de plume, "Little Swastika," comes from an international movement that's trying to "reclaim" the swastika symbol, which originally was a sign of strength, luck, and other decidedly un-fascist attitudes before infamously being used by the Nazis in World War II. Tattoo studios all over the world have begun holding "Free the Swastika" events to further this cause.

## Mark Mahoney (United States)

**Shamrock Social Club, shamrocksocialclub.com**

Hollywood-based Mark Mahoney is considered by many to be the founding father of black-and-gray style, and despite being one of the most in-demand tattoo artists for the celebrity crowd, he still maintains that his studio is "Where the Elite and the Underworld Meet." He is a pioneer in the art of tattoo photorealism, and was one of the first artists to specialize in portrait tattoos. Since his studio first opened in the 1970s, his client list of movie stars and musicians has included Mickey Rourke, Britney Spears, Brad Pitt, Lady Gaga, Danny Trejo, and dozens more.

The other artists in his studio include the up-and-coming Dr. Woo (Brian Woo), who's made a name for himself with his realistic black-and-gray three-dimensional tattoos, and intricate, tiny finger tattoos; East the Asian Typhoon, who creates incredibly beautiful, highly detailed sleeves featuring coy and Japanese dragons; and Max Hanson, whose deceptively simple black-and-gray illustrations look like photographs set into the skin.

Unlike a lot of studios, the Shamrock Social Club absolutely does not make appointments via e-mail. If you want to come in, you have to call the

studio on the phone and speak to a live human—which apparently has not deterred the constant stream of customers one bit.

## Joey Pang (China)

**Tattoo Temple, tattootemple.hk**

Joey Pang is considered a pioneer in the field, creating tattoos that mimic brushstrokes, rendered so that they appear to be painted on the skin, instead of tattooed into it. Her exquisite tattoos combine traditional Asian art forms such as calligraphy and the *guóhuà* style found on of hanging scrolls and silk

Joey Pang's tattoos beautifully and expertly mimic the brushstrokes of the Chinese calligraphy pieces and silk paintings she draws much of her inspiration from.          *Joey Pang*

partition screens with tattooing, incorporating classic Chinese and Japanese imagery such as cherry blossoms, birds, and other images from nature.

While she gets a lot of work from people who want full Japanese-style bodysuit tattoos and Western-inspired pieces, her sparse tattoos featuring cherry blossoms, landscapes, and animals that invoke the spirit of Chinese calligraphy, making exquisite use of bare skin and negative space, truly set her in a class of her own.

## Simone Pfaff and Volker Merschky (Germany)

**Buena Vista Tattoo Club, buenavistatattooclub.de**

Volker Merschky and Simone Pfaff collaborate with each other on all their tattoos, and have worked together for more than twenty-two years on various projects. In 1998, they opened the Buena Vista Tattoo Club and founded the "Trash Polka" tattoo style, which still influences and inspires tattoo artists from all over the world.

The style resembles fine art collages in that it combines realistic images with smears, smudges, and kinetic designs that generate a discordant, chaotic look. Sometimes lines of text are incorporated into the often-morbid photorealistic black-and-white designs, resembling pieces of handwritten notepaper pasted to the underlying tattoo, or official government documents superimposed over the flesh, or like they're letterpress words and phrases stamped directly onto the subject.

Trash Polka pieces are only done in red or black ink. According to Volko, this style is a combination of "realism and trash; the nature and the abstract; technology and humanity; past, present, and future; opposites that we are trying to urge into a creative dance to harmony and rhythm in tune with the body." Trash Polka tattoos are only true Trash Polka if they come from the Buena Vista Tattoo Club shop, similar to how champagne isn't actually champagne if it isn't produced in the Champagne region of France. Naturally, that statement has gone relatively unnoticed, as Trash Polka as an official tattoo genre has begun to appear in tattoos studios in the United States.

## Roxx (United States)

**2Spirit Tattoos, 2spirittattoo.com**

For over thirty years, Roxx has been on the forefront of tribal and blackwork tattooing, which gets its name from the embroidery style (also called Spanish embroidery) in which pictures and patterns are created exclusively using black lines and shapes. Roxx's work draws from indigenous, spiritual, and

tribal cultures from around the world, sacred patterns occurring in nature, science, and technology, and from architectural forms. Her finished work looks both ancient and futuristic, with strong black lines featuring everything from patterns that look like ancient tribal tattoos to fabric and lace patterns to designs that look like they belong to the inner circuitry of a complicated

The tattoo duo of Simone Pfaff and Volker Merschky have pioneered the style of Trash Polka tattooing, a combination of black-and-white noir and collage.

*Simone Pfaff and Volker Merschky*

Roxx's amazing blackwork tattoos mimic forms found both in nature and in the inner circuitry of machines.                                                                      *Roxx*

machine. As a rule, her clients allow Roxx to come up with the perfect design for them, give her the go-ahead, and then they simply put themselves in her hands until the work is done.

Roxx's schedule is filled months in advance, as clients come to her from all over the world for her award-winning creations. Because there is so much detail and often, so much solid black spaces in her designs, her tattoos take several sessions to complete. Her studio, 2Spirit Tattoos, located up in the hills and surrounded by the beauty and openness of the natural world that appears so much in her work, has several other blackwork tattooists in-house. Guest artists also stop frequent the studio, including Lisa Orth, whose tattoos depict animals, landscapes, and almost anything you can think of that uses just black lines and negative space. Orth's work looks a lot like some of the really ornate Icelandic and Japanese scrimshaw, with strong outlines and a sense of movement in each piece. She only does tattoos based on her original artwork, and each tattoo has the same museum quality as her canvas-based work.

## Dan Sinnes (Luxembourg)

**Luxembourg Electric Avenue Tattoo, www.facebook.com/LuxembourgElectricAvenue**
As an artist, it appears that Dan Sinnes can tattoo in just about any style. His website showcases bodies adorned with ornate blackwork scrolls, delicate flowers, Cubism, dotwork, cartoon characters, mandalas, bizarre Japanese-style pieces featuring characters piloting bowls full of ramen noodles, frightening, multi-eyed spiders, and *irezumi*-style full bodysuits. While his work seems heavily inspired by Japanese prints and classic tattoos, that just doesn't cover the whole catalog of his creations at all.

However, the work that has gotten him the most attention are his small, detailed erotic tattoos based on *shunga* prints, a style of Japanese erotic art based on graphic sexual acts. In his interpretations, however, it's not people copulating—it's penises dressed in long, flowing robes, standing at attention as if about to give a lecture, or a vagina wearing a wig full of hairpins and holding a fan. Even more frightening are his portrayals of spiders with vaginas set into their backs as they stalk helpless flies, or monsters with eye-filled vaginas set into their faces. Sinnes is based in the tiny country of Luxembourg, and his dedication to traditional Japanese tattoos has helped to quickly develop his international reputation for creating highly original and beautiful sleeve tattoos.

Dan Sinnes's work combines highly skilled technique with profane imagery for unexpected results.                                                    *Dan Sinnes*

## Nazareno Tubaro (Argentina)

nazareno-tubaro.com

Nazareno Tubaro's tattoos are a striking combination of blackwork and dotwork, with varying shades of black created by the denseness of the dot patterns. Many of his tattoos incorporate geometric designs and mandalas composed of hard edges and soft, curvilinear forms that almost look like tattooed optical illusions. Many of his pieces appear to be tribal, with repeated flower and plant motifs, but aren't necessarily associated with any one specific tribe—rather, they seem to draw inspiration from sources all over the world at once.

Because of the nature of dotwork, many of his tattoos are composed using old-fashioned hand-poking methods, which is much, much more time-intensive than a tattoo made with a machine. Operating out of his own studio, he labors over his tattoos (and clients) in excruciating detail over the course of many months, with the finished work well worth every minute it takes.

## Amanda Wachob (United States)

Fun City Tattoo, www.funcitytattoo.com, www.amandawachob.com \

Amanda Wachob is one of the most exciting modern pioneers in tattoo art. Her work is wildly experimental, with many of her tattoos looking more like paintings or iridescent puddles of oil or melted metal, down to the appearance of brushstrokes, texture, and solid

Amanda Wachob's highly experimental and extremely beautiful tattoos look more like liquid pooling on the surface of the skin than ink set into it. *Amanda Wachob*

contrast to the surrounding skin. They don't look like something that could be made with a regular tattoo machine and ink, but somehow, they are.

Her work has been greatly lauded by the art world outside of tattooing, and her subjects and photographs of her subjects have been included in museum exhibits around the world, including the Metropolitan Museum of New York, the Eretz Israel Museum in Tel Aviv, and the Gewerbemuseum in

Jessica Weichers's sweet, charming tattoos look amazingly like someone drew them on the surface of the skin with a crayon, down to the expected texture of the medium.                                                                *Jessica Weichers*

Switzerland. When she's not touring or involved in a residency, she still comes in to New York's Fun City Tattoo once a week to work on clients.

## Jessica Weichers (United States)

**Seed of Life Tattoo, www.seedoflifetattoos.com**

Jessica Weichers's work is feminine, beautiful, playful, and full of joy. Many of her designs are full of flowers and plants that seem inspired by Turkish and Indian fabrics and embroidery techniques, while other designs are inspired by children's book characters and motifs. While she employs heavy outlines and subtle shading for much of her work, she also creates lush watercolor pieces as well as beautiful, baffling tattoos that somehow look like they were directly drawn on the client's skin with glitter crayon.

Over the years, Weichers has made an impressive name for herself working with women who have had their breasts removed or reconstructed due to cancer. While some of her clients come in specifically for her amazing areola-reconstruction work, many clients opt for having their mastectomy scars simply covered by one of her subtle and beautiful floral designs, or to commission a piece based around a specific theme instead.

# Tattoo Conventions

## Where to Go, What to Do

The first international tattoo convention was held in Hawaii in 1972, organized by legendary tattoo artist Norman Keith Collins, aka Sailor Jerry. Only seven tattoo artists attended, including his apprentice, Kate Hellenbrand (Shanghai Kate). The purpose of that first convention was the purpose of every convention since then—to get tattoo artists together to exchange ideas and techniques, and, especially with later conventions, to bring together tattoo artists and tattoo enthusiasts.

Many tattoo artists make a decent—albeit hard—living traveling from one convention to another, either giving seminars on tattooing techniques or tattooing as many people as possible during the whirlwind weekend of the convention.

One of the best things about a tattoo convention is that because so many artists travel around the world, working conventions, you suddenly don't have to rely on your local artists to give you the tattoo you wanted. At a tattoo convention, you can potentially get a tattoo from an artist who lives on the other side of the planet, or at least a couple of states away. Thanks to the Internet, you can look up all the artists who are going to be at your local convention in advance, arrange a time spot with one you'd like to see before the artists even get to town, and simply waltz into the convention at the arranged time and get a tattoo.

There are few things in life as thrilling for a tattoo enthusiast as going to a tattoo convention. Many of us feel like we're hiding a part of ourselves in our day-to-day life—especially at work, where visible tattoos are often frowned on—and there's something amazing about stepping into a convention hall and seeing hundreds, if not thousands, of other people who feel the same way about tattoos and body art as you do.

There are several ways to attend a convention. You can be either completely open to every single thing, and try to do and see every single booth and artist (if this is you, make sure you wear comfortable shoes); you can research the convention ahead of time and pinpoint exactly the artists and exhibits you want to see; or, if you're a tattoo artist yourself, you can come

to the convention as a professional who just wants to learn new techniques, network with other tattoo artists, and perhaps attend a couple of professional seminars and classes. The only way to tell if you "did" a convention "right" is if you end the evening happy and tired. If you did it "wrong," you'll likely be upset and never want to go to another convention again.

Front and center at every tattoo convention are strict health and safety standards. In fact, everyone who gets a booth at a show must sign a contract that includes specific regulations and often requires a special license. It is important to know though that, because of the popularity, many shows are put on by promoters just looking to make money and who may not be paying attention to specific standards related to biohazard waste and health standards. It is best to stay away from those shows that appear to be more like a carnival than a tattoo industry certified show. That brings us to the issue of the best trade shows to attend. Some of the most popular are also the largest and are verified by the National Tattoo Association (nationaltattooassocia-tion.com).

These popular shows include the National Tattoo Association Convention held in the springtime and the Alliance of Professional Tattooists held in July with rotating city locations each year. Both of these have featured famous tattoo artists, bands and live music, a wide range of exhibits, and is known for their focus on health and safety.

With literally hundreds of tattoo conventions held around the world each year, there are plenty to choose from to experience what one offers. Even if you are not sure you want a tattoo, going to a convention will help you become more comfortable with the process as you can watch tattoos being done and talk to artists. You might even leave with your very first ink.

## What to Expect

Most tattoo conventions follow a general format. The first day starts with a welcome celebration, sometimes a banquet, sometimes an awards show, some-times a floor show—it's all dependent on the specific convention. Sometimes, these opening night festivities are closed to the public, or are an additional cost to your admissions fee. Usually the convention website has a schedule posted by the day before the opening festivities, so if there is an additional charge to get in, you can see from the site if it's worth your time. If you're just coming to the convention to get a tattoo, and the first night consists of speeches, a floor show featuring pierced gymnasts or fire eaters, and a banquet, you may want to save your money and just come the day of your tattoo appointment. However, if you want to completely immerse yourself in

Putting together a tattoo convention is a big deal for everyone involved—not just the convention attendees.                                                                    *Wikimedia Commons*

the giddy, hedonistic world of tattooing, the opening night festivities are a must, and well worth a couple extra dollars.

The convention gets started in earnest the first full day of the event. Many times, you can't buy tickets in advance. This is done to weed out potential ticket scalpers, gang members, and people obviously under the influence, so come early and prepare to wait in line. If you're just here to get your tattoo and go home, make sure you wear appropriate clothing—part of the excitement of getting tattooed at a convention is that hundreds or even thousands of people will probably stop by at some point to see you being tattooed, and you probably don't want to be sitting there with your pants down to your ankles or in your brassiere the whole time, when a pair of loose-fitting shorts or a tank top would have given the artist equal access to your skin. If it's winter, and you have to wear weather-appropriate clothing to get to the convention, pack an extra set of clothing to bring in with you. You won't be the only one to do so.

Many tattoo artists will have their entire weekend booked for tattoos, so if you managed to get an appointment, come early and be on time. If it's a large convention, there will be floor maps available to tell you exactly where you artist has set up his or her booth. If it's a small convention, there's probably an information desk that can quickly point you in the right direction. If you haven't set up an appointment with a tattoo artist but are feeling spontaneous, you may be able to just walk up to a booth and get one. Sometimes, people may book an artist online but have to cancel at the last moment—in that case, the artist will be desperate to fill that time slot. Look for booths that either have a sign up stating that appointments are available or have a tattoo

artist sitting idly in his or her booth, trying to catch the eyes of passersby and saying "hello" a lot. Booths like this are a good place to start. Bear in mind that the only tattoos that are possible are ones that can be done in a single session, so once you're in that chair, you're probably there for however long it takes to finish the tattoo. If the artist has another booking later that day, and your tattoo will take longer than the allotted time to complete, the artist will tell you he or she either can't do it or can only do part of it, and then will help you set up a session with a local artist to finish it after the work from the first session has healed. Also, make sure you bring enough cash, or a credit card, to cover the session.

If you're a tattoo artist yourself, the morning and early afternoon are the best time to hit the tattoo workshops and seminars. Again, checking the schedule of events the day before is key here, because sometimes, especially at the very large conventions, there might be two or three workshops or seminars stacked up against one another, and it's a good idea to decide in advance which one you're going to attend. Everything from workshops on shading techniques to seminars on new technology to classes on the very basics of tattooing is usually offered. Also, keep an eye out for some fascinating discussions about the history of tattooing—many times, professors from respected universities show up at tattoo conventions to give lectures on tribal tattooing practices or bring in museum collections of preserved tattoos. Seminars are also a great place to meet other tattoo artists, and networking can lead to additional client referrals down the road, or just a friend in the business who knows what you're going through as an artist.

On top of checking out the other tattoo artists at the tattoo festival, be sure to collect your share of business cards and stickers. These sorts of promotional items make for a fun collection for the enthusiast or collector alike. In addition, you may want to update your body jewelry from any of the piercing retailers, get a new body piercing, or shop for trendy and unique tattoo-related apparel. Most piercings are relatively quick procedures, so you could potentially stop by a booth for a piercing and still see most of the convention without too much time spent being worked on.

Around late afternoon, the focus of the convention usually starts to drift away from networking, seminars, and tattooing to entertainment. Many tattoo festivals feature musical acts, while other events include sideshow acts, dance or burlesque shows, as well as tattoo competitions where artists are recognized for excellence in a particular style based on their work at the show. And then, of course, even after the convention day is officially over, there are usually plenty of parties to go to either in the hotel where the convention is held, or in the city around the convention. Your dedication to this part of the evening is entirely up to you.

## What Not to Do

There's always a chance for tattoo regret, so be careful before you rush in and make a costly mistake. Plan your ideas carefully and have a goal in mind rather than get all caught up in the excitement. You should also dress accordingly for any anticipated art. Loose button-down shirts, dresses, or shorts should the weather permit make safe clothing options. If you really want a specific tattoo, but there aren't any artists available who have the time or talent to give you what you want, there's no reason why you can't just plan on getting that tattoo some other time. Keep in mind that removing a tattoo can cost at least three times as much as actually getting a tattoo, so unless you have an unlimited tattoo-and-tattoo-removal budget, there's nothing wrong with leaving a tattoo convention without actually getting a tattoo.

If you do find an artist willing to give you a tattoo, don't haggle over the price. Despite the circus-like atmosphere of a convention, you are not at a flea market, and the artists in attendance aren't junk dealers or used car salespeople. They are professional craftspeople, with traveling expenses, who likely dropped a lot of money to come to your town and make their services available to those who want their work. If you don't think their price is in your range, thank them for their time and move on to another artist. After comparing quality and prices, you may be back! Like Sailor Jerry once said, "Good tattoos aren't cheap, and cheap tattoos aren't good."

## Some Helpful Tips

Book your hotel rooms well in advance. Some conventions attract crowds in the thousands, and not everyone is a local with a place down the street. If you're from out of town, you may want to start looking for rooms a good month in advance. If you are local, make sure you get to the site of the convention early, as these things do sell out.

Be patient with and polite to everyone at the convention, including other guests, the staff, and the artists. Everyone is in the same boat as you—if it's crowded, it's crowded for everyone; if it's hot, stinky, loud, slow, etc., maintain respect and understanding for everyone around you. It's a tough, inconvenient environment at times, but it's always worth being considerate.

Research and contact the artist(s) you wish to get work from in advance. If there aren't enough examples of an artist's work on the convention website, do some Internet or magazine research yourself. Most tattoo magazines post their issues online, so if the artists you're considering have been featured in *Tattoo Magazine* or *Inked*, their interviews and tattoo examples can be found on those sites. If you miss the opportunity to book a session online, be at the

If you're curious about getting a tattoo, but not ready to jump in yet, a convention is a great place to watch other people getting inked.                                        *Wikimedia Commons*

convention first thing when the doors open on the first day to try to get an appointment set up! Some of these artists can book the whole show in the first thirty minutes of the opening day. Don't let the chance slip by, because unless you travel the world chasing tattoo conventions, you may never have another opportunity to get tattooed by them again. Also, unless you know which artist you want to get work on by, take your time at each booth and examine all the portfolios you can until you see someone with the talent to do what it is you want done.

Be prepared to leave a deposit. This one always seems to surprise some people. If you are making an appointment to get tattooed, and an artist has to take time in advance to draw up what you want, then he or she needs a deposit both for preliminary work and to guarantee your spot on a busy day

Many celebrity tattoo artists, like Oliver Peck, can be booked in advance at traveling tattoo conventions, or at least be present to sign autographs.          *Wikimedia Commons*

at the show. Artists are there to do tattoos, and the last thing they need is to book a time slot and have a no-show.

Be on time for your appointment. Even though this is a convention, and not an appointment taking place in a tattoo artist's studio, you are still expected to show up on time and follow all the behaviors expected when you are in a tattoo studio (bathe, wear loose clothing that the artists can work around, and don't forget your wallet). The same goes if you're the artist giving the tattoo. There's no valid excuse for not behaving like a professional, showing up on time and ready to go when you agreed to start. Failure to do so is disrespectful, and it goes both ways.

Tip your artist. If your tattoo's done well and you are happy with the end result, show your appreciation by leaving a tip. A good percentage of what you've been charged for the tattoo is going to go to the organization that put on the convention and to the studio the tattoo artist works for, so any tip money you give your artist will make his or her life that much easier.

## Conventions

There are at approximately eight hundred tattoo conventions internationally every single year, so if you missed the one close to your home, there's always another one coming along somewhere nearby. If anything, chasing tattoo conventions is a great excuse for a road trip—after all, that's what the tattoo artists do. While new ones are being added to the convention circuit, here's just a small sampling of some of the more established ones:

**AM-JAM Tattoo Expo**
www.facebook.com/Am-Jam-Tattoo-Expo-251190338247254/

**Amsterdam Tattoo Convention**
www.tattooexpo.eu/en/amsterdam

**Australian Tattoo Expo**
www.tattooexpo.com.au

**Body Art Expo Phoenix**
bodyartexpo.com

**Chicago Tattoo Arts Convention**
www.villainarts.com/tattoo-conventions-villain-arts/
    chicago-tattoo-arts-convention

**Cleveland Tattoo Arts Convention**
www.villainarts.com/tattoo-conventions-villain-arts/
    cleveland-tattoo-arts-convention

**Convencion de Tatuajes CDMX**
convenciondetatuajes.com

**Due South Tattoo & Art Expo**
duesouthtattoo.com

**East Flanders Tattoo Convention**
www.eastflanderstattoo.be

**Evergreen Tattoo Invitational**
www.evergreentattoo.com

**Feather Falls Tattoo Expo**
featherfallscasino.com/feather-falls-tattoo-expo

**Fresno Tattoo Expo**
centralvalleytattoo.com

**Fuel the Arts Expo**
www.fuelthearts.com

**Inked and Geeked Expo**
inkedandgeekedfest.wixsite.com/home

**Hampton Roads Tattoo Arts Festival**
hrtattoofest.com

**Hell City Tattoo Festival**
hellcity.com

**Ink Life Tour**
inklifetour.com

**Ink Mania Tattoo & Art Expo**
inkmaniaexpo.com

**Ink'n the Couve**
www.itat2to.com/inknthecouve

**Inked Hearts Tattoo Expo**
www.inkedhearts.com/

**Inkmasters Tattoo Show**
inkmasterstattooexpo.com

**Kansas City Tattoo Arts Convention**
www.villainarts.com/tattoo-conventions-villain-arts/
    kansas-city-tattoo-arts-convention

**Lady Ink Days**
www.ladyinkdays.de

**Lubbock Tattoo Expo**
www.lubbocktattooexpo.com/

**Milano Tattoo Convention**
www.milanotattooconvention.it

**MusInk Tattoo Convention & Music Festival**
musinkfest.com

**National and International Tattoo Convention**
www.nationaltattooassociation.com

**Nepal Tattoo Convention**
nepaltattooconvention.com

**New York Tattoo Show United Ink**
www.newyorktattooshow.com

**New York Empire State Tattoo Expo**
www.empirestatetattooexpo.com

**NYC Tattoo Convention**
nyctattooconvention.com

**Philadelphia Tattoo Arts Convention**
http://www.villainarts.com/tattoo-conventions-villain-arts/
philadelphia-tattoo-arts-convention/

**Pittsburgh Bleed Back and Gold Tattoo Expo**
www.pittsburghtattooexpo.com

**Por Vida International Tattoo Art Festival**
porvidacs.com

**Salt Lake City Tattoo Convention**
www.slctattoo.com

**Santa Cruz Tattoo and Music Festival**
santacruztattooexpo.com

**Seaside Tattoo Show**
www.seasidetattooshow.com

**Seattle Tattoo Expo**
www.seattletattooexpo.com

**Sevilla Tattoo Convention**
spaintattooexpo.com

**Skindustry Tattoo Expo**
www.skindustryexpo.com

**Slinging Ink Tattoo Expo**
www.slinginginktattooexpo.com/en

**South African International Tattoo Exposition**
southafricantattooconvention.com

**Star City Tattoo and Arts Expo**
www.starcityexpo.com

**Star of Texas Tattoo Art Revival**
www.golivefast.com

**Taipei Tattoo Show**
www.taipeitattooshow.com

**Tattoo Expo Maastricht**
www.tattooexpo.eu/en/maastricht

**Tattoofest**
www.tattoofest.com

**Vietnam Tattoo Convention**
vntattooconvention.com/vi

# What If I Die?

## Tattoos, Postmortem

Probably the absolute last thing you want to think about after getting your brand-new tattoo is what's going to happen to that beautiful piece of skin art after you die. The fact of the matter is, though, if you've gone to an artist who specializes in expensive, time-consuming original compositions, there may be no other tattoo in the world like yours. Isn't it a shame to think that your tattoo will disappear along with you in death? After all, if most of your organs can go to save someone's life, why can't your tattoo be saved for future generations to appreciate as well?

Luckily, there are a few organizations around the world that now specialize in preserving tattoos, and even advertise tattoo removal and preservation in funerary catalogs and newsletters. The process of saving your tattoos is relatively easy—in fact, the biggest hurdle is making sure you've arranged with your lawyer, perhaps when you're drawing up your will, that you want the tattoos removed and preserved. From there, you can make arrangements with both your family and the company that will be doing the preservation in advance so that everybody knows your plans. You can always change your mind and decide not to save your tattoos, but if this is something that sounds like a good idea right now, and you die tomorrow, won't you be glad that you went ahead and had everything set up ahead of time? For those who see their tattoos as art and part of their personality, preserved, mounted, and framed tattoos are joining the traditions of keeping a loved one's wisps of hair in a locket or as ashes in an urn on the mantel.

### Walls and Skin

www.wallsandskin.com/preserveyourtattoos/

Walls and Skin is a tattoo shop and equipment supply company that also has facilities set up to cryogenically freeze your tattoos. Located in Amsterdam, the store advertises itself as the only shop in the world that offers this service. Shop owners Peter van der Helm, Judith van Bezu, and their Foundation for

the Art and Science of Tattooing have been active since 2014, with the goal of preserving the history of tattoos.

Technically, when you sign up with the foundation, you are donating your tattooed skin to them for exhibition. However, relatives can "borrow" your preserved skin for a free loan for an indefinite period. If the tattooed skin samples are requested for temporary or traveling museum exhibits, the foundation will contact your relatives about whether your tattoo can be displayed. Your tattoo may also be photographed for reference purposes, to be used in museum catalogs, online resources, in reference books, and other tattoo-related publications.

The cost to preserve a four-inch-square tattoo is roughly $400, and the foundation has a variety of options for how you want your tattoo displayed once removed. After a pathologist removes the tattoo, that doctor will send the skin, frozen or packed in formaldehyde, to a lab in Europe. In the lab, pathologists extract fat from the skin and replace it with a liquid polymer, typically silicone, much as the exhibit Body Works preserved entire human bodies for their traveling museum. Because the skin has essentially become plastic, it's almost indestructible and can be displayed in a variety of ways. You may either choose to have the skin stretched for dry display behind a glass frame, or opt to have it suspended in a bottle of oil as a wet display, as was often done during the eighteenth through the nineteenth centuries.

## Save My Ink

**www.savemyink.tattoo**
Save Our Ink / The National Association for the Preservation of Skin Art is a nonprofit service that works directly with funeral homes to remove and preserve your tattoo. It is currently the best-known and most reputable services of this kind in the United States. Operated by licensed embalmers and funeral directors Michael Sherwood, Kyle Sherwood, and Kelly Lanckiewicz, Save My Ink will work with local funeral homes to remove your tattoo and present it to your loved ones in a glass-fronted frame you've picked out ahead of time. Their goal is to make the whole process as dignified and respectful as possible, and to create an everlasting memorial of your tattoo that can be displayed as a piece of art. Their process, according to a press release, prevents the decomposition of the skin tissue and preserves the tattoo art. The result is nontoxic and safe to touch—a bit like leather.

The practice of preserving tattoos on human skin is not new. Save My Ink wants to present this practice not as macabre but rather as a way of remembering unique individuals who expressed themselves through the longstanding tradition of body art. Charles Hamm, executive director and chairman of

Many pieces of skin were collected from soldiers' bodies on the battlefield to be preserved for private collections during the Victorian Age, such as this piece of human skin showing a lady, possibly a lover, surrounded by a garland of flowers.          *Wellcome Images*

the board, explained in a press release that "you would never burn a Picasso or any piece of art you invested in and had a passion for. Your tattoo is also art with a unique story, just on a different canvas." Hamm first came up with the idea for the organization when he had some "extra skin" cut off by a plastic surgeon that he'd had tattooed—the surgeon let him keep the skin, and he took it back to his friends in the funeral business to see if they could preserve it. Hamm himself already had over $10,000 worth of tattoo work done on his body, and thought that if the idea of passing his tattoos on to his descendant appealed to him, then there must be other people out there who felt the same way.

The removal can be done in any funeral home, but for the process to work, Save My Ink must be alerted within eighteen hours of the tattoo owner's passing. Participating funeral homes are all provided with a kit specifically designed to facilitate removing the tattoo, and once the body's brought in, the funeral home's embalmer will carefully remove the specified tattoo. From there, he or she will place it in the nontoxic temporary compound provided by Save My Ink, who will then collect the tattoo, chemically treat the skin, frame it, and send it to the beneficiary sometime within the following six months. The only restriction to the service is that they will not preserve face or genital tattoos. And, in a nod to ethics, the decision to preserve the tattoo must be made by the tattoo-wearer, not the next of kin. If you don't want your tattoo extracted and passed on, Save My Ink will respect that.

One of the first postmortem tattoos preserved by the organization came from a man who had died unexpectedly in his early thirties, leaving behind a wife and young son. Save My Skin preserved the tattoo, which was a heart with his son's name, Hunter, inside it. Soon after the boy's father had gotten the tattoo, he had decided to put an order through to have it saved so that Hunter could have a tangible representation of his father and could hear the story of how and why his dad chose that tattoo.

## Museums with Tattoo Displays

The largest collection of human skins is at the Wellcome Collection at London's Science Museum (www.sciencemuseum.org.uk), which has over three hundred individual tattoo fragments. Most of the pieces in the collection were purchased by Henry Wellcome, for whom the Wellcome Collection is named, from various nineteenth-century French surgeons. During the Victorian era, collecting human body parts was a popular, albeit macabre, fad, and tattooed skin from people of all walks of life was high up on the collectible list. Surgeons and collectors alike would scour battlefields and even morgues in search of tattooed skin, which they would carefully remove and treat with tannins to display in a frame or put in a bottle of oil for preservation purposes. Most of the pieces of skin on display at the Science Museum are tanned like leather, with only a few pieces suspended in oil.

The tattoo collection at the Institute of Forensic Research at Jagiellonian University (www.en.uj.edu.pl/en) in Krakow, Poland, consists of sixty pieces of tattooed skin preserved in formaldehyde. The tattoos were collected from the prisoners of the nearby state penitentiary on Montelupich Street. The majority of the prison tattoos represent examples of the secret code, or "pattern language," used by prisoners at the time. The collection was created with the goal of deciphering the code, with the hopes that by looking closely

at the prisoners' tattoos, their traits, temper, past, place of residence, or the criminal group in which they were involved could be determined.

Conditions in Polish prisons allowed only for primitive tools and dangerous chemicals to be used in tattooing. Paper clips, pins, wires, razor blades, and pieces of glass were used to puncture the skin and powdered coal, charcoal, burned rubber, cork, pencil refills, ink, watercolors, and crayons were used as color pigments, often mixed with water, urine, soap, cream, or fat. In the 1970s, the CSI Department of Militia Headquarters in Warsaw published a special document detailing their findings for prosecution agencies to use in analyzing prison populations. A catalog that precisely described the meanings behind the over 2,300 tattoos studied was created, and is still an official guide used in many Polish and Russian prisons today.

The Medical Pathology Museum at Tokyo University, Japan, contains 105 tattooed skins from the early twentieth century, many of which are full-body tattoos. The collection was the life's work of pathologist Dr. Masaichi Fukushi, who was determined to keep a record of true Japanese tattooing before it became corrupted or lost due to cultural influences from outside of Japan. He often paid for the tattoos of people who couldn't afford to get their full-body tattoos finished on the condition that they would allow him to skin their bodies upon their death and preserve the tattoos. When they did die, he would come and collect the body himself, remove the tattooed skin in his hospital, preserve it, and keep it stretched over a torso form in a glass case, like a taxidermist, as opposed to stretching it in an unnatural display as most museums of the time did. Fukushi became very well respected and admired by many of Tokyo's top tattoo artists, and even served as a judge at many tattoo conventions in the district and abroad. In 1927, Fukushi took his work overseas to the west, where he gave lectures on the art of Japanese tattooing. Unfortunately, while in Chicago, one of the doctor's trunks of tattooed skins was stolen and has never been recovered.

During his lifetime, Fukushi took over three thousand photographs of his work, filing them along with all the known personal details of the skins' previous owners, including their names, ages, and where they lived. Sadly, many of these catalogs were lost when Tokyo University was bombed in 1945. Luckily, the skins themselves were stored in a different location and can still be seen today.

Dr. Fukushi's son, Kalsunari Fukushi, inherited the collection, and over the years, he's published numerous papers and articles about tattooing, with work appearing in the books *Japanese Tattooing Colour Illustrated* (1972), *Horiyoshi's World* (1983), and Ed Hardy's magazine *TattooTime*.

# What If I Don't Like It?

## Tattoo Removal ABCs

One of the reasons people get tattoos is to make a statement, either that they love someone or belong to something or believe in something. It is a true commitment, in that a tattoo will not wash off, no matter how hard you scrub with soap and water. But what happens if, as people tend to do, you change? What if you fall out of love with the person whose name is emblazoned on your arm, or you no longer believe in whatever it is that caused you to proclaim it so boldly on your body, or you just get tired of people asking you about your tattoo?

People have been getting tattoos for thousands of years, and perhaps for just as long, people have been trying to get rid of tattoos. Mummies from ancient Egypt show signs of attempted tattoo removal, while ancient Greeks and Romans had varying recipes for tattoo removal, most of them excruciatingly painful.

As the technology involved in tattoo removal has gotten better since the introduction of the Q-switched laser in the 1970s, more people have gotten tattoos simply because there's the awareness that it might not have to be forever. It's not uncommon now for a person to walk into a tattoo parlor one day to get inked, have almost immediate regrets, and walk into a dermatologist's office a few weeks later to get it removed.

### The Basics

The outer layer of the human skin is called the epidermis. It's a thin, waterproof layer of tissue that contains no blood vessels and is essentially there to protect the body from getting an infection. When you get a tattoo, the needle isn't doing anything to the epidermis. The needle is actually going below this waterproof layer and leaving a deposit of ink directly into the layer of skin below, called the dermis.

The dermis holds the ink of a tattoo. The needle of the tattoo machine punctures the dermis thousands of times per minutes—much less, if you're receiving a home-poke or traditional tribal tattoo—leaving enough ink in the dermis to create a design that's visible through the epidermis. Trapped inside the skin, the tattoo will last the rest of your life, changing with you as you age or gain or lose weight. The ink used by professional tattoo parlors is considered to be much safer than that used by amateur tattoos artists, who often use India ink or even just break open a ballpoint pen. Even so, some European researchers believe that when even professional tattoo ink is broken up by lasers, it can sometimes create dangerous, possibly cancer-causing by-products that are absorbed into the body.

As with any trade, some tattoo artists are more skilled than others. An inexperienced or sloppy tattoo artist might end up placing the tattoo too deep into the dermis, which is incredibly painful, looks faded, and slightly raises the skin after it heals, due to the additional scar tissue buildup. Even after a tattoo placed too deep in the dermis is removed, this original raised scar can be a permanent reminder of the experience.

## Covering an Unwanted Tattoo

The easiest way to get rid of a small, specific tattoo is to simply cover it with another tattoo. This works especially well with hand-poked tattoos, such as a gang-related tattoo or just something you did on your own for fun, as the ink deposits aren't spaced as close together or as dense as a tattoo received from a professional. In this case, most tattoo artists can either recommend a design and design placement that can completely cover up the old tattoo, or even incorporate the original design into a brand-new tattoo. The one downside of getting a cover-up tattoo is if as the new tattoo begins to fade with time, the old tattoo once again becomes visible through the design, requiring an additional touch-up.

Sometimes, a sterile solution of sodium chloride (salt water) is injected into the skin. While saline injections can't completely remove a tattoo, they can help fade or lighten an existing tattoo prior to getting a cover-up tattoo. The recovery time is roughly the same as getting a regular tattoo, and there's almost no scarring or changes in pigmentation. Saline solutions are sometimes injected into a tattoo prior to receiving laser tattoo removal as well.

## Dermabrasion

Dermabrasion used to be one of the few options available for removing a tattoo. In dermabrasion, small amounts of a highly gritty substance—sand,

iron, or diamond dust, or a similar substance—or a small, high-speed brush or wheel now called a dermatome are applied to the tattooed area to essentially sand or exfoliate away the top layers of skin. Since tattoo ink is located about a millimeter below the skin, the top layer of skin must be removed as well as the dermis layer containing the ink.

Today, an anesthetic is given to the person getting the tattoo removed, but in the past, it was likely done without any sort of numbing agent at all. The process is repeated over a period of months until the tattoo, or as much of it as possible, is removed. The procedure is far from precise, and the brush can easily abrade extra skin. After dermabrasion treatment, the skin will look and feel very raw, and because the skin is open, it's more sensitive to infections.

Dermabrasion is not designed for large tattoos or any with complex colors and shades. Overall, this procedure may work for small tattoos, but is very limited when it comes to bigger pieces. The process almost always results in some scarring, although with the introduction and use of the dermatome, the scarring is less pronounced and is usually gone within six months to a year.

## Salabrasion

Salabrasion is similar to dermabrasion in that once again, a gritty substance is rubbed into the tattooed area in order to try to remove it. In salabrasion, however, the gritty substance is a salt solution, which is rubbed into the skin, heated, and the skin layers are scraped away. When the area heals, the tattoo may be gone, but once again, scars are likely to be left behind.

## Chemical Removal

While we don't have specific accounts of tattoo removal done by preliterate cultures, we do have a written account of a chemical procedure passed down to us by the sixth-century Greek doctor Aetius, the author of the *Tetrabiblon*, one of the earliest encyclopedias of medicine. During his time, the only people who had tattoos were slaves, criminals, soldiers, all of whom were tattooed by authority figures to show their place in society. In order to be completely accepted by the rest of society or declare one's status as a free man, those tattoos had to be removed.

Aetius wrote:

> "In cases where we wish to remove such tattoos, we must use the following preparations. . . . There follow two prescriptions, one involving lime, gypsum, and sodium carbonate, the other pepper, rue, and honey. When applying firs, clean the tattoos with nitre, smear them with resin of terebinth, and bandage for five days. On the sixth prick the tattoos

with a pin, sponge away the blood, and then spread a little salt on the pricks, then after an interval of stadioi (presumably the time taken to travel this distance), apply the aforesaid prescription and cover it with a linen bandage. Leave it on five days, and on the sixth smear on some of prescription with a feather. The tattoos are removed in twenty days, without great ulceration and without a scar."

Aetius's prescription probably worked, as any corrosive preparation that causes infection and sloughing off the superficial layers of skin will, to some extent, obliterate tattoo marks. Other Greek and Roman physicians had their own special formulas that must have done the job in some cases. Among the other remarkable prescriptions are using the scum at the bottom of a chamber pot mixed with "Very strong vinegar" (Archigne, 97 CE), pigeon feces mixed with vinegar and applied with a poultice "for a very long time" (Marcellus, 138 CE), and Spanish Fly (dried and crushed blister beetle) mixed as a powder with sulfur, wax, and oil (Scribonius Largus, 54 CE).

Much later, in 1928, author Marvin Shie wrote:

"The use of tannic acid and silver nitrate . . . the most satisfactory. A 50 percent solution of tannic acid in water is then tattooed into the design . . . the area is also painted with the tannic acid solution . . . as the tattooing progresses. Then the area is washed with cold water. Sterile petrolatum is applied, to prevent discoloration. . . . Then a stick of silver nitrate is rubbed vigorously over the area forming a thick black deposit of silver tannate. This is all wiped off and washed with cold water. The point is to have the silver tannate penetrate the corium (or dermis) layer of the skin so that the tattooed area becomes hard and dry, and slowly separates from the deep layers of the corium. In about twelve days the edges are free, and in fifteen or sixteen days, the black, dry slough comes off in one piece resembling a thin piece of leather. This contains the epithelium, the silver tannate in the corium, the superficial layers of the corium, and the tattoo pigment."

Basically, the tattooed area was tanned like leather and peeled off the patient, which must have been excruciating.

## Excision

Another method that has fallen almost completely out of practice is the surgical removal of tattoos. This process works best with small tattoos, as it almost always leaves a scar that many people consider even more unsightly than the original tattoo. In the last half of the twentieth century, surgical removal was often an alternative offered to gang members who wanted to be rid of identifying gang tattoos relatively quickly.

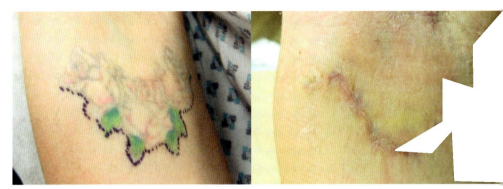

Before laser removal was available, the most common tattoo removal procedures involved either dermabrasion or excision, both of which left severe scarring.    *Wikimedia Commons*

In the process, a surgical sac is forced under the skin of the tattoo and inflated to stretch the skin out. When the stretching creates enough excess skin on either side of the tattoo, the tattooed area is cut from the balloon of skin and the sides of the incision are pulled and sewn or glued together.

## Laser Removal

Is it any wonder that, considering the alternatives, when laser tattoo removal finally became available, pretty much everyone who could went with this option? Not only does laser tattoo removal cause relatively little pain (many patients describe the procedure as feeling like being snapped with a rubber band over and over) but in most cases, there's very little scarring, and any resulting scars fade well over time.

Experimental observations of the effects of short-pulsed lasers on tattoos began as early as the 1960s, which expanded to include argon lasers and carbon dioxide lasers in the 1970s. Early laser treatment had limited but promising success, although the treatment still resulted in burn scars on the patients. In the early 1980s, a new clinical study began in Canniesburn Hospital's Burns and Plastic Surgery Unit, in Glasgow, Scotland, into the effects of Q-switched ruby laser energy on blue/black tattoos. With the early successes of the study, continuing tests grew to include removal of other colors with the Q-switched lasers as well as possible carcinogenic side effects of the treatments. After few to no side effects in the irradiated tissues were found, the procedure became available in Scotland in the 1980s, and by the 1990s, all over the world.

In the process of laser removal, the tattooed area is treated to a high-energy light pulse, which is absorbed through the epidermis only by the tattoo inks in the dermis, while the surrounding skin is left untouched. The

Information about tattoo removal services and on-site consultations are offered at almost every tattoo convention these days.                    *Wikimedia Commons*

pigment is fragmented by the laser energy and is gradually absorbed by the body's immune system. Multiple visits are required to remove most tattoos, generally scheduled weeks to months apart to allow the body to heal between treatments. Darker colors, like black and blue, respond to laser treatment the quickest, while light colors like white and yellow take the longest to disappear.

Even though most amateur tattoos are applied unevenly and at different depths in the dermis, they're the easiest to remove, and can sometimes be completely removed in just one visit. The reason for this is that the ink of an amateur tattoo is generally applied much less densely than a professionally made tattoo, so there's less ink for the laser to break up during treatment. The second factor is that most amateur tattoos are done with just black ink, which is almost immediately absorbed and broken up by the laser.

The location of a tattoo is yet one more factor to take into consideration when and if the time comes to get a tattoo removed. Generally, tattoos on the extremities, such as the wrists, hands, feet, and ankles, take the longest to disappear. If one has the exact same tattoo on the shoulder and on the ankle, the one on the shoulder make take half as many treatments to disappear as the one on the ankle. Other considerations involve skin color, how much scarring resulted from the original tattoo, and how many sessions the original tattoo took to completely apply. A predictive tool, the "Kirby-Desai Scale" was developed by Dr. Will Kirby and Dr. Alpesh Desai, dermatologists with specialization in tattoo removal techniques, to assess the potential success and number of treatments necessary for laser tattoo removal.

The Kirby-Desai Scale assigns numerical values to six parameters: skin type, location, color, amount of ink, scarring or tissue change, and layering. The scores are then added up to show the estimated number of treatments required for completely getting rid of the tattoo. Since its introduction in 2009, most practitioners use the Kirby-Desai Scale, which means you can get a close estimate of how many treatments your tattoo will need (and how much the total removal's going to cost) on your very first visit.

There are several Q-switched laser frequencies a specialist uses during the process of tattoo removal, which are adjusted according to the color being targeted. Because of the complexity involved in resetting a laser, generally, only one setting at a time is used during a tattoo-removal session.

- Q-switched Frequency-doubled Nd:YAG: 532 nm: Used for red and orange inks, this frequency is also used to remove age spots and sun spots.
- Q-switched Ruby: 694 nm: Used for green and blue inks. Because it targets darker colors, it can also cause color changes in the natural surrounding skin color and is generally recommended for people with light skin.
- Q-switched Alexandrite: 755 nm: Also used for dark tattoo pigments, this frequency is the weakest of all, but uses the fastest (picosecond) pulse of all the lasers, and is considered by some experts to work faster than the other Q-switched lasers.
- Q-switched Nd:YAG: 1064 nm. This is the best wavelength for tattoo removal in darker skin types and for black ink, as the near-infrared light is the least absorbed by the melatonin in the skin. This laser wavelength is also absorbed by all dark tattoo pigments and is the safest wavelength to use on the tissue due to the low melanin absorption and low hemoglobin absorption.

## Intense Pulsed Light (IPL) Therapy

IPL has been used by dermatologists for years to fade age spots and moles, and only recently has it begun to be used for tattoos as well. In IPL therapy, broad spectrum laser light is used instead of a specific type of light per color type, as with Q-switched laser removal. An IPL laser causes the pigments in the tattoo to break up, and they are then safely absorbed by the body.

IPL therapy seems to work better for large tattoos than Q-switched laser just because you can cover a larger area of skin, and multiple colors, at a time, reducing the number of visits to a specialist. However, with IPL therapy, you're charged per pulse of light rather than per visit, and the cost can be prohibitive for most customers. Also, because of the risk of internal bleeding, people who take blood thinners or who are diabetic cannot receive IPL treatment.

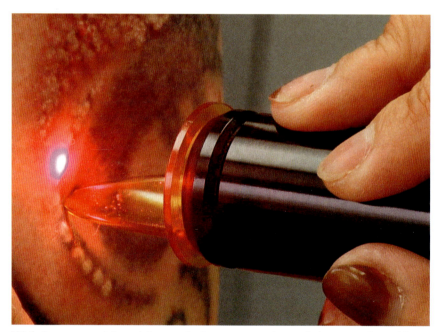

While laser removal doesn't leave as bad a scar as previous-existing procedures, it's not painless, and it does cause some scarring.                    *Wikimedia Commons*

# What Happens Next?

## The Future of Tattooing

Since tattoos have been around for much of humanity's history, it's not unreasonable to assume that they'll be around for much of the rest of it. However, as the meaning and purpose of various tattoos have changed drastically through time and from one civilization to the next, it's impossible to truly know why people in the future get tattoos. Even the technology changes significantly over time—while many people prefer to get a tribal, hand-poked and hand-tapped tattoo, getting a tattoo from a modern studio artist with a tattoo machine is equally as valid a method.

Everyone from neurologists to biohackers is reinventing the very idea of the tattoo. With the right technology, tattoos can both look beautiful and serve as a digital device as useful and complex as a smartphone. With the right subdermal technology, you can monitor your health, carry around your digital portfolio and résumé, or even charge your mobile devices.

### Digital Tattoos

Some biohackers believe that in the future, all tattoos will be digital, or contained entirely within a subdermal chip. This means that people won't be able to see your tattoo unless they have a device that can read it, such as a smartphone or an iPad. University of Reading professor Kevin Warwick might be the most famous person to implant an RFID (radio-frequency identification) chip into himself, which he did in 1998—however, Warwick was motivated not by any artistic impulse, but by his desire to explore what it meant to live as a cyborg.

Artist Anthony Antonellis is one example of a biohacker with a digital tattoo. In 2013, he implanted an RFID chip—essentially, the same type of unit that a vet would implant in a cat or a dog for tracking and identification purposes—in his hand that could store and transmit one kilobyte of information through a tiny antenna. He programmed the chip with a simple animated GIF that could be read by anyone who swiped his hand with their

phone, or, presumably, came close enough to him to receive the signal his "tattoo" was sending out.

Karl Marc, a tattoo artist who works out of the Mystery Tattoo Club in Paris, France, was featured in a Ballantine's Scotch Whiskey commercial displaying what he called "the world's first animated tattoo." By adding a QR code to a tattoo design and scanning it with a smartphone, anyone can activate software that makes the tattoo move when seen through the phone's camera screen. The really cool thing about this is that, because websites change all the time, you have no real control over the content that links to your tattoo—unless, of course, the QR code links only to your site, which would give you the opportunity to upload new content to your own tattoo as often as you liked.

## Photonic/LED Tattoos

Photonic/LED (light-emitting diodes) tattoos are created when LED displays with silicon circuitry are implanted just below the skin, in the area where the ink for a regular tattoo is injected. Photonic tattoos are made up of silicon electronics that are less that 250 nanometers thick—less than 1/1000 of a strand of hair—and are built onto water-soluble, biocompatible silk substrates. After the structure is implanted, the tattoo is injected with saline, which causes the silk substrates to conform to fit the surrounding tissue. Eventually, the silk supporting structure will dissolve completely and leave only the silicon circuitry, which is used to power the LEDs in the circuit. Because the structure is silicon, your body won't reject the electronics, which can be used to power the LEDs now embedded in the skin.

While photonic tattoos aren't available to the public yet, they're currently being tested by scientists on the University of Pennsylvania's campus for use in the medical industry. Brian Litt, a neurologist and bioengineer, believes that they could be used to build futuristic medical devices, such as giving diabetics information about their blood sugar level. However, the technology could also be used to power next-generation body art, such as animated tattoos.

## Robots vs. Humans

Recently, a team of French design students from ENSCI les Ateliers made news when they adapted a 3D printer to tattoo a fake arm—and later, a real one. The team, sponsored by the French cultural ministry, took a 3D MakerBot printer, replaced its resin extruder with a tattoo needle, and programmed it to tattoo a perfect circle on a team member's arm. As per the MakerBot user "code," the team made their deign available to other members

of the open-source community, and soon, tattoo machines were debuting at music events and fairs all over the world.

Soon after, Johan and Pierre from Appropriate Audiences and Autodesk's Pier9 programmed an industrial robot to tattoo a prosthetic leg. Instead of sticking to drawing a circle, this time they programmed the robot to tattoo a variety of simple shapes, including a spiral. The most startling thing about their robot, however, was not that it could replicate the shapes, but that it was capable of adding basic shading to its work, something that the hacked MakerBots had been unable to do. Another advantage that the industrial robot had over the MakerBot was that it was not confined to working on flat surfaces, making it so that the machine could possibly render much larger tattoos than the ones made by the MakerBot.

While the idea of being able to get a tattoo from a coin-operated machine sounds exciting, it probably won't happen anytime soon. Many professional tattoo artists have pointed out that most people don't sit perfectly during a tattooing session, and that part of their job is working around these involuntary twitches so that they don't ruin a tattoo. Other have pointed out that as of now, an automaton-powered tattoo needle still takes a lot of time to fully draw out a tattoo, so a complicated tattoo will still take many hours to finish, and while a machine doesn't need to take a break to heal, the client definitely will. Continuity between sessions is a definite issue in these cases, and many have suggested that a tattoo "stamp," in which an entire tattoo is applied at once with multiple needles, might be a better option than a machine that draws tattoos.

## Disappearing Ink

Many times when people are considering getting a tattoo, a major concern is if you'll be the type of person who enjoys having this tattoo ten or twenty years from now. The tattoo removal business increased a whopping 500 percent from 2015 to 2017, and a reported 16 percent of people with new tattoos already regret them within a year of going under the needle.

However, companies like Ephemeral Tattoos (www.ephemeraltattoos.com) may have come up with a solution to this. The New York–based company has developed a tattoo ink that will last from three months to a year, and, if that's too long for you to live with your tattoo, the company is also working on a removal solution that can be used anytime for safe, easy, effective, and—most importantly—very inexpensive removal of tattoos done with their ink. The inks are made up of tiny dye molecules that are much smaller than those used in traditional tattoo ink, which allows the body to break them down much more easily and quickly.

# Recommended Reading

## Where Do You Go from Here?

It doesn't take much research to realize that there have been a lot of books written about tattoos. In fact, on your way to finding this book, you probably passed shelves full of them.

While writing this book, I also found hundreds of volumes on the subject, many of which I set aside for possible use in *Tattoo FAQ*. Out of all of them, though, there were some that stood above the rest in content, quality, and readability, and are worth adding to any tattoo aficionado's collection.

### 1000 Tattoos

Henk Schiffmacher, editor
published 2005, Taschen Verlag, Köln, Germany
574 pages

This book is exactly what the title says it is—it's a book of one thousand tattoos. Compiled by the former owner of the world-famous Amsterdam Tattoo Museum, it contains tattoos from around the world and throughout history. The great thing about this book is that most of these photographs are from Schiffmacher's personal collection, so they're not the same images that keep popping up in tattoo history books over and over again—there's a huge collection of tattoos from 1970s Germany and the Netherlands in general in here, as well as a large section on tattoos from 1930s–1950s Great Britain. Taschen is one of the few publishers that I specifically look for when seeking out art books in general, just because the content, photographs, and overall layout of their books is always spectacular. This one is no exception, and even though there's barely any text in it at all, just flipping through the pages and looking at the pictures tells more about the history of tattoos than many text-heavy academic books.

## Before They Pass Away

Jimmy Nelson
published 2014, teNeues, Kempen, Germany
423 pages

If you're ever going to blow your book budget on one glorious book, it should be this one. This massive (11″ x 15″) book of gorgeous photography features elegant portraits of every mostly untouched indigenous group in the world, from the Huli Wigmen to the Tiji of Mount Everest to the Gauchos of Patagonia. It's the sort of book that leaves you full of awe and relief that so much magic is still left in the world.

While the book is a little light on text—because it really is a photography book—the text that is there is highly detailed and informative. Maps are provided throughout to show where the people being depicted live, as well as how long they've been there.

## Drawing with Great Needles: Ancient Tattoo Traditions of North America

Aaron Deter-Wolf and Carol Diaz-Granados, editors
published 2013, University of Texas Press, Austin, Texas
291 pages

*Drawing with Great Needles* is a collection of academic essays on every aspect imaginable of Native American tattooing traditions. This book is one of the only collections that focuses specifically on the indigenous peoples of North America, and includes chapters on Columbus's and subsequent Europeans' first encounters with the tattooed peoples of the Southeast United States, detailed chapters on tattooing tools and the variety of inks used according to region, the meanings of tattoos according to tribal affiliation, the evolution of Native American tattooing practices after contact with Europeans, and an extensive chapter on tattooing traditions that have survived up into today.

The illustrations are as informative as the essays themselves. Not only are the portraits of various chiefs and tribal leaders printed throughout, but very extensive charts detailing everything from the transmission of tattooing styles from one tribe to another to the locations of pre-Columbian archaeological digs where tattoo ephemera have been found across the continent are included. Considering that the Spanish who first landed in the Americas—as well as many of the European missionaries and bureaucrats who followed—considered tattooing a sign of Satan and did their best to completely eradicate

any evidence of it from the native cultures, it is truly amazing that a collection like this can be put together so many years after the fact.

## Earthly Remains: The History and Science of Preserved Human Bodies

Andrew T. Chamberlain and Michael Parker Pearson
published 2001, Oxford University Press, New York, New York
207 pages

*Earthly Remains* is an extremely readable and easy-to-grasp book about a very complicated subject: why and how some bodies remain preserved for thousands of years as well as why most bodies do not stand up to the test of time. Mummies from around the world are discussed in great detail, from Ötzi and the Pazyryk remains to the bog bodies found throughout the British Isles and northern Europe, as well as the cultural artifacts found with them. An exceptional collection of photographs is used throughout the book, including some showing nice detail of the skin-stitched tattoos of the Eskimo mummies found in Greenland.

## Mekranoti: Living Among the Painted People of the Amazon

Gustaaf Verswijver
published 1996, Prestel-Verlag, Munich–New York
135 pages

This book is an amazing first-person account of Belgium anthropologist Gustaaf Verswijver's many years living among the tribes of the Amazon Basin, specifically, the Mekranoti and their neighbors. The tribes of this region are known as the "Painted People" because of their elaborate body-staining and tattooing practices, which consist of thick black patterns all over their bodies stained by genipap juice, and tattoos to note how many kills a man had made during his lifetime of intertribal battles.

Both a stunning photographic odyssey and a wonderful collection of personal narratives, the book details Verswijver's gradual learning of the Mekranoti's language—the first non-Amazonian to do so—as well as his detailing of the day-to-day life and practices of a people who lived in near-total isolation from the rest of the world for thousands of years.

# Native Grace: Prints of the New World

W. Graham Arader III
published 1988, Thomasson-Grant, Charlottesville, Virginia
127 pages

This large coffee-table book is a must-have for anyone interested in the pictorial art made by the first naturalists and explorers of America, from the fanciful black-and-white etchings of sixteenth-century German artist Theodor de Bry to the much more faithfully rendered Native American portraits painted by eighteenth-century artists Thomas McKenney and George Catlin and the early nineteenth-century artist Karl Bodmer.

# Painted Bodies: African Body Painting, Tattoos & Scarification

Carol Beckwith and Angela Fisher
published 2012, Rizzoli International Publications, Inc., New York, New York
288 pages

This beautiful, huge (12″ x 16″), full-colored photography book is an amazing addition to anyone's collection on body art. Internationally renowned photographers Beckwith and Fisher traveled the entire continent of Africa to take these photos of culturally protected indigenous tribes ranging from Maasai herdsmen in southern Africa to the Wodaabe of the north.

A wide variety of body ornamentation is covered in this collection, and all of it is presented to not appear exploitive or culturally condemning, as many collections that have included the variety of scarification practices common all over Africa tend to do. Especially wonderful is the section on seductive body art, which features a caravan of Wodaabe and Swahili women showing off their elaborately hennaed hands and feet as well as their tiny beauty-mark tattoos, sitting in brightly colored caravans that look completely out of place against the insistent brown that makes up the dry desert background.

# Russian Criminal Tattoo Encyclopaedia, Vols. 1, 2, & 3

Danzig Baldaev and Sergei Vasiliev
published 2009 (reprint of 2004 edition) FUEL Publishing, London UK
1,200 pages, combined editions

This collection is a must-have for anyone interested in deciphering the secret language of Russian tattoos—and, in fact, this is the collection that filmmaker David Cronenberg consulted during the making of his 2007 film *Eastern Promises*. More than three thousand tattoos were collected for these

pages, in both black-and-white photographs by Sergei Vasiliev and in carefully rendered drawings by prison attendant Danzig Baldaev. Baldaev states in the intro to the series that he began collecting prison tattoos at the urging of his father, a designated "enemy of the people." Over his lifetime as an employee of the Ministry of the Interior beginning in the 1950s and right up until the fall of the Soviet Union, with the support of the KGB, Baldaev kept meticulous records of the meanings of reoccurring tattoos as well as completely original ones from inmates of over twenty labor colonies, female, juvenile, and high security prisons from all over the former USSR.

## Russian Prison Tattoos: Codes of Authority, Domination, and Struggle

Alix Lambert
published 2003, Schiffer Publishing Ltd., Atglen, Pennsylvania
160 pages

This book of full-color and black-and-white photography takes one on a stark journey through the Russian prison system, from an autopsy in the Moscow Prison morgue to the common room in a woman's prison colony in Samara. Everything from various tattooing equipment used by inmates throughout the Russian prison system—usually made with sharp metal wire fastened to a wind-up motor—to unusual tattooing techniques, such as slipping a plastic spoon inside one's eyelid to give an eyelid tattoo without accidentally blinding the recipient—is covered in here, as well as short interviews with many of the prisoners themselves. There's some discussion on the meaning of the tattoos, too, but most displayed in the photographs are ones that the prisoners chose or designed for personal reasons.

The book is fascinating and put together really well, but it is not for the faint of heart. Alix Lambert's unflinching photographs show the squalid conditions of the men and women's Russian prison system that has killed as many prisoners as are released due to communicable diseases and infections caused by untreated illnesses, parasites, and insect and rodent infestations, as well as the realities facing convicts who do manage to serve their time and make it back out into the outside world.

## The Tattooed Lady: A History

Amelia Klem Osterud
published 2009, Taylor Trade Publishing, Lanham, Maryland
154 pages

This wonderful book is all about tattooed ladies from the Victorian age and up through the present, including the ladies from the classic sideshow or traveling circus circuit to main acts who were invited to show their tattoos off to royalty and pose for permanent fixtures in wax museum exhibits around the world. The book is absolutely packed with the personal histories of many of these amazing and sometimes-scandalous ladies, featuring over a hundred black-and-white and full-color photographs.

Along with the history of the women featured in the book is a fair amount of philosophical discussion on what place in society the tattooed women held at various times in history. Many were married to their managers, resulting in often uneven power struggles in their relationships. There's also much discussion about how much skin a tattooed woman was expected to show during different times in history, and how tattooed ladies were able to create the illusion to audiences of being fully tattooed, while really only having exactly the right amount of exposed skin covered in art. The book carries the subject right up to the present, featuring some of the tattooed ladies still making a living on the circuit today.

## Wear Your Dreams: My Life in Tattoos

Ed Hardy with Joel Selvin
published 2013, Thomas Dunne Books, St. Martin's Press, New York, New York
292 pages

*Wear Your Dreams* is the autobiography of legendary tattoo artist Ed Hardy, starting with his childhood in Corona del Mar, California, in the 1950s, when he first started offering his classmates tattoos by drawing on them with colored pencils. These hand-drawn "tattoos," shown in a couple of pictures in the photo section of the book, were incredibly sophisticated for a ten-year-old, and strongly influenced by the memorabilia his father, a former soldier of fortune, brought back from his adventures around the world.

The book is an amazing adventure to read, with the biggest contrasts coming from the balance that Ed, who easily got accepted to the San Francisco Art Institute after high school, struck throughout his life between his love and talent for truly fine art and the somewhat seedy world of tattoo culture of the 1960s through the early 1980s. It also includes his observations on becoming a mainstream fashion icon in the 1990s up to the present. The book is highly entertaining, and reading it feels like you've been cornered in a bar by a guy with the greatest stories ever, who will not let you leave until he's told you everything. You just can't put it down until it's done.

## The Tattoo History Source Book

Steve Gilbert
published 2000, Re/Search Publications / Juno Books, San Francisco,
California / New York, New York
216 pages

This book is an amazing collection of journal entries, photographs, anec-
dotes, and interviews from explorers who made first contact with tattooed
cultures around the world as well as pioneers and innovators in the tattoo
world. There's a great section on tattooing in the post–Civil War United
States, with excerpts from Charles Wagner's autobiography and photos of
the circus performers he tattooed in his time, as well as excerpts from the
memoirs of England's George Burchett. Also included are many lengthy
excerpts from medical journals written by a slew of eighteenth-to-twentieth-
century doctors and psychologists explaining the motivations behind getting
tattoos, which are especially humorous when read one right after another as
each new lecture disproves the one that came before it.

The photographs and illustrations used in this are especially wonderful,
showing in great detail both pictures and descriptions of what specific tattoos
mean to each group of people discussed.

## Tattooing of the North American Indians

A. T. Sinclair
published 2006, Kessinger Publishing, Whitefish, Montana (reprinted from
the *American Anthropologist*, Vol. II, #3)
38 pages

This slim book is a reprint of an extensive article first published in the
*American Anthropologist* in 1909. Sinclair was one of the first post-colonial
American anthropologists to recognize the rich tradition of tattooing that
had been practiced all over the Americas, and one of the first to notably
lament that such scanty records had been kept of the individual cultural
groups' tattoos.

In the short thirty-eight pages that make up this fascinating text, Sinclair
covers the tattooing traditions of over a hundred indigenous peoples from
South America up to Alaska—many tribes of which no longer exist in any
form—including many quotes and notes from notable explorers who were
often the only people to see the tattooed people themselves before their
tribes were either assimilated or completely decimated by disease or the other
common side effects of first contact with Europeans.

## The World Atlas of Tattoo

Anna Felicity Friedman
published 2015, Yale University Press, New Haven, Connecticut
399 pages
This coffee-table book is both a gorgeous art and art history book to just look through and your introduction to how amazing tattoos can be when rendered by a truly talented artist. The work of one hundred experimental, tribal, old-school, traditional, photo-realistic, and just plain highly skilled tattoo artists is featured in these pages, with a concise one-page introduction to each tattoo artist followed by representative examples of the artist's work. The layout of this book is exceptional, in that the photographs are spaced just so that you feel like you're being taken on a carefully curated journey through each individual artist's portfolio instead of just pawing through a pile of jumbled images.

## The World of Tattoo: An Illustrated History

Maarten Hesselt van Dinter
published 2005, KIT Publishers, Amsterdam, Holland
304 pages

*The World of Tattoo* is an extremely detailed history of just about everything known about tattoos and tattooing practices from around the world. Van Dinter has packed thousands of years of history into this book, taking you from the earliest known tattoos up through the present. Unlike many texts, he doesn't neglect the tattooing histories of Christian-era Europe or lower Africa, refuting many other previous experts' contentions that tattooing wasn't a common practice in either region.

   This book approaches every cultural group covered with a uniformly respectful reverence, while still discussing tattoos, their meanings, and tattooing practices in almost clinical detail. It's an excellent reference guide for students of art history and tattoo history alike, and manages to cover just about every region of the world, from the Amazonian tribes in South America to the South Pacific Marquesans, in exquisite detail.

# Bibliography

## Books

Arader, W. Graham III. *Native Grace: Prints of the New World 1590–1876*. Charlottesville, Virginia: Thomasson-Grant Inc., 1988

Bailey, Diane. *Tattoo Art Around the World*. New York, New York: Rosen Publishing, 2012

Baldaev, Danzig and Sergei Vasiliev. *Russian Criminal Tattoo Encyclopaedia, Vols. 1, 2, & 3*. London, United Kingdom: FUEL Publishing, 2009

Beckwith, Carol and Angela Fisher. *Painted Bodies: African Body Painting, Tattoos & Scarification*. New York, New York: Rizzoli International Publications, 2012

Buell, Janet. *Time Travelers: Ancient Horsemen of Siberia*. Brookfield, Connecticut: Twenty-First Century Books, 1998

Chamberlain, Andrew T. and Michael Parker Pearson. *Earthly Remains: The History and Science of Preserved Human Bodies*. New York, New York: Oxford University Press, 2001

Deter-Wolf, Aaron and Carol Diaz-Granados, editors. *Drawing with Great Needles: Ancient Tattoo Traditions of North America*. Austin, Texas: University of Texas Press, 2013

Friedman, Anna Felicity. *The World Atlas of Tattoo*. New Haven, Connecticut: Yale University Press, 2015

Gilbert, Steve. *Tattoo History: A Source Book*. New York, New York: Re/Search Publications, 2000

Hardy, Ed with Joel Selvin. *Wear Your Dreams: My Life in Tattoos*. New York, New York: Thomas Dunne Books / St. Martin's Press 2013

Hardy, Lal, editor. *The Mammoth Book of Tattoos*. Philadelphia, Pennsylvania: Running Press Book Publishers, 2009

Lambert, Alix. *Russian Prison Tattoos: Codes of Authority, Domination, and Struggle*. Atglen, Pennsylvania: Schiffer Publishing Ltd., 2003

Levin, Judith. *Tattoos and Indigenous Peoples*. New York, New York: Rosen Publishing, 2009

Levy, Janey. *Tattoos in Modern Society*. New York, New York: Rosen Publishing, 2009

Miller, Jean-Chris. *The Body Art Book*. New York, New York: The Berkeley Publishing Group, 1997

Mifflin, Margot. *Bodies of Subversion: A Secret History of Women and Tattoo*. San Francisco, California: Re/Search Publications, 1997

Mitchel, Doug. *Advanced Tattoo Art: How-to Secrets from the Masters*. Stillwater, Minnesota: Wolfgang Publications, 2006

Nelson, Jimmy. *Before They Pass Away*. New York, New York: teNeues Publishing Group, 2014

Osterud, Amelia Klem. *The Tattooed Lady: A History, 2nd edition*. Lanham, Maryland: Taylor Trade Publishing, 2009

Reardon, John. *The Complete Idiot's Guide to Getting a Tattoo*. New York, New York: Penguin Group, 2008

Rush, John A. *Spiritual Tattoo: A Cultural History of Tattooing, Piercing, Scarification, Branding, and Implants*. Berkeley, California: Frog Ltd., 2005

Sinclair, A. T. *Tattooing of the North American Indians*. Whitefish, Montana: Kessinger Publishing, 2006 (reprinted from the *American Anthropologist*, Vol. II, #3)

Spalding, Frank. *Erasing the Ink: Getting Rid of Your Tattoo*. New York, New York: Rosen Publishing, 2012

Vale, V. and Andrew Juno, editors. *Modern Primitives: An Investigation of Contemporary Adornment & Ritual*. San Francisco, California: Re/Search Publications, 1989

van Dinter, Maarten Hesselt. *The World of Tattoo: An Illustrated History*. Amsterdam, the Netherlands: KIT Publishers, 2005

Verswijver, Gustaaf. *Mekranoti: Living Among the Painted People of the Amazon*. Munich–New York: Prestel-Verlag, 1996

Vitebsky, Piers. *The Reindeer People: Living with Animals and Spirits in Siberia*. New York, New York: Mariner Books, 2005

Von D, Kat. *High Voltage Tattoo*. New York, New York: Collins Design, 2009

## Periodicals, Blogs, Websites, and Other References

Academy of Responsible Tattooing. http://www.tattooschool-art.com/.

"Ancient Tattoos." *Archaeology.org*, October 9, 2013. http://www.archaeology.org/issues/107-1311/features/tattoos.

Art Career Project, The. "How to Become a Tattoo Artist." http://www.theartcareerproject.com/become-tattoo-artist/.

Bebinger, Martha. "Extra-Permanent Ink: Preserving Your Tattoos After Death." *NPR.org*, October 11, 2014. http://www.npr.org/2014/10/11/355192276/extra-permanent-ink-preserving-your-tattoos-after-death.

Campbell-Dollaghan. "This Temporary Tattoo Is Actually a Battery That's Powered by Your Sweat." *Gizmodo.com*, August 13, 2014. http://gizmodo.com/this-temporary-tattoo-is-actually-a-battery-thats-power-1620716607.

Canada Border Services Agency. "Tattoos and Their Meaning." http://info.publicintelligence.net/CBSA-TattooHandbook.pdf.

Carroll, George H. Photochromatic tattoo. US Patent 6470891 B2. Filed December 13, 1999. Issued October 29, 2002. http://www.google.com/patents/US6470891.

Cartwright-Jones, Catherine. "The Techniques of Persian Henna." *The Henna Page: Encyclopedia of Henna*. http://www.hennapage.com/henna/encyclopedia/Persian_Henna_Techniques.pdf.

Das, Subhamoy. "Mehendi or Henna Dye History & Religious Significance." *ThoughtCo.com*, November 28, 2016. https://www.thoughtco.com/mehendi-or-henna-dye-1770473.

Eby, Margaret. "Celebrity Tattoo Artist Keith (Bang Bang) McCurdy Has a Thick Skin for A-List Ink." *Daily News*, June 2, 2013. http://www.nydailynews.com/entertainment/gossip/keith-bang -bang-mccurdy-tattoo -artist-stars-article-1.1358890.

Estes, Adam Clark. "The Freaky, Bioelectric Future of Tattoos." *Gizmodo.com*, January 6, 2014. http://gizmodo.com/the-freaky-bioelectric -future-of-tattoos-1494169250.

Fox News. "A Guide to Tattoo Styles: Part 2." magazine.foxnews.com/style-beauty/guide-tattoo-styles-part-2.

Hodgkinson, Will. "Russian Criminal Tattoos: Breaking the Code." *Guardian*. October 26, 2010. https://http://www.theguardian.com/artanddesign/2010/oct/26/russian-criminal-tattoos.

Holland, Hereward. "Inking Myanmar's Identity." *Al Jazeera*, January 28, 2014. http://www.aljazeera.com/indepth/features/2014/01/inking-myanmar-identity-201412771243649337.html.

Hughes, Alex. "Disappearing Ink: The Future of Tattoos." *Quantumrun.com*, November 1, 2016. http://www.quantumrun.com/article/disappearing -ink-future-tattoos.

Ink Done Right. http://www.inkdoneright.com.

Kao, Hsin-Liu (Cindy), Christian Holz, Asta Roseway, Andres Calvo, Chris Schmandt. *DuoSkin: Rapidly Prototyping On-Skin User Interfaces Using*

*Skin-Friendly Materials.* New York: ACM, 2016. duoskin.media.mit.edu/duoskin_iswc16.pdf.

Kelly, Daniel. "Japanese Tattoo Art." *Artelino.com.* https://www.artelino.com/articles/japanese_tattoo_art.asp.

Klein, Sarah. "How to Safely Get a Tattoo Removed." *Health.com,* June 11, 2010. http://www.cnn.com/2010/HEALTH/06/11/remove.tattoo.health/index.html.

Kraft, Caleb. "Are Robots the Future of the Tattoo Industry?" *Make:,* August 9, 2016. http://makezine.com/2016/08/09/are-robots-the-future-of-the-tattoo-industry.

Krutak, Lars. "Many Stitches for Life: The Antiquity of Thread and Needle Tattooing." http://www.larskrutak.com/many-stitches-for-life-the-antiquity-of-thread-and-needle-tattooing/.

Linberry, Cate. "Tattoos: The Ancient and Mysterious History." *Smithsonian Magazine,* January 1, 2007. http://www.smithsonianmag.com/history/tattoos-144038580.

Low, Harry. "The Man Who Sold His Back to an Art Dealer." *BBC News Magazine,* February 1, 2017. http://www.bbc.com/news/magazine-38601603.

MacRae, Michael. "Technology Takes Tattoos into the Future." *ASME.org,* September 2014. https://www.asme.org/engineering-topics/articles/design/technology-takes-tattoos-into-future.

Madrigal, Alexis C. "Artist Embeds RFID Chip in His Hand to Spread GIF Art." *Atlantic,* August 21, 2013. https://www.theatlantic.com/technology/archive/2013/08/artist-embeds-rfid-chip-in-his-hand-to-spread-gif-art/278929.

Marikar, Sheila. "Dr. Woo, the Tattoo Artist for the Fashion Set." *New York Times,* December 19, 2014. https://http://www.nytimes.com/2014/12/21/fashion/dr-woo-the-tattoo-artist-for-the-hollywood-set.html?_r=0.

McHugh, Molly. "How L'Oreal Built a UV-Measuring Temporary Tattoo." *Wired.com,* January 8, 2016. https://http://www.wired.com/2016/01/how-loreal-built-a-uv-measuring-temporary-tattoo/.

*Medic8.com.* "Intense Pulsed Light (IPL) Tattoo Removal Therapy." http://www.medic8.com/healthguide/tattoo/ipl-tattoo-removal.html.

Odile, Marin. "The Human Stain: A Deep History of Tattoo Removal." *Atlantic,* November 19, 2013. http://www.theatlantic.com/technology/archive/2013/11/the-human-stain-a-deep-history-of-tattoo-removal/281630/.

Oremus, Will. "Choose Your Own Sixth Sense." *Slate.com*, March 14, 2013. http://www.slate.com/articles/technology/superman/2013/03/cyborgs_grinders_and_body_hackers_diy_tools_for_adding_sensory_perceptions.html.

Pollak, Michael. "Tattooing Embraced Long Ago by New Yorkers." *New York Times*, July 10, 2015. http://www.nytimes.com/2015/07/12/nyregion/tattooing-embraced-long-ago-by-new-yorkers.html?_r=0.

Presser, Brandon. "Facial Tattoos: The Primal Female Rite in Papua New Guinea." *Daily Beast*. August 11, 2014. http://www.thedailybeast.com/articles/2014/08/11/facial-tattoos-the-tribal-female-rite-in-papua-new-guinea.html.

Sciolino, Elaine. "French Debate: Is Maori Head Body Part or Art?" *New York Times*, October 26, 2007. http://www.nytimes.com/2007/10/26/world/europe/26france.html.

Silk & Stone. "About Henna." silknstone.com/About-Henna.html.

Tattoo Info. "Tattoo Copyright." http://www.tattooinfo.net/Scripts/prodView.asp?idproduct=30.

*UC San Diego Library, Science and Engineering Blog.* "This Day in Patent History: Tattoo Machine." https://libraries.ucsd.edu/blogs/se/this-day-in-patent-history-tattoo-machine/.

Vanishing Tattoo. "Tattoos of the Early Hunter-Gatherers of the Arctic." http://www.vanishingtattoo.com/arctic_tattoos.html.

———. "Greek and Roman Tattoos." http://www.vanishingtattoo.com/tattoo_museum/greek_roman_tattoos.html.

———. "Tattoos in the USA." http://www.vanishingtattoo.com/tattoo_museum/united_states_tattoos.html.

# Index

# THE FAQ SERIES

**AC/DC FAQ**
*by Susan Masino*
Backbeat Books
9781480394506.................$24.99

**Armageddon Films FAQ**
*by Dale Sherman*
Applause Books
9781617131196........................$24.99

**The Band FAQ**
*by Peter Aaron*
Backbeat Books
9781617136139......................$19.99

**Baseball FAQ**
*by Tom DeMichael*
Backbeat Books
9781617136061.......................$24.99

**The Beach Boys FAQ**
*by Jon Stebbins*
Backbeat Books
9780879309879.................$22.99

**The Beat Generation FAQ**
*by Rich Weidman*
Backbeat Books
9781617136016 ......................$19.99

**Beer FAQ**
*by Jeff Cioletti*
Backbeat Books
9781617136115 .......................$24.99

**Black Sabbath FAQ**
*by Martin Popoff*
Backbeat Books
9780879309572....................$19.99

**Bob Dylan FAQ**
*by Bruce Pollock*
Backbeat Books
9781617136078 .......................$19.99

**Britcoms FAQ**
*by Dave Thompson*
Applause Books
9781495018992 ......................$19.99

**Bruce Springsteen FAQ**
*by John D. Luerssen*
Backbeat Books
9781617130939.......................$22.99

**A Chorus Line FAQ**
*by Tom Rowan*
Applause Books
9781480367548 ....................$19.99

**The Clash FAQ**
*by Gary J. Jucha*
Backbeat Books
9781480364509 ...................$19.99

**Doctor Who FAQ**
*by Dave Thompson*
Applause Books
9781557838544....................$22.99

**The Doors FAQ**
*by Rich Weidman*
Backbeat Books
9781617130175 .......................$24.99

**Dracula FAQ**
*by Bruce Scivally*
Backbeat Books
9781617136009 .....................$19.99

**The Eagles FAQ**
*by Andrew Vaughan*
Backbeat Books
9781480385412.....................$24.99

**Elvis Films FAQ**
*by Paul Simpson*
Applause Books
9781557838582....................$24.99

**Elvis Music FAQ**
*by Mike Eder*
Backbeat Books
9781617130496.....................$24.99

**Eric Clapton FAQ**
*by David Bowling*
Backbeat Books
9781617134548 .....................$22.99

**Fab Four FAQ**
*by Stuart Shea and
Robert Rodriguez*
Hal Leonard Books
9781423421382........................$19.99

**Fab Four FAQ 2.0**
*by Robert Rodriguez*
Backbeat Books
9780879309688...................$19.99

**Film Noir FAQ**
*by David J. Hogan*
Applause Books
9781557838551.....................$22.99

**Football FAQ**
*by Dave Thompson*
Backbeat Books
9781495007484 ...................$24.99

**Frank Zappa FAQ**
*by John Corcelli*
Backbeat Books
9781617136030 ....................$19.99

**Godzilla FAQ**
*by Brian Solomon*
Applause Books
9781495045684 ...................$19.99

**The Grateful Dead FAQ**
*by Tony Sclafani*
Backbeat Books
9781617130861......................$24.99

**Guns N' Roses FAQ**
*by Rich Weidman*
Backbeat Books
9781495025884 ...................$19.99

**Haunted America FAQ**
*by Dave Thompson*
Backbeat Books
9781480392625.....................$19.99

**Horror Films FAQ**
*by John Kenneth Muir*
Applause Books
9781557839503....................$22.99

**James Bond FAQ**
*by Tom DeMichael*
Applause Books
9781557838568....................$22.99

**Jimi Hendrix FAQ**
*by Gary J. Jucha*
Backbeat Books
9781617130953.......................$22.99

**Johnny Cash FAQ**
*by C. Eric Banister*
Backbeat Books
9781480385405................. $24.99

**KISS FAQ**
*by Dale Sherman*
Backbeat Books
9781617130915........................ $24.99

**Led Zeppelin FAQ**
*by George Case*
Backbeat Books
9781617130250 ..................... $22.99

**Lucille Ball FAQ**
*by James Sheridan
and Barry Monush*
Applause Books
9781617740824........................$19.99

**M.A.S.H. FAQ**
*by Dale Sherman*
Applause Books
9781480355897......................$19.99

**Michael Jackson FAQ**
*by Kit O'Toole*
Backbeat Books
9781480371064......................$19.99

**Modern Sci-Fi Films FAQ**
*by Tom DeMichael*
Applause Books
9781480350618 .................... $24.99

**Monty Python FAQ**
*by Chris Barsanti, Brian Cogan,
and Jeff Massey*
Applause Books
9781495049439 ..................$19.99

**Morrissey FAQ**
*by D. McKinney*
Backbeat Books
9781480394483................... $24.99

**Neil Young FAQ**
*by Glen Boyd*
Backbeat Books
9781617130373.......................$19.99

**Nirvana FAQ**
*by John D. Luerssen*
Backbeat Books
9781617134500...................... $24.99

**Pearl Jam FAQ**
*by Bernard M. Corbett and
Thomas Edward Harkins*
Backbeat Books
9781617136122 .........................$19.99

**Pink Floyd FAQ**
*by Stuart Shea*
Backbeat Books
9780879309503...................$19.99

**Pro Wrestling FAQ**
*by Brian Solomon*
Backbeat Books
9781617135996.......................$29.99

**Prog Rock FAQ**
*by Will Romano*
Backbeat Books
9781617135873 ................. $24.99

**Quentin Tarantino FAQ**
*by Dale Sherman*
Applause Books
9781480355880 ................. $24.99

**Robin Hood FAQ**
*by Dave Thompson*
Applause Books
9781495048227 ....................$19.99

**The Rocky Horror
Picture Show FAQ**
*by Dave Thompson*
Applause Books
9781495007477 .....................$19.99

**Rush FAQ**
*by Max Mobley*
Backbeat Books
9781617134517 .........................$19.99

**Saturday Night Live FAQ**
*by Stephen Tropiano*
Applause Books
9781557839510...................... $24.99

**Seinfeld FAQ**
*by Nicholas Nigro*
Applause Books
9781557838575.................... $24.99

**Sherlock Holmes FAQ**
*by Dave Thompson*
Applause Books
9781480331495.................... $24.99

**The Smiths FAQ**
*by John D. Luerssen*
Backbeat Books
9781480394490................. $24.99

**Soccer FAQ**
*by Dave Thompson*
Backbeat Books
9781617135989...................... $24.99

**The Sound of Music FAQ**
*by Barry Monush*
Applause Books
9781480360433................... $27.99

**South Park FAQ**
*by Dave Thompson*
Applause Books
9781480350649................... $24.99

**Star Trek FAQ
(Unofficial and Unauthorized)**
*by Mark Clark*
Applause Books
9781557837929......................$19.99

**Star Trek FAQ 2.0
(Unofficial and Unauthorized)**
*by Mark Clark*
Applause Books
9781557837936......................$22.99

**Star Wars FAQ**
*by Mark Clark*
Applause Books
9781480360181..................... $24.99

**Steely Dan FAQ**
*by Anthony Robustelli*
Backbeat Books
9781495025129 ..................$19.99

**Stephen King Films FAQ**
*by Scott Von Doviak*
Applause Books
9781480355514.................... $24.99

**Three Stooges FAQ**
*by David J. Hogan*
Applause Books
9781557837882.....................$22.99

**TV Finales FAQ**
*by Stephen Tropiano and
Holly Van Buren*
Applause Books
9781480391444......................$19.99

**The Twilight Zone FAQ**
*by Dave Thompson*
Applause Books
9781480396180...................$19.99

**Twin Peaks FAQ**
*by David Bushman and
Arthur Smith*
Applause Books
9781495015861.......................$19.99

**UFO FAQ**
*by David J. Hogan*
Backbeat Books
9781480393851 ..................$19.99

**Video Games FAQ**
*by Mark J.P. Wolf*
Backbeat Books
9781617136306 ......................$19.99

**The Who FAQ**
*by Mike Segretto*
Backbeat Books
9781480361034 ................. $24.99

**The Wizard of Oz FAQ**
*by David J. Hogan*
Applause Books
9781480350625 ................... $24.99

**The X-Files FAQ**
*by John Kenneth Muir*
Applause Books
9781480369740................... $24.99